PLAINS INDIAN DRAWINGS 1865-1935

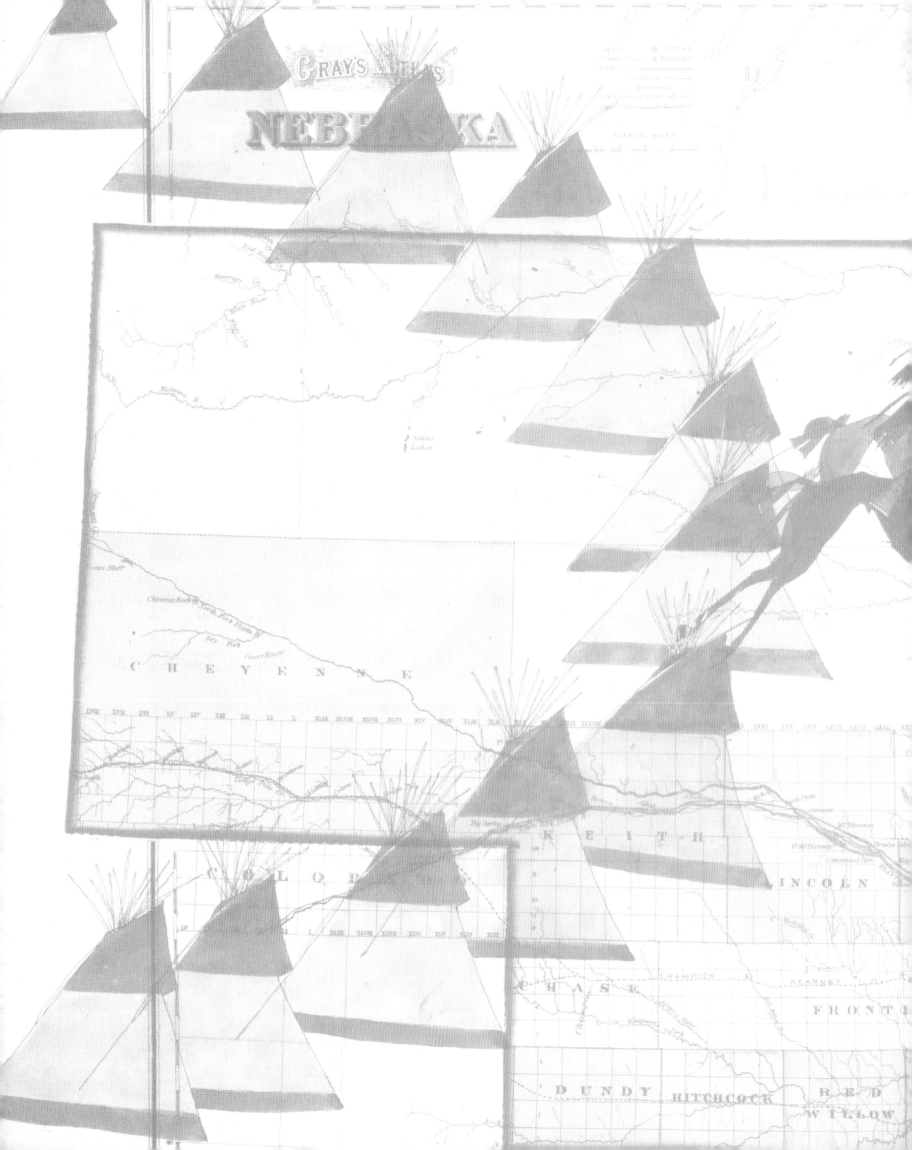

PLAINS INDIAN DRAWINGS 1865-1935
PAGES FROM A VISUAL HISTORY

Edited by
Janet Catherine Berlo

Essays by
Janet Catherine Berlo, Anna Blume,
Candace S. Greene, Marilee Jantzer-White,
Gerald McMaster, Jacki Thompson Rand,
W. Jackson Rushing, and Edwin L. Wade

Artists' statements by
Colleen Cutschall, Edgar Heap of Birds,
Jane Ash Poitras, and Francis Yellow

Catalogue entries by
Janet Catherine Berlo, Anna Blume,
Jennifer A. Crets, Candace S. Greene,
Marilee Jantzer-White, Joyce M. Szabo,
and Jennifer Vigil

Harry N. Abrams, Inc., Publishers,
in association with
The American Federation of Arts
and The Drawing Center

For Harry N. Abrams, Inc.:
Project Director: Margaret L. Kaplan
Editor: Diana Murphy
Designer: Ellen Nygaard Ford

For The American Federation of Arts:
Project Director: Michaelyn Mitchell

Library of Congress Cataloging-in-Publication Data

Plains Indian drawings, 1865–1935 : pages from a visual history / edited by Janet Catherine Berlo.
 p. cm.
 "In association with the American Federation of Arts and the Drawing Center."
 Includes bibliographical references and index.
 ISBN 0-8109-3742-5 (clothbound).
 ISBN 1-885444-02-8 (Amer. Fed. Arts, pbk.)
 1. Indian art—Great Plains—History—19th century—Exhibitions. 2. Indian art—Great Plains—History—20th century—Exhibitions.
I. Berlo, Janet Catherine. II. American Federation of Arts. III. Drawing Center (New York, N.Y.)
E78.G73P525 1996
741.97'089'97—dc20 96-5517

Published in 1996 by Harry N. Abrams, Incorporated, New York, A Times Mirror Company, in association with The American Federation of Arts and The Drawing Center, New York

The details on pp. 2–3, 6, 11, 63, 73, 90–91, 144–45, and 180–81 are taken from the images on pp. 71, 35, 42, 68, 77, 136, 15, and 71, respectively.

Photographs of works of art reproduced in this publication have been provided in most cases by the owners or custodians of the works, identified in the caption.

Figs. 5 and 6 on p. 31 originally appeared in Father J. Powell, *People of the Sacred Mountain* (San Francisco: Harper & Row, Publishers, Inc., 1981). Copyright by Foundation for the Preservation of American Indian Art & Culture, Inc.

Exhibition Tour

The Drawing Center
New York, New York
November 2–December 21, 1996

Milwaukee Art Museum
Milwaukee, Wisconsin
January 17–March 30, 1997

Joslyn Art Museum
Omaha, Nebraska
April 26–July 13, 1997

Frick Art Museum
Pittsburgh, Pennsylvania
August 7–October 19, 1997

This catalogue has been published in conjunction with *Plains Indian Drawings, 1865–1935: Pages from a Visual History*, an exhibition organized by The Drawing Center, New York, and The American Federation of Arts.

It has been made possible with generous support from the Henry Luce Foundation and the Rockefeller Foundation. Additional funding has been provided by the National Endowment for the Arts and the New York State Council on the Arts. The exhibition is a project of ART ACCESS II, a program of the AFA with major support from the Lila Wallace–Reader's Digest Fund. Philip Morris Companies Inc. is the sponsor of the national tour.

The American Federation of Arts is a nonprofit art museum service organization that provides traveling art exhibitions and educational, professional, and technical support programs developed in collaboration with the museum community. Through these programs, the AFA seeks to strengthen the ability of museums to enrich the public's experience and understanding of art.

The Drawing Center is the only not-for-profit institution in the country to focus solely on the exhibition of drawings, both contemporary and historical. It was established in 1976 to provide opportunities for emerging and under-recognized artists and to demonstrate the significance and diversity of drawings throughout history.

Note to the reader: The titles of the drawings are purely descriptive, unless the title is in italics, which indicates it is the caption written on the drawing.

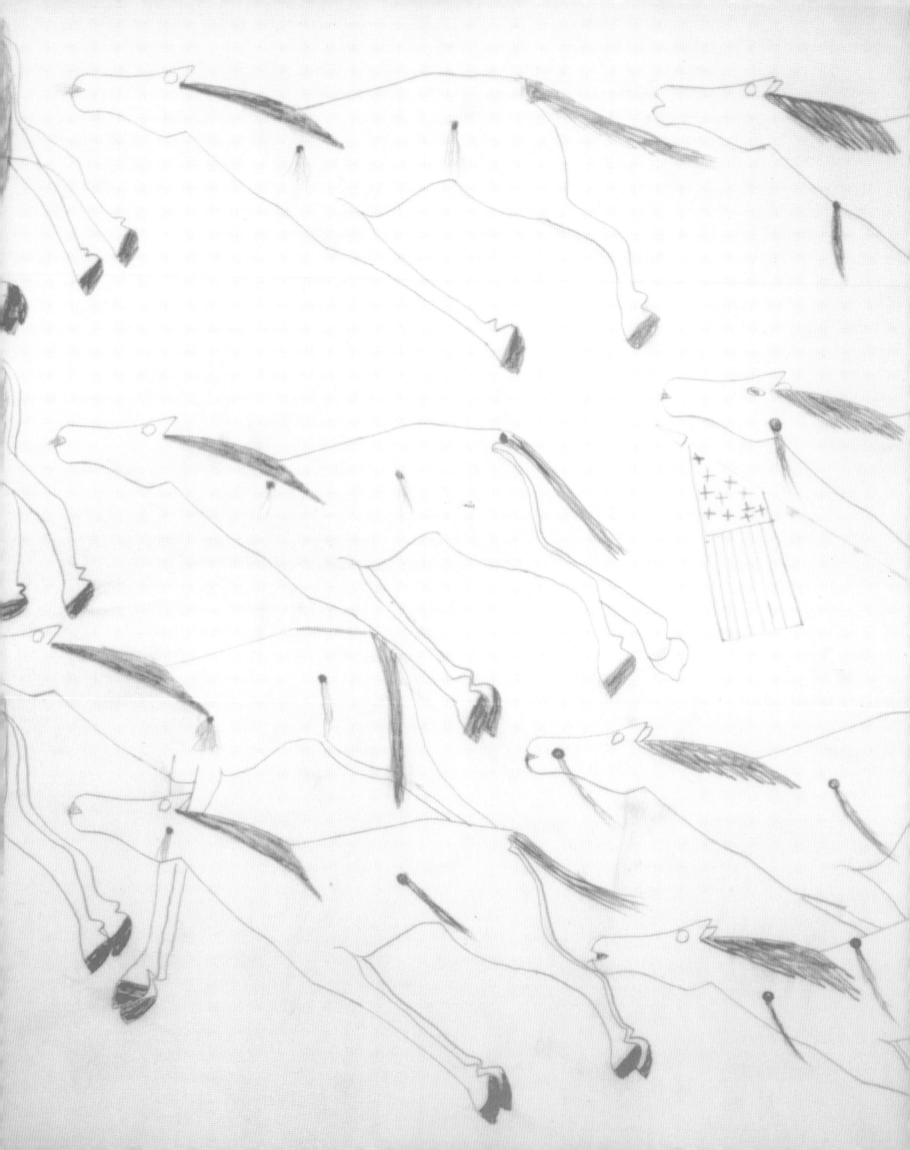

CONTENTS

Acknowledgments

When Ann Philbin and I had our initial discussions in February 1994 about mounting an exhibition of Plains Indian drawings at the Drawing Center, I never imagined what a remarkable journey I was undertaking. I am grateful to Ann for her long-term vision and enthusiasm for the show, and to Anna Blume for suggesting that Philbin and Berlo would be a good team.

I have learned a lot from the members of this research team. I am grateful that Gerald McMaster was willing to take time out of his busy schedule as an artist, writer, and museum curator to co-curate the exhibition with me. All the members of the advisory board for this project gave good advice. I am particularly grateful for the special efforts of Candace S. Greene and Edwin L. Wade. It has been a privilege to work with the numerous fine scholars and artists associated with the exhibition and a particular treat to work with four impressive graduate students: Anna Blume, Jennifer A. Crets, Marilee Jantzer-White, and Jennifer Vigil. In addition, Jennifer A. Vigil served as Native American curatorial intern for the project, and provided special help during the final stages of writing and editing the catalogue.

Several people deserve thanks for their support throughout the process of organizing the show and catalogue. Thomas Padon at the American Federation of Arts was initially the project's steward; I am grateful for his guidance and enthusiasm. Three remarkable women at the AFA, Donna Gustafson, Sarah Lark Higby, and Michaelyn Mitchell, have been a joy to work with. At Abrams, I have appreciated Diana Murphy's deft editorial guidance and Ellen Nygaard Ford's keen artistic vision. Aldona Jonaitis, Ruth Phillips, Anna Blume, W. Jackson Rushing, and Arthur Amiotte read drafts of several of my contributions to the catalogue. I am grateful for their insightful comments. Bradley Gale's sweet temperament and fine cooking sustained a harried writer and editor during the summer of 1995. I am grateful for the research assistance of Robin Rainey in the initial stages of this project, and the computer and editorial skills of Kim Patten during its final stages.

Some of the research on the Northern Plains drawings in this book and the show was done in collaboration with Arthur Amiotte, under the auspices of our joint Getty Senior Scholars Research Grant from 1994 to 1996. It has been one of the highlights of my professional life to work with this learned scholar and gentle man. I regret that his own illness and family responsibilities during the summer and autumn of 1995 prevented him from participating in this publication. My own research was further supported by a National Endowment for the Humanities Fellowship for College Teachers for 1994–95. I am thankful for the two-year leave of absence from the University of Missouri–St. Louis that enabled me to conduct this work, and for the support of two fine administrators there: E. Terrence Jones, dean of the College of Arts and Sciences, and Martin Sage, associate dean of the college.

Janet Catherine Berlo
St. Louis, Missouri
September 1995

This volume is published on the occasion of the first extensive historical survey of late nineteenth- and early twentieth-century Plains Indian drawings. It has been an honor for the organizing institutions, the Drawing Center and the American Federation of Arts, to undertake this landmark project, and with great pleasure we extend our thanks to the many individuals and organizations who have contributed to its realization.

We owe a large and very special debt of gratitude to Janet Catherine Berlo, co-curator of the exhibition and editor of the accompanying publication. Ms. Berlo, a professor at the University of Missouri–St. Louis and one of the foremost scholars of Native American art, undertook this project with great dedication and insight. Of particular significance was her commitment to considering her research part of a larger dialogue. Therefore it was fitting that Ms. Berlo chose to organize the exhibition with Gerald McMaster, Plains Cree artist and curator at the Canadian Museum of Civilization, Quebec. Mr. McMaster was an invaluable addition to the curatorial team, offering sound and informed counsel throughout the exhibition's development.

From the beginning of this project, securing the advice and guidance of others who have contributed to the understanding of Plains Indian arts and culture was of primary importance. We are thankful to Ms. Berlo for assembling a group of Native American artists as well as historians of Native arts, who were consulted on many matters, from the selection of drawings to decisions regarding public programming.

Our appreciation is extended to the following advisors: Arthur Amiotte, Anna Blume, Colleen Cutschall, Candace S. Greene, Edgar Heap of Birds, W. Jackson Rushing, and Edwin L. Wade. In addition to providing advice, most of the committee members also contributed to this publication, the most comprehensive treatment of Plains Indian drawings to date.

Special thanks are extended to the lenders who so graciously consented to loan works from their collections. Their generosity has given the exhibition its quality and depth. In addition, we are extremely grateful to the institutions who have joined us in the presentation of this exhibition. We extend our appreciation to Russell Bowman at the Milwaukee Art Museum; Graham Beal at the Joslyn Art Museum, Omaha; and DeCourcy McIntosh at the Frick Art Museum, Pittsburgh.

The realization of this project required the collaboration of a committed group of individuals at three institutions. At the Drawing Center, we thank viewing program curator James Elaine, who has been an advocate of this exhibition since its inception, as well as assistant curator Elizabeth Finch and registrar Sarah Falkner, who were instrumental in coordinating many aspects of the project. At Harry N. Abrams, Inc., we wish to thank Margaret Kaplan, senior vice president and executive editor; Diana Murphy, senior editor; and Ellen Nygaard Ford, designer. At the AFA, we acknowledge the efforts of Melanie Franklin, former exhibitions assistant; Rachel Granholm, head of education; Donna Gustafson, curator of exhibitions, who oversaw the organization of the exhibition; Sarah Higby, assistant to the director of exhibitions; Alexandra Mairs, former exhibitions/publications assistant; Corrine Maloney, exhibitions assistant; Michaelyn Mitchell, head of publications, who oversaw the organization of the publication; Thomas Padon, director of exhibitions; Diane Rosenblum, registrar; Jillian Slonim, director of public information; and Jennifer Smith, public information associate.

An exhibition of this scope necessarily entails extensive research and planning, and it was evident from the start that this work could not be accomplished without special funding. We are fortunate to have received support from several sources. Special thanks are offered to Ellen Holtzman, program director for the arts, the Henry Luce Foundation, and to Tomás Ybarra-Frausto, associate director of arts and humanities, the Rockefeller Foundation. We are also most grateful to the National Endowment for the Arts and the New York State Council on the Arts for the grants that aided this presentation. As sponsors of the national tour, Philip Morris Companies Inc., and in particular Stephanie French, has our deep gratitude. To all of these contributors, we offer our profound thanks.

Ann M. Philbin
Director
The Drawing Center

Serena Rattazzi
Director
The American Federation of Arts

Preface

Janet Catherine Berlo

Within the last twenty years, scholars as well as the general public have shown a heightened interest in drawings made by Plains Indian men during the last third of the nineteenth century and the first third of the twentieth. These drawings were not really considered art much before the 1960s, for reasons having to do with Euro-American prejudices against materials and genres that did not seem "authentic," or "traditional" (those loaded words we have been interrogating in recent scholarship on Native American arts). Ledger drawings, as they are called whether drawn in business ledgers or drawing books, have increasingly been included in exhibitions and scholarly writings on Native American art, and command high prices at auctions and galleries. Yet our analysis and interpretation of such drawings is in its infancy.

Plains Indian drawings, made in the seventy-year period between 1865 and 1935, tell many stories. But writings about these drawings have focused too much on one set of questions, based on European models: Who is the artist? Who is depicted? What are the identifying details of the narrative? These drawings have seldom been treated as complex works of art rather than simple historical or ethnographic documents (Lessard 1992). Yet the unraveling of ethnographic details is only one narrative thread in a complexly woven story. We sadly underestimate the evocative power of these works if we unwind only that thread. To most art historians and Native scholars in the 1990s, what is of greater interest are the subtleties of interpretation involving social, religious, and economic history and artistic biography, which reveal each work as an individual creative phenomenon within a complex social nexus.

Works of art are, of course, historical documents, but as all art historians know, they are not *merely* historical documents. The artist inscribes his or her intentions but also, at times, a residue that transcends those intentions. In the case of ledger drawings, what is revealed is an unsettling portrait of one historical era, and a complex sociocultural portrait of individuals within that era. These works were made at a pivotal time when Native American cultures were under assault, people were being confined to reservations, and the parameters of their world were deeply shaken.

Many different stories are told in ledger drawings; the essays, dialogues, catalogue entries, and artists' statements in this volume aim to address these stories in a range of diverse ways. In the catalogue entries we have focused on examining the work of individual artists, whether we know their names or not. It is timely, we believe, to reintroduce the original historian of the Great Plains, the nineteenth-century Native American artist/warrior/historian whose voice has too often been unheard in discussions of the new Western history, but whose voice has been emerging in recent scholarship on Plains art (Maurer 1992).

The works of art in this exhibition and publication have been drawn from public and private collections. Drawings by Arapaho, Cheyenne, Kiowa, and Lakota artists are represented, for these were the major cultural traditions in which drawings were produced. While smaller numbers of works are known from Assiniboine, Crow, Gros Ventre, and other groups, space limitations have not allowed us to include them (but see Heidenreich 1981, 1984; Cowles 1982; Robertson 1993; and Warner 1985).

Ledger drawings stand at the threshold of modernity. They look back at the past and forward to a future for Native peoples that is dramatically transformed. Many contemporary Native American artists have been nourished by ledger drawings as a stylistic or thematic source for their work.

So it is important to ask, and then to listen to, the multiple, subtle answers that are given to the question: How do ledger drawings resonate today for Native American artists exploring issues of identity, ethnicity, power, and humor in their own works? For this reason, we have invited several notable contemporary Plains artists to comment on particular drawings and on the genre in general, as a tradition with meaning for their own artistic practice.

Recent paradigm shifts in anthropological and art historical scholarship remind us that there is never a simple one-to-one correspondence between an image and a historical event. All artistic representations are multivalent. Their meanings accrue as they are made and used, as they change hands, and as they become significant again many years after their creation. Ledger drawings are no exception. Historian Susan Hegeman maintains that Native texts demonstrate an epistemological flexibility born out of political and cultural necessity (1989); she advocates that our scholarship about them must likewise maintain such flexibility. Just as Native American texts may not necessarily conform to our expectations of the generic categories of "history" or "poetry," so, too, Native American arts may inscribe meanings that are not easily narrated by Western conventions of art historical scholarship alone. For these reasons, a multitude of approaches must be employed, involving Native American artists and historians, academically trained art historians, anthropologists, and others, in order for us to appreciate these multivalent works. We hope that the writings of the multidisciplinary research and advisory team that has come together to make this exhibition and catalogue will help to move the study of late nineteenth-century Plains graphic arts to a new level of understanding.

...erty belonging to the Cheyenne Indians lost or destroyed at Sand Creek, Colora...

...U.S. troops, Commanded by Colonel Chivington, on the

English	Condition after the attack			Nearest living relation				Property lost			Specific value of property as designated by the Commission		
	Killed	Wounded	Missing	Wife	Children	Fathers or Mothers	Grand Children	Horses	Mules	Lodges & furniture	Dollars	Cents	
White Hat	1	-	-	1	3	-	-	6	1	1	425	00	
Bear Skin	1	-	-	1	4	-	-	6	2	1	475	00	
Wounded Bear	1	-	-	1	2	-	-	-	-	1	75	00	
Bear Feather	1	-	-	1	5	-	-	8	1	1	525	00	
Crow Necklace	1	-	-	1	3	-	-	13	1	1	775	00	
Two Seams	1	-	-	2	3	-	-	15	3	1	975	00	
Black Wolf	1	-	-	2	3	-	-	33	5	1	1975	00	
White Antelope	1	-	-	1	5	-	4	6	2	1	475	00	
One Eye	1	-	-	3	6	-	-	10	-	1	875	00	
Tall Bear	1	-	-	1	3	-	2	10	1	1	625	00	Grand children fema...
Black Kettle	-	-	1	2	1	-	-	21	6	1	1425	00	
Feather Head	1	-	-	1	5	-	3	16	2	2	1030	00	
Tall Wolf	1	-	-	1	-	-	-	1	1	1	175	00	Children Killed
Keep of Crows	1	-	-	-	1	-	-	1	-	1	125	00	Wife
Spotted Crow	1	-	-	1	4	-	-	9	2	1	625	00	
Man standing in the water	1	-	-	2	-	-	-	-	-	1	75	00	This Man was in...
Big Head	1	-	-	2	1	-	-	20	-	1	1075	00	
Red Arm	1	-	-	1	2	-	-	6	-	1	375	00	
Sitting Bear	1	-	-	1	3	-	-	12	1	1	725	00	
The Kiowa	1	-	-	1	6	-	-	-	-	1	75	00	
Big Shell	1	-	-	1	1	-	-	10	1	1	625	00	

Essays

Drawing and Being Drawn In: The Late Nineteenth-Century Plains Graphic Artist and the Intercultural Encounter

Janet Catherine Berlo

On Drawing

A profound sense of history has long compelled Indian peoples of the Great Plains of North America to chronicle their lives pictorially. Images inscribed on rock walls served for hundreds of years as a large-scale, public way of marking historical events and visionary experiences. Narrative scenes on buffalo hide robes and tipis provided records of a man's experiences and visions. His exploits in war or success in the hunt would be painted on his garments and his shelter to validate and memorialize those heroic deeds. This was personal history made public, for all to see.

In some nations, particularly the Kiowa on the Southern Plains and the Lakota on the Northern Plains, historical accounts transcended a particular individual's experiences, reflecting family or band history, and were inscribed pictorially in "winter counts"—records of what happened last winter, and the winter before that, extending back for decades, or occasionally, centuries.[1] The visual images in the winter counts and other painted hides served to fix an essentially oral history in the mind's eye. Such images also helped preserve that history for future generations.

As the nineteenth century progressed, Plains men adopted a new, smaller-scale medium for their pictorial histories: they began to draw on paper, using pens, pencils, and watercolors.[2] These new mediums were provided by explorers and traders early in the century, and by military men and Indian agents in the second half of the century. The white men who trickled across the continent and up the great rivers in the 1830s and 40s became an unstoppable flood tide of soldiers and settlers after 1860.[3] Their presence changed Plains Indian life irrevocably.

The first Native histories of those profound changes occur in the drawings made by Plains men. The large, bound ledger book—a pedestrian item used for inventory by traders and military officers—was appropriated by Indian artists on the Great Plains as a new surface upon which to draw. The use of autograph books, sketchbooks, note paper, recycled stationery, and other paper materials followed. Sometimes pencils and notebooks were among the goods exchanged in trade; sometimes they were part of the plunder taken from white soldiers' bodies on battlefields (see cat. no. 47). Drawings made with these new materials were both a continuation of traditional male representational and historical arts, and a new avenue for exploration. While recording personal and tribal history, they also provided an artistic record of the profound changes occurring in indigenous life in the nineteenth century. Moreover, drawings in books and on sheets of paper served as an important medium of intercultural communication.

Early travelers to the Great Plains repeatedly noted the power that visual images held for Aboriginal people, and how impressed the Native Americans were with some of the pictorial arts of their visitors. In the 1830s, George Catlin described the eagerness with which Crow, Blackfeet, and Assiniboine men viewed his painting: "My painting room has become so great a lounge, and I so great a 'medicine-man,' that all other amusements are left, and all other topics of conversation and gossip are postponed for future consideration" (1973:42).

Similarly, the work of Swiss artist Karl Bodmer, a member of Prince Maximilian of Wied's expedition of 1832–34, engendered great excitement. Like artists everywhere when confronted with new modes of expression, Native men who observed the work of Catlin and Bodmer were fascinated by the different methods and materials used by these accomplished artists. Prince

Maximilian noted in his journals the enthusiasm with which many men posed for portraits, and how they admired their detailed likenesses. During the winter of 1833–34 on the upper Missouri River, Bodmer befriended Mato-Tope, a Mandan chief. Bodmer not only painted multiple portraits of Mato-Tope, but also shared his own paper, pencils, and watercolors with him. Remarkably, one of Mato-Tope's own drawings from this season survives; it has become a familiar icon of nineteenth-century Plains art (Ewers 1957; Maurer 1992:fig. 149). Clearly, the Mandan artist had learned an appreciation for the manner in which details of clothing and body painting can enhance a drawing, for Mato-Tope carefully delineated face painting, quillwork, and other details in his self-portrait, appropriating Bodmer's delicacy of line and pattern as his own. In contrast, the indigenous Plains tradition of representation dictated a great economy of means in drawing: elegant stick-figures in a semi-abstract style with limited detail (pl. 1; see cat. nos. 13, 14).

As early as the 1840s, Indian artists used the new materials to chronicle the tumultuous changes resulting from contact with whites, as exemplified in drawings collected near Fort Benton by Nicolas Point, a Jesuit companion of Father DeSmet, the tireless missionary who traveled the upper Missouri from 1840 to 1848. One particularly poignant drawing shows a trader selling distilled liquor to an Indian (Peterson 1993:113). No doubt Father Point provided materials to the artists who created such drawings, for he was, himself, an architect and draftsman who made many drawings of the people and places encountered in his missionary work (Peterson 1993:72–77).

Rudolf Friederich Kurz, a Swiss artist who lived and sketched among the Indians of the upper Missouri River from 1846 to

1852, wrote several times in his journal that some of the Indians were extremely suspicious of the realistic likenesses he drew. And well they might have been—for in the preceding decades, virulent outbreaks of smallpox had followed in the wake of white visitors. It perhaps made sense to lay blame at the feet of the powerful artists of the visiting delegations. "Not withstanding their mistrust, however," he wrote, "they were so impelled by curiosity that they would stand in wonder before the drawings and took great pleasure in looking at them and in recognizing Pere DeSmet, Picotte, and Captain Laberge from some rough sketches I made of those gentlemen" (Hewitt 1937:77).

While it was standard practice for these nineteenth-century white artists to boast in their diaries and letters of how the Indians were impressed by Euro-American canons of realism, Kurz admits that such was not always the case: "While I was sketching this afternoon the Sioux visited me. He brought two interesting drawings. He was not satisfied with my work; he could do better. Forthwith I supplied him with drawing paper."[4]

The circumstances in which Bodmer and Point collected indigenous drawings further highlight how the Plains graphic arts tradition of drawing on paper and in books is essentially an art of intercultural communication. Drawings were a common meeting ground for those few whites trying to build bridges of understanding with Native Americans. In the 1840s, DeSmet and Point emphasized that they used pictures to educate and convert the Indians (Peterson 1993:108). For the next fifty years, Indians used pictorial means to educate whites about indigenous traditions and histories.

Father DeSmet provides one anecdote that illustrates the importance that a well-made graphic image held for the Lakota. In 1846, he visited the Lakota assembled on the upper Missouri River, where he preached, baptized children, and distributed medals of Pope Pius IX to the head men. One of these chiefs showed the "Black Robe" one of his prized possessions: "He at once opened a little box and drew forth from it a package, carefully wrapped up in buckskin. He unrolled it, and, to my great surprise, I saw a colored picture of General Diebitsch [a Russian officer who served in the Napoleonic wars], in full uniform and mounted on a beautiful war horse. For years the Russian had been the Manitou of war to the Sioux chief; he invoked him and offered him his calumet, before all his enterprises against his enemies, and attributed to him the success of the many victories he had gained" (Chittenden and Richardson 1969:634). While such a brilliantly colored foreign image was held in high esteem by one Lakota chief, it is just as clear that drawings made on paper and in ledger books by Plains warriors themselves were equally powerful, for they evoked an indigenous history. The vivid reminder of victories in past warfare no doubt helped ensure victory in the next skirmish or pony raid. These drawings were produced in greatest number in the 1870s, 80s, and 90s; a handful have survived from the four decades before that, and the drawings continued to be made for several decades thereafter. (The essays by Greene and Berlo in this volume further explore the historical context and indigenous use of these drawings.)

The earliest securely dated works in this volume are the Arapaho drawings made by Little Shield (see pl. 1) before 1868. They are remarkable for the elegant simplicity of line, and the economy by which much historical data is conveyed. The latest works we will consider date from the 1930s, when elderly Lakota men were still being commissioned by historians, anthropologists, and collectors to chronicle the old ways in the old style (see cat. nos. 134, 135, 151–53).

It is one of the tragic ironies of history that United States military men on the Plains, sent to wipe out Native culture, were intensely interested in the drawings they plundered from dead warriors on battlefields and commissioned from Indian scouts as mementos of their days in "Indian country." That the indigenous people were killed and their art valued as relics of a vanishing civilization is one of the many perverse paradoxes of the late nineteenth-century anti-Indian military campaigns.[5] Along with beadwork and hide painting, examples of which military men collected, drawing books were an especially coveted type of relic, for they directly documented the wars themselves.

The Summit Springs book in the Colorado Historical Society was, in the words of the flyleaf inscription, "captured by the 5th U.S. Cavalry on their charge through the Indian village, July 10, '69. 60 Indians killed, and many wounded." At another battle a few years later, a New York newspaper correspondent reported that he saw "books taken from the teepees, on the leaves of which had been sketched the exploits of the Cheyenne braves" (Powell 1976:38). Capt. John G. Bourke, who spent much of the 1870s involved in military campaigns in the West, took drawing books from Indian camps that his company ransacked. He also bought books and drawings from Indians, military men, and traders, amassing well over one thousand such drawings (Porter 1986:63–64), among them cat. nos. 17–21. It is noteworthy that Bourke mounted his own large display of these drawings in Omaha in 1881.[6] Bourke's exhibition, and the attention paid to Sitting Bull's drawings in the popular press of the times (as discussed in my other essay in this volume), suggest that such art works were of intense interest to the public then, too.

In the 1870s, while blood was being shed and Indian drawing books were being plundered as spoils of war in Dakota Territory and Indian Territory (present-day

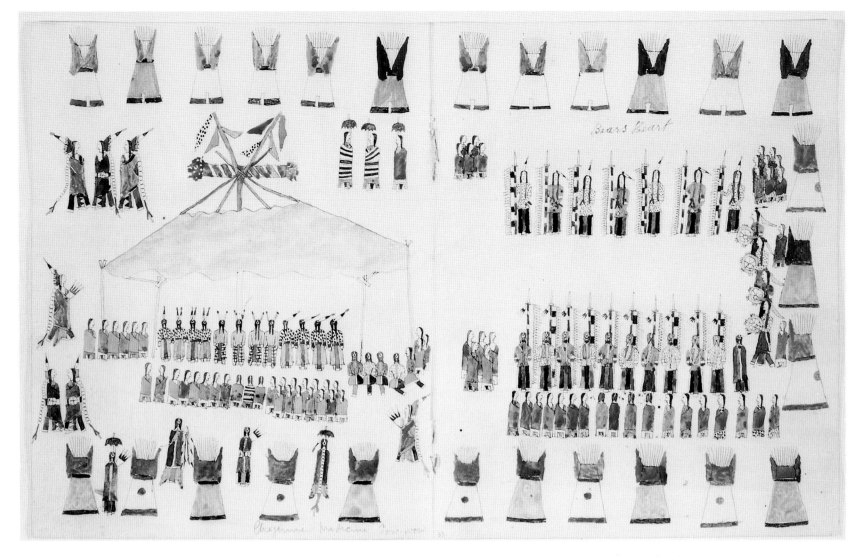

Figure 1. Bear's Heart, Cheyenne.
Cheyenne Medicine Pow-wow. 1876–77.
Pencil and ink, 8 x 12⅞ in. Massachusetts
Historical Society, Boston

Oklahoma), a different sort of battle was being waged in a military prison in Florida, a battle for the hearts and minds of Indian men. Oddly enough, this conflict involved the intercultural exchange of books as well.

Capt. Richard H. Pratt, who had served since 1867 as a military officer on the Southern Plains, was the jailer for some six dozen Cheyenne, Kiowa, Arapaho, and other prisoners who had been rounded up, accused of various crimes against white settlers and soldiers, and transported by train from Indian Territory to St. Augustine, Florida, in the spring of 1875. They would spend the next three years as prisoners of war in a seventeenth-century Spanish stone fort, then called Fort Marion.[7]

As part of an experiment in penal reform, one that drew the attention of Harriet Beecher Stowe and other reformers of the day, Pratt insisted that the prisoners be taught reading and writing, be given religious instruction, and be assigned to manual labor (pl. 2; see cat. no. 56). They earned money and privileges by making items to sell to tourists, such as bows and arrows, fans and pottery jars painted with scenes of Indian life, and, most notably, small drawing books filled with vivid autobiographical pictures.[8]

Scores of these books were made between 1875 and 1878, the years of the men's incarceration. They were sold to tourists for two dollars apiece. While it is hard to know precisely what motivated Pratt in encouraging the Indian men to make these drawing books, in part he

seemed to see the books as a vehicle for educating white America about his successful penal/educational colony. Surely a belief in the Victorian, Christian virtues of industry and purposeful work were a part of it as well. Perhaps he simply saw the making of these books as a harmless pastime, one that brought income to the men. With the hindsight of one hundred and twenty years, however, we can clearly see the power of these small but eloquent images in keeping a tribal spirit alive inside the Cheyenne and Kiowa men whose hair had been cut and who were forced to wear military-issue garments. A "schoolboy" in a blue serge uniform drawing pictures of the old way of life is keeping that way of life alive; to draw the past is to remember it and to convey it to others (see fig. 1). In some draw-

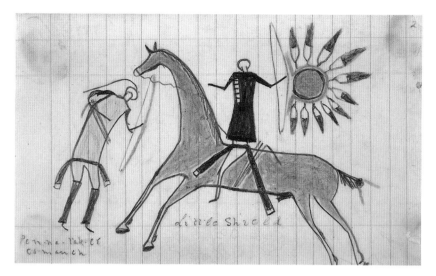

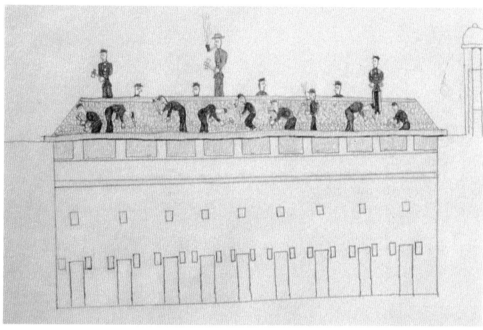

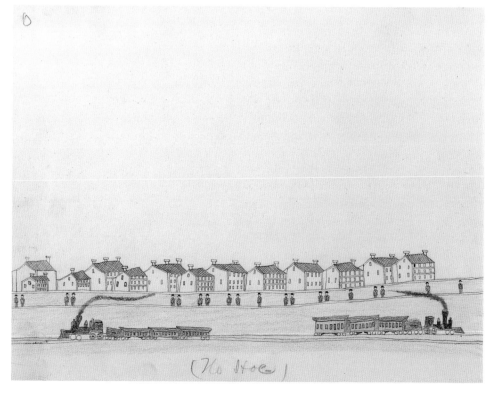

ings, the prisoners were making sense of the profound transformations they underwent during the cross-country passage by train and steamboat to a dank stone fort (see cat. no. 103). In others, the artists labored as ethnographers of an alien culture, chronicling the large cities, the Victorian ladies, and the curious customs they observed (pl. 4; see cat. no. 60).

Books held a valued place in the lives both of incarcerated warriors in Florida and of those still fighting for their lands in the West. Some of this regard for the power of books was transferred from white culture, but some was grounded in an indigenous Aboriginal belief in the power of history and of images, now combined with a new belief in the power of the written word. The renowned Lakota intellectual George Bushotter (1864–1892) was one of many late nineteenth-century Indians who recognized the value of books. As a boy, he took newspaper, folded and cut it, and sewed it together to make a small book, which he would pretend to read. As a student at the Hampton Institute in Virginia from 1879 to 1881, he drew pictures of the changing lifeways of the Lakota. Notably, Bushotter later became the first Lakota to write a Lakota history in his own language.[9]

Another Aboriginal historian who valued the importance of books was Old Bear, a Cheyenne who lived in Lame Deer, Montana, at the turn of the century. When famed ethnologist George Bird Grinnell brought back to the Cheyenne in 1898 a drawing book that had been captured on a battlefield in 1876 (see cat. no. 47), Old Bear was irate over the defacement of the book. As Grinnell wrote, "I have been lucky enough to find a man who drew his own picture in the book and has identified most of the portraits. Old Bear, just referred to, recognized the book as soon as it was handed to him, and professed great indignation that many of the pictures had been taken out of it. It was once much larger, he says" (Grinnell n.d.: cover letter). Twenty-two years after having last seen the book, Old Bear was distressed by the loss of some of the historical data in it.

On Being Drawn In

Among the most visually powerful drawings are those that show little influence from non-Native sources—the simple, spare renderings of human figures and horses that provide a stenographic account of life on the Plains (see cat. nos. 17–21). But among the most eloquent—and the most heartwrenching—are those that trace, both in subject matter and style, the gradual "drawing in" of Native American people to the hegemonic worldview of the dominant, white culture. These drawings chronicle both resistance and acquiescence to this "drawing in." It is worthwhile to try to see through the palimpsest of meanings that have accrued to these drawings: the meanings that the artists themselves invested in their works, and the meanings that white military officers on the Great Plains or tourists at Fort Marion found in these drawings. In their essays in this volume, Marilee Jantzer-White and Edwin L. Wade and Jackie Thompson Rand consider this topic in more detail.

A third and fourth layer, of course, are the meanings the drawings hold for scholars and Native American peoples more than one hundred years after they were drawn (as this book as a whole, and the artists' statements, in particular, bear witness). From our vantage point, we can only hypothesize about the various meanings these drawings had for maker and buyer. In the case of the Fort Marion drawings, the free-form depictions of traditional life and rigid portrayals of the regimentation at Fort Marion contrast vividly (see cat. nos. 44, 45). These artists were making sense of the habits of two cultures diametrically opposed in their worldviews. To be stripped of traditional garb, dressed in monotonous-looking military-issue uniforms, forced to stand at attention for inspection and to sit still for sermons were certainly disorienting experiences. Such regimentation was markedly different from the relative autonomy enjoyed by young warriors in Plains military societies. The artists chronicled these events in an effort to make sense of the senseless changes in their lives.

The men's jailer and other social reformers of the day believed fervently that education and religious conversion would "solve the Indian problem" in a more noble way than the bloody military battles taking place out West.[10] To them, perhaps, the

drawings that depicted the order, structure, and conformity of the new life were palpable proof of the transformation in Native Americans' minds and habits deemed essential for these peoples to be incorporated into the dominant culture. Moreover, the little books served as portable testimonials that could be circulated to other, like-minded reformers as evidence of social change (see cat. nos. 44, 45).

Certainly the prisoners at Fort Marion were used as the proof upon which the next few decades' valorization of educational reform was built, in schools such as Carlisle Indian School and the Hampton Institute, where some of the Fort Marion prisoners were among the first class of students. Later generations of students wrote about their experiences at these schools, but the Fort Marion drawings remain the first Native accounts, rendered when the autobiographical tradition was still almost entirely an oral and pictorial one (Wong 1989a, 1989b).

In the Fort Marion drawings, to see the transformation of a brave autonomous warrior into a docile schoolboy is to be reminded of a people's dispossession. These works often seem to depict a grim resignation to the new order of life combined with a profound fascination with all of the mechanical and procedural details that make up this curious new life (see pls. 2, 3).

One consequence of being drawn in to the dominant culture was that some artists felt the need to commit acts of self-censorship in their works. For example, the Fort Marion artists rarely depicted battles against the U.S. Army in their drawing books (see cat. nos. 44, 45). Much more frequently they portrayed hunting scenes or skirmishes in which other Indians, rather than whites, are the adversaries.

In one Cheyenne ledger, a number of the drawings were altered, presumably by the artist, before the book was sold to a non-Indian. In some instances, the white enemies were given long hair and made to look like Indians, wooden houses were overdrawn with tipis, and wagon wheels turned into shields (figs. 2, 3). Was this an effort to rewrite—or, rather, re-pictorialize—history in order not to offend the white purchaser of the book?

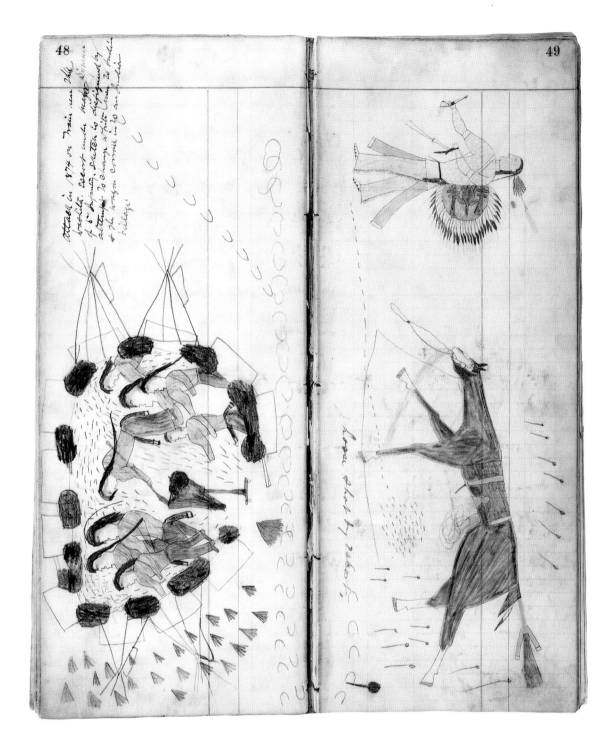

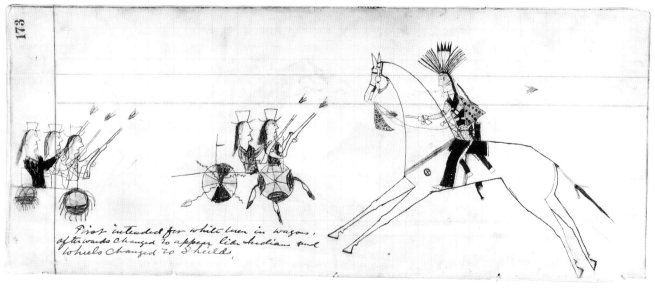

Figures 2, 3. Artist unknown, Cheyenne. Untitled. 1870s? The Newberry Library, Chicago. The artist drew over the imagery to transform white enemies to Native American ones.

In 1881, when the famed Hunkpapa Lakota chief, Sitting Bull, was a prisoner of war at Fort Randall in Dakota Territory, a missionary who was curious about Lakota history showed him a familiar sheaf of images: they were drawings that Sitting Bull's uncle, Four Horns, had made of events in Sitting Bull's life (see cat. nos. 124, 125). Apparently, Sitting Bull would only comment on some of the earliest events: his first coup as a young boy, and a fight with an Indian enemy. He seemed to feel it would be best to remain silent on those drawings that depicted fights with the cavalry. In subsequent drawings that Sitting Bull made for sale or as gifts to non-Indians, he avoided such controversial subjects (Utley 1993:243–44).

Black Hawk worked during the bitter winter of 1880–81 on his beautiful drawings of Lakota ceremonies that he sold to the Indian Trader for fifty cents apiece (see Yellow, pls. 1, 2 [p. 71]). In doing this, he was not only providing food for his family, but he was also reminding them of who they were, and how rich their culture was, even in times of extreme hardship. From our vantage point a century later, we can see that Black Hawk also opened a vivid window into Lakota ceremonialism that informs a new generation of indigenous people avidly interested in the history of their religious practices.

To make a picture can be a revolutionary act, an autobiographical act, an act of covert resistance. It can be a way of mourning the past, and fixing it in historical time as well. While many artists made drawings for sale to outsiders to earn money during a time of poverty, dislocation, and outright starvation, it has been too little appreciated that the act of making even those drawings intended for sale also held profound meaning for those who made them. It is an act of resistance to chronicle the old ways and keep them alive.

The eloquent images made by Plains Indian graphic artists in the nineteenth century and the first decades of the twentieth century speak to us today on many levels about Native history, oppression, resistance, autonomy, and artistry. In their sheer beauty, they also speak eloquently about the powerful urge to draw. We are still just beginning to limn their many meanings.

Notes

1. See Maurer (1992:15–45) for a historical overview of the Plains pictorial tradition. His catalogue includes numerous fine winter counts and other historical paintings on skin, muslin, and paper.

2. They also began to use plain yard goods such as muslin and canvas to continue the tradition of large-scale epic battles and histories. See, for example, Maurer 1992: figs. 140, 143, 154, 155.

3. As Little Crow, a leader of the Santee Sioux in Minnesota, said at the time of the 1862 uprising, "The white men are like the locusts when they fly: so thick that the whole sky is a snowstorm. You may kill one, two, ten; yes, as many as the leaves in the forest yonder, and their brothers will not miss them. Kill one, two, ten, and ten times ten will come to kill you. Count your fingers all day long and white men with guns in their hands will come faster than you can count" (Anderson and Woolworth 1988:40).

4. Kurz goes on to say: "First he made a drawing of his 'coup.' Then, with ink, he drew a buffalo, very well indeed for a savage. In their drawings Indians attempt to make especially prominent some outstanding distinguishing feature. For instance, in drawing the figure of a man they stress not his form but something distinctive in his dress that indicates his rank; hence they represent the human form with far less accuracy than they draw animals. Among the Indians, their manner of representing the form of man has remained so much the same for thousands of years that they look upon their accepted form as historically sacrosanct, much as we regard drawings in heraldry. We must take into consideration, moreover, that the human form is not represented in the same manner by all nations; on the contrary, each nation has its own conventional manner" (Hewitt 1937:301).

5. The literature on these battles is enormous. For an introduction, see Milner et al. 1994, and Utley 1973.

6. See Bourke 1872–96:2860–62. For an account of the fascinating transformation of Bourke the military officer into Bourke the ethnologist, see Porter 1986.

7. It is today a national monument, known by its original Spanish name, Castillo San Marcos. For Pratt's own memories of his years with the prisoners at Fort Marion, see Pratt 1964:91–190.

8. The superb, groundbreaking work on the Fort Marion drawings was done by Petersen (1971). More recently Szabo has provided a fine introduction to the same topic, focusing principally on the work of one artist, Howling Wolf (1994c). For Harriet Beecher Stowe's contemporary view of the Fort Marion prison experiment see Stowe (1877). For illustrations of the painted fans and pottery jars, see Hultgren (1987).

9. See DeMallie for Bushotter's love of books (1978:92) and for a history of his life (1978:passim). Several of the drawings he made at school have been published in Ewers et al. (1985:figs. 10–12).

10. The phrase "solve the Indian problem" was one that appeared often in the military and reformist writings of the era. See Mardock (1971) for a discussion of these issues.

Encyclopedias of Experience: A Curatorial Dialogue on Drawing and Drawing Books

Janet Catherine Berlo and Gerald McMaster

This dialogue grew out of conversations, both verbal and epistolary, carried on between Berlo and McMaster from December 1994 through September 1995.

Janet Catherine Berlo: The most remarkable thing about ledger drawings as a genre is that they depict the comprehensiveness of the Plains Indian worldview in the second half of the nineteenth century. These books are encyclopedias of experience. Some books mark the beginnings of sacred historical time (see cat. no. 128). Others chronicle very specific historical moments: military encounters between Lakota and Crow (see cat. no. 107); an arduous odyssey across the country to a Florida jail (fig. 1). It seems so clear that the combined acts of drawing and telling put all these tumultuous events into perspective and made them comprehensible.

Gerald McMaster: "Encyclopedias of experience"—I like your metaphor. By presenting a number of intact books as well as individual drawings, we have, in effect, presented an encyclopedia of nineteenth-century Aboriginal experience, although not in the traditional sense. The books do stand as articulations of life and history, truth, dreams, and tragedy. Aren't a large majority of the loose drawings from books?

JCB: Yes. Although there are some instances in which Plains artists used single sheets of paper upon which to draw, it is far more common that they made numerous drawings in books. In some cases, all the drawings in one book are by one hand; in others, they are by several artists.

In his diary, John Gregory Bourke, who amassed the largest collection of ledger books and drawings in the nineteenth century, wrote in 1877 that his Indian scout had told him that such books "are not necessarily the military history of one person: pretty nearly every boy has one which he keeps as a memento of his own progress.

But it is extremely common for intimate friends to insert in each other's books evidence of mutual esteem by drawing scenes from their past lives (to serve about the same purpose as the interchange of photographs and autographs does with us)" (Bourke 1872–96, vol. 20:1972–73).

GM: There is a sense of sharing and exchanging between males that is more out of familiarity and friendship than curiosity. I see this practiced at powwows and other community events, for example, where men and women are segregated, out of respect and tradition. It is that sense of *communitas* that Victor Turner writes about, where boys and men of the same age tend to stay close together in camaraderie and to help each other out (Turner 1969). In a way, the act of drawing in each other's book expresses that camaraderie. The paradox is that, as we know, within this closeness tremendous individuality existed.

JCB: Today we tend to think of ledger drawings as individual images. Moreover, because of the way that objects have to be displayed, and because of a Western predilection for the single image, I think many people forget that these were books, with many images.

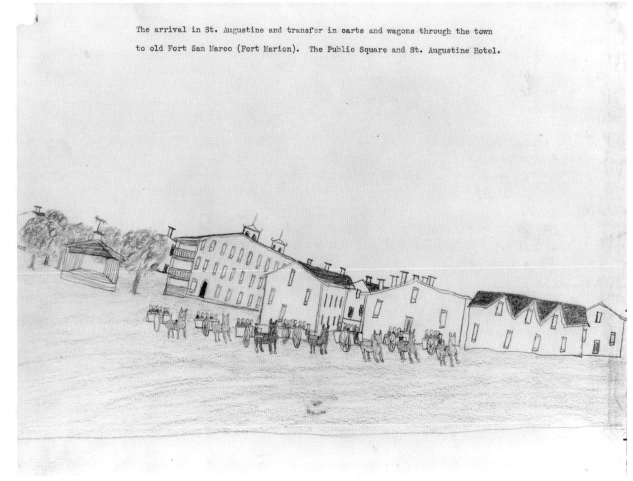

The arrival in St. Augustine and transfer in carts and wagons through the town to old Fort San Marco (Fort Marion). The Public Square and St. Augustine Hotel.

GM: To me, the idea of the book fits so well into the aesthetic of the Plains Indian. A book is a relatively small object, easily transportable. Its compactness was ideal for nomads. Aboriginal people were not writers in the Western sense. Still, they had to communicate beyond orality and use of the hands. Articulation through drawings was a most appropriate vehicle to sustain tribal communication; furthermore, a book was much easier to carry than large buffalo robes painted with historical and autobiographical images!

These books were personal items, a record of one individual's thoughts and actions. As such, the drawings were most likely meant to be kept together, as a book, all neat and compact. Indeed, it would be amazing to find out if some of the artists had slipcases made of beaded or quilled leather, as was done for some of the later ration cards, to show how important the books were to their owners.

JCB: That's an interesting idea. The Lakota certainly made wonderful beaded covers for their Bibles. The only records of special handling of drawing books suggest that in some cases they were worn on the person, for example, when a man went into battle. In this way, the ledger book functioned as a painted hide robe did for men of the generation before: they wore their battle stories on their person. (It happened repeatedly that these little record books were found by U.S. soldiers and taken from the bodies of slain warriors on the battlefields.) In other instances, people talk about the book being wrapped in a cloth, or kept in a trunk—some type of treatment to demarcate it as special.[1]

GM: The aesthetic of compactness had a function. The introduction of the book complemented Plains Aboriginal life perfectly. These books became containers, like bags, pouches, and parfleches, each one very personal. It's so simple and discreet. They are marvelously poetic volumes that were made for only a short time.

JCB: The act of making drawings in books may have been practiced for just a few decades, but people may be surprised to learn that the historical impulse was probably an ancient one on the Plains. Winter counts were Native historical documents used by Plains people, particularly Lakota and Kiowa. They were originally painted on buffalo hides. Each year was represented by one or two pictographs that served as mnemonic devices for the tribal historians. By the 1880s, some of these histories were written down in small books (see cat. nos. 128, 129). And some have been carried on well into the twentieth century, in ledger books, copybooks, or discarded school notebooks.

The modern books exhibit the same embrace of history that the nineteenth-century winter counts and drawing books did. One Lakota book, called *Red Horse Owner's Winter Count*, was still being kept in the 1960s, by the grandniece of Red Horse Owner (Karol 1969). In addition to events of personal or band significance, there are also recordings of events of larger meaning, ranging from "first time they rode horses against the enemy" (in the year 1789) to "New Deal" (in 1936).

Who knows how many more of these books exist, unknown to outsiders, but very important to the families who have kept them for generations?

GM: There is a contradiction that occurs to me as we speak. These books were personal records presented in compact form, but when we decide to exhibit them in a gallery and a catalogue, we are confronted with the problem of public presentation, of shifting from a private to a public gaze. In addition, the catalogue mimes the original.

JCB: I assume you mean that both the catalogue and the ledger present the drawings in book form, although the catalogue presents them with the overlay of *our* words, and *our* historical research and documentation.

GM: Yes. And when we get to the matter of the public gaze, the situation becomes problematic. How do we come to terms with the drawings as individual commodities? The viewer must understand the difference between the book as a Plains aesthetic format, and the individual drawing, which conforms more to our modern sensibility. There are external pressures to break apart these microcosms and place them on gallery walls, behind glass, with the usual labels, all for close scrutiny. This paradigm contradicts the original notion of keeping the pages together. For the original owners of these drawing books, there was no gallery wall.

JCB: And we have the concurrent phenomenon of the modern-art and the auction market, in which the books are taken apart and sold for high prices. So there are a lot of intersecting forces that cause us to think of these works as individual drawings. This does have a positive aspect, for so many of the drawings *are* singular works of arresting power. I'm thinking of the vision of the Medicine Beings in the Henderson Ledger, for example (cat. no. 9), or Wohaw's often-published metaphorical drawing (pl. 1). But in some respects, it's like taking a line of poetry out of context—the sentence may have some eloquent imagery, but its full impact comes when it is placed in the larger work.

GM: Looking at individual drawings, I see that their original identity has been distorted and/or lost by what I call a "palimpsest." We've got to return to the original—to avoid it is to lose an important base of understanding. The palimpsest idea is primarily an interest on the part of art historians and museologists in questions of who owned a work, how it changed hands, what price was paid, and so on. This is called "value," although the idea of "provenance" does involve trying to locate origin (that is, identity). I tend to believe that Aboriginal people would be more concerned with the original meaning, where the idea is more important than the object.

JCB: I don't think that Aboriginal people are the only ones who want to know the original meaning. This is one of the concerns of historians of any sort. But don't you think that cultural studies and postmodernist

studies of the last few years have, if anything, at least taught us that there is no one "original meaning"? It has a number of provisional, shifting, situational answers. And that is certainly often true about Native American objects—because religion and meaning were so often highly personal and subjective, especially on the Great Plains.

And, to bring the focus back to ledger drawings, these were highly personal objects, with meanings that altered as the drawings were added to, as they changed hands, as they passed from one artist/warrior/historian to another, or passed as a family legacy from father to child. So, for me, one layer of the palimpsest through which we view these drawings is the layer of history. Let's take one book as an example, a famous one called High Bull's Victory Roster (see cat. no. 47). It originally belonged to a Sgt. Brown of the Seventh Cavalry. High Bull, a Cheyenne warrior, took the book from Brown's body at Little Big Horn in 1876. High Bull recorded his own history, sometimes right over Brown's lists and notations. While this can be viewed as simple parsimony of materials, it also serves to assert this artist/warrior's history in a very palpable way. He captured it, and added his history to it. Some months later, High Bull, in turn, was killed by white soldiers who recaptured the book (Powell 1975b). It ended up as another sort of trophy in the collection of George Heye, which has recently been "recaptured" by Aboriginal people in the form of the National Museum of the American Indian. So wherein lies the "original meaning"? I see only a series of overlapping meanings.

GM: I prefer to think that the National Museum of the American Indian has counted coup, which is a very Plains thing to do.

I wanted to ask you, Janet, as an art historian looking at these works, what evokes a response in you?

JCB: I'm interested in seeing how artists use their art to respond to cultural change and upheaval. Among the Southern Plains artists transported to and incarcerated at Fort Marion, Florida, in 1875, one finds a three-pronged response. Many of the drawings seek to re-create "the good old days" on the Southern Plains. They show in loving detail the exhilaration of horsemanship, and the bravery in hunting and warfare that were characteristic of pre-reservation pictorial arts (see cat. nos. 44, 58). In this, they are functionally identical to the pre-reservation male art of hide-painting, where hides served as a vehicle for chronicling personal exploits of bravery and autobiography.

Other drawings show that bravery is transformed in this alien and perilous setting: they recount the journey to the Florida prison and the transformation of free-ranging warriors into schoolboy-inmates (see Blume, pl. 3 [p. 41]). There is also a new vein of nostalgia mined here, for the artists don't simply recount their brave deeds, as they would have in pre-reservation pictorial arts; they also depict many scenes of traditional camp life: courting women, preparing food, women scraping hides. To me, these drawings reveal great loneliness and longing for the past (see cat. nos. 48, 97).

GM: "The good old days." A perplexing concept. Old Plains Cree people say "ka-yas," which means "a long time ago," or "paya-guow," "one time." In the first instance, the idea situates an event beyond personal experience, as if something was being handed down through each generation. In the latter, "one time" may be within personal experience. "Ka-yas" is almost nostalgic, "paya-guow" is about personal memory. At least this is how I would interpret the two terms. It may be, indeed, with these concepts, with some traditional temporal standard, that we can begin some kind of analysis of the drawings. Thus: Is something within my personal or tribal experience? Because Aboriginal people had no written historical records (although some winter counts do come close), visual representations are our greatest connection to tribal truths.

When we talk about "the good old days," it has a nostalgic ring; we remember the past in positive terms, sometimes to the point of romance. Certainly Plains artists saw drawing as a medium through which to represent their memories. I once read someone aptly describe this need to hold onto the past as "clutching souvenirs of an ever-retreating past," where the past becomes so overpowering that we find it difficult to look forward. This, however, is a state of mind that is of interest to us when we speak about the artists, but it is not sufficient in helping us outline or mark a historical narrative using the drawings.

Today we have photographs that provide instant access to our past, that pinpoint key moments in time. These may be either documentary, aesthetic, or both. Documentary images are usually more nostalgic, while aesthetic images carry other heightened feelings (although documentary images may be also aesthetic, of course). My point is, how do we, the audience, look at these drawings, with modern, Aboriginal, postcolonialist (or all and other) sensibilities? If we view these works nostalgically, then they may suffer being reduced to sentimentality, which is not what we want to do. Rather, these works not only represent points in time ("paya-guow") but also the spiritual, mythic, or sacred time ("ka-yas"). When we use terms like "the good old days," we run the risk of using a language that sentimentalizes their importance.

JCB: I don't think that seeing nostalgia in some of these works reduces them or sentimentalizes them. Great sadness surrounds the circumstances in which many of them were produced. Young, vigorous Kiowa and Cheyenne warriors, who were incarcerated in the mid-1870s in a stone fort on the Florida coast, were recalling freedom, women, and buffalo back on the Southern Plains. Elderly Lakota men hemmed in on reservations in the 1880s, 90s, and into the twentieth century, were looking back to a time when they were vibrant, young men who determined their own destinies.

GM: I have to leave the door open as to how we articulate the notion of "memory," not so much as nostalgia but on the same level as we view winter counts. In other words, we must try not to overdetermine the works by assigning them to certain categories.

So what categories do we use? I'm not sure. But I would say that our use of the term "nostalgia" must be reconsidered, at least limited to one association, which I

would prefer be used when speaking of the unfortunate incarceration of the warriors at Fort Marion. They have more to be nostalgic about, since their predicament was so circumscribed compared to those others simply accepting the changes gradually taking place around them.

Somehow the sense of identity in the latter was strengthened by resolve, and they were able to adjust to the changes. They were more apt to stand together as a community and deal with the issues together. Indeed, they had a home, albeit a changed home. The prisoners, by contrast, yearned for their families, communities, and homes.

Granted, I do realize the prisoners' art works spoke of their prison experience, but wasn't that a way to deal with severance? Their work was documentary; in it, the artists were trying to tell others about the realities of their experiences. But was anyone listening?

The individuals who had freer opportunities to visualize their quotidian experience, I would like to think, created "art," an expression that would have been more appropriate to a nineteenth-century understanding of the term, as opposed to a more contemporary view, in which art is created out of struggle. I would not characterize what those nineteenth-century artists were doing as engaging in nostalgia, because their tradition was narration, articulating truth to others; to falsify (make up, pretend, perhaps romanticize) was not virtuous. I think the discourse of nostalgia is misleading, or inappropriate.

JCB: During the last months, while looking intensively at so many drawings, I have been moved by numerous aspects of these works: the artistic mastery they reveal, their intimacy of scale, and the impulse of the artist as a historian to chronicle and record. Let's examine the sense of history in these works.

My own interest in ledger drawings was ignited by a chance encounter some fifteen years ago with the Wohaw book in the Missouri Historical Society, which records aspects of Kiowa history of the 1870s (see cat. nos. 95–101). But lately I've been thinking about the longer view of history, evident in some drawings. The most epic view of history is found in winter count books made by a Lakota named Battiste Good (see cat. no. 128). His winter count is remarkable for its consideration of the big picture. He begins Lakota history in the year A.D. 900, with a sacred genesis to recorded history. The Lakota are visited by a beautiful woman who presents them with a sacred pipe. Then she turns into a white buffalo calf and goes back to her buffalo nation.

Other drawings by Battiste Good present the origin of the Sun Dance and the horse, in the time before precise recorded history, which for him starts in 1701. From there the artist presents a pictograph for each year, and linear history unfolds. One memorable image is the depiction of the winter of 1879–80. A young man wears a cap, and holds a pencil in his left hand. He has two tablets, upon which are written "1 2 3." The year 1880 was recalled as "Sent the boys and girls to school winter" (cat. no. 129).

A curious aside, Gerald: not only could Battiste Good write, but he was also particularly interested in dates and numbers, and he filled his book with careful chronological notations. Curiously, when Garrick Mallery published these drawings in *Picture Writing of the American Indians*, he omitted all written text and numbers, so that it looks like "pristine" pictographic imagery. Indeed, Mallery writes that the text and numbers are a result of Good's "meddlesome vanity," and are "presumptuous emendations" (1893:288)!

GM: It's interesting that Mallery omitted written texts and numbers from Good's drawings. Why, beyond making the drawings look pure and pristine? Were the "speaking parts" an access to knowledge and civilization, and, therefore, for the art to remain traditional (that is: "savage"), the writing had to be curtailed? Whatever Mallery's motivation, these artists must have gathered from their own practice that ownership of certain images and objects did signify power. This is another issue to think about when we see the books reduced to individual drawings and marketed as such. I am not suggesting that we cannot study the drawings individually, but collectively the books have greater synergy. They are, indeed, encyclopedias of experience.

JCB: Not only did Battiste Good make several versions of these winter counts, but his son-in-law apparently continued replicating them. He made a good business in selling them. This brings up another topic we should discuss: the replication of images. We seldom find, in the Native American world, the idea of the "prime object" (to borrow George Kubler's words [1962:39–45]). Instead, it is the *idea* that is owned, and the right to replicate that idea can be given or sold. So we often see drawings that in the Euro-American world would be called "copies," but I'm not sure that that is the right terminology here.

Many of the Southern Plains men incarcerated at Fort Marion drew multiple versions of the same event. And, as I discuss in my essay on Lakota drawings, Four Horns made drawings of events in the lives of his nephew Sitting Bull and Sitting Bull's adopted brother. These are said to be copies of Sitting Bull's own drawings. But the only original Sitting Bull drawings that survive are ones he made over a decade later.

GM: We have to look at the subject of the replication of images from several points of view since it makes problematic the idea of value, which is a social construction. I've had discussions of copyright in a few contexts, but always the idea reverted to Western conceptions, not because they are any more tenacious or that Western law has defined its parameters better, but because any notion of traditional/Aboriginal copyright is little understood or articulated.

JCB: Candace Greene wrote a marvelous article on Kiowa notions of copyright, or what she calls "intangible property rights," published in a legal journal, interestingly enough (Greene and Drescher 1994).

GM: If we look at the notion of replication, we often think it is about copying the likeness of something else or reproducing the identity of something. From this we sense that there is an original from which the image is taken. That is why we place a tremendous amount of value or worth in the "original," the first one. Everything else is just a "knock-off," right? We regard the

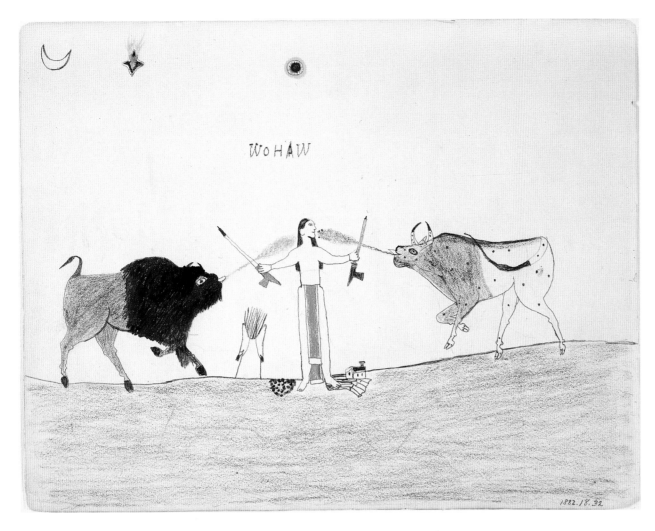

Plate 1. Wohaw, Kiowa. *Wohaw in Two Worlds.* Pencil and crayon, 8¾ x 11¼ in. Missouri Historical Society, St. Louis, 1882.18.32

WOHAW

1882.18.32

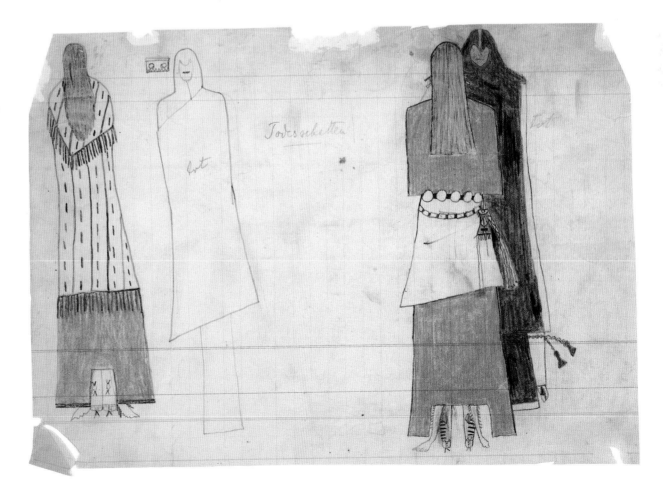

Plate 2. Artist unknown, Arapaho? Courting Couples. 1870–80? Pencil and crayon, 7¼ x 10⁵⁄₁₆ in. Texas Memorial Museum, University of Texas at Austin, 1988.23R. The German inscription reads "Death Shadow"; the writer was evidently unfamiliar with the widespread Plains custom of courting within the private space of a cloak.

original far more meaningfully. Why? This has many complex answers, but we can at least discuss the difference in understanding between Western and Plains Aboriginal thought and practice.

The discursive practice called art history is based on the analysis of tangible objects. These objects form the basis of art history's narrative, comparing and contrasting all sorts of objects, valuing some more than others, along the way establishing some kind of standard of value. We have to consider how the industrial age has made it possible for anything to be replicated by machinery. Walter Benjamin talked about this in his seminal essay (1960). It is my understanding that Aboriginal people in the nineteenth century saw the problematics of replication not so much in terms of objects, but in terms of access to and ownership of ideas. Aboriginal people, particularly nomadic ones, saw the importance of ideas. Tribal peoples had less regard for tangible objects, since valuing them more would have caused them to worry about their accumulation and, thus, overabundance, which were antithetical to a nomadic lifestyle. Objects like moccasins wore out each year, no matter how well-crafted or aesthetically pleasing. Instead, it seemed logical to put stock in something that could be articulated by ritual, ceremony, and experience. These were ideas, complete with stories, songs, and prayers. Honors could be accumulated as well, and they were signified by a variety of symbols, feathers, and other transportable objects.

JCB: Including ledger books, whose original function on the Plains was, after all, to record men's war honors. Look at the Red Hawk book or Four Horns's drawings (see cat. nos. 124, 125, 136–42).

GM: It's not that accumulation did not exist, but it was easy to trade away objects, to other Aboriginal people as well as to tourists. And since they were only objects, the owners still had the ideas along with all rights and privileges.

JCB: Exactly. So a man might commission an artist to draw the images and icons he owned. Or he might transfer ownership of certain images to a descendant, who would then have the right to replicate those images, even if it were not directly part of his or her own personal history.

Another issue that comes up, and it's not unrelated to ownership of images and ideas, is the interrelation of text and image in ledger books. Sometimes there are texts in Lakota, or even in English, that clearly were written by the artist (see cat. nos. 151–53). In other cases, captions were written later, by the white owner who often claims that "an Indian interpreted the images for him." Yet the non-Indian owner asserts his own possession of the book by inscribing *his* text. Increasingly it seems to me that these texts are very problematic and get in the way of understanding exactly what sort of history is being presented (pl. 2; see also cat. no. 138 and Jantzer-White, fig. 1 [p. 50]).

Sometimes images that outsiders have interpreted as epic events of one sort have turned out to have very different meanings. We can get into trouble when we give too much credence to the written "explanations" or "captions" that often accompany drawings. One example is one of the first ledger books published, a small book by Howling Wolf. Each picture is accompanied by a brief text written by Ben Clark, a scout and interpreter at Fort Reno, near the Cheyenne Agency where Howling Wolf lived. One drawing is supposed to portray "the first white men seen by the Cheyenne," while another (cat. no. 55) is said to depict "the first horses owned by the Cheyenne" (Petersen 1968:33).

Taking these descriptions at face value, I found these images quite interesting because they represent a kind of abstract historical moment. But as it turns out, the two drawings are meant to be read together as events surrounding the 1840 treaty between various Southern Plains tribes (see cat. no. 55). So they represent a very specific historical moment—albeit one before Howling Wolf was born—about which he may have heard a great deal, and which was still of import to the Cheyenne in 1880, when he was drawing. So Howling Wolf was conducting a kind of history painting here, of a sort that is very familiar

to us from European art history. I suspect that most people, when they think of Indian art, do not think of this. It seems that we always want to privilege the text, but doing so can actually diminish the valid historical statements made by the drawings themselves, as Jantzer-White's essay demonstrates.

GM: In regard to "the sense of history" contained in these works, I would add that their presence as a whole begins to establish a narrative space within art history, one that has yet to be accepted. For contemporary Aboriginal people, especially artists, this genre of drawings forges links, a kind of mythic bond rooted in a lost or fragmented past. This publication acknowledges that an art historical narrative exists, so that these older works are no longer sites of memory where the artists see them as a nostalgic longing for a psychic space. They are more real than that.

These drawings evoke strong identities; as well, they assert an autonomy of spirit that attracts us all, in different ways. I am a lover of drawings to begin with, because they are intimate and immediate. Somehow, in our era, we've lost these qualities. So very little is personal anymore because the public wants to see into that private world. The very act of drawing creates a private social space, like writing a letter, or reading a book. It is an intimacy that conceals so much yet is not dangerous. When we have the privilege of looking in a drawing book of someone else's, we feel we've entered a private space. This is how I feel when looking at these ledger books.

JCB: I agree. Over the last months, as I've traveled to collections conducting research for this project, I have experienced those moments of anticipation when an unopened book is placed on the storeroom table in front of you. It is qualitatively quite different from just looking at a matted drawing. It does have to do with that sense of hiddenness. There's also, for the modern viewer, the paradox that when we open a book we expect to see pages filled with monochromatic lines of text, not jewellike visualizations of history.

GM: These books are not much different from personal medicine bags, which contain items knowable only to their owners. But I believe these artists wanted the contemporary Aboriginal to know their personal joys and sorrows, their successes and failures, their memories of a fleeting past and a sense of homelessness in the face of modernization.

When I observe the sense of history in these works, I begin to understand synchrony and diachrony. Earlier, you used the terms "epic view" and "big picture," referring to history. To me, it is invaluable for our audience to understand these ideas: that Aboriginal people had a very strong sense of history; that it wasn't all mythic; that "ka-yas" was well understood by everyone because it signified their narrative of themselves. To extend the stories of the past was, in effect, to construct their identities in the present, much the same as contemporary Aboriginal people (including artists) draw on the works and stories of *their* ancestors.

JCB: In his autobiographical narrative *The Names*, Kiowa author N. Scott Momaday visualizes his ancestor, Pohd-lohk, taking his prized ledger book out of his bureau drawer and examining it. Momaday writes, "Now that he was old, Pohd-lohk liked to look backwards in time, and although he could neither read nor write, the book was his means. It was an instrument with which he could reckon his place in the world" (1976:48).

GM: Today Aboriginal people know the extent to which the dominant society's master narrative has undermined their certainties and foundations. Any connection to these drawing books goes a long way to establishing a sense of history. Someone once told me that the defining moment of aboriginality is to understand that our roots extend deep into the earth. Unfortunately, there has been a great deal of effort to obliterate this understanding and, in turn, to impose a different narrative. With our interest in and examination of these nineteenth-century drawings, we are sweeping away the cobwebs and bringing to light those strong connections, that sense of distinct history.

Note

1. The documentation that accompanies Battiste Good's winter count (cat. nos. 128, 129) says that the artist's son "went to the round top trunk, unlocked same, and took out a small package, wrapped in a tan colored cloth and tied with a piece of bright print, which was used for a string. . . . He unwrapped the cloth from around the book, and took it between his two hands, and with bowed head said this prayer: 'I belong to God, and I belong to the People, and the People belong to me.'" No author, typewritten manuscript, November 12, 1939, Denver Art Museum, 1963.272.

Structure and Meaning in Cheyenne Ledger Art

Candace S. Greene

Ledger drawings, like their precursors on rock surfaces or buffalo robes, were intended to communicate messages. Like all messages, however, pictures could be read on a number of levels. Information was encoded both explicitly in the content of the image and implicitly in the form of a drawing. The various messages were mutually reinforcing, and all were concerned with the male role in Cheyenne society.

Most ledger drawings are narrative in form, telling the story of an event. These stories were no doubt easily read by their contemporary audience, the members of which could recognize individuals by their personal insignia and could follow events through familiar conventions to represent time, space, and the course of action. The story of a specific event was only the most obvious and explicit level of communication, however. Drawings were produced in order to display an individual's deeds as a means to advertise and validate his status based on his accomplishments. The message of a drawing was thus about the person as much as about the event. On a broader societal level, drawings gave public recognition to socially approved behavior and presented graphic models for emulation, encouraging all young men toward similar achievements.[1] Less overtly, Plains ledger art also carried messages about social relationships and provided a visual framework for their expression.

In addition to explicit communication, Cheyenne pictographic art carried more subtle messages that tied together the subjects depicted and shaped social perception. While explicit messages were conveyed by the narrative content of pictures, other messages were implicit in the underlying structure and were expressed through composition and placement of figures. Rather than a purely visual approach to compositional analysis looking at line, mass, and color, a structural analysis concentrates on the spatial placement of culturally defined categories in relation to one another. Viewed

from this perspective, composition can be seen as the spatial mapping of the social dimension. Pictures that are quite different visually may be structurally identical.

Cheyenne pictographic art is built upon a small number of compositional types, and regular patterns govern the placement of figures within the compositions.[2] The most common form in Cheyenne pictographic art is bilateral composition. The majority of Cheyenne drawings show two figures in interaction. The placement of these figures side by side on the page generates a simple bilateral pattern that forms the basic structure of the art (see cat. nos. 19, 24, 26). This compositional arrangement appears over and over in a wide range of subjects. Larger, more complex scenes are created by combining a series of bilateral pairings, such as several courting couples, or opposing two groups of figures (figs. 1, 2). These figures generally contrast with one another through various distinguishing traits—either inherent characteristics of the figure, such as gender or tribal membership, which would be the same if the figure were removed from the picture, or situational status that is only defined by his or her role in the context of the picture. Even with inherent characteristics, reference to the context of the picture is necessary to determine which are relevant. Every figure fills a number of categories simultaneously (male, Cheyenne, warrior, shield bearer, and so on), and the viewer's attention is directed to a particular aspect of the figure only by its contrast with the other figure in the picture. Through a combination of inherent status and situational role, the pictures present a series of oppositions placed within a bilateral structure.

An examination of the content within this bilateral structure reveals that the placement of figures on either left or right is highly patterned.[3] This regularity of placement suggests that the structure is meaningful in organizing content. The

spatial relationship of the figures as drawn upon the page is based on their social relationship, as culturally constructed by the Cheyenne.

The structure conveys information at three different levels. First, the consistent lateral placement of members of pairs emphasizes the opposition between them. They are opposed by virtue of contrasting placement as well as of contrasting appearance. Second, the use of a common structure for different pictures of similar activities unites them in a consistent pattern. The common elements stand out among the wealth of differences associated with the particular scene, and the individual event can be placed as part of a socially recognized category, such as hunting. While there is variation in detail, the nature of the relationship between the central figures is the same. Third, the use of a common structure for pictures of different types of activities promotes comparison among them. Before we consider this comparative system, let us look at the basic system of bilateral opposition.

The table below shows the patterns of left and right figure placement that commonly occur in Cheyenne pictographic art. The percentage figures demonstrate that there is a high degree of consistency in such placement. To interpret these patterns it is necessary to consider Cheyenne perceptions of the relationships between the figures that are opposed.

Patterns of Figure Placement

SUBJECT	FIGURE PLACEMENT		PERCENTAGE
	LEFT	RIGHT	
warfare	non-Cheyenne	Cheyenne	84%
peace	non-Cheyenne	Cheyenne	82%
hunting	prey animal	hunter	84%
horse raiding	horse	captor	90%
courting	female	male	72%

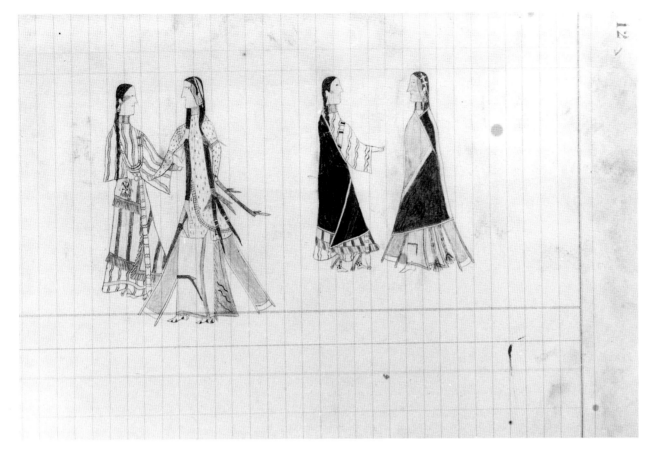

Figure 1. Artist unknown, Cheyenne. Two Pairs of Courting Figures. 1880s. Oklahoma Museum of Natural History, Norman, cat. no. NAM 9.6.298

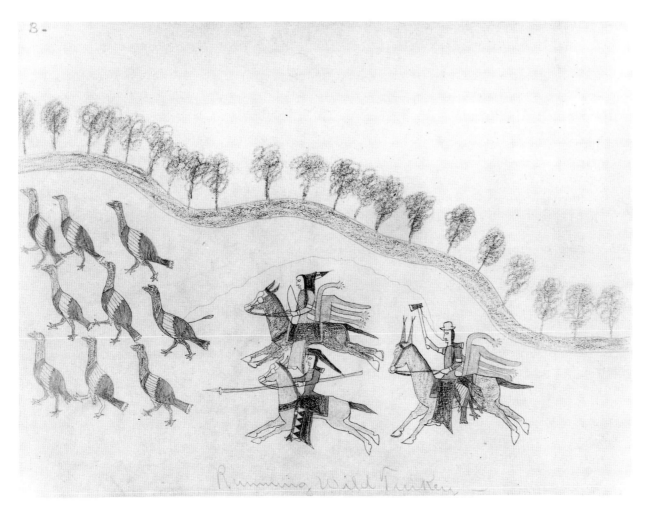

Figure 2. Making Medicine, Cheyenne. A Party of Hunters Pursues a Flock of Turkeys. 1875–78. National Anthropological Archives, National Museum of Natural History, Smithsonian Institution, Washington, D.C., cat. no. 39B

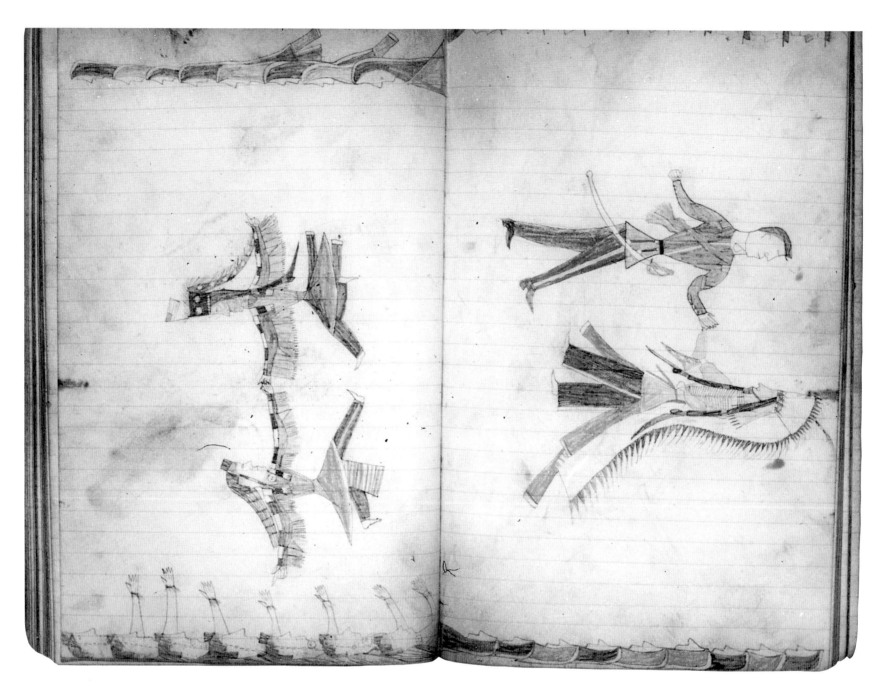

Figure 3. Artist unknown, Cheyenne. A Peace
Council Between the Cheyenne and the Crow.
1870s. National Anthropological Archives,
National Museum of Natural History,
Smithsonian Institution, Washington, D.C.,
cat. no. 7463

Scenes of warfare are the most common single subject found in the pictographic record. In these the Cheyenne is normally placed on the right and the non-Cheyenne on the left (such as cat. no. 26). Such placement reflects the Cheyenne sense of tribal identity. The Cheyenne word for themselves is "Tsistsistas," or "the people." Like many cultural groups, the Cheyenne view themselves as not only separate from all other people but also superior. This superiority is due to spiritual enlightenment, which can be drawn upon to dominate others. The tangible symbol of such spiritual blessing is the Sacred Arrows, which give Cheyenne men power over other men (Powell 1969:xxiii). This same contrast of Cheyenne and non-Cheyenne is carried over into scenes of peaceful intertribal interaction (fig. 3). In these pictures as well, the Cheyenne appears on the right-hand side.

Bilateral composition is also used frequently for hunting scenes. The hunter is consistently placed on the right and the animal he is pursuing is placed on the left (fig. 2). Cheyenne folk taxonomy divides the animal world into a number of discrete categories. One primary distinction is between "animals that paint" and animals that do not "paint." The basis of this division is explained in the story "The Great Race," which details a competition among the creatures to determine who would be the predators and who the prey. Two teams were formed, the humans siding with the birds and canines, all of whom painted their faces for the competition, which they won. "The paints applied for the race became permanent. Animals that can be eaten— game animals—have no paint" (Moore 1984:297). As part of the winning team, men gained dominance over the prey species on the vanquished team. This power is reinforced by the spiritual assistance provided by the Sacred Arrows. Two of the arrows are "man arrows," which provide assistance in war; two are "buffalo arrows," which give power over bison and other game (Dorsey 1905:2; see also Powell 1969 for an extended discussion). In pictures of hunting, the dominant hunter is placed to the right of the prey animal that he is overcoming.

Scenes of horse stealing may be seen as a variant of hunting, for they, too, place the man to the right of the animal he is capturing. As a source of wealth as well as a daily necessity, horses held a position of importance in Cheyenne society. They were not considered a source of spiritual power, however, and were clearly not among the animals that paint. While not hunted for food like other prey, as a domesticated species they fell under human control.

Pictures in which men and women appear together cover a range of situations. Some clearly show the Cheyenne courting custom of a man and woman wrapped in the same blanket. Others imply courting activity, such as a man wearing his blanket pulled over his head to conceal his identity while he waits for a woman; or a woman carrying a bucket, suggesting that she is on her way to the creek to fetch water, an opportune time to catch a few moments alone with her. Other pictures show men and women without any indication of their relationship, or depict them engaged in noncourting activities such as traveling, cooking, or other camp tasks. In all of these, men appear on the right and women on the left. This consistent placement suggests that patterning in relations between the sexes extends beyond courting, and that in these pictures the gender of the individual is the critical organizing factor, not the activity depicted.[4]

Several authors have noted that movement from right to left is a characteristic of Plains pictographic art. A careful analysis of Cheyenne drawings, looking at the direction in which figures face or in which they move, reveals that we can only generalize about this practice to a certain extent. Forty-four percent of all pictures show movement to the left, while only four percent have movement toward the right. However, forty-five percent show movement toward the center, where the figures face each other (see cat. no. 21), and seven percent show no clear direction of movement. Action toward the left is common and vastly exceeds movement toward the right, but it does not dominate composition.

I believe that what we are perceiving in these drawings is a compositional schema at once more fundamental and more subtle. It is the relationship between the figures as defined by structure. In each of the cases discussed above, the figure on the right can be seen as the initiator of the action depicted and the figure on the left the receiver, or to use a grammatical analogy, the right-hand figure is the subject and the left-hand figure the object. They are the actor and the acted upon. Regardless of the direction in which figures happen to move in a picture, their relationship can be expressed as A—>B, where A is the figure on the right, B the figure on the left, and the arrow represents the relationship between them.[5] Thus, in Cheyenne pictures the position on the right has the same connotation in pictorial space that it has in the ideological realm, where the right side is possessed of greater energy or spiritual force, and thus dominates the left. In pictures of warfare or hunting, this domination is expressed physically. In scenes of male/ female interaction, the relationship is metaphysical. Males are possessed of spiritual energy. Females are not, but can receive such energy from males. The man's position on the right in courting pictures is reflective of this division and potential transfer.

In the table above, we can see that the positioning of figures belonging to various categories is highly patterned but not universal. An evaluation of the narrative content of these apparent exceptions reveals that the principle of right dominating left is in fact operative, but that the usual social position of the figures has been reversed. The use of inherent categories such as "Cheyenne" or "female" is simply not adequate to represent the message of the drawing, for situational factors have altered the relative positions of individuals. Modification of placement in scenes of warfare occurs most frequently when the Cheyenne is shown being overpowered by his enemies.[6] Such pictures present a conflict between the basic ideology of the Cheyenne being possessed of superior spiritual force and the reality of his being physically bested.[7] In these instances the artist was forced to make a choice between conflicting principles. In eighty-four percent of pictures I have examined of Cheyenne defeats, the artists chose to place the conquering enemy in the powerful right-hand position. Other apparent exceptions to the

usual patterns of figure placement may also be in accordance with this underlying structural principle. Figure 4 illustrates a reversal in the usual right-left placement of hunter and bison. The positioning is, however, entirely appropriate for the narrative of a picture in which the wounded animal has taken control of the situation. The reversal of positions enhances the humor of this scene through inversion of the expected. Male-female placement also appears to be switched in the scene reproduced in figure 5. This is a picture of a Scalp Dance, in which women carrying trophies taken from enemies dance to the accompaniment of drum music. However, the Scalp Dance was managed by the Halfmen-Halfwomen, transvestite males who were possessed of great power (Grinnell 1972,2:39–41; Hoebel 1978:83). The figures on the right in this scene may not be women but spiritually powerful men.[8]

As noted above, the use of a common structure for different pictures suggests a relationship among the various activities shown.[9] The structure creates a parallel among different subjects based on the flow of influence, A—> B and C—> D. An analogy is created, such that A is to B as C is to D. Apparently differing types of relationships are brought together into a consistent pattern and are shown to have the same underlying logic, so that an understanding of one gives insight into another. The analogic relationship promotes the use of one activity as a metaphor for another. The most common subjects of ledger art are combat, courting, and hunting. Metaphoric connections among these activities are expressed in the structure of pictures and are represented more explicitly in other forms of expressive culture, such as music, dance, and so on. These important domains of male life were symbolically connected, and one might be used as a metaphor for another.

Warfare and courtship were particularly closely associated, and many instances can be found in which women were likened to the enemy being pursued. Grinnell noted that love songs were often sung by men on the warpath. "Wolf songs . . . are songs of travel, or roaming about, and were com-

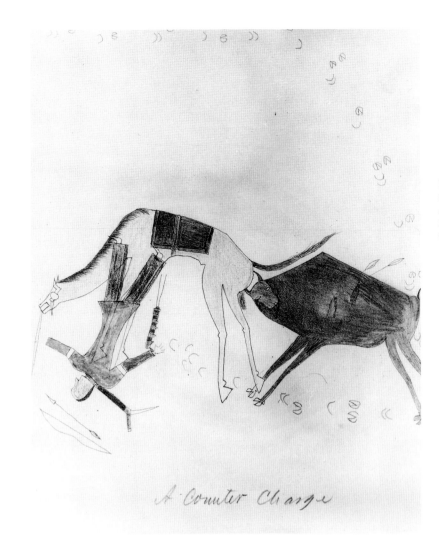

A Counter Charge

Figure 4. Artist unknown, Cheyenne. A Buffalo Calf Attacks a Hunter. 1875–78. National Anthropological Archives, National Museum of Natural History, Smithsonian Institution, Washington, D.C., cat. no. 39A

monly sung by scouts or young men who were out looking for enemies, since a scout was called a 'wolf!'" He attributed this association to the fact that such men might feel lonely or depressed and be heartened by thoughts of their sweethearts at home, but an analysis of the words of the songs suggests that a metaphoric association is being drawn upon. One song goes, "Friends, take courage, I see my sweetheart." Another says, "Come out of your lodge, so that I may see you," and another, "My love, come out into the prairie, so that I may come near you and meet you" (Grinnell 1972, 2:392–93). These songs are worded as if addressed to a lover, but the implicit metaphor makes them particularly appropriate for a scout in search of an enemy.

The metaphoric connection of warfare and relations between the sexes was acted out at times in playful attacks upon groups of women. Women who were returning from collecting Indian turnips might build a mock fortification with their digging sticks and the roots they had gathered, challenging the men and pelting any who approached with buffalo chips. Only a man who had struck an enemy (counted coup) within a fortification in real warfare could pass their line, recount his deed, and take what food he wished. A similar mock raid might be carried out against the women's quilling society, in which only a man who had entered the lodge of an enemy might enter their gathering and carry away food (Grinnell 1972, 1:68–69, 165).

Hunting was also metaphorically equated with warfare. Just as the enemy might be referred to as one's sweetheart, game

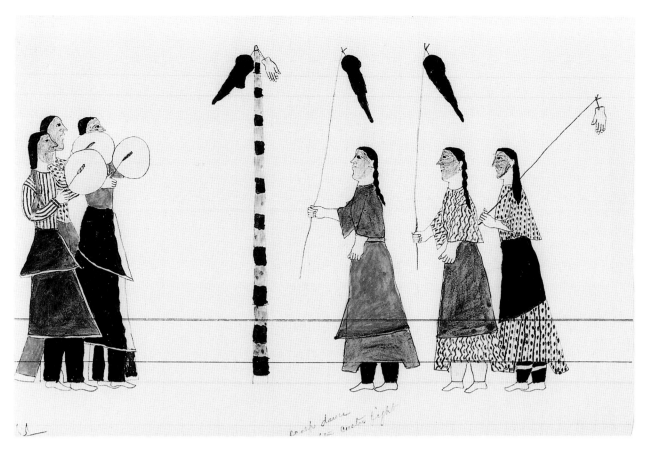

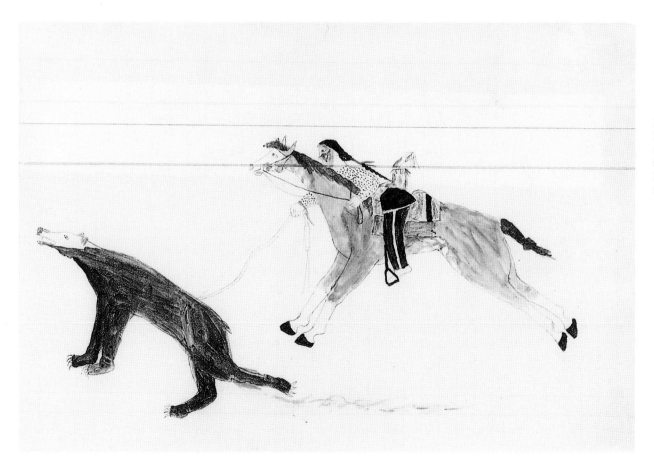

animals might be called "ehamehan," or "our enemies" (Moore 1974:180). Coup were sometimes counted during a hunt with the prey animal likened to an enemy struck in war (Grinnell 1972, 2:30). This association is occasionally expressed explicitly in pictures showing mounted warriors counting coup on animals (fig. 6), and it is implied in others in which men are shown hunting, but dressed and armed as if for war.

Hunting and courtship are also connected, making the circle complete. Buffalo, the primary game animal during the hunting period, were considered female (Moore 1974:163), while the hunting of buffalo was exclusively a male activity, thus suggesting a general connection between the two pursuits. The association is made explicit in a number of Cheyenne stories in which the animal a hunter is pursuing is transformed into a woman, whom he marries, or in which a man discovers that his mysterious wife is really an animal, as in the well-known story "The Buffalo Wife" (Grinnell 1926:87–88).

All three themes—warfare, hunting, and courting—may be subtly blended. In addition to explicit depictions of counting coup on a prey animal, there are other Cheyenne drawings of hunting in which warfare is suggested as the hunter wears a war bonnet or carries a shield. The majority of these warfare/hunting pictures show a bear being pursued. Bears are a major symbol of femaleness due to their association with the Deep Earth (Moore 1974:163). The prominence of bears in pictures connecting warfare and hunting suggests that such scenes are in fact a triple allusion to the metaphoric connection of hunting, warfare, and courtship.

Cheyenne pictographic art had a strong narrative component that served to represent historic events and the accomplishments of specific individuals. The underlying structure of the art form, however, moved beyond the concerns of the individual to make statements of broader social implication. These multiple levels of meaning were mutually reinforcing, as the personal narrative was positioned within the broader cultural narrative. Each event, beyond its meaning for the individuals involved, was integrated into a pattern of culture, itself a mosaic constructed from individual acts and their interpretation. The model for emulation that pictures presented could be read at many levels.

The structure of Cheyenne drawings simultaneously defined and was defined by socially constructed categories. While the narrative content identified the action of a scene, the structure defined the nature of the relationship between the actors. This relationship was in part derived from inherent aspects of the status of the individual, but was also dependent upon the role he or she held in the particular situation. The bilateral composition positioned the figures in a drawing as an oppositional set. His or her status in regard to the opposite figure, under the circumstances depicted, determined his or her place within the picture and within society at that moment, now frozen in time. The positioning on the page was endowed with significance due to the value that the Cheyenne placed upon right- and left-hand positions. The spatial arrangement of the picture thus charted the spiritual power relations between the figures depicted.

The use of a common structure for pictures of many different events emphasized the relationships among them. Pictures of like subjects, such as counting coup, were united into a pattern, and the structure emphasized the connections among individual events. Apparently disparate activities were likewise linked to each other. The use of a common structure for pictures of different subjects created an analogic relationship among them. The Cheyenne elaborated this logical connection into a series of metaphoric associations among warfare, hunting, and courting, which were expressed in many mediums. Although only occasionally explicitly expressed in pictures, the metaphoric relationship was evoked by the bilateral structure and the placement of figures. Cheyenne pictographic art tied together the important concerns of men's lives, explaining each in terms of the others.

Notes

1. Plains pictographic art is often described as consisting of stereotyped scenes of warfare, horse stealing, and, occasionally, courting. An actual count of the subject matter of Cheyenne drawings presents a rather different picture, however. Half of all the drawings I have viewed do show warfare, but only two percent of drawings show horse stealing. While some of the fights depicted may have occurred during horse raids, it was the combat that the artist chose to commemorate. The second most common subject is courting (fourteen percent), followed by individual portraiture (nine percent), and hunting (seven percent). The artists at Fort Marion often depicted scenes of trains, lighthouses, and other aspects of white culture that they encountered, but such illustrations account for only three percent of the Cheyenne drawings I have analyzed.

2. The statistics cited in this paper are based upon a formal analysis of 1,700 well-documented Cheyenne drawings, the majority in ledger books dating to the last quarter of the nineteenth century. Full data on this material are available in Greene (1985). Many hundreds of additional pictures examined since that time are consistent with the earlier findings but have not been incorporated into the statistical analysis.

3. Cheyenne intellectual discussions of directionality as recorded by scholars from Mooney (1907) to Moore (1987) have always focused on the quadripartite divisions of the cosmos and other four-part systems modeled upon it. Although apparently not often discussed, a regular system of lateral preference is described in the literature for many aspects of Cheyenne life, ranging from the domestic to the ceremonial (Greene 1985:89–93). Such lateral preference has been documented in cultures around the world, although it is evidently not universal. There is, however, considerable variation in how prominently it is expressed in different cultures and what forms such expression takes (Hertz 1960; Needham 1974).

4. The most pervasive contrast in Cheyenne ideology is that of male and female. "First in importance, in Cheyenne society as in the cosmology, is the symbolic expression of sexual roles—the special significance of being a man or a woman" (Moore 1974:144). "The difference between them . . . is that men are spiritual and women are material" (Moore 1974:272). Women could, however, receive spiritual energy from males through sexual contact. This is reflected in the Cheyenne theory of procreation, in which the child "is materially the product of its mother's body, but spiritually the offspring of its father" (Moore 1974:151); women are considered basically sterile and "spiritually inert" (Moore 1974:162). This contrast is mapped in the Cheyenne cosmology, as the zenith is generally considered the principle point of Maheo, the All-Father, while the Deep Earth, defined as sterile soil, is envisioned as the Earth Mother.

5. The enormous influence of cultural conventions on reading lateral positioning has been impressed upon me as I have struggled with how to represent this relationship graphically. Logically, it should be written with the graphic symbols placed as "B <—A," as A represents the figure on the right and B the figure on the left. However, the left-to-right system of written English mitigates against this arrangement, as the arrow points in a direction opposite from that of the line of text in which it is placed.

6. While it may seem surprising that artists chose to record such defeats, the Cheyenne recognized that success was not always possible. Valor in defeat, particularly against heavy odds, could also be honorable.

7. Warriors sought to increase their "medicine" or war power by personal contact with the spirit world through visions or by the transfer of power from another who had achieved such contact. Supernatural power was never, however, infallible, and at times a warrior's medicine failed. Either the enemy had stronger medicine, or the efficacy of a man's medicine was reduced because a taboo associated with it had been broken.

8. A large number of the drawings that do not follow established structural conventions are by a prominent Cheyenne artist, Yellow Nose. I have been unable to determine any consistent lateral patterning in his work. Yellow Nose was Ute by birth and was captured by the Cheyenne in 1858, when he was only four years old. He was adopted into the family of Spotted Wolf, where he was raised according to Cheyenne customs, and he became a warrior of note (Grinnell 1956:201 fn). I believe that Yellow Nose's deviation from pictorial conventions should be attributed to personal idiosyncracy, rather than seen as representing a more significant trend.

9. In my analysis I am indebted to the work of Claude Lévi-Strauss, who moved structural analysis from a study of relationships to an analysis of the logical relationships between relationships. See particularly *Totemism* (1963).

A Brief History of Lakota Drawings, 1870–1935

Janet Catherine Berlo

In 1876, the popular national magazine *Harper's Weekly* published what may be the first art-historical evaluation of a Lakota drawing. Under the pen name "Porte Crayon,"[1] a journalist wrote about a series of drawings by Four Horns:

There is no attempt at shading, but the outlines are filled in with flat tints, very crudely laid on, with red and blue chalk, yellow ochre, green, and the same brown ink or pigment used in the outlines. . . .

This coloring, however, serves to impart life and meaning to the designs, to relieve the groupings from confusion, and is sometimes so arranged so as to produce quite an artistic effect of chiaroscuro. It may be further noted that there is no attempt at foreshortening, the objects and figures being all shown in flat profile, and without exception, all looking and moving in the same direction, that is, from right to left.

Of all the objects presented by the artist, the figure of the buffalo bull is elaborated with the most intelligent and loving minuteness. The horses and mules are drawn with a free and well-assured hand, with a tendency to mannerism, relieved somewhat by distinctive character in color, markings, and details. He is least happy in his delineations of the human figure, draperies, and accouterments, although in some scenes his attitudes are spirited and his costumes sufficiently marked to enable us to identify the sex and country of those who have had the honor to sit for their portraits to this distinguished limner (Crayon 1876:625).

Despite his arch tone, this critic is more sympathetic to an artist of another culture than we might expect of one writing in 1876.

Four Horns's drawings, made in 1870 (see pl. 1 and cat. no. 124), are, to our knowledge, the earliest securely dated Lakota works on paper that have survived.[2] They mark the beginning of a graphic arts tradition in which Western mediums of

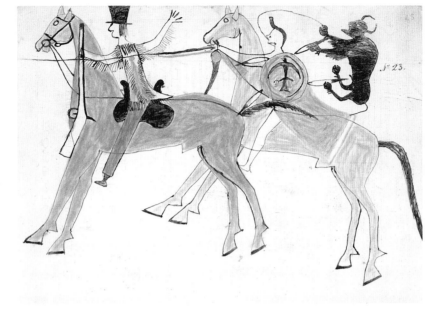

graphite, ink, and paper were used; the tradition continued uninterrupted for more than sixty years. Seen from a Lakota perspective, however, they stand simply at the midpoint of an ongoing pictorial tradition that extends from prerecorded history to the present.

Like other Plains Indians, the Lakota had a drawing and painting tradition that antedated by many years the arrival on the Plains of white men, with their pencils, pens, ink, and paper. Painted hides in museum collections bear witness to a male artistic tradition that encompassed both history and autobiography (see "Drawing and Being Drawn In, p. 12). In this brief essay, I will merely outline the rudiments of the Lakota graphic arts tradition as it existed during a sixty-five-year period, from 1870 to 1935, focusing on works on paper. One problem with such an endeavor is that not all Lakota drawings can be firmly dated; for some we can establish a *terminus ante quem* because their date of acquisition was carefully noted by a collector, Indian agent, or museum. While some authors have constructed a developmental scheme for Plains drawings based on stylistic attributes (Rodee 1965;

Ewers 1939), style is not necessarily a reliable indicator of date, for some artists deliberately chose to identify themselves either with their own youthful exploits or those of their ancestors by means of a deliberate archaizing of style. Some Lakota artists, well into the twentieth century, clearly believed that the appropriate visual language to employ when talking about the past was one that involved a kind of shorthand, in which only a few laconic elements—actor, action, and a minimum of defining iconographic details—were shown.

Despite these caveats, I shall examine chronologically some highlights of the Lakota drawing tradition, focusing on the work of one or two representative or particularly noteworthy artists of each decade, many of whom are represented in the catalogue section of this publication.

The 1870s: Four Horns

As mentioned above, Four Horns's drawings are the earliest securely dated Lakota drawings.[3] They were executed in a relatively unacculturated Plains drawing style, with sketchily drawn figures and a minimal use of costume detail or identifying insignia (see pl. 1).

While these works were sold to a non-Native, we do not know if they were expressly executed for that purpose; if so, they would represent one of the earliest dated examples of deliberate intercultural commerce in Plains graphic arts, a commerce that would flourish a mere five years later.[4] In the drawings, on roster sheets of the Thirty-First U.S. Infantry, Four Horns depicted another man's life. Plains men often commissioned better artists to make drawings of their exploits; but in this case, Four Horns apparently made copies of drawings by his nephew Sitting Bull and Sitting Bull's adopted brother, Jumping Bull (Stirling 1938:1).[5]

In many of Four Horns's drawings, the most crisply rendered images are the small upright bull (Sitting Bull's name sign) and his shield, upon which is painted a bird of prey. These also happen to be the icons that are invested with the most important meaning. Background is either absent entirely, or rendered by a series of horizontal dashes (see pl. 1, cat. no. 124, and Maurer 1992:figs. 182, 183).

Many of the traits manifested in Four Horns's drawings are present in other drawings done in the 1870s (see cat. nos. 112, 113). Increased emphasis is placed on individual details of clothing and insignia as important means of telling the story. For example, Pawnee women are recognized by their distinctive moccasin style. A herd of horses is depicted, short-hand fashion, by a half-dozen heads.

In November 1878, forty-nine young Lakota and individuals from other Northern Plains tribes arrived at Hampton Institute in Virginia to join the young Southern Plains men who had come directly from their incarceration at Fort Marion, Florida. Many of these students made drawings; presumably the Lakota artists were influenced by the Fort Marion artists to expand their repertory of subjects and styles. While we find in some of the drawings, by Sioux artists, remembrances of traditional life on the plains (see cat. no. 127), we also see the first visual descriptions of ceremonial actors such as Black Tail Deer Dancers and Elk Dreamers (Ewers, Mangelsdorf, and Wierzbowski 1985:figs. 7, 29, 37). In Lakota drawings of the 1880s and 90s (see cat. nos. 114–23), such images are among the most prevalent. Other Hampton drawings portray the dramatic changes and new phe-nomena that reservation life had brought to a recently mobile people, such as log cabins and plowed fields (Ewers et al. 1985:figs. 10, 12, 15).

For Northern Plains people the Hampton Institute drawings are the first chronicle of the dramatic processes of acculturation. Similar themes had been rendered vividly, and in greater numbers, by Southern Plains artists while imprisoned at Fort Marion in 1875–78. In just a few years, however, Lakota artists living on the Northern Plains would find that to sell their drawings they would have to ignore much of the reality of life around them and draw either tradition-al ceremonial activities or old-style warrior exploits.

The 1880s: Red Horse, Black Hawk, and Sinte

To most Lakota, confinement to reserva-tions seemed irrevocable by 1880, and the surrender of Sitting Bull in 1881 convinced even the last traditionalists that they could hold out no longer. Many people were impoverished due to graft and corruption among the agents who were supposed to be providing the allotments of food and annuity goods dictated by treaty.

Lakota artists took diverse paths during this decade. Some, like Red Dog and Sitting Bull,[6] continued to execute autobiographi-cal and biographical images of warrior life. Other artists dramatically expanded the subject matter and style of Lakota graphic arts. In 1881, Red Horse, a Minniconjou Lakota, produced forty-two astonishing drawings of the 1876 Battle of Little Big Horn. Among the most powerful images of this era for their eloquent depictions of the carnage of war, they stand as profound tes-timony concerning this pivotal battle by one of its participants. Conceived on a larg-er scale than most ledger drawings (on twenty-four- by twenty-six-inch sheets of manila paper), some of these have an epic or panoramic quality that allies them more with muslin paintings than with the small-scale drawings done in ledger books.

With the unflinching eye of a warrior artist, Red Horse chronicled the chaos of battle, and the stripped and mutilated bod-ies of Custer's cavalry men, producing a riv-eting image that was captured by white photographers a few days after the battle (Mauer 1992:figs. 156–61). Equally impres-sive is Red Horse's economy of line in expressing the quiet aftermath of the fight. No more action, no more bullets flying—just dead and dying horses, outstretched limply on the ground (fig. 1).

Figure 1. Red Horse, Lakota. Dead Cavalry Horses. 1881. National Anthropological Archives, National Museum of Natural History, Smithsonian Institution, Washington, D.C., 2367a.25

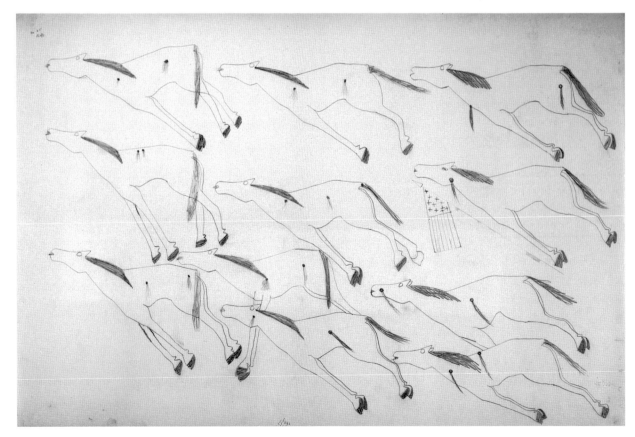

During the same year, Black Hawk, a Sans Arc Lakota living to the west, on the Cheyenne River Sioux Agency in Dakota Territory, made drawings in a ledger for the owner of the trading post at the agency. Black Hawk's book of seventy-five drawings recently emerged from obscurity, and now stands as the most complete visual record we have of Lakota ceremonial imagery. It is also the earliest known example in which a Lakota artist chronicled not simply personal history or the military history of his cohorts but a larger view of ceremonial life in a series of interrelated works.[7] While the impulse to make a visual record of ceremonialism would become more common in the next decade, Black Hawk's drawings are noteworthy not only for their excellent execution but also for the profound spiritual and artistic vision that underlies them.

Black Hawk chronicled his vision of a Thunder Being, rendered as a spotted, horned creature riding a mythological animal (see cat. no. 116). He also portrayed intricate details of Lakota ceremonialism in a series of drawings of buffalo dancers and buffalo altars (see Yellow, pls. 1, 2 [p. 71]; cat. nos. 118, 119). He also provided a high level of ethnographic detail in his numerous depictions of Crow Dancers (see cat. no. 117) and Lakota warriors' encounters with the Crow.

Another artist of the 1880s is Sinte, whose work has remained almost completely unknown and unpublished (see cat. nos. 143–48). Some of Sinte's drawings fall well within the pictorial conventions established by previous generations. Yet, like Black Hawk's drawings, Sinte's works reveal that the 1880s was a time of expansion of subject matter and stylistic conventions for the Lakota artist. Sinte created works for Rudolf Cronau, a German journalist.

In a traditional mode, Sinte depicted himself as a high-ranking warrior with his horned and feathered headdress and crooked lance (cat. no. 145). To this long-established mode of presentation, he added others. In one image (fig. 2), Sinte portrayed himself frontally, with a horse to his left. He gestures with an upraised tomahawk to six front-facing women in striped trade blankets, who stand to his right. In another scene, Sinte drew a catalogue of six ani-

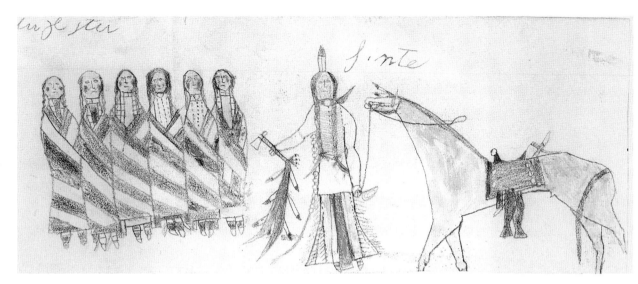

mals important to the Lakota (cat. no. 143). Yet not all of the animals he depicted are ordinary zoological species; like Black Hawk, Sinte represented spirit beings, powerful forces who manifested themselves in visions to individual Lakota (see AMNH 50.2100, not illustrated).

Exploring another genre of drawings reminiscent of some made a decade earlier by the Fort Marion captives (compare cat. no. 86), Sinte drew Western-style buildings on graph paper (cat. no. 148). In a larger drawing he accurately mapped the Pine Ridge Agency as it existed in the 1880s, meticulously depicting the church, boarding school, and various smaller structures (see cat. no. 147).

As an artist, Sinte was clearly able to move comfortably between traditional representations of mounted warriors, nature studies, and mapping a modern town with almost cartographic accuracy. This is important to note, for many Native American artists, past and present, move comfortably between traditional and more contemporary styles.

1890 to 1910: Bone Shirt and Bad Heart Bull

White, middle-class America of the 1890s witnessed the acceleration of a craze for Indian arts and crafts. A brisk commerce in beadwork, basketry, pottery, and many other goods swept across the nation.[8] Of special interest were small items and miniatures that could be displayed in a Victorian parlor or in an "Indian corner." At least a minor feature of the curio trade during this decade was an interest in small autograph albums filled with Lakota drawings, such as that by Walter Bone Shirt (fig. 3).

Some of Bone Shirt's drawings depict the common subject of men on horseback (see cat. no. 122). Individuality is not revealed by a name sign or a written inscription, but it may be encoded in the imagery on the shields, for typically a man's shield was an emblem drawn from a personal vision; such emblems were well known to his peers. In general, however, we sense that these are not specific men and their particular deeds, but rather generic representations of men whose power stems from their relationship to the forces of the universe, as represented in the symbolic paintings on their horses and shields.

Figure 2. Sinte, Lakota. *Sioux Indian Sinte with His Six Wives.* 1886. American Museum of Natural History, New York, 50.2100(14f). The collector's original notes on these drawings say that the women on the left are Sinte's six wives. While prosperous Lakota did sometimes have more than one wife, six would be unusual. Perhaps Sinte was engaging in a bit of Lakota humor.

In making this autograph book, Bone Shirt seems to have been most interested in ceremonial participants (see cat. nos. 120, 121): Buffalo Dreamers, Black Tailed Deer Dancers, and Sun Dancers fill the pages, and the minute details of their regalia and accoutrements are painstakingly drawn.

Artists such as Walter Bone Shirt were fulfilling a dual purpose in making these small but vivid images of Lakota ceremonialism. For them, it was an act of remembering and reconstituting the most sacred activities of traditional life. Yet they were also selling these miniaturized memories, so it became an act engendering cross-cultural understanding—reaching out to convey some essential bits of information about Lakota identity.

At the same time that Bone Shirt was filling small autograph books, and Red Hawk was continuing the decades-old tradition of making simple biographical pictographs of warrior exploits (see cat. nos. 136–42), one Lakota artist was engaged in a project of enormous scope and magnitude. Between 1890 and 1913, Amos Bad Heart Bull (1869–1913) systematically drew in a large ledger he had purchased for that purpose. By the time of his death, he had completed some 408 drawings ranging from early history of the Lakota and their traditional ceremonialism to the Battle of Little Big Horn, the Ghost Dance, the murder of Sitting Bull, and the massacre at Wounded Knee.[9]

Before beginning this work, Bad Heart Bull had made a winter count (the traditional mnemonic means of recording tribal history using a pictorial symbol for a significant event of each winter, or year). In Helen Blish's words, it was while working on that endeavor that the artist "realized the quantity of materials that was being left untouched—the battles, rituals, ceremonies, and various activities and interests that were not being recorded and yet were vitally significant in the life of the people" (Blish 1967:8).

Bad Heart Bull rendered a panoptic view of Lakota life, carefully conveying details both visually and via inscriptions written in Lakota (with an occasional name in English). As Blish points out, it is significant that Bad Heart Bull did not undertake his epic work for any tribal archive or for tribal elders; it was not an "official" Lakota history (1967:8). It is equally significant that the ledger was not made at the behest of any anthropologist, collector, or other outsider who desired a record of Lakota life. It was a personal achievement that satisfied Bad Heart Bull's own vision of what it meant to be an artist and historian.[10]

In terms of his artistic capabilities, Bad Heart Bull moved easily from sweeping scenes of warfare to miniature, maplike renderings, to intimate depictions of courtship and ceremony. He chronicled warfare between Lakotas and Crows during the 1850s–70s, as well as their adaptation to farming and ranching in the 1880s and 90s (Blish 1967:figs. 80, 81, 210, 362, 363). Bad Heart Bull experimented with new modes of representation, fearlessly tackling three-dimensionality, back and three-quarter views, and aerial perspective. His work is dynamic and vigorous, and it stands as an unparalleled achievement in the history of Native American art.[11]

1910 and Beyond:
No Two Horns and White Bull

In the early twentieth century, anthropologists and other scholars worked on the Great Plains, documenting the remnants of the important nineteenth-century indigenous traditions that lived on in the memories of the older generation.[12] The drawings that survive from this period were, for the most part, made for sale to such scholars or to the tourist trade.

No Two Horns was a Hunkpapa Lakota. His work in several mediums has been well documented (Wooley and Horse Capture 1993). His drawings on paper (pl. 2, cat. nos. 130–33), made in about 1915, have great energy and vitality. It is noteworthy that stylistically they are almost indistinguishable from Lakota drawings of forty years before (with the possible exception of the amount and precision of iconographic detail, such as headgear, shield imagery, and the like).

As art historian Evan Maurer has observed, such visual conservatism is not "a flaw of impoverishment but instead an affirmation of tradition that honors deep

Figure 3. Cover of autograph album containing drawings by Walter Bone Shirt. ca. 1895. Private collection

cultural and spiritual values" (Maurer 1992:31). When No Two Horns deliberately used nineteenth-century conventions to depict events of that period, he was making an artistic choice that linked him with his own youth and with generations of artists who had preceded him. At the same time, however, he was producing the drawings for sale to outsiders eager for representations of the "old days," and these images undoubtedly filled their criteria for "authenticity" in Indian art (however specious we might find those criteria today).

White Bull, a Lakota of Minniconjou and Hunkpapa heritage, took part in the most important battles that occurred during his youth. As an old man in the 1920s, he made money by recounting his history in both pictorial and narrative form for scholars and collectors (see pl. 3, cat. nos. 151–53).[13] We see in the case of White Bull's work a dramatic shift, from the mere dollar or two paid to prisoners at Fort Marion for their drawing books in the 1870s, to substantial sums for similar historical and artistic accounts made a half century later.

Like No Two Horns, White Bull limited himself to the pictorial conventions of the 1870s. But he augmented his images with a detailed Lakota text that elaborates on the events portrayed. Whereas in earlier years Plains artists sometimes avoided depicting conflicts between Natives and whites in drawings intended for sale to whites, even going so far as to alter the details of the images, turning white enemies into Native ones (Berlo, "Drawing and Being Drawn In," figs. 2, 3 [p. 17]), White Bull was pleased to show his importance in notorious battles against the U.S. Army. For example, White Bull depicted his participation in the Fetterman Fight and the Battle of Little Big Horn, and he repeatedly proclaimed his relationship to Sitting Bull in the text that accompanies his drawings. In other works, he recalled with great pleasure the escapades of horse stealing (pl. 3).

In the period between 1870 and 1935, the Lakota drawing tradition did not develop in a unilinear fashion. While the traditional pictographic shorthand, the legacy of generations of hide painters, continued to be central to Lakota artists, in the 1880s and 90s some artists experimented with more fully blown narrative approaches. Moreover, the graphic experiments in this sixty-five year period provided the foundation for Lakota visual arts of the twentieth century.

Oscar Howe (1915–1983), the premier modernist of the Northern Plains, based his groundbreaking work on the narrative traditions of earlier Lakota artists. His well-known and influential experiments with a cubist style of narrative painting in casein on paper, which he began in the 1950s, in turn influenced a number of other artists, among them Arthur Amiotte (b. 1942) and Colleen Cutschall (b. 1951). Amiotte's collages conjoin pictographic images with those from photographs and advertising (see Rushing, fig. 10 [p. 61]), while Cutschall's narrative paintings of Lakota cosmology blend male and female artistic traditions.[14] The urge to narrate is strong in Lakota graphic arts—be it one's heroic deeds, as in the case of Four Horns; the ceremonial achievements of one's culture, as in the drawings of Black Hawk; the ironic, sad, and humorous strands of twentieth-century Indian culture, as in Amiotte's work; or the poetic truths of ancient cosmogony, as in Cutschall's.

In 1913, when a Hunkpapa man named Old Bull[15] taught ethnomusicologist Frances Densmore about the historical traditions of his people, he told her, "We come to you as from the dead. The things about which you ask us have been dead to us for many years. In bringing them to our minds we are calling them from the dead, and when we have told you about them they will go back to the dead, to remain forever" (Densmore 1918:412). Fortunately, Old Bull was mistaken about the death of the traditions of his people. By means of his own vivid images of Lakota history (see cat. nos. 134, 135) and those of many other illustrious artists, the history—and art history—of the Lakota people were not consigned to the realm of the dead. Their works helped engender the renaissance in Lakota culture, art, and spirituality that has taken place in the second half of the twentieth century. These images, many of them over one hundred years old, will continue to nourish successive generations of Lakota historians and artists of this century as well as the next.

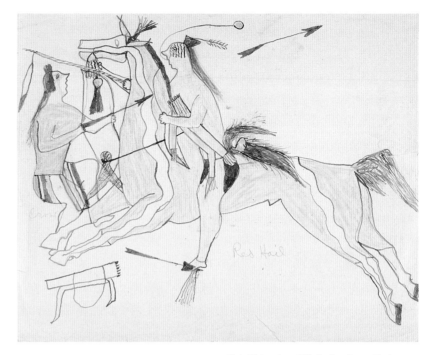

Plate 2 (also cat. no. 130). No Two Horns, Hunkpapa Lakota. Red Hail Counts Coup on a Crow. ca. 1915. State Historical Society of North Dakota (State Historical Board), Bismarck, 9380.E

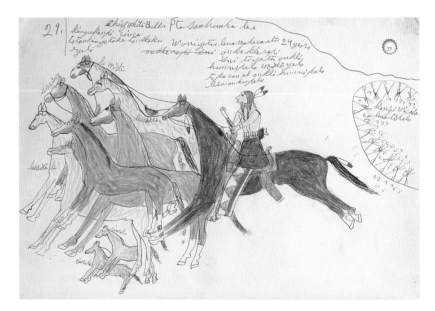

Plate 3 (also cat. no. 151). White Bull, Minniconjou and Hunkpapa Lakota. White Bull Steals Crow Horses. Burdick Ledger. 1931. Elwyn B. Robinson Department of Special Collections, Chester Fritz Library, University of North Dakota, Grand Forks, OGL 183.29

Notes

1. This name means "crayon-carrier." In the nineteenth century, a porte-crayon was understood to mean the wooden or metal holder for lead, chalk, or charcoal used by artists (Petroski 1990:48).

2. In the older literature, the Lakota are more often called the Western or Teton Sioux. The seven bands of the Lakota are the Oglala, Brule, Hunkpapa, Minniconjou, Blackfoot, Two Kettle, and Sans Arc.

3. Yet Four Horns's drawings are almost certainly not the earliest ones executed. In the collection of the National Museum of the American Indian is a book of drawings said to be by a Sioux artist named Samuel. While the catalogue data is sketchy, it notes that the book was "Collected by General William Nicholson Grier during Indian Campaigns in the West 1835-1861" (NMAI 23.2855). The drawings are on the unlined pages of a small notebook and depict scenes of mounted warriors as well as warriors in procession on foot. The collection history of this drawing book is not secure enough to warrant the book's inclusion here.

For a discussion of the possible dating of Swift Dog's drawings to the 1860s, see cat. nos. 149, 150.

4. Only three years later, the Hunkpapa Lakota artist Running Antelope recorded his autobiography in watercolor in a drawing book for Dr. W. J. Hoffman, and provided the explanation for the events depicted, which transpired in the 1850s. See Mallery 1886:208–14.

5. The reason I am confident of a date of 1870 is that the principal publication on these drawings states that Sitting Bull executed the originals following the Sioux victory over the Crow in 1870; Four Horns's versions were collected by Kimball in that same year (Stirling 1938:1–3).

6. There are two well-known versions of the visual autobiography of the famous Hunkpapa leader Sitting Bull: the Pettinger Record and the Smith Record (Stirling 1938:35–57; Maurer 1992:figs. 177–80), both painted at Fort Randall in 1882. The Smith Record was collected by Lt. Wallace Tear, who was stationed at the fort. Tear writes that Sitting Bull "made these pictures for me to show his gratitude for blankets and clothing furnished his children last winter before the government supply of clothing for his band arrived" (Stirling 1938:37). The drawings are in an army ledger, and Sitting Bull signed his own name to them (unlike the pictographic name signs Four Horns used a dozen years before in his versions of Sitting Bull's earlier works).

In both the Pettinger and Smith records, the human figures have the same relatively flat, sketchy quality as in Four Horns's versions of a decade before, with the occasional exception of a frontal figure (Stirling 1938:51, 52). The horses, however, are quite rounded, conveying a sense of three-dimensionality. Stirling notes that the German artist Rudolph Cronau (see p. 185) made Sitting Bull's acquaintance in 1881 and "spent some time teaching him how to draw" (1938:35). Since Sitting Bull was an accomplished artist long before this date, we can assume Stirling means that Sitting Bull and Cronau, from radically different cultural and artistic traditions, shared their diverse styles and materials, much as Bodmer and Catlin had done with other Plains artists some fifty years before (see "Drawing and Being Drawn In," p. 12).

7. In calling the Black Hawk book the earliest example of a larger view of ceremonial life, I recognize that individual students at the Hampton Institute in the years after 1879 drew images of ceremonial activity, but these narratives are not as complex as in works by Black Hawk or Bad Heart Bull.

8. For discussions of items made to sell to this market, see, for example, Cohodas (1992), Jonaitis (1992), Phillips (1989), Phillips and Steiner (forthcoming), and Bol (forthcoming).

9. While Bad Heart Bull's original work is no longer available for study, having been buried with his sister in 1947, Helen Blish's *A Pictographic History of the Oglala Sioux* (1967) thoroughly documents the drawing book, based on her own study of it between 1927 and 1940 and interviews with the artist's relatives.

10. It may be noteworthy that Bad Heart Bull's uncle, Short Bull, was himself a noted artist and historian (see Wildhage 1990; McCoy 1992) who moved to Pine Ridge in 1890, the year that Bad Heart Bull commenced his magnum opus.

11. While art historians may mourn the loss of this unique art object, burial was, and is, for the Lakota an appropriate way of dealing with such a powerful and personal item. Customarily one's most cherished possessions are either buried with the deceased or burned. Lakota people believe that objects can be imbued with "naji"— spiritual potency. Because of this power, established customs dictate proper ownership, distribution, and disposal of these items.

12. See, for example, Densmore (1918), Neihardt (1972), Vestal (1934), and Wissler (1912).

13. In 1931, the historian Walter Stanley Campbell paid White Bull seventy dollars for his autobiography rendered in both text and image; Usher Burdick had paid him fifty dollars some months before for a similar account drawn in a business ledger. Campbell (under his pen name, Stanley Vestal) published a biography of White Bull (Vestal 1934), which was based in part on White Bull's autobiography.

14. For a discussion of twentieth-century Lakota artists, see Amiotte (1989:138–46), Cutschall (1990), Maurer (1992:fig. 301), and Berlo (n.d.).

15. Densmore calls him Old Buffalo, but he is clearly Moses Old Bull, who illustrated and narrated the same stories of his heroism to Densmore in 1913 and to Walter Stanley Campbell over sixteen years later. See Densmore (1918:412–18) and Miles and Lovett (1994).

In a Place of Writing

Anna Blume

During the most brutal and extensive period of U.S. government violence against Native Americans, between roughly 1860 and 1900, certain warriors of the Great Plains would take ledger books, turn them horizontally, and begin to draw. These narrow, lined, vertical, bound books, meant for recording details of commerce or tallying prisoners, were unmistakable artifacts of white settlers and the United States military. Through layers of trauma over impending or actual loss—lost homes, lost language, lost land—Native Americans would draw over this space of foreign calculations, thereby transforming the nature of their own drawing and the ledger book itself, creating a middle place, an in-between place, in a place of writing (pls. 1, 2).

The choice to draw in such a place, at such a time, participates in the very content of these ledger drawings, where a traumatic event "is not assimilated or experienced fully at the time, but only belatedly, in its repeated possession of the one who experiences it. To be traumatized is precisely to be possessed by an image or event" (Caruth 1995:5). Possessed by images of their past, and images of the possibility of a present, Native Americans drew in ledger books as part of the process of their own interpretation and survival.

Writing in books and ledgers, written treaties, and stenographed dialogues were all elements at the center and periphery of Native life as it was changing—changing specifically in respect to United States expansion across the West. While imprisoned at certain forts, especially Fort Marion, or enlisted in vocational schools like the Carlisle School in Pennsylvania, Native Americans were also taught to write and read. Usually in primers or ledgerlike books used by elementary-school children, Native warriors and women were given instruction in the English alphabet and other elements of writing.

At Fort Marion, after extreme violence, capture, and sequestering, over half of the warriors, twenty-six out of forty-two, began to draw (Petersen 1971:16). One Cheyenne named Bear's Heart would later tell his story in English in an auditorium in Virginia. His language is monotone, his grammatical constructions elemental, in this narrative acceptance of acculturation:

Before Indians went to school, Capt. Pratt he gave Indians clothes just like white men, but Indians not want hair cut. Sunday Indians go to church St. Augustine: down from head, Indians same as white men; but heads, long hair just like Indians. By and by after Indians go to church, they say I want my hair cut; my teachers very good.

Two years I stay at St. Augustine, then come Hampton. At Hampton I go to school and work (Petersen 1971:99–100).

In his drawings, however, Bear's Heart has a different voice from his English speaking voice. In a book, as imported and foreign as English itself, Bear's Heart depicted with sophisticated and elaborate detail the differences between a gathering of Cheyenne and a group of military soldiers. On a single page oriented vertically, he drew three rows of soldiers with uniforms, rifles, horses, and a U.S. government flag (see Heap of Birds, pl. 1 [p. 67]). Only the foremost soldier of each row stands articulated from the homogeneous troops. In his depiction of the Cheyenne Sun Dance, however, drawn on two pages, Bear's Heart meticulously and specifically differentiated Cheyenne figures and their lodges (see Berlo, "Drawing and Being Drawn In," fig. 1 [p. 14]). Compared to one another, these drawings are respective topographies of cultural difference; they are maps of Bear's Heart's perception of where he has come from and where and in what environment he was as he drew these images. Imprisoned, in the process of a survival whose terms are systematic acculturation, Bear's Heart entered his

memory of a Cheyenne gathering and ceremony. His drawing is a performance of memory with meticulous detail; an emblem of something inside and familiar. Conversely, his view of the military, like a wall and prison bars, is a series of stutters, a repeated monotony of something flat, inevitable, and distant, outside an inner memory.

Wohaw, a Kiowa also imprisoned at Fort Marion in 1875, made several drawings that represent the transformation of his identity in the process of mandatory schooling. In a white, undifferentiated space, slightly foreshortened, a group of Native American men with cut hair and identical blue trousers and black coats sit along desks on a bench poised to write, as a schoolmistress stands with a pointer in one hand and piece of paper in another (pl. 3). We know from this drawing and other images Wohaw made that he had seen and closely observed photographic images. His composition resembles that of a snapshot, with the teacher in mid-motion and students with their hands raised in a specific moment of time. The perpendicular placement of the two desks and the attempt at foreshortening the desktops display his interest in Western image making. Some of the men have the backs of their heads turned toward the viewer, which gives even greater force to the appearance of uniformity and lack of individuation. To the right, outside the logic of the schoolroom, outside its desks and filled-in blocks of clothing, is a lightly penciled image of a Native American with a feather drawn at the back of his uncut hair. This mysterious figure looms at the same height as the standing teacher, the students outwardly unaware of and inattentive to his presence. Wohaw's placement of this enigmatic Native figure appears to be a correlate to the teacher and her teaching; it looms like the image of an inner eye, faint yet present, present in the drawing as evidence of a split and troubled consciousness.

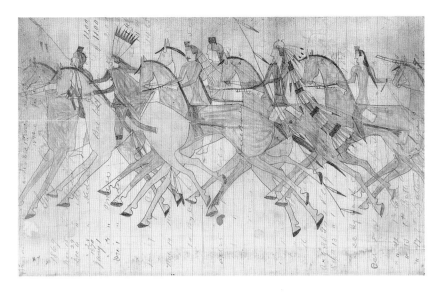

Plate 1. Artist unknown, Cheyenne. Untitled. Bourke Drawings. 1871–76. United States Military Academy Library, West Point, New York (1760)

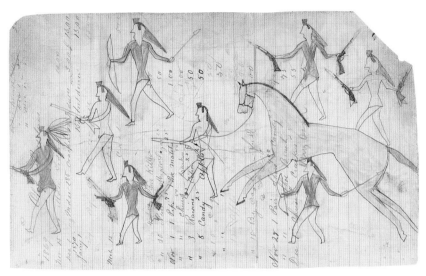

Plate 2. Artist unknown, Cheyenne. Untitled. Bourke Drawings. 1871–76. United States Military Academy Library, West Point, New York (1780)

Like writing itself, drawing must have been encouraged among those imprisoned at Fort Marion or these works would not have proliferated and been so well preserved. From the point of view of the military wardens, teachers, and clergy, this picking up of pencils to draw on paper must have appeared as another sign of the success of conversion from savage to civilized. The drawings, however, were more complex than that. In them and in the very act of making them, the imprisoned warriors could, with images, begin to interpret the specifics of their condition. They could experiment with who they were becoming and they would, literally "possessed by an image," work through the trauma of the present and recent past.

Outside of forts or schools, treaties and calculations were constantly being written to define territories or lost properties. On October 14, 1865, Col. John Chivington oversaw the tallying of an Abstract of Property of the Cheyenne, which was lost or destroyed at Sand Creek, Colorado (fig. 1). (This is particularly ironic, for Chivington had led the massacre at Sand Creek. See cat. no. 43.) For pages, Cheyenne warrior names are listed, first in a phonetic form of their Cheyenne names, then in their English translated names, from Na-ke-cha to White Bear. Next, under the rubric of property, are the categories of their status: killed, wounded, uninjured—and the status of their families, land, and possessions. In the far right column of these ledger entries is the culmination: the "specific value of property loss designated by the commission," in dollars and cents.

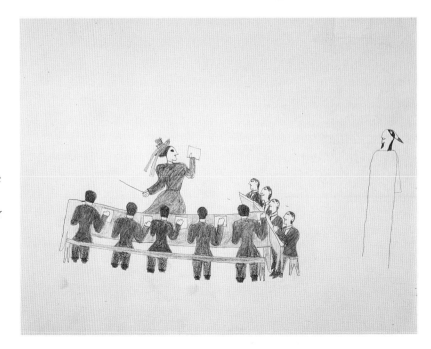

Plate 3. Wohaw, Kiowa. Classroom at Fort Marion. 1876–77. Pencil and crayon, 8³⁄₄ x 11¹⁄₄ in. Missouri Historical Society, 1882.18.15

The act of writing, which circumscribed access to land and which translated devastated villages into ledger books and dollar amounts, had a constituent and ubiquitous presence in the process of expansion. As they witnessed their lives being affected in part by the technology of writing, writing and written documents took on specific meanings for Plains peoples. In this climate, warriors chose ledger books as places to draw images of their perceptions and exploits. The bound book or lined pages where writing was done was like a silent rifle that, once possessed, even without the necessary ammunition, could potentially give the warrior some of the power of his opponents, which had proven to be so devastating.

In his 1877 diary John Gregory Bourke pasted numerous Cheyenne drawings, which were originally from a drawn-over ledger book, now lost. The Cheyenne warriors had in some unknown way come upon a ledger book, dated 1870, that was filled with lists of commodities such as sugar, raisins, and shoes (see cat. nos. 17, 20, 21). Over the existing writings, the Cheyenne artists drew full-page images of warriors ready for battle, holding rifles and lances, their horses in suspended movement (see pl. 1). In another image, the Cheyenne depicted warriors on foot holding rifles, bows, and lances, literally walking on a field of calculations (see pl. 2). The artists juxtaposed warriors and words, movement and written tabulations. Like moving into an unknown territory, they weave themselves in and project themselves over the logic and space of writing. Once drawn in, the ledger book was for them a talisman of sorts, a meeting place of cultures where the Native warrior repeatedly confronted the elusive discourse of U.S. expansion.

Several years after the Cheyenne drew in this ledger, it came into the hands of Bourke, General Crook's aide in the Third U.S. Cavalry in Wyoming Territory. Bourke kept many volumes of diaries throughout his military life. They reveal his growing interest as an ethnographer of the lives of Native Americans, both in writing and photography (Porter 1986). Charting the circulation of this ledger book from its original state as a tabulation of commodities, to the Cheyenne warrior-artists, to Bourke's diary,

Figure 1. *Abstract of Property Belonging to the Cheyenne Indians, Lost or Destroyed at Sand Creek Colorado by Colonel Chivington October 14th, 1865.* National Archives, Washington, D.C., T494 V. 7, 273

gives us a glimpse of how representations, drawn or written, were bound up in the very history of the West, not simply as neutral documents but as contested grounds themselves in the struggle over land and supremacy.

On January 12, 1864, Kit Carson, along with Capt. Albert Pfeiffer of the United States military, surrounded, ambushed, massacred, and captured the remaining few Navajo in a village at the east end of Canyon de Chelly. "Before returning to Fort Canby, Carson ordered complete destruction of Navaho properties within the canyon—including their fine peach orchards, more than five thousand trees" (Brown 1991:27). It is redundant to repeat why such violence occurred between the U.S. forces and the indigenous peoples of the West. But that is the reverberant nature of trauma both for those who experience it and for those who attempt to be its witness: this incessant need to repeat, in its wake, stories in varying forms, to evoke something one must struggle to remember.

The United States was expanding, both in population and commerce. The Native American was neither included in nor welcomed as a citizen of the U.S. as the republic was forging its relatively new identity. As a people, they were legally maintained as foreigners in the territories where they had once lived freely. The hundreds of official treaties written during this final period of land dispossession were documents between a sovereign United States and foreign Native nations. Yet, what was being fought for and against in U.S. territorial expansion over the Plains was not simply sufficient land for railroads and settlers and gold mines. Alongside these material and economic concerns was a need to erase the details of Native life from the Natives themselves.

Not unlike other campaigns of international genocide, U.S. expansion across the Plains was a battle fought as much for racial supremacy as for economic advancement. Hence the excessive destruction of the five thousand peach trees ordered by Kit Carson in 1864. To kill and capture the inhabitants of the village, situated on desirable land, is within the code and logic of warfare for territorial advancement. To expend the energy to cut down and destroy thousands of peach trees, however, points to an overreaching in acquisition. It demonstrates an attempt to eradicate culture in the landscape and culture in the minds of Native nations.

In its drive for territorial acquisitions and cultural dominance over Native Americans, the U.S. government expanded on a tradition of treaty writing established by Europeans settlers and local tribes (Vaughan 1985). In the early years of European settlement, relations with Native Americans were heterogeneous; there was no central plan or central government to effect a policy. Two hundred years later, the terms and stakes of such treaties had substantially changed. In place of the individual settlers was the U.S. government. Instead of families and acres, whole tribes and vast expanses of land were being negotiated. The language of the treaty had also changed. No longer were these written documents about local land; they were comprehensive proscriptions about how Native Americans, if they were to survive at all, must accommodate the dominant cultural values set out by the U.S. government.

In the 1868 Fort Laramie Treaty between the United States and the peoples of the Northern and Central Plains, this process becomes apparent from article to article:

Article 2. The United States agrees that the following district of country, to wit: commencing where the 107th degree of longitude west of Greenwich crosses the south boundary of Montana Territory . . .
Article 6. If any individual belonging to said tribes of Indians, or legally incorporated with them, being the head of a family, shall desire to commence farming, he shall have the privilege to select, in the presence and with the assistance of the agent then in charge, a tract of land within said reservation . . .
Article 7. In order to insure the civilization of the tribe entering into this treaty, the necessity of Education is admitted, especially by such of them as are, or may be, settled on said agricultural reservation, and they therefore pledge themselves to compel their children, male and female, between the ages of six and sixteen years, to attend school . . . (fig. 2)

After meridians of Native land were circumscribed into reservations and platitudes of good will expressed, the specific mechanisms of acculturation were set out as part of an issue of property. Article 2 defines the reservation in topographical terms. Article 6 stipulates the parceling of land within the reservation on the commitment of "the head of the family" to commence "farming." Therefore, ownership of land would not be guaranteed unless a particular prescribed form of agriculture was performed. This was alien to the inhabitants of the region, who had supported themselves by hunting buffalo and other nomadic forms of sustenance. Article 7 specifically addresses the role of education in the "civilizing" process.

In the mid-nineteenth century, treaties had become blueprints of a "final solution" of sorts to contain and if possible transform Native American tribes into settler communities, with country store, tilled land, school, and church. "In order to insure the civilization of the tribe . . ."—the sentence contains the force of assumptions that civilization, like the land itself, is something rightfully owned and parceled out by the U.S. government.

Figure 2. *Crow Treaty. May 7, 1868* (included in the Fort Laramie Treaty). National Archives, Washington, D.C., Document T494 V. 7, 780

Schools like the Carlisle Indian Training School in Pennsylvania were primarily places of transformation of appearances and induction into vocations such as shoe or hat making. There was a resident photographer, John Choate, who would photograph Native Americans upon their entry into the school and then several months later. One of these before and after photographs is of the Navajo Tom Torlino who was photographed upon his arrival in 1885, and later that year after induction (Bush and Mitchell 1994:90–91) (fig. 3). The two photographs are the same size, yet the person Tom Torlino has radically changed. The gap between the first and second image reveals the step-by-step violence of erasure of Native American culture and the immediate imposition of late nineteenth-century American mores.

In 1885, Tom Torlino began as a dark-skinned Navajo with large round earrings, long dark hair, an elaborate necklace with two large and numerous small crosses, and a hand-woven blanket over his shoulder. In the second portrait he is strangely lighter skinned, with short, parted, cropped hair. He wears a suit with tie and tie pin. In addition, the lighting appears to have been manipulated to render him literally more white. The intentions of Choate's photographic mission are obvious: to show how the Carlisle school could transform Natives into its own image of civility. Yet the photograph reveals much more than was intended. The details of clothing, the countless crosses, and the different look in his eyes point to the particular trace of Native American experiences, which cannot be reduced to the school's intention.

A few years before Choate was photographing Native Americans at the Carlisle school, the prisoners in Fort Marion, as well as other Indian peoples across the Plains, were drawing in books. In doing so, they established for a short span of time a counter form of expression. In this specific period of violence, which was of extreme scale and magnitude, Native Americans drew in ledger books with an urgency about the nature of their memory and their present lives. Among Wohaw's Fort Marion drawings is a portrait of himself with a buffalo, tipi, and gathered food on one side

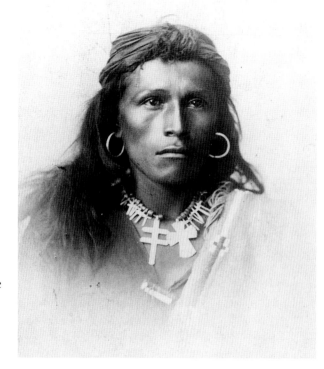
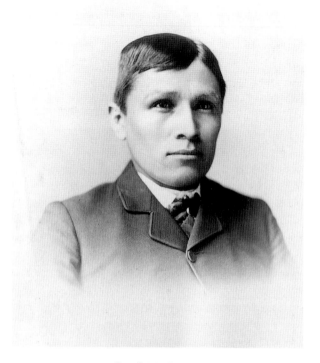

Figure 3. John Choate. *Tom Torlino, Navajo from Arizona, on Arrival at the Indian Training School, Carlisle, Pennsylvania*. 1885. Albumen print, 8³/₈ x 5¹/₈ in. each. Princeton Collections of Western Americana

and a settler's cow, house, and plowed field on the other (see Berlo and McMaster, pl. 1 [p. 23]). Wohaw depicted himself in Kiowa dress with uncut hair, more in the image of the enigmatic Native figure in his schoolroom drawing (see pl. 3) than his class- and prisonmates in their blue military uniforms (see Wade and Rand, pl. 3 [p. 48]). He had learned to write, for his name appears above his head, and to draw animals with foreshortened limbs in motion. The buffalo and bison move rapidly toward him while he stands stable looking between two different worlds, neither of which he can simply enter. It is in a realm of looking and deliberating, negotiating and choosing, that he drew his own self-image, fully conscious of change and crisis.

In the turbulent years at the end of the nineteenth century, there was an interconnected web of killing and writing, drawing and photographing on the Great Plains. Ledger books, with their drawings by Native Americans, exist in the interstices between writing, drawing, and violence; their production is a metaphor for history in the Great Plains itself.

The Subtle Art of Resistance: Encounter and Accommodation in the Art of Fort Marion

Edwin L. Wade and Jacki Thompson Rand

Until recently, the remarkable aesthetic and intellectual sophistication of late nineteenth-century Plains drawings, and especially the creations of the Fort Marion prisoners of war on which this essay focuses, have been misunderstood and underappreciated.[1] The original curio-seeking public of the late nineteenth century perceived these drawings as either naive renderings by pacified "savages" of the material and social wonders of American culture—our trains, boats, buildings, bridges, costuming, social and military activities—or the prisoners' homesick nostalgic doodles of a bygone idealized life on the Plains—their hunting, trading, courting, rituals, and traditional lifeways.

Although a more sympathetic, less pejorative attitude has recently been directed by the academic community toward ledger art, these thematic categories of Historical Authenticity and Nostalgic Romanticization have persisted. In part, this is the consequence of a latent paternalism that still colors the non-Indian perception of such art. For within the writings of contemporary scholars, an unintentional but condescending surprise is often expressed at the versatility and adaptability of these warrior-artists. They are applauded for having captured our attention and engaged our minds. The underlying message is clear: we did not expect Indians to exhibit such capability. Likewise, the descriptive categories applied to the drawings, regardless of the specific terminology of individual scholars, all rely upon the historic perspective of two overarching themes: first, images of the new—which translates as "wonder"; and second, images of the old—which translates as "nostalgia." In both instances the Native artist is relegated to a secondary position within Western society, chronicling either what we, the superior culture, have offered Native peoples or what we have taken from them.

This essay explores the drawings as evidence of a major transformation that occurred within Indian tribal communities during a period of changing social conditions. The culmination of those external forces of change, the reservation, is frequently seen as the beginning of a downward spiral for Native societies. Remarkably, Native American artistic expression failed to collapse in on itself even under extreme conditions of deprivation and social engineering. Indeed, what we find among the prison artists at Fort Marion is the appearance of an art form that reflects the emerging values of tribal society in transition. Pictographic hide painting, the antecedent to ledger drawing, served a social purpose in confirming the status of individual prestige-conscious warriors. The art of Fort Marion prisoners affirmed more general ideals of social solidarity through the exploration of tribal histories, elevation of the commonplace as a central artistic theme, and assertion of Native American dignity in the face of cultural purification experiments. The drawings made at Fort Marion from 1875 to 1878 are nothing less than an incipient national literature.

Multiple subthemes, narrative conventions, and subliminal messages exist within the drawings. They reveal a complex series of communication acts through the production and exchange of art. Especially pronounced is the subtheme of the Journey, which visually chronicles the incarceration and deportation of the Indian prisoners from Oklahoma in April 1875 to their arrival at Fort Marion in St. Augustine, Florida, on May 22. A number of artists, including Wohaw, Zotom, Howling Wolf, Squint Eyes, Making Medicine, Cohoe, Bear's Heart, and Etahdleuh, made drawings of this theme (see the essay by Jantzer-White in this volume). Individual artists favored certain aspects of the trip; Zotom, for example, depicted the killing of Grey Beard (pl. 1), and Howling Wolf drew elaborate harborscapes with sailing ships and steamships (Szabo 1994c:pl. 15).

Other thematic conventions, often overlooked but significant in the messages they conveyed, are the use of self-portraiture and comparative images of equivalence. A drawing by the Cheyenne artist Making Medicine is revealing (see cat. no. 66). As did a few other prison artists like Buffalo Meat and Wohaw, Making Medicine created an interesting group of images depicting the artist outfitted in his newly acquired U.S. military garb juxtaposed against a compositionally identical drawing of the warrior in his native military attire. A variant of this theme is seen in another drawing by Making Medicine, in which a group of U.S. Artillery officers (see cat. no. 67) is compared to a self-portrait of Making Medicine. Wohaw composed a similar image (Harris 1989:pl. 32).[2]

All these works can be read in a number of ways, depending upon the predisposition of the viewer. The casually interested Anglo tourist could interpret them as the Indians' attempts to emulate whites. To the Anglo social reformists and mission school personnel, the message suggests the Indian artists' capitulation to their improvement and transformation in the image of white society. For the artists, the use of such imagery allowed a retention of self-esteem and spoke clearly of their sense of equality with white society. All these positions are substantiated and voiced in the correspondence, interviews, and later memories about this remarkable time and event. And as with all human interaction, no one set of opinions or perceptions totally dominated. The messages were freely available to all parties.

It is appropriate when evaluating these drawings to recall that they are the visual narratives of the first encounter between Indian tribal and Anglo industrial society and the subsequent enforced Indian accommodation to this Anglo-Christian world.

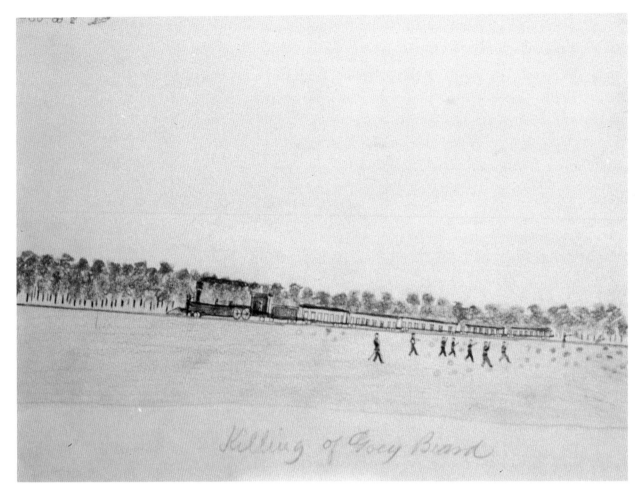

Plate 1 (also cat. no. 105). Zotom, Kiowa. *Killing of Grey Beard.* 1876–77. The National Cowboy Hall of Fame and Western Heritage Center, Oklahoma City, Arthur and Shifra Silberman Collection, 95.2.680

Plate 2. Zotom, Kiowa. *On the Parapet of Ft. Marion Next Day After Arrival.* 1876–77. Pencil and colored pencil, 8½ x 11 in. The National Cowboy Hall of Fame and Western Heritage Center, Oklahoma City, Arthur and Shifra Silberman Collection, 95.2.633

This Native art of encounter and accommodation, though invented for an Anglo tourist audience, nevertheless spoke multidirectionally: Indian to Anglo, Anglo to Indian, Anglo to Anglo, Indian to Indian. The multitiered communication of these deceptively "simple" works rested upon the interpretive ambiguity of the images, the evaluative predisposition of the viewers to see what they wanted to see, and a fundamental inequality in rights and respect between the Native producers and the Anglo consumers. The messages were mixed, and that multilingualism served often contradictory agendas. Let us explore a few specific examples.

One Kiowa prisoner, Zotom, was particularly prolific. Like his fellow warrior-artists, Zotom executed both the generic then-and-now imagery of the "savagery-to-civilized-citizen" transformation and the iconic visual sequence of the Journey from the surrender of the Indian combatants of the Red River War in Indian Territory (1873–75) to their incarceration at Fort Marion. Among Zotom's more arresting works is an image entitled *On the Parapet of Ft. Marion Next Day After Arrival* (pl. 2). The drawing shows the Kiowa, Cheyenne, Arapaho, and Comanche prisoners standing along the crenelated parapet of Fort Marion (an old Spanish castillo). Facing toward the sea, away from the viewer, they are flanked by two military guards with a cannon pointed at them. Possibly they are observing the departure of two distant sea vessels similar to those that had delivered them to Jacksonville, Florida, the previous day. This work is loaded with interpretive potential. We will never know the feelings or specific

aspirations of the Kiowa artist or the original Anglo collector of the work. However, enough is known of the time, the place, the social agenda of the nation and particular interest groups, and even of the artist to project a variety of messages.

Superficially, the message between Indian and Anglo in this image is one of surrender and accommodation, ideas that held enormous appeal for tourists and reformers alike. "The Journey" portrayed the inevitable outcome of Native America's encounter with Anglo progress. Some visitors were sympathetic, some hostile, but most sought entertainment, which they found in the spectacle of "pacified savages." Drawings were sold as novelties, thereby diminishing the significance of the subject matter and emphasizing the visual impact of the images. The military symbolism of *On the Parapet* communicated the warriors' subaltern status, which the Anglo audience presumably welcomed. Indeed, for the most part, the Fort Marion artists avoided themes of direct military confrontation between Indians and Anglos—some would suggest, at the behest of Capt. Pratt and other military officials (Szabo 1994b:6). The censorship of war scenes reinforced the popularity of passive images.

Neither Pratt nor the artists anticipated the intense Anglo interest that would be directed toward this art and its makers. We know that he and his staff instituted the drawing project to provide activity for the bored prisoners as well as a little pocket change generated from curio sales. Probably the artists drew in compliance with official demand initially without expecting that their images could effect attitudinal change among Anglos. However,

the remarkable resourcefulness of these men soon allowed them to explore through art their new social and political environs. *On the Parapet* marks the conclusion of the Journey sequence with the internment of the warriors at the fort. Whether the specific image of the prisoners on the parapet was of interest to tourists is impossible to ascertain, since it is always linked to the narrative structure of the warriors' surrender and deportation from Indian Territory. The topic of the Journey, however, was most intriguing to the Anglo public, who actively sought it in curios. We know that tourist demand for warrior curios outstripped their supply. The artists had waiting orders for painted fans and, as evidenced by figure 3, for drawing books on the Journey as well. This interesting strip of paper is inscribed, "Zotom is busy drawing a book of," and on it, rendered in shorthand-style, are ten sequential stages from the warriors' surrender to their journey East.

The subject of Anglo to Anglo communication about Fort Marion drawings is complex and cannot be fully documented in this brief text. Again, multiple messages were circulating among interested whites as to the content of the drawings, a conversation that continues, as evidenced by the present collection of essays. It is in this dialogue that the perception of nostalgia arises. Of particular interest is the goal and role of nineteenth-century social reform in establishing an evaluative atmosphere for interpreting these works. Reformers fell into two principal camps. True assimilationists such as Pratt believed in killing the Indian, through education, intermarriage, and

Figure 1. Zotom, Kiowa. Sketch for a drawing of the Journey. 1876–77. The National Cowboy Hall of Fame and Western Heritage Center, Oklahoma City, Arthur and Shifra Silberman Collection, 95.2.778

urbanization—saving the man by absorbing him into mainstream society. Others such as Samuel Chapman Armstrong, the son of missionaries and the founder and first principal of the Hampton Institute in Hampton, Virginia, followed the old segregationist model. They sought to improve the Indian through vocational training before returning him to the reservation.[3] As cited earlier, reformists like Pratt and his eastern friends promoted the concept of nostalgia as the motivating force behind the creation of images of bygone days on the Plains. There is truth to this proposition, since obviously any deportee misses his homeland. Yet the manipulation of nostalgia to signify threat, an underlying resistance and resentment by Native peoples of white society, and a willingness on their part to backslide into a former barbarism was central to the reformist agenda. Without "savages" there could not exist a role for social conversion, and without the need for conversion reformists were out of work. Thus, the contrived threat of potential "savagery" continued to exist long after the close of the Indian Wars, thereby ensuring a place for the ongoing husbandry of a wayward flock.[4]

The perception of nostalgia is further enhanced by the descriptive texts that accompany the drawings. More than one handwriting style is evident, and if we compare those scripts with the English writing lessons of the prisoners it becomes evident that often they are the narratives of Anglos, rather than Natives. We must be vigilant in questioning whether these captions are relevant to the intent of the artist. In the case of *On the Parapet*, the entire tone and supposed message of the work is set by the caption. Here, Anglo is speaking directly to Anglo, suggesting a despair and dislocation felt by the prisoners, which may or may not have been the case. We know that both the day of arrival and the following day at Fort Marion the prisoners were lined up for photographs. Is there a photographer in front of this group of men? Perhaps Pratt and other prison officials are calling roll and assigning quarters. Could it be the exercise period? The point is that we just do not know what is going on but have been seduced into a false sense of knowledge by a third party's perception. (For further remarks on the interrelation of these images and their captions, see the essay by Jantzer-White in this volume.)

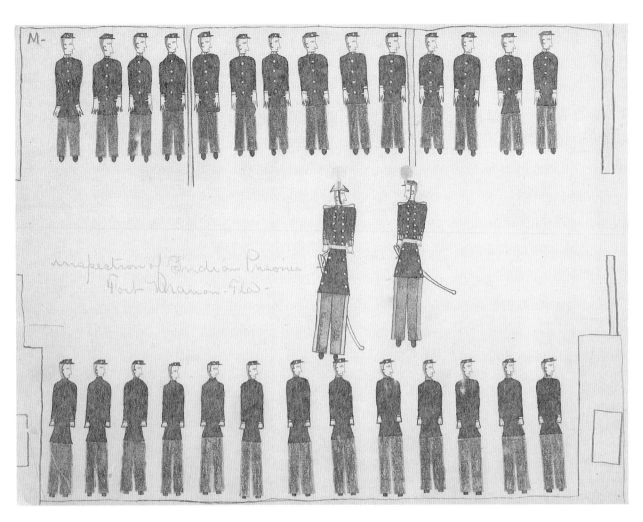

The dialogue between Indians contained within these images is the most difficult information to ascertain. At the time that these drawings were executed, the Anglo community had little interest in what the artists had to say. In the scraps of personal profiles, conversations, and Native American perceptions that have been recorded, the Indian emerges as a versatile, adaptive, and highly intellectual being.[5] Many learned an entirely alien language, English, within three years. They submerged their identities within the protective personas of accommodation and survived. They quickly perceived the unspoken truth of the Anglo-Indian relationship: that Indians existed for the convenience and entertainment of white society. To step beyond those bounds and explicitly exert self-determination meant extermination. Nevertheless, the artists mastered the subtle language of nuance through Native strategies of humor, caricature, exaggeration, and fantasy, and thereby expressed their personal voices.

We will never know Zotom's feelings about his drawing *On the Parapet*. Whether he felt nostalgic when he created the work is questionable. Zotom exhibited a personal strength and arrogant resistance to white ways that earned him the dislike of Pratt. Upon his return home after three years at Fort Marion, he quickly reverted to his indigenous ways and renounced white practices (Petersen 1971:171–92). A warrior accustomed to hardship, Zotom embraced difficulty as a means to measure his personal strength and success. From a Kiowa perspective, it is as likely that the fortress represented a place of power and challenge that if met and learned from, would surrender secret knowledge. It was a high place, a man-made mountain overlooking endless sea, similar to the sacred hills and mounts of the Southern Plains to which men retired to seek knowledge.

The Fort Marion drawings reveal a fundamental change in the Southern Plains approach to narrative art with the introduction of romance. The use of this concept corresponds to the medieval European literary genre known as the *roman*. The subject of the earlier Plains pictorial tradition, with its emphasis on warriors and their military prowess, was the equivalent of a tribal European *chanson de geste* (song of heroic deeds). Both traditions celebrated the great man of arms, committed to the protection of his nation and known for his loyalty to his peers. For such men glorious death, fatalistically embraced against unconquerable foes, was the triumphant mark of success. As in early medieval Europe, the changing social and economic realities of Native America brought the emergence of a new form of national hero. The Fort Marion warrior-artists incorporated many of the attributes of the romantic hero into their drawings. Unlike their tribal forefathers, these new heroes self-consciously displayed social as well as martial skills. They prided themselves on living up to an established high standard of behavior, a polished sense of decorum and manners, and a personal testing of one's character. These subjects are all evident in the prison drawings, whether in the "spit and polish" military garb of the prisoners (pl. 3), or in the acts of doffing their caps and bowing genteelly to Victorian ladies. The view of society as a whole, in which the little delicacies of life are revealed through a social dance, camp trading, and the courting of young women, is also a component of romance, not nostalgia. Most important, this new romantic visual text allowed for the public expression of Native American beliefs and values in a non-confrontational manner, and the Anglo audience responded favorably to these positive images of Indians. Thus the Native cultures developed an effective instrument of maintaining ethnic boundaries. More than evidencing their skills at accommodation, the drawings of the Fort Marion prisoners speak of the artists' accountability to their respective communities, the resilience of Indian identity, and the subtle forms of resistance that carried Native America into the twentieth century.

Notes

1. In May 1875, Capt. Richard Pratt delivered seventy-three Southern Plains Indian prisoners of war to the U.S. Army post at Fort Marion in St. Augustine, Florida. Having waged an unsuccessful campaign to deter an intrusive Anglo population, the recalcitrant Kiowa, Comanche, Arapaho, and Cheyenne warriors surrendered to the United States government at Fort Sill, Indian Territory. Seventy-two men and one Caddo woman were placed in Pratt's custody. Pratt's military career in the West, familiarity with Plains people, and, most significant, his reformist zeal, prompted him to volunteer as supervisor of the prisoners' removal to Florida. He also supervised their three-year incarceration there.

Pratt and other reformers of the time endeavored to effect the transformation of Native Americans in the image of Anglo America. Once at Fort Marion, Pratt created a controlled environment modeled according to assimilationist goals. He engaged the prisoners in English-language training, religious studies and devotion, manual labor, drills, and the production of art for sale to tourists. Subsequently, twenty-six of the younger Kiowa and Cheyenne men produced hundreds of drawings. Modern materials, including pens, pencils, and paper supplied by Pratt, substituted for traditional surfaces and implements. The drawings, born out of a Great Plains pictographic tradition, depicted pre-reservation life and the prisoners' contemporary circumstances. With Pratt's encouragement, the Indians sold their art to local curiosity seekers and the numerous visitors who came to see captive Plains warriors. The drawings became widely distributed, and are now held in various museum, archival, and private collections throughout the United States (see Pratt 1964; Petersen 1971).

2. Another distinct body of work that is totally narrative and free of the commercial conventions of curio drawings is comprised of the personal pictographic letters exchanged between artists and their families. In them, we see the unfulfilled potential for ledger art to have evolved from generic pictograms into an emotive literary script (see letter from Etahdleuh to Zotom, ca. 1876–77, The National Cowboy Hall of Fame and Western Heritage Center, Oklahoma City, Arthur and Shifra Silberman Collection, 95.2.636; see also Szabo 1991a).

3. The literature on missionaries and reformers is considerable. Some reformers were active on a policy level, while others put those policies into practice. Pratt most definitely fell into the latter group. Missionaries and reformers did not always agree on the goals, means, and methods of solving the "Indian problem." Many wholeheartedly believed in removal, hoping that segregating Indians from the worst elements of white "frontier" society would give them time to prepare for their incorporation into the mainstream. Many grew disillusioned with the corrupted Indian service and degrading reservation system, calling for both to be dismantled. The one idea that they held in common, however, was that the transformation of Native Americans was necessary and appropriate. Some of the standard works on this subject for this period are: Prucha 1976; Hoxie 1984, Mardock 1971; and for specific reference to Pratt, Eastman 1935.

4. The Indians' "civilized" status hung precariously by a thread, providing ample opportunity for the reenactment of their salvation. A young Kiowa wrote to his friend Etahdleuh at the Hampton Institute of his worries: "I am going to stick to my clothes and what I know about the white man's way, but when my pantaloons and coat wear out I don't know where I shall get any more." Similarly, Buffalo Meat and Quoyounah wrote to Pratt lamenting their lack of "white clothes," and that although Quoyounah did not wish it so, he "had to take leggins." These "Pathetic Letters from Indians" compelled Pratt to overcome his "reluctance" to have the Indians appear to be begging, and he personally issued a plea for clothing and other goods to prevent them from a forced abandonment of the white man's road. *Southern Workman* 7 (July 1878), 50; 8 (June 1879), 68.

5. Cora Mae Folsom, a teacher of Indian students at the Hampton Institute, describes one Indian-Anglo interaction in her memoirs. One year the Hampton Indian students performed *Hiawatha* at Virginia Hall Chapel to commemorate the installation of a stained-glass window in honor and memory of Pocahontas. Henry Benjamin Whipple, the Episcopal bishop of Minnesota and an advocate of Indian reform, and other dignitaries were in attendance. The play proceeded smoothly until the wedding scene, when Iago rose to speak in the "Indian language." "Being a gentleman of imagination as well as of facile tongue, he took advantage of the occasion to tell the audience some home truths not at all flattering." To the amusement of the other Indian actors, Iago stated in "best oratorical style" that "I can stand here, my friends, and say to you anything that I wish. I can call you 'witkokoka' [fools] if I want to and you will only sit there and smile and smile and smile" (Folsom n.d.).

Narrative and Landscape in the Drawings of Etahdleuh Doanmoe

Marilee Jantzer-White

Between 1875 and 1878, Kiowa artist Etahdleuh Doanmoe completed at least sixty drawings while incarcerated at Fort Marion, Florida. In his art, Doanmoe drew on his experiences on the Southern Plains, his sentencing and subsequent journey to Fort Marion, and the years he spent there.[1] Accused of killing two buffalo hunters as well as participating in the battle at Adobe Walls, Texas, Doanmoe remained in the East for ten years. Unique to this imprisonment was the fact that incarceration transgressed its customary physical boundaries and would include an intellectual dimension as well. For in their approaches to literacy, the Indians sentenced to Fort Marion employed pictorial means rather than the alphabetic script used by Euro-Americans.[2]

While imprisoned these men produced an unprecedented number of drawings of events they had personally experienced, and this outpouring provides an invaluable source for examining Plains Indian art. Writing about the drawings, however, poses several problems. Not least among these is whether analyses of these drawings can escape being subsumed by the Western methodologies used in their explication. Doanmoe's drawings present a unique opportunity to examine this issue since, following his death in 1888, textual annotations, provided by Capt. Richard H. Pratt, commander at Fort Marion, were typed across the front of most of them. The interplay between the images and texts, each describing historical events, is the primary focus of this essay. A brief discussion of one of the drawings introduces Doanmoe's art, and serves as a springboard for a consideration of what might be at stake in analyses of ledger art.

In figure 1, Doanmoe shows Kicking Bird (a Kiowa leader who, with his supporters, consented to reservation confinement) accompanied by Pratt and two cavalrymen riding to meet another Kiowa leader, Big Bow. Kicking Bird and Big Bow each carry

flags of truce, while, in the distance, Big Bow's followers await the parley's outcome. The caption states that Pratt and Kicking Bird met "the hostile Kiowas under Big Bow and Mahmaute in the Wichita mountains" and that "Big Bow bargained with General Davidson [commander at Fort Sill, Oklahoma] to surrender his followers provided that he was made immune from punishment." The text interprets the image in a way that unites Big Bow and General Davidson in a ploy and casts Big Bow in the role of a betrayer—he trades his followers for his personal freedom. Yet according to Fort Sill files, Davidson initiated the offer to persuade Big Bow's followers to surrender (Nye 1969:296–313). In the drawing, Kicking Bird accompanies Pratt to facilitate the surrender, while Big Bow, described in

the text as "one of the worst marauders among the Kiowa," supposedly betrays his followers to escape retribution.

In contrast with Pratt's textual account, Doanmoe's drawing does not differentiate between the two leaders, Kicking Bird and Big Bow, but gives equal importance to each with respect to size and detail. In so doing, Doanmoe departed from Kiowa pre-reservation pictorial conventions that gave priority to attributes of identity, either in the form of personal and tribal regalia or pictorial name signs added above each figure. When text describes the drawing, however, the drive to produce a cohesive narrative supports a single conclusion: that Big Bow was duplicitous and he and his

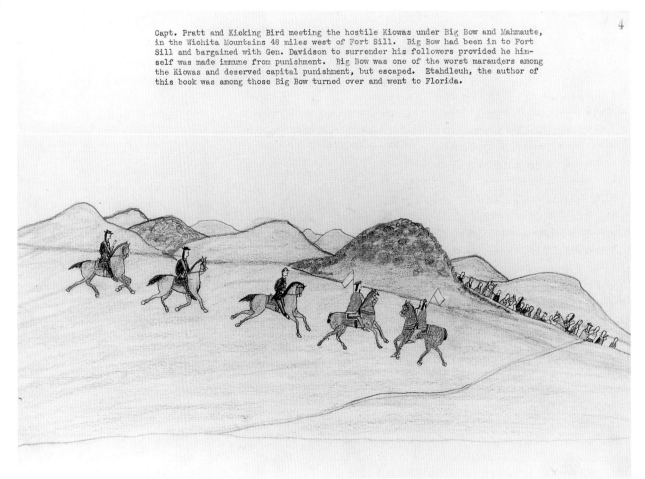

Capt. Pratt and Kicking Bird meeting the hostile Kiowas under Big Bow and Mahmaute, in the Wichita Mountains 48 miles west of Fort Sill. Big Bow had been in to Fort Sill and bargained with Gen. Davidson to surrender his followers provided he himself was made immune from punishment. Big Bow was one of the worst marauders among the Kiowas and deserved capital punishment, but escaped. Etahdleuh, the author of this book was among those Big Bow turned over and went to Florida.

4

followers represented a renegade group among the Kiowas. If we focus on the drawing alone, Doanmoe's aesthetic choices reveal the complexity involved in attempting to interpret the nuances of pictorial systems of communicating.[3]

Systemic differences between Western alphabetic and Southern Plains pictographic systems require interpretive approaches that foreground Plains literacy practices while taking into account the problems raised when ledger drawings are viewed through a Western lens. The juncture of Plains pictorial practices and oral traditions with Western theories and practices requires close attention. Inquiries neglecting either risk privileging the imagery or the methods used in their explanation. Moreover, in Plains pictorial systems, as with Western alphabetic texts, the visual product represents but one component, while the drawing's function and its larger context constitute a second. How these are married, however, differs according to the dictates of their corresponding societies.

Drawings such as Doanmoe's, regarded by many scholars as "documentary sources," hinged on personal observations, the recountings of which were subject to peer scrutiny, both on the Plains and at Fort Marion. Ledger art provided the imagery, but with a caveat. As with other Kiowa notational systems that used pictorial means, for example, Kiowa calendar counts, ledger images were both mnemonic devices and individual narratives in which meaning included an oral element.[4] Pictorial imagery made history and memory visible. Recall of depicted events took place not as isolated exchanges between solitary reader and text, but in a social context. Meanings were crafted in a nexus of relationships that stressed both pictorial and oral traditions.

Pratt commissioned the Doanmoe drawings illustrated here and, although they drew upon Kiowa representational practices in which individual drawings reproduced separate, usually unrelated events, he selected examples to be bound together in a sketchbook that he titled *A Kiowa Odyssey*.[5] Pratt's prescience regarding the drawings' historical potential is evidenced by his attempt to ensure their specific "interpretation."[6] In a note previously affixed to Doanmoe's drawings, Pratt wrote that "Etahdleuh's artistic talent cannot be questioned nor the accuracy of detail though marred by faulty perspective."[7] While the word "perspective" probably describes what Pratt interpreted as naiveté in rendering three-dimensional reality, his description is ironic given Pratt's own "perspectives" typed across those of Doanmoe's, as illustrated by his drawings.

From the sketchbook's title, *A Kiowa Odyssey*, to the cumulative effect of its contents—drawings depicting a Kiowa camp session, the journey between the Southern Plains and Florida, and Fort Marion's re-education programs (see cat. nos. 79–88)—the narrative constructed is unidirectional. Viewed through Western narrative conventions, it read as a metaphor for Doanmoe's own journey, from Plains warrior to Christian missionary (his profession on returning to Kiowa territory). The power of this narrative masks Pratt's role as co-author of *A Kiowa Odyssey*. Pratt obscured his role by omitting the pronoun 'I,' so the text transcends the contingent nature of its narrative. Put in simplest terms, *A Kiowa Odyssey* reflects more Pratt's narrative than Doanmoe's drawings.

The inextricable link between images and their narrating suggests that Kiowa memories and their recording interacted through a complex weaving of imagery and oral tradition. In contrast with Western practices, where the writing process often entails the use of hierarchies (in the sense of the authoritative account), Kiowa pictorial systems placed value in their capacity to generate retellings. According to Kiowa author M. Scott Momaday, "A word has power in and of itself. It comes from nothing into sound and meaning; it gives origin to all things. By means of words can a man deal with the world on equal terms. And the word is sacred (Momaday 1969:33)." Momaday locates "man's" idea of himself and its essence in language. While most Western theorists eschew positions that argue for an essence or single truth among the many possible meanings of art, the location of "a" truth was probably also uncertain in the practice of nineteenth-century Plains drawing. Yet, simultaneously, the factors that made for validity in interpretation depended on the veracity with which the event was depicted. When viewed in this context, what might analysis of such drawings reveal about the ways in which Kiowas used pictographic systems to interact with the world?

The narrative strategies that Pratt employed in *A Kiowa Odyssey* conflict with those used in traditional Kiowa narrative practices. In Kiowa calendar counts, each pictograph documented a single episode that forged together reality and memory in consecutive but unrelated events.[8] Iconic signs for winter or summer accompanied images that, in their kinship with oral traditions, remained attached to the individual or collective body. Momaday has described Kiowa processes of transcribing memory similarly, as "that experience of the mind which is legendary as well as historical, personal as well as cultural," in which "the imaginative experience and the historical express equally the traditions of man's reality." For Momaday, the temporal dimension interwove the mythic and the historical,[9] and transcended Western narrative practices that are wedded to linear trajectories.

In the wake of Western colonization, the new experiences of Native Americans required extending the network of symbolic references to depict altered realities. One of these changes included increased attention to landscape details, an important tool for documenting historical processes of change. Inclusion of landscape features in Kiowa ledger art marked a departure from pre-reservation practices that downplayed topographical details, yet it infused drawings with a vocabulary that expressed the altered political circumstances.

This seems most apparent in Doanmoe's drawings that include landscape.[10] Among Kiowas, landscape symbolized, in the words of Momaday, "the religion of the Plains, [and] a love and possession of the open land." Using an artistic language imbued with symbols of both freedom and captivity, Doanmoe employed depictions of spatial relations to map out communal and personal affiliations, and in the process, self and identity. Observing Plains traditions, Doanmoe drew on pictorial modes that recorded historical events as remembered in their moment of happening.

Comparison between Doanmoe's Kiowa camp scene (see cat. no. 79) and his drawing of Pratt's house at Fort Marion (fig. 2) illustrates this point. In the former work, Doanmoe depicted a Kiowa council session on the Southern Plains in which individually painted tipis (designators of personal own-

ership and status) are arrayed across the Kiowa landscape. Two United States flags stand within the council circle and, in the distance, the dry, brown Wichita mountains identify the season as summer. Topographical details fill the paper, referring to a specific place. Many years later, Momaday (1969) would describe this area as the "immense landscape of the continental interior," using language rich in metaphors that evoke expansive space as the signature of Kiowa land. Doanmoe's drawings similarly employ metaphor, tapping a pictorial vocabulary cued to matters of both locale and identity.

Condensed in Doanmoe's drawing of Pratt's house are symbols of a new world order. Using three-dimensional space as an isolating factor, Doanmoe carefully depicted the fence in front of Pratt's house as curved, extending off into the distance, and segregated Pratt's quarters from their surrounding environs, aesthetically employing spatial techniques that replicated physical reality. His unusual use of three-dimensional perspective contrasts with the layering techniques he more commonly employed to represent near and distant objects. This choice finds a tangible counterpart in actual circumstances, in which the United States apportioned territory by delimiting space. Doanmoe's depiction of trees and landscape features within Pratt's private domain (guarded and fenced off) succinctly illustrated the changing face of landscape by recording the man-made alterations that were reshaping the terrain.

Disjunctions between Plains pictorial and Western textual practices are evident in two other drawings. In his depictions of the chapel and classroom at Fort Marion, Doanmoe constructed a space that lies at the interface of two worlds (figs. 3, 4). The caption on the first reads "The weekly religious service in the Chapel of the Fort," and on the second, "many of them learned to write and speak English." Pratt's text naturalized the inculcation of Western norms by framing them in terms of Western educational and religious opportunities. In the process of explication, the text blurred the boundaries between mandate and opportunity. If we focus on the image alone, Doanmoe's drawing of his fellow students zealously attending to their lesson gains

another dimension. The chapel and school interiors are starkly isolated by enclosing walls. These spaces contrast sharply with the expansiveness that Doanmoe typically employed for Kiowa council and dance scenes. By comparison, Fort Marion's interiors are claustrophobic, sparsely rendered, and restricted to the center of the page. They seem inseparable from their historical context, the re-education classes at Fort Marion's prison. The multihued colors Doanmoe used in drawing Southern Plains Indians, their horses and regalia, and Kiowa landscapes are absent, replaced by monochromatic grays, reminiscent of the prisoners' equally dull, dark blue uniforms.[11]

Considered within the context of Plains practices and the Fort Marion experience, Doanmoe's drawings warrant further attention. Indigenous forms of social, cultural, and intellectual activity influenced Doanmoe's artistic strategies. Analogous to practices on the Plains, where, in the words of Seneca Tom Hill, "designs became metaphors for beliefs" (1994), Doanmoe's

drawings resonate aesthetically and philosophically with Kiowa perspectives on the meanings of land. In a letter to Pratt dated July 4, 1879, Doanmoe wrote from Carlisle Indian School:

Dear Capt. Pratt,
. . .I just got a letter from home. It is very nice letter from my brothers, Mo-beatdle-te and Kiowa Against Two, and they want me to come there. Capt. Pratt, I wish to go with you when you go that way and talk with them and see what can be done for them. I wish to do that this summer. When I think that way I feel [in a] hurry about doing something for these Indians.
Yours truly
Etahdleuh Doanmoe[12]

This letter attests not only to Doanmoe's persistent desire to return to Kiowa territory but also to his Western alphabetic skills. Lack of finances thwarted Doanmoe's goals

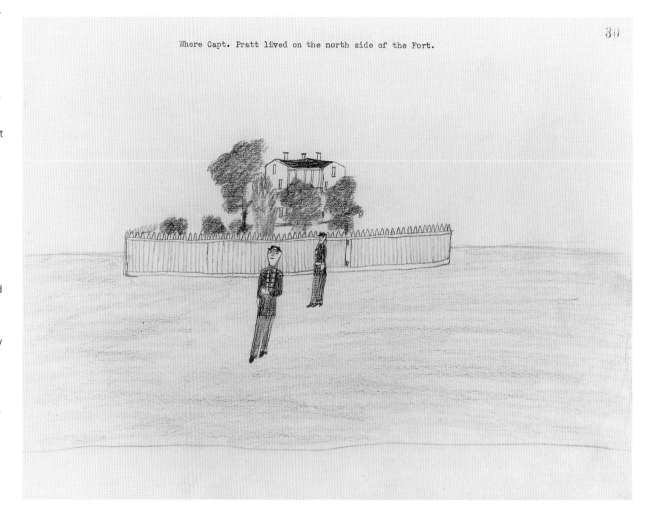

Where Capt. Pratt lived on the north side of the Fort.

30

The weekly religious service in the Chapel of the Fort.

Figure 3. Etahdleuh Doanmoe, Kiowa. *The Weekly Religious Service.* 1876–77. Yale Collection of Western Americana, Beinecke Rare Book and Manuscript Library, Yale University, New Haven, Connecticut, 28

29

One of the classes in the casements of the Fort. During the three years of imprisonment the prisoners were taught by volunteer teachers, and many of them learned to write and speak English.

Figure 4. Etahdleuh Doanmoe, Kiowa. *One of the Classes in the Casements.* 1876–77. Yale Collection of Western Americana, Beinecke Rare Book and Manuscript Library, New Haven, Connecticut, 29

until 1884, when he returned home with adequate funds to construct a wood frame house, a luxury then possessed by only a few prominent Kiowas. Yet, any fixed, referential meaning that might be given to Doanmoe's return to Kiowa territory as a Christian minister should not be construed as a moment in the triumph of Western assimilation. In letters to Pratt, Doanmoe stated the importance of his financial position, as he transformed Western mandates into both religious conviction and a vehicle to achieve Kiowa status, a "coup" to signify his prestige on returning home.[13]

Though fluent in an alphabetic mode of communication, Doanmoe chose not to provide his own written texts for his drawings. His reasons are unknown to us. That he had opportunities for doing so during his several years in the East must be assumed. That he did not may be the result of mere happenstance. Or was alphabetic text ill-suited to explaining Kiowa pictorial conventions due to fundamental differences between the two literacy systems?

In her structural analysis of Cheyenne art, Candace Greene has demonstrated that the compositional structure of Cheyenne ledger art served as a visual metaphor for social and cultural relationships (1985; see also Greene's essay in this volume). She has also shown that this art's key organizing principle, counting coup (touching the enemy to gain honor), had lost its significance at Fort Marion.[14] Greene's conclusions are significant for this discussion in that she documented strong similarities between Cheyenne and Kiowa pictographic systems.[15] While ledger art may have lost its central metaphor, the potential of metaphor as a structuring device remained intact. Exiled from his native land, Doanmoe recorded U. S. territorial expansion in drawings in which details of the Western built environment dominated the natural landscape. Confinement to reservations brought changed relationships with the land, newly set out in terms dictated by the dominant society. Trains, houses, churches, and forts abound in Doanmoe's landscapes, graphically recording a Western presence that not only altered physical topography but also poignantly symbolized the actual physical and material displacements he experienced.

Walter D. Mignolo has recently suggested that in our study of indigenous practices, we must pursue "not only alternative literacies but also the alternative politics of intellectual inquiry."[16] Mignolo argues for adopting concepts grounded in Indigenous literacy systems. This strategy, while representing a worthwhile endeavor, does not go far enough. Western logic and rationality classify everything in their purview, both knowable and unknowable. Yet what is selected for analysis or critique might be, from Indigenous perspectives, not well served by the autonomy that accompanies the reading of an alphabetic text.[17] Moreover, opinions frequently differ markedly regarding whether Western scholarly and institutional approaches can take into account Indigenous subjectivities that eschew rationalizing and objectifying methodologies. Even more troublesome, most analyses are conducted in an arena of competing dialogues, in which the critiques themselves fall under the intellectual purview of Western methodologies.

Thus, while my discussion of Pratt's sketchbook, *A Kiowa Odyssey*, privileges Doanmoe's drawings at the expense of their alphabetic texts, my approach attempts to give priority to the contexts in which such ledger drawings were conceived.[18] Late nineteenth-century Plains Indian drawings were crafted within intellectual milieus in which imagery and oral traditions worked symbiotically. Artistic interpretation hinged on the artist's perspective, itself verified through peer critiques. Ledger art originally functioned within a communal arena, but even at Fort Marion the "prisoner artists" explained their drawings for viewers, carrying forward the oral-formulaic styles used on the Plains. Although Doanmoe's ledger drawings were made for Western consumption, the concepts that informed their production lay within the social and political conventions that shaped Kiowa definitions of self and provided a coherent sense of order in the Kiowa world. By privileging the cultural and intellectual milieu of Doanmoe's drawings, I have sought to highlight tensions between Doanmoe's art and Pratt's texts, pictorial forms of literacy and

Western analytic practices. Invaluable as Western approaches might be, critiques derived from American Indian concepts are essential to avoid removing art such as Doanmoe's from the historical, social, and intellectual context in which it was produced and received.

Notes

1. Several spellings exist for Etahdleuh Doanmoe, such as Etalye Dunmoe and Etalyidonmo. Most frequently used is Etahdleuh Doanmoe, which translates as "He hunts for boys." See Mooney (1898:215). For an extended analysis of U.S.–American Indian interactions on the Southern Plains, see Hoig 1993. Like the rest of the seventy-two American Indians imprisoned at Fort Marion, Doanmoe was not only prisoner but also hostage, assurance that his people would cease engaging in warfare on the Southern Plains. The prisoners included members from five Southern Plains tribes—Comanche, Southern Cheyenne, Caddo, Arapaho, and Kiowa. For an analysis of the Fort Marion experience, see Petersen (1971:135–59). Although Pratt commissioned the drawings, Doanmoe selected the subjects depicted (Karen Petersen, personal communication, 1994). On drawings produced on the Southern Plains, see Greene (1992a:50–58), and for an account that discusses an artist who continued to produce work after the prison experience, see Szabo (1992, 1994c).

2. I define literacy in this essay as using a systemized method for presenting and recording ideas, whether in pictorial, oral, or alphabetic form; this method is employed as part of a conventionalized practice among a group of people. This essay should be read in conjunction with the catalogue entries on Etahdleuh Doanmoe's drawings for the fullest understanding of his works (see cat. nos. 79–88).

3. In addition, Kiowa histories describe Kicking Bird in complex terms. Some Kiowas regarded Kicking Bird as an opportunist who might trade Kiowa land and freedom for goods for his own people, and as untrustworthy because of his associations with white soldiers. However, Kicking Bird was highly esteemed because he interceded to procure the best terms of surrender for the Kiowas. Doanmoe's drawing holds in tension Big Bow and Kicking Bird, each an important leader with numerous supporters. For differing interpretations of Big Bow's role, see Petersen (1971:157), who states that Big Bow persuaded his men to come in to the agency, and Hoig (1993:284), who contends that Kicking Bird acted as the emissary who persuaded the Kiowas to surrender.

4. For calendar counts, see Mooney (1898:144–45). The ensuing interpretations encompassed a complex blend of rejections and verifications. While calendar counts and ledger drawings differed radically in the circumstances of their creation, parallels between their methods of communicating can be posited.

5. Pratt Papers, box 44, folder 7, and box 22, folder 719, Beinecke Rare Book and Manuscript Library. It is also entirely possible that Pratt's son, Mason, selected the drawings for binding, and it is difficult to ascertain from archival materials which was the case. The sketchbook was at some point disassembled, although we do not know when. For artists who did not use narrative conventions, see Szabo (1989).

6. Pratt's pressing interest in documenting history is evidenced by his voluminous records detailing his military career. See Pratt's autobiography, 1964. In addition, his gift to Yale University of Doanmoe's drawings carried the stipulation that Pratt's records provide the basis for his biography, and that the biography be published.

7. Mason Pratt, Pratt Papers, box 44, folder 7.

8. One example offered by Mooney (1898:144) was the Sett'an calendar count, which recorded two events each year. Accounts were privately owned but brought out periodically for the purpose of recounting both "mythic and historic traditions" and the passing on of tribal histories.

9. While Momaday's concepts of reality (1969:4) and perhaps identity are interwoven with oral traditions, images form an integral part of that equation. For discussion of the importance attached to imagery and its veracity in pictographic images, see Doanmoe cat. no. 85 in this volume, Battey (1968), Dodge (1882), Grinnell (1972), and the notes of Dr. Z. T. Daniel (cited in Ewers 1983a:52–61), a physician working among the Blackfeet in 1892.

10. The pivotal role played by visual expressions is clearly seen in heraldic imagery, the use of designs on shields and/or tipis for the purpose of displaying status. In traditional Plains painting, a warrior's heraldic imagery gave visual testimony to his success as a warrior, and hence his relationship with his protective spirit and the spiritual world.

Hoig (1993) provides an informative account of wars on the Southern Plains. In 1869 Gen. Philip Sheridan released chiefs Santanta and Lone Wolf, who had been held as hostages to assure their peoples' compliance. The conflicts that erupted had been foreseen by Kiowa leader Satank, who stated at the 1867 signing of Medicine Lodge Treaty (which contained a clause protecting Kiowa hunting rights in the Texas Panhandle region) that "in the distant past, the world seemed large enough for the red and white man: the broad plains seem now to contract . . . the white man grows jealous . . . and with the cloud of jealousy and anger tells us to be gone." See *Cincinnati Commercial* (November 4, 1867).

11. In an essay that explores image making by Plains Indians, Seneca Tom Hill has described "the desire to communicate psychological insights" as a pivotal feature of Plains art forms, while noting that the role color played is often neglected in analyses (Hill 1994:65–69). The function of color in ledger art must, of course, take into account the availability of materials, since a selection of colors was not always readily accessible. Yet, inasmuch as Pratt commissioned Doanmoe's drawings, it may be assumed that acquisition of materials was an insignificant problem. Although emphasis on the formal attributes of any artist's work risks reading such characteristics as reflecting artistic intent, the marked difference between Doanmoe's pedagogical scenes, his depiction of Pratt's house, and his other drawings remains striking.

12. Letters from Doanmoe to Pratt, Pratt Papers, box 2, folder 67. Doanmoe's conversion narrative should be read with a consideration of the state of alienation produced by the colonial context. Immediately after his release from Fort Marion in 1878, Doanmoe studied at the Hampton Institute. He remained there until 1879, when he entered Carlisle as one of its first groups of Indian students. Another letter he wrote to Pratt echoes this theme of alienation: "Dear Capt. Pratt, If you go out west this summer, I want to go very much and I want to see if I can do something for you. I want to talk with my people in my own tongue and if they can hear me [and] what I said to them" (June 1879, Pratt Papers, box 2, folder 67).

13. Letter from Doanmoe to Pratt, June 17, 1886, Pratt Papers, box 2, folder 67.

14. Cheyenne pictographic art may be separated into geometric and representational, the latter either being either visionary or pictographic. For the Cheyenne, pictographic art functions to display and to convey a specific message. My focus in this essay is on pictographic art. Counting coup provided the dominant metaphor for portraying warfare and hunting scenes, as well as for depicting relations between the sexes.

15. The correspondences between Cheyenne and Kiowa pictorial systems also extend to sign language. According to Clark (1885), in sign language, visual imagery likewise attended to matters of identity using topographical terminology. For example, tribal territory was indicated by pointing to the ground using hand signs that referenced rivers or other physically constant boundaries. Continental expanse and the numerous languages spoken by Plains Indians led to developing a common visual means in order to transcend geographical barriers, while simultaneously maintaining the individual languages central to identities. Sign language used physical landmarks to designate individual and tribal identities, akin to the way in which Doanmoe's depictions of trains and architecture, signifying signposts of Western presence and identity, predominate in his drawings that illustrate his journey to and confinement at Fort Marion.

16. Mignolo (1994:270–313) notes that debates about writing traditions in the Americas are based on Western theories about relationships between speech and writing, and has suggested that alternative methods are necessary to avoid academic colonialism.

17. I use the word "autonomy" to refer to the solitary act of reading, which contrasts with the reciprocity between people that defines the oral exchange.

18. Ledger drawings present many obstacles to textual analysis that, unfortunately, cannot be adequately examined in this essay. One noteworthy example is punning, a practice commonly employed in Kiowa language and by Doanmoe in his drawings. Among the thirty-seven Doanmoe drawings in Pratt's collection, seven included depictions of the United States flag. In four of the drawings, Doanmoe accurately recreated the flag. Each of them depicts scenes of captivity: the first shows Fort Sill on the horizon, the second portrays prisoners entering Fort Sill before being shipped East, the third details the process of selecting prisoners for the journey East, and the fourth illustrates the loading of prisoners into army wagons for the trip. In the remaining three drawings, showing a Kiowa camp, a Florida shark-catching trip, and an excursion around St. Augustine's plaza, Doanmoe altered the U.S. flag. Rather than portraying white stars on a blue background, Doanmoe drew a blue eagle on a white field. The eagle symbolized power and was highly esteemed among Kiowas; it was a potent symbol for the United States as well. Doanmoe's use of punning to play with visual imagery and the meanings of that imagery underscores the problems faced by textual analyses of his drawings. For an in-depth discussion of Kiowa grammar, see Watkins (1984).

The Legacy of Ledger Book Drawings in Twentieth-Century Native American Art

W. Jackson Rushing

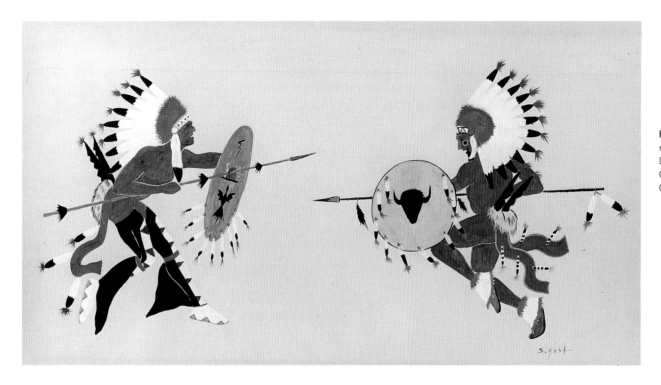

In the early years of the twentieth century, ledger book drawings—and the Plains Indian graphic traditions they embodied—became part of the foundation for a style now widely known as traditional Indian painting. The earliest manifestation of the modern legacy of ledger book art was in the watercolors of the so-called Five Kiowas— Spencer Asah, James Auchiah, Jack Hokeah, Stephen Mopope, and Monroe Tsatoke. The first four received art training from Sister Olivia Taylor, a Choctaw at St. Patrick's Mission School in Anadarko, Oklahoma, in about 1914; all of them had art lessons with Indian Service Field Matron Susan Ryan Peters in about 1918. Taylor also arranged for them to attend special classes at the University of Oklahoma beginning in 1926 (Dunn 1968:218–23 and Ellison 1972:14–19).[1] Like ledger drawings, their watercolors were figurative and often narrative and autobiographical (fig. 1). Two of their elders, the painters Charles White Buffalo Ohettoint and his brother Haungooah, also known as Silverhorn,

constituted a living bridge between the Five Kiowas and pre-reservation days on the Southern Plains. Ohettoint, who made drawings while imprisoned with other Plains Indian men at Fort Marion, Florida, in 1875, was joined by several members of his family, including Silverhorn, in painting tipis, calendars, and ceremonial objects (Ellison 1972:14 and Silberman 1978:15). Silverhorn was a prolific artist who painted designs on Kiowa Sun Dancers; his earliest drawings, such as the one depicting the warrior Little Mountain slaying a Navajo (cat. no. 90), were influenced by the Fort Marion style. His oeuvre included numerous works on paper, hide, and muslin; especially noteworthy is a series of Silverhorn drawing books from 1891 that include what are probably the earliest pictorial representations of Plains Indian peyote ritual (Ellison 1972:12; Greene 1992b:162; Wiedman and Greene 1988:32–41).

Mopope recalled watching his granduncle Ohettoint paint a Tipi of Battle Pictures and that his first art instruction came from his other granduncle, Silverhorn. Similarly, Auchiah was descended from a distinguished medicine woman and mixer of colors, and as a young man he once entered a tipi where a Ghost Dance painting was underway (Ellison 1972:14 and Silberman 1978:15–16). Thus, in the words of the renowned collector of Plains Indian art, the late Arthur Silberman, "the era of ledger drawings and the beginning of early contemporary Kiowa painting roughly overlapped" (Silberman 1978:15). Indeed, as Rosemary Ellison, director of the Southern Plains Indian Museum in Anadarko, has observed, Ohettoint and Silverhorn "played an important role in the early informal training" of Mopope, Hokeah, and Asah, "all of whom were related" (Ellison 1972:14).[2] Furthermore, John C. Ewers, a preeminent authority on Plains pictorial art, wrote that a "good case can be made for viewing the works of the five Kiowa boys and other

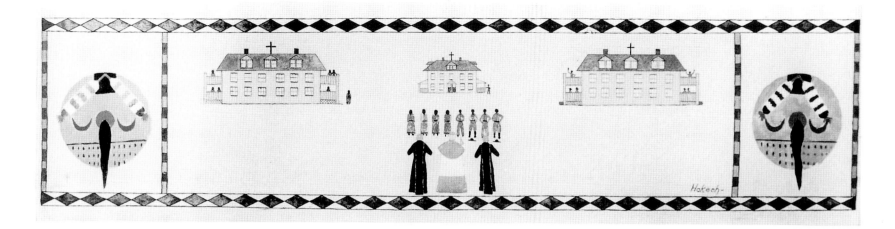

Figure 2. Jack Hokeah, Kiowa. *On November 25, 1892, St. Patrick's Mission School Was Opened. Bishop Meerschaert Blesses the New School and Administers Confirmation.* 1929. Oil on celotex, 22 x 57 in. Panel 7 from Memorial Chapel, St. Patrick's Mission School, Anadarko, Oklahoma

Plains Indian artists in the 1920s and 30s as a continuation" of the nostalgic works made by "the Plains Indian prisoners at Fort Marion." The efforts of the Five Kiowas, he noted, was no doubt "encouraged by Indian artists of the 1880s [such as Silverhorn] who were still living" (Ewers 1971:50).

At the University of Oklahoma the young Kiowa painters flourished under the tutelage of Prof. Oscar B. Jacobson, director of the art department, who arranged for their paintings to be shown in 1928 at the First International Congress of Folk Arts in Prague and who published a portfolio of the exhibition in France the following year (Dunn 1968:219–20; Jacobson 1929). Jacobson was also instrumental in the inclusion of their paintings in the *Exposition of Indian Tribal Arts,* which toured the United States from 1931 to 1933 and was the first substantial effort to present contemporary Indian art as *art* and not ethnographic material (Dunn 1968:220; Exposition of Indian Tribal Art 1931:n.p.).[3] In 1929 the four who had attended St. Patrick's Mission School returned there to paint murals in a memorial chapel honoring Father Isidore Ricklin, O. S. B. Ellison has noted that these paintings "are extremely important in the development of contemporary Southern Plains Indian art as they represent the earliest examples of mural painting by Indian artists" in this region (Ellison 1972:18). Significant also is the fact that these murals, although produced under the supervision of Father Aloysius Hitta, are thematically and stylistically related to ledger book drawings, calendar counts, and other mnemonic paintings: they are flat, linear, history paintings that emphasize the individual artist's interpretation of the event. One of the murals, paint-

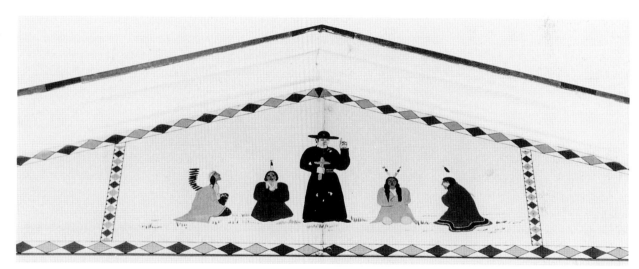

Figure 3. Jack Hokeah, James Auchiah, Spencer Asah, and Stephen Mopope, Kiowas. *Father Isidore Ricklin, Founder of St. Patrick's Mission, in Council with Chiefs.* 1929. Oil on celotex, 22 x 57 in. Panel 17 from Memorial Chapel, St. Patrick's Mission School, Anadarko, Oklahoma

ed mostly by Hokeah, depicts the opening of the school in 1892 and includes a decorative border (suggestive of parfleche designs), which frames images of buffalo shields that were painted by Asah (fig. 2). Another of the murals (fig. 3), which is unsigned, shows Father Ricklin in council with four chiefs. Ellison suggests that all four artists contributed to this panel, each representing a relative as one of the chieftains, including Auchiah's relative, the great Chief Santanta (second from the left), who

wears a peace medal (Ellison 1972:18). This representation of a chieftain wearing a peace medal was prefigured by a ledger drawing done in 1877 by the Kiowa artist Wohaw, High-Ranking Kiowa and Their Tipis (cat. no. 95).

Beginning in 1930, the Five Kiowas began promoting their paintings in the Southwest at the annual Inter-Tribal Ceremonial in Gallup, New Mexico, where they often performed as singers and dancers. The artists were originally spon-

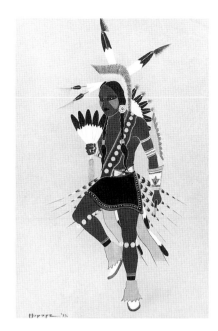

sored by Indian Field Service matron Susan Peters, but by 1935 they were arranging these trips themselves (Dunn 1968:220). Asah, Hokeah, and Mopope in particular were distinguished dancers, and according to Ellison, both Peters and Jacobson recognized the "value of promoting the paintings in conjunction with dance performances by the artists" (Ellison 1972:19). Like many ledger book drawings, the watercolors that document these award-winning dances are proud pictorial celebrations of an individual's dynamic performance (fig. 4). In reference to such paintings Ellison has explained the artistic and cultural continuum inscribed in the work of the Five Kiowas: "The subject matter of the paintings of this period was extremely individualistic; mainly depicting single figure compositions featuring dancers. These paintings were primarily self-portraits of the artists themselves or their friends. This concentration on the individual in artistic representations is a carryover from traditional artistic forms which comprised highly materialistic and personal recordings of achievements portrayed by and for the individual" (Ellison 1972:19).

Hokeah, who spent ten years in New Mexico as the adopted son of the celebrated potter Maria Martinez, participated in a mural project at the Santa Fe Indian School (SFIS) in 1932. Under the supervision of the Santa Fe muralist Olive Rush, Hokeah joined a group of student and professional painters, including Maria's husband Julian Martinez, in producing works that were shown at the Corcoran Gallery in Washington, D.C., Rockefeller Center in New York, and at the *Century of Progress Exposition* in Chicago (Dunn 1968:243–44, 248). The critical and commercial success enjoyed in New Mexico (and elsewhere) in the early 1930s by Hokeah and the other Kiowa painters, whose collective style was based in part on Plains ledger books, was but one aspect of the positive critical reception of Native American art in that decade. Along with the public's highly favorable response to the *Exposition of Indian Tribal Arts* and an increased number of books and exhibitions, there were also institutional changes that reflected an ever-growing national interest in the aesthetic values of Native culture.[4] For example, schools operating under the aegis of the Bureau of Indian Affairs began to stress the importance of Indian crafts, and in

1935 the Department of the Interior established the Indian Arts and Crafts Board, which sought to strengthen the market for high-quality Indian objects (Hyer 1990:10; Schrader 1983).

One of the most important of these institutional changes was the Studio for Native Painting established at the SFIS in 1932 by artist and art educator Dorothy Dunn. At the core of Dunn's curriculum was her conception of a "naturalistic," that is, authentic, style of Native American painting derived from such pre-modern sources as pottery designs, kiva murals, and hide paintings, and from "transitional" forms, such as ledger book drawings.[5] Although there were always more Southwestern (Puebloans, primarily) than Plains Indian students enrolled at the Studio, Dunn was sensitive to the latter's need for appropriate aesthetic models. From her extensive travels and research she knew well the historic traditions of Plains painting, and in 1935 she arranged for several distinguished museums to lend Plains objects to the Studio, which her students examined for "authenticity of spirit . . . [and] historic content" (Dunn 1968:283–84).[6] The style that emerged from the studio, and which was practiced by a number of accomplished Plains artists, including Oscar Howe, a Lakota, and Allan Houser, a Chiricauha

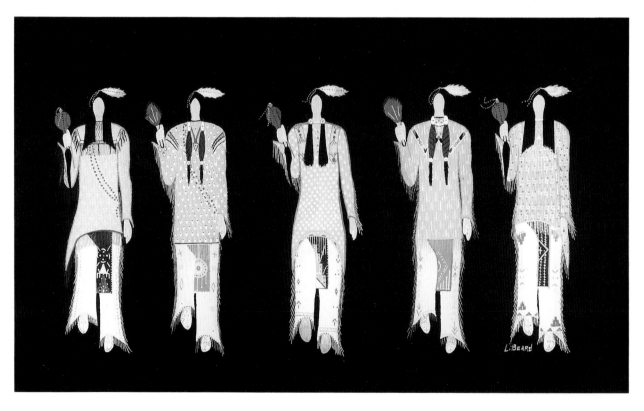

Apache, tended to emphasize the formal qualities the Five Kiowas shared with the first generation of modern Pueblo painters from San Ildefonso (for example, Crescencio Martinez, Tonita Pena, Awa Tsireh): decorative designs, elemental figuration, and broad areas of flat color contained by precise contour lines. In promoting such naturalistic qualities, Dunn always held up for praise what she described as the "best she had seen in Indian art." With this in mind, it is worth noting that she found Hokeah's work "arresting and powerful" and that for her the most significant fact of Plains painting was that it was a "representational and wholly individualistic art evolved from a totemic fetishistic one" (Dunn 1968:258, 223, 183).

An exhaustive analysis of the many Studio style paintings that reference Plains ledger book drawings is beyond the scope of this brief essay. However, works by three painters who attended the SFIS provide at least a glimpse of the continuing importance of such drawings (and hide paintings) to "traditional Indian painting" after 1930. In *Ghost Dancers* (fig. 5), a student work by Lorenzo Beard, a Cheyenne-Arapaho, five anonymous, thus timeless, dancers are represented in the flat, linear style of ledger books and the Five Kiowas. Formal and frontal, these figures, which are simultaneously tangible and apparitional, recall a Silverhorn ledger drawing (from the Silberman collection) of dancers lined up single file, parallel to the picture plane, with their backs to the viewer. Similarly, Silverhorn's drawing *Ghost Dance Circles* (not illustrated) shares with Beard's painting an attention to "ethnographic" detail. This is not surprising, given that Beard, according to his teacher, "consulted tribal sources of ceremony and legend for creating modern variations upon them" (Dunn 1968:309).

During his student days at the Studio, George Keahbone, a Kiowa, produced a finely brushed, boldly colored painting titled *The Mud Bath Ceremony* (fig. 6) that was probably based on an earlier work by his tribesman, Silverhorn. Commissioned by anthropologist James Mooney, *The Sham Battle to Capture the Central Pole* (fig. 7), is one of five Silverhorn hide paintings that depict events associated with the Kiowa

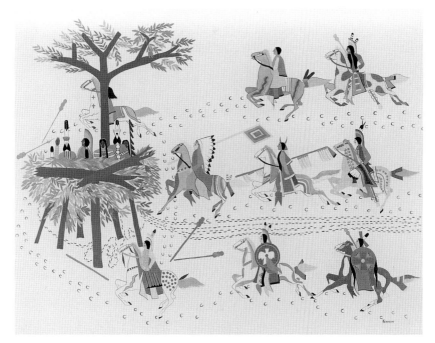

Figure 6. George Keahbone, Kiowa. *The Mud Bath Ceremony*. ca. 1935. Tempera. United States Department of the Interior, Indian Arts and Craft Board

Figure 7. Silverhorn, Kiowa. *The Sham Battle to Capture the Central Pole*. 1902. Pigment on hide. Department of Anthropology, National Museum of Natural History, Smithsonian Institution, Washington, D.C., 229895

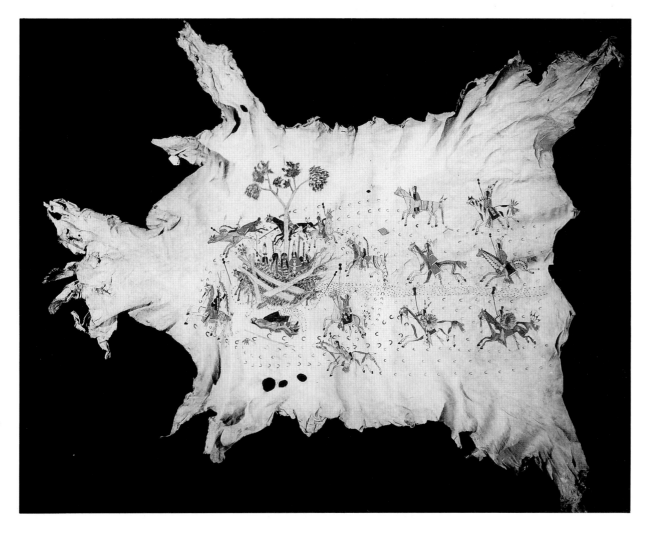

Medicine Lodge (that is, Sun Dance) Ceremony. Like the Silverhorn model, Keahbone's work shows members of various military societies (including an honorary female member at the top), who brandish coup sticks made from "leafy willow branches," staging a mock battle on the center pole (Greene 1992b:162, 164). Besides the obvious fact that Keahbone's composition is almost identical to Silverhorn's, he likewise employs the Plains convention of hoofprints to indicate narrative movement. As for Keahbone's likely awareness of Silverhorn's version, Dunn recalled that her student "coupled his knowledge of tribal customs with research to produce some emphatic paintings obviously related to the Oklahoma Kiowa art movement" (Dunn 1968:309).[7]

Oscar Howe, who is perhaps best remembered for challenging the limitations of traditional Indian painting by incorporating the angular facets of a cubistic structure into his work in the mid-1950s, also graduated from the SFIS, and his student painting *Sioux Warriors* (1936) was based on the pictographic style of figuration seen in ledger books.[8] In fact, in Dunn's classroom, learning figuration began with pictographic studies, which then became the basis for narrative images (Rushing 1995a:32–33). And even after Howe perplexed the Indian art world with his cubist-inspired compositions, he still made such works as *Sioux Rider* (fig. 8), which engages the ledger book tradition with its stylized forms and dynamic composition, dramatizing in a Dionysian manner the horse culture of the Plains. Although more consciously attuned to the formal elements (the balancing of arcing and opposed diagonal forms), Howe's horse and rider recall earlier Lakota ledger drawings, such as *No Two Horns Fights a Crow* (see cat. no. 149). However, I would be remiss not to mention that even as student artists in the 1930s were inscribing ledger art in contemporary paintings as a way of longing for and signifying the past, the Lakota painter White Bull, a nephew and adopted son of Sitting Bull, was producing on commission a pictorial autobiography that continued the Lakota graphic traditions of the 1870s (see cat. nos. 151, 153).

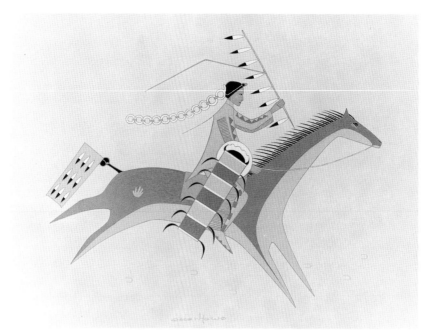

Figure 8. Oscar Howe, Lakota. *Sioux Rider.* 1959. Tempera on paper. Joslyn Art Museum, Omaha, Nebraska

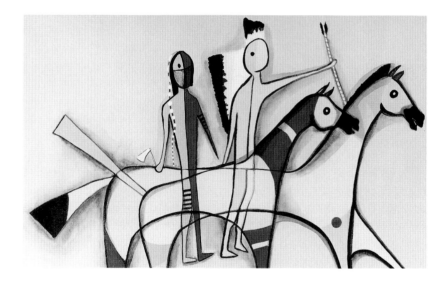

Figure 9. Sharron Ahtone Harjo, Kiowa. *Return Them Safely to Home.* 1971. Acrylic on canvas, 30 x 37¾ in. United States Department of the Interior, Indian Arts and Craft Board, Southern Plains Museum and Craft Center

The Oklahoma counterpart, so to speak, to the Studio was the art department established at Bacone Junior College in Muskogee in 1935 by the artist Acee Blue Eagle, a Creek-Pawnee. In the ensuing decades, under the direction of such noted artists as Woodrow Wilson Crumbo, a Creek-Potawatomi, Richard West, a Cheyenne, and Ruthe Blalock Jones, a Delaware-Shawnee, the program at Bacone was instrumental in the institutionalization of the "highly-stylized illustrational mode of painting popularized among American Indians during the 1930s" (Ellison 1972:19). Here, too, students continued to draw on the aesthetic strengths of ledger art and that of the Five Kiowas. For example, Kiowa painter Sharron Harjo's *Return Them Safely to Home*

(fig. 9)—based on actual events from the 1860s—is intentionally archaic, and thus, avant-garde: she returns to the so-called X-ray style of early Plains pictography to establish a surface that is paradoxically flat *and* suggestive of depth.

The legacy of ledger book drawings has been explored in recent art from a variety of perspectives, employing a range of materials, techniques, and aesthetic strategies. Many Northern Plains artists continue to draw upon ledger art as inspiration for their work. In the late 1980s, Lakota artist Arthur Amiotte, whose great-grandfather, Standing Bear, continued to draw in a pictographic style even after he was conscious of the "realism" of photography, began a

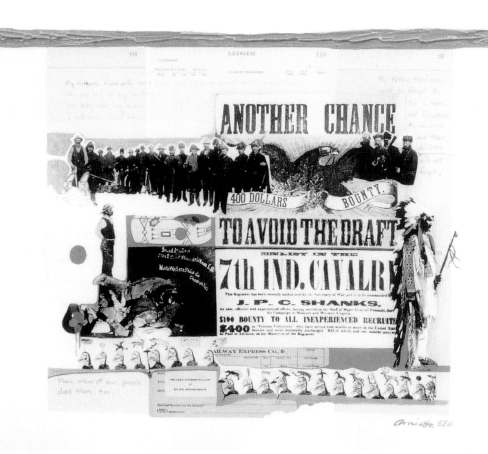

Figure 10. Arthur Amiotte, Lakota. *Wounded Knee.* 1988. Mixed media. Red Cloud Indian School, Pine Ridge, South Dakota

Figure 11. Joanna Osburne-Bigfeather, Cherokee. *Fragment.* 1991. Mixed media. Private collection, courtesy of the artist

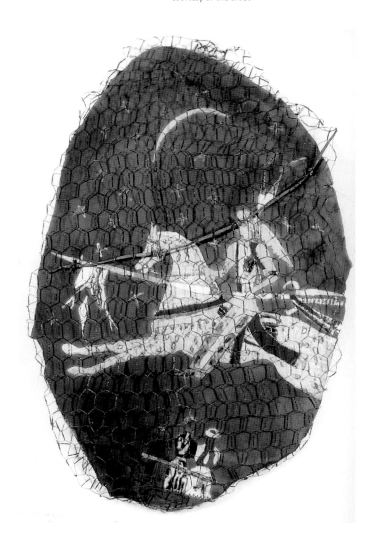

series of impressive mixed-media collages that investigated Lakota pictorial traditions during the dynamic but art historically neglected reservation period (Amiotte and Berlo:1995).[9] *Sometimes They Do, Sometimes They Don't* (1988) combines handwritten text, Amiotte's own watercolor portrait of Standing Bear, and "appropriated" images, including intentionally archaic, pictographic portraits of historic Lakota men (which are adapted from Red Cloud's pictorial census of 1884[10]). This calculated mix of "predictable" and "deviant" images resists trite romanticization and stereotypical perceptions of Indians, even as it introduces a much-needed element of humor into Northern Plains art. Some of the works in this series, including *Sitting Bull's Ledger II* (1989), have ledger paper as their support, and this in itself has symbolic connotations for Amiotte: "I was exploring the tradition of ledger art, but I was also thinking of the other, original meaning of ledger: a place for the keeping track of sums. . . . It is sort of a bittersweet notion—the whole idea of ledgers, and accounting for what was taken from Indians and what we were given in exchange" (Amiotte and Berlo 1995).

Like the ledger art tradition on which he is building, Amiotte's *Wounded Knee* (fig. 10) is narrative and representational, and combines personal and tribal histories. It is also perfectly postmodern, however, in its pastiche of hybrid elements: stylistic homage to ledger art; headlines that sound the trumpet of history; personal annotations; recycled images from the artist's own oeuvre; and the "vehicle" itself—modernist collage, which fragments and juxtaposes bits of visual information.

In her Ledger series, Cherokee ceramicist Joanna Osburne-Bigfeather sought to make didactic art that probed the fetishization of objects (historic ledger books) often made under financial duress and which now realize startling prices at auction. Professing a love for the ledger drawings that she studied in museums as she grew up, Osburne-Bigfeather's Ledger series, including *Antelope Hunt* (1991), recapitulates the figurative style on three-dimensional ceramic forms to demonstrate that these are "alluring images" for the collector, no matter what surface they are represented on (Osburne-Bigfeather, personal communica-

tion, 1995). She is therefore not emulating the style so much as using it to raise issues about production and consumption of Native art today. Both the shape and texture of *Fragment* (fig. 11), which features pictographic figuration derived from ledger art, imply the artifactual, and the barbed and chicken wire encasing (that is, reserving) the entire object refers to Indian art's incarceration in a "golden" era preferred by collectors. Some works in this series, such as *Broken Promises* (1991), are overtly political, while others, such as *New York Influences* (1991), which features a large, open ledger/sketchbook—like those used by the artist in Manhattan—resting on a bag of broken treaties, mix autobiographical and historical references.

The work of Stan Natchez, a Shoshone-Paiute, is also infused with irony and is informed by both a political consciousness and an awareness of appropriation as an aesthetic strategy. Instead of using ledger paper as a picture support, in such works as *Leader Charge* (1992), and *Magpie and the American Dream* (1993), Natchez "defaces" or invalidates stock certificates (from the Southern Railway and the May department stores) by creating ledger-style images on them with oil paint and beadwork. Natchez thus simultaneously celebrates and honors the heroic warrior-artists of the ledger book era even as he indicts Euro-American commerce for its role in the dislocation of Native peoples. *Leader Charge* is made complete, so to speak, by a tricksterish gesture: Natchez signs his name at the bottom right next to that of Morton May, who founded a chain of department stores, and who assembled a significant collection of tribal art from Africa, Oceania, and North America, which he bequeathed to the St. Louis Art Museum.

For these contemporary artists, then, Plains ledger book art is an element from the historic past and yet it remains close at hand. For example, there is simply too much (art-historical) distance between them and "classic" ledger book drawings for

them not to approach the *style* itself as an archaism or precious heirloom. It is a mode of representation that signifies the kind of power and legitimacy that warrants reverence and respect. Merely to copy it would be to misunderstand the ethos of artistic individualism at its core. And yet, as the recent works discussed here indicate, the aesthetic and cultural strengths manifest in ledger art continue to inspire and motivate artists who can see the twenty-first century on the horizon. But it is either the essence of ledger art or ledger style as a subject, not the style as style, that intrigues them. By essence I mean a cluster of characteristics: politically engaged, historically informed, Indian-centered narrative art that bears witness to a fierce struggle to survive against overwhelming odds. The real legacy of ledger art in our times is therefore not stylistic, but conceptual. Amiotte and the other contemporary artists mentioned here are proud, resistant storytellers who are determined to record for posterity—as did the Fort Marion artists before them—the indigenous account of what happened, to whom, and why. The Cheyenne-Arapaho artist Edgar Heap of Birds, noted for his public art projects that investigate and interrogate the Euro-American version of "westward expansion," was perhaps the first to observe the conceptual legacy of ledger book drawings in contemporary Native art: "Today strong artworks with warrior spirit . . . [like] those from Ft. Marion, remain as a method of a more modern warfare. . . . [We] are proud to find Native artists, whose families may once have been restricted to reserves in Oklahoma or elsewhere in America, stepping forth to comment as modern warriors. . . . [We] are on the edge of the battle to inform and re-educate the white man about his Native host (Heap of Birds 1989:22)."[11]

Long after the incarceration of Southern Plains people at Fort Marion and the extermination of Northern Plains people at Wounded Knee, the struggle by Native American artists to inform and educate the Euro-American public about indigenous history, values, and aspirations continues to find expression in works drawing on the ledger tradition.

Notes

1. One of the enigmas of the historiography of modern Kiowa painting is why Louise Smokey (also known as Bougetah), who, as Dunn indicates, also attended classes at the university at the behest of Indian Field Service matron Susan Ryan Peters, has become a somewhat forgotten figure. Future scholarship must focus not only on locating and identifying more of her work should it exist, but also on her relationship with her male peers. Was the brevity of her career due to the fact that figurative painting was traditionally practiced by men in Kiowa culture? Unlike the Five Kiowas, she was apparently neither a singer nor a dancer, and did not join them when Peters began arranging their participation in the Indian Inter-Tribal Ceremonial in Gallup, New Mexico, in 1930.

2. Two other accomplished Kiowa painters, George Geionety and George Silverhorn, were also descended from Silverhorn.

3. For the *Exposition of Indian Tribal Arts*, see Hodge, La Farge, and Spinden 1931, Rushing 1995b:97–103.

4. On the reception of Native American art in the 1930s, see Rushing 1995b:97–104.

5. For Dunn's commitment to the "naturalistic" style, see Bernstein 1995:15–23.

6. See also Rushing 1995a:39–40.

7. Although it postdated Keahbone's obvious awareness of them, some of the Silverhorn paintings commissioned by Mooney were published in Alexander 1938.

8. For an illustration, see Dunn 1968:307, fig. 110. Originally collected by Margretta S. Dietrich, a social activist and one of Dunn's most ardent supporters, this painting is now in the Dorothy Dunn Kramer collection at the Museum of Indian Arts and Culture in Santa Fe.

9. My thanks to Janet Catherine Berlo for sharing this information with me and for facilitating my research for this essay.

10. For Red Cloud's pictorial census, see Mallery 1893:445–46.

11. See also the discussion of his comment in Rushing 1992:31, and Heap of Birds's artist statement in this volume.

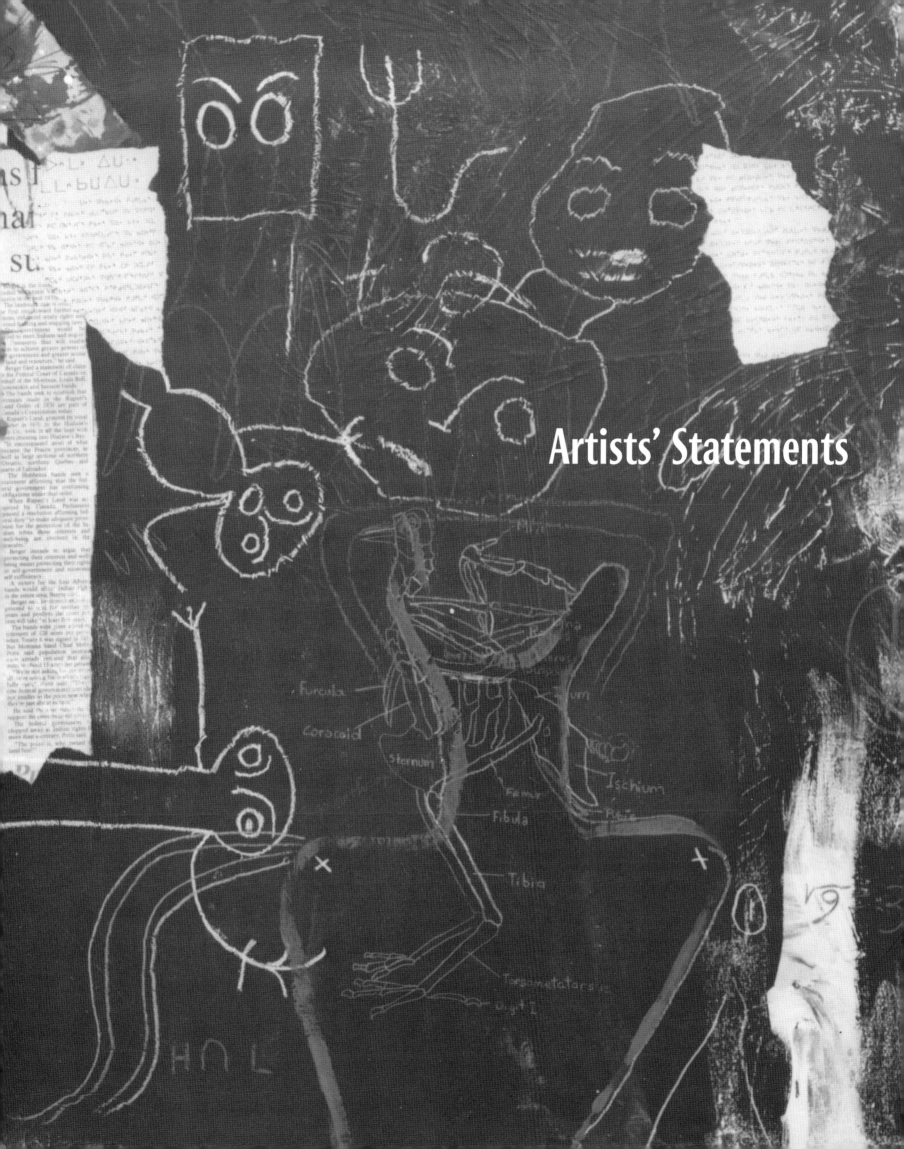

Artists' Statements

The Seen and the Unseen Form the Narrative...

Colleen Cutschall
Lakota

I was born in 1951, in a decade which I consider to be the time of most intensive assimilation for Native people. I was baptized a Catholic, lived in a small urban center, and had minimal exposure to the early graphic traditions of the Lakota. My first real contact with anything related at all to ledger art was in the 1960s, through the intertribal or Santa Fe style of painting, which was the only kind of contemporary art being done at the time. The basics of that style are similar to ledger art, made up of contour line drawings, no background, and often seeming static in spite of efforts to convey action or movement. It is a style of drawing and painting that is appealing to a novice because of the economy of line and the freedom to eliminate complicated foregrounds and backgrounds.

As an art student, I had access to some books on Native art. In them, I studied the hide paintings for content and design. It was then that I realized that traditionally women did not produce narrative art but were restricted to the geometric design styles that I, too, then pursued. Also, in the majority of images that I had seen of women in hide painting and ledger art, they normally appeared on the outskirts of all the important action. Women seemed to be incidental, either engaged in mundane domestic activities or serving as the audience for men's parades and ceremonies. A drawing by Walter Bone Shirt (pl. 1) is different, in that the woman shares center stage with the horse. Intellectually, it is easy to appreciate that the wonderful quilled saddlebags and painted parfleches that decorate the horse were produced by this woman. In Lakota terms, she would have been wealthy to even have a horse of her own. Note, though, that she seems literally bound up, carrying her load, which recalls all of the cultural restrictions that women face in any society. She is plain and all too ordinary, in contrast to the horse

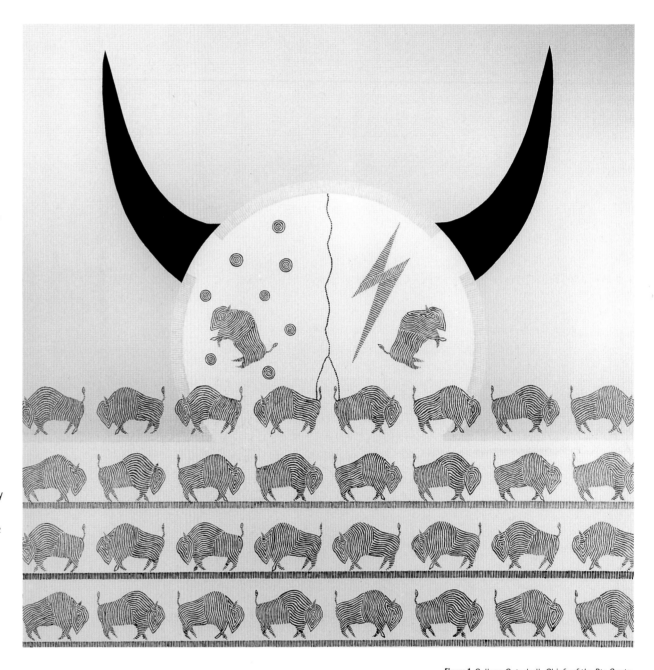

Figure 1. Colleen Cutschall. *Chiefs of the Pte Oyate.* 1990. Acrylic on canvas. 48 x 48 in. Art Gallery of Southwestern Manitoba, B.C.

and in contrast to most of the Lakota women I know. I simply consider this a problem of male authorship.

I cannot change what my culture was in the past, but I am very glad that the artist's restrictions have broken down in the last two generations. My personal reaction to this historical situation was to embark in 1978 on a series of paintings of Lakota women, and later, women from other tribes. Interestingly, they emerged as an amalgamation of Western art traditions and Lakota contour line drawing; often, like ledger art, they had no background.

Over the years, I continued studying Lakota art, culture, and philosophy in all its forms. I became particularly interested in pictography as it was applied to pipe bags and beaded and quilled vests of the late nineteenth and early twentieth centuries. The strength of line, design, and texture was most appealing. Least appealing to me was the warrior image and the violence associated with that image. It seemed appropriate as a symbol of cultural resistance, but otherwise it had little relevance to the lives of most contemporary Lakota. Like many other Native people in the 1970s and 80s, I was intent on reclaiming the traditional aspects of my culture, or at least participating in those traditions, such as the Sun Dance and the Vision Quest.

Drawings such as Walter Bone Shirt's depiction of the Sun Dance are filled with so much mystery, whether or not you know what is happening in the narrative. As illustrated in plate 2, the Lakota Sun Dance of the nineteenth century was primarily a male activity, with women and children as the audience. At one point, on my own reserve, the Sun Dance had become so profane that it was part of the summer fair, along with the carnival and the rodeo. It then ceased altogether as an easily accessible ceremony. This important world-renewal ritual became a catalyst for my life and my art. The Sun Dance itself incorporates sacred visual images, ritual acts, song,

and dance. It is a perfect reflection of Lakota thought and philosophy. In recent years, the Sun Dance has begun to include women dancers in the ritual, primarily because of the pressure placed on holy men by women to tend their souls. Women wanted to be spiritually active and were willing to take on the sacrifices and the responsibility of participating and sponsoring such ceremonies.

In Bone Shirt's drawing, we see only the man dancing and sun gazing. To the sacred tree or *axis mundi* are attached symbols: a man who desires life and the animals who help provide that life. Below are the cloth flags representing each of the four directions or winds. In Lakota thought, this suggests that the Sun Dance prayer for life is being sent out in every direction. And behind the dancer, that prayer is being answered by the life force coming into the circle. The little specks recall the grains of tobacco placed in a sacred pipe that represent all the potential for new life. This is a drawing where the seen and the unseen come together to form the narrative.

While ledger art itself is not sacred art, images like these speak directly to our sacred traditions. That these traditions survive at all speaks to the tenacity of the Lakota people. Historical arts of this kind are important to generations of Native people who have lost their sacred traditions and are in the process of recovering them today. The fact that these rituals can bring so much meaning to ordinary lives has become the primary motivation of my work, which has moved from a strict emphasis on painting (see fig. 1 and Cutschall 1990) into sculpture and installation work.

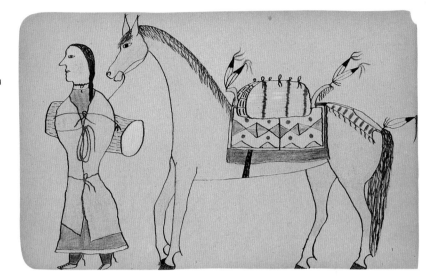

Plate 1 (also cat. no. 123). Walter Bone Shirt, Lakota. A Woman and Her Horse. Mid-1890s. Private collection

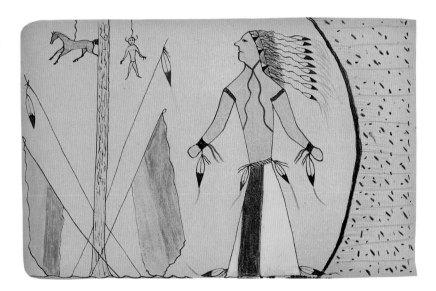

Plate 2 (also cat. no. 121). Walter Bone Shirt, Lakota. Sun Dancer and Rawhide Offerings. Mid-1890s. Private collection

Of Circularity and Linearity in the Work of Bear's Heart

Edgar Heap of Birds
Cheyenne-Arapaho

From the western Plains known as land of the round horizon, sky, and earth, from a thriving ceremonial community that resides in conical dwellings, placed upon grasses, forming wide arcs, these circles shall forever open to the east, welcoming the sun's travel across our sky. As the drum summons the spirits to the renewal lodge, with its four poles, which trace the summer and winter solstices, the poles above, songs shall spiral upward again in the circular cycle of life.

All of these elemental, spherical forms represent our planetary home and the true passage of time in an honorable way. This homage lives on today in spirit from Bear's Heart, that grandfather and warrior society leader. In the eyes of the contemporary Kit Fox, Dog Soldier, Bow String, and Elk Warrior societies, tribal organizations of renewal and protection, we are thankful for Bear's Heart's sincere offerings.

In his startling artwork, he has depicted the harsh, linear mentality of the white aggressor as it was imposed onto the circular Cheyenne world. Through the vision of this warrior society member and ceremonial participant, schooled in the values of renewal, commitment, and cyclical exchange, we see the stark, encroaching line of armed white soldiers (pl. 1). The military figures seem endless in their appearance. So, too, did the Native hosts perceive the invasion of this land as an endless onslaught. Bear's Heart's drawing speaks also of the steady forward movements of the white man. These invaders, motivated by commerce, began on the eastern shore of this continent, crushing Native nations as they passed to the west. A linear form moves forward conceptually without regard to its return to a starting place. This mentality requires no responsibility to carry forth, only ambition to move ahead. In reference to our circular world's ecology and humanity, the linear conquest often destroys that which is truly dear in its wake.

Bear's Heart's drawing of the imposing armed soldiers arose from his own personal experience. The politics that it elicits are simply a direct comment from his life. The strong lead forged by Bear's Heart should be followed by our contemporary art practice. For today's Native artist, it is imperative to pronounce strong personal observations concerning the individual and political conditions that we experience (see fig. 1). At times this visual expression should speak of human rights and issues of tribal sovereignty, but most important, our art must articulate viewpoints from a deeply personal perspective.

The direct stylistic form should evolve without restrictions of presumed tribal traditions. Perhaps the preeminent exercise in sovereign freedom shall become the offering of one's free-form thoughts as they are reflected from daily life. In the spirit of such expressions one can then begin to describe one's self without limitations of prejudicial racial or anthropological agendas. In honor of Bear's Heart, these goals should be achieved.

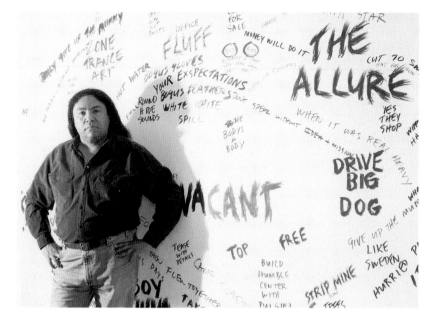

Figure 1. Edgar Heap of Birds with his 1994 work *The Allure*, marker on paper, 6 ft. 6 in. x 9 ft. 6 in.

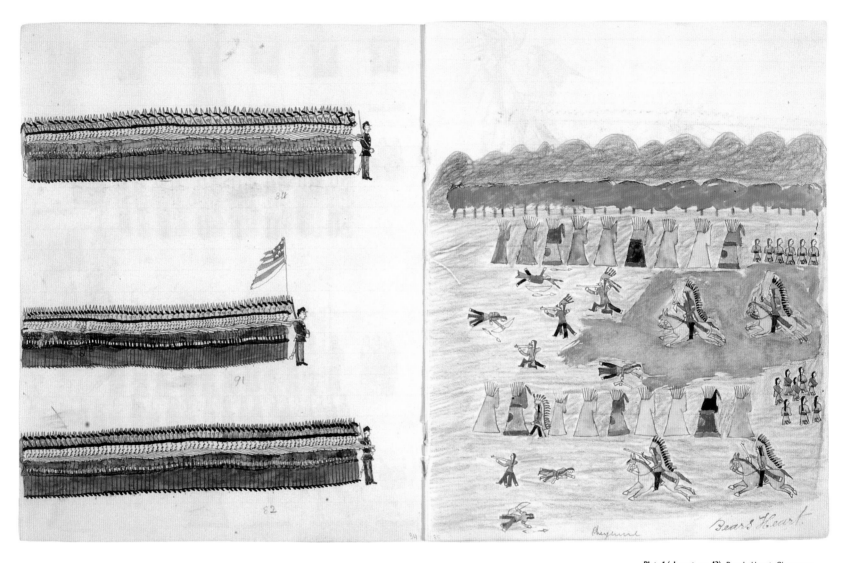

Plate 1 (also cat. no. 43). Bear's Heart, Cheyenne. Troops Amassed Against a Cheyenne Village. 1876–77. Massachusetts Historical Society, Boston

Paradigms for Hope and Posterity:
Wohaw's Sun Dance Drawing

Jane Ash Poitras
Cree-Chipewyan

In 1875, many Indians of the Southern Plains were incarcerated in Fort Marion prison, in Florida, hundreds of miles from their natural habitat. One was shot during the trip; another died soon after reaching Florida. Those who survived were introduced to a life far from the freedom they had once enjoyed. As an artist myself, one bit of freedom I hang onto is my creativity. One can be subjected to many inhumane conditions, but, for survival of the soul, the mind is always free through art.

Art opens us to the sacred, a periodic reentry into time primordial. Artists, regardless of where they come from, adapt and transform to maintain themselves as the visionaries that they are. Artists as shamans live forever through their creations. In their creations is a privileged land, where laws are abolished and time stands still.

When I look at the drawings of Wohaw, a Kiowa warrior imprisoned at Fort Marion between 1875 and 1878, I see an artist recreating the vision of his free Plains life (see pl. 1). The Plains Indian was a person of vision. Through vision, a man or woman could come into contact with the sacred world, and be granted spirit helpers and knowledge beyond the profane. In order to keep the vision alive, art forms such as painting, singing, performance, and storytelling were created to give testimony and to valorize the vision. Once this was done, the spiritual powers of the sacred were there forever to bring harmony to the people.

Artists were the shamans who could communicate the supernatural world to the rest of the community. This knowledge, in the form of art, taught myths, dreams, and sacred powers to all. These powers were healing, and were far removed from the empirical scientific world. In order for the artist to receive these visionary powers, he or she had first to master the world of

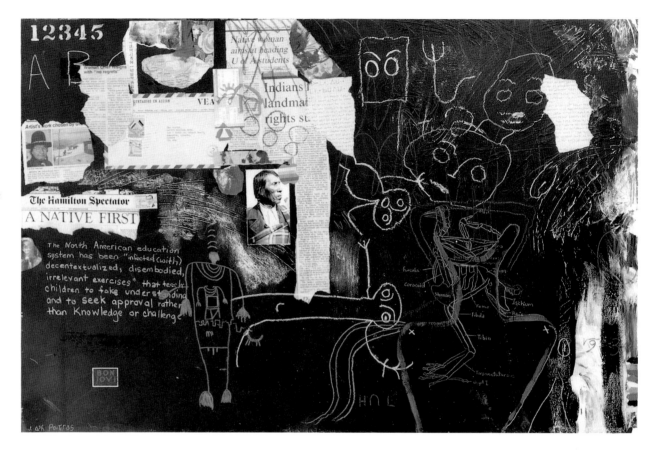

Figure 1. Jane Ash Poitras. *Shaman Indian Blackboard.* 1989. Mixed media, 27³/₄ x 41⁷/₈ in. Kamloops Art Gallery, Kamloops, Canada

trance. Through trance, artists could communicate with the spirits of the upper and the lower worlds. "During a trance, a young 'visionary' would establish contact with nonhumans and pledge a secret allegiance to one of them who would grant him protection at any time and bestow four gifts upon him: a sacred pouch, a talisman, a new name—which remained secret, for it had magical powers—and a chant which the protégé used to call out for help" (Horse Capture et al. 1993:34).

The shaman is a mediator of the sacred and communicates through creativity the language of the heavens: ART. It is here that he or she can direct the soul back to the sick, for "it is the shaman who accompanies the souls of the dead to their dwelling places, and he, again, who embarks on long ecstatic journeys in Heaven to present the soul of the sacrificed animal to the gods and implore their divine benediction" (Eliade 1975:61). The Sun Dance is one ceremony where the great specialist in spiritual questions, the shaman, carries out the mystical exercise and rebirths himself to be one with the spiritual world.

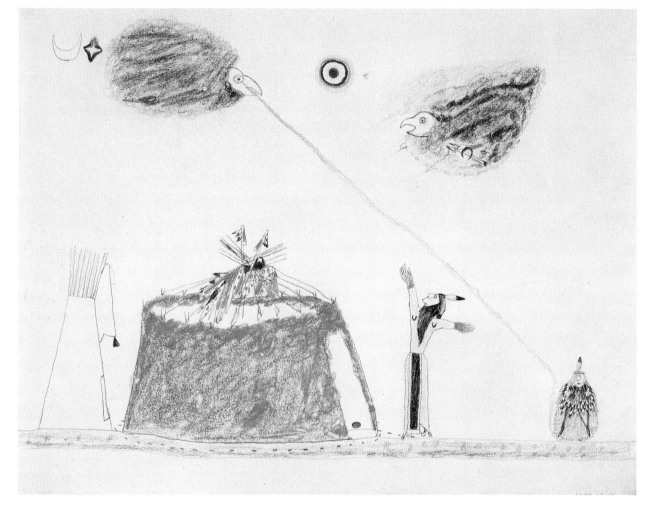

Plate 1 (also cat. no. 99). Wohaw, Kiowa. The Taimay Power and the Sun Dance Lodge. 1876–77. Missouri Historical Society, St. Louis, 1882.18.46

In Wohaw's drawing, the vision appears in the guise of a thunderbird and is asked to protect the Sun Dance. The Sun Dance is one of many powerful ceremonies carried out to initiate young warriors to the sacred. After enduring excruciating pain, a Sun Dancer is blessed by receiving visions and spirit helpers. After his ordeal, the Sun Dancer is reborn to the sacred. The more rebirth a visionary survives, the more power he has in the sacred world—power used to help, to heal, and to communicate good to the community.

Wohaw's drawing is not some secular genre illustration of a life experience; it is a timeless vision empowering all who look at it. Wohaw accepted the historical conditions of his people. He had recourse to no miracle to escape from historicity— although he worked plenty of visionary healings in order to modify the historical situation of others, by curing the mind through sharing his art. The initiation of a trans-human experience, the repetition of an exemplary scenario and the breakaway from profane time through a visionary moment, are the essential arts of shamans' behavior. This is also the behavior of many

Indian societies, where the very sources of existence are sought in the sacred.

Western man is no longer the expert of the world, no longer managing Indians by insisting that he knows what is best for them. It is not enough to admire the art of North American Indians; Western man must rediscover the spiritual sources of this art in himself. And until this is done, the power of the sacred will remain out of reach, and the anxiety of Western man living in time will continue to haunt his soul.

Cetan Sapa Tatehila, Black Hawk's Love

Francis Yellow
Lakota

What kind
of human being
could be
all those things
at the same time

Spiritual Leader
Warrior
Ethno-historian
Healer
Artist

Besides being
Her Husband
Their Dad
how did Cetan Sapa
"Black Hawk"
continue
to be
all of that
inside of the Prisoner of War

Black Hawk
the red renaissance man
or was he
a Common Man
a Common Man
you see
cannot be
less than
or
more than

The Lakota ways
teach
about connectedness
good relations
and the timeless circle of life

For all that we've forgotten
all that was taken
all that was destroyed
all that is lost
what do we know
of Cetan Sapa
but his drawings
and his Pony Claim papers

Even so
we descendants
of Cetan Sapa
know
how to know
with only Xerox copies
of our art
to look at

We know
Cetan Sapa the Spiritual Leader
wasn't ashamed
of Cetan Sapa the Warrior

this day
his grandchildren
can see
a brave spirit
in Cetan Sapa's drawn line
demonstrating his love

We know
Cetan Sapa the Ethno-historian
wasn't unmindful
of Cetan Sapa the Healer

this day
his future generations
can hear
a steady voice
in Cetan Sapa's drawn line
speaking of his humility

We know
Cetan Sapa the Artist
wasn't the best part
of Cetan Sapa the Husband

this day
his grandchildren
can recognize
a nurturing character
in Cetan Sapa's drawn line
sharing the meaning of his vision

We know that Cetan Sapa the Dad
wasn't abandoned
by Cetan Sapa the Prisoner of War

this day
his future generations
can feel
a big-heartedness
in Cetan Sapa's drawn line
asserting his freedom

we grandchildren
the objects of a long forgotten grandpa's
love
this sacred red day
keep
the love

Cetan Sapa's love
made real
on paper
across time
beyond death
with pencil and crayon
and something
that's moving
unseen

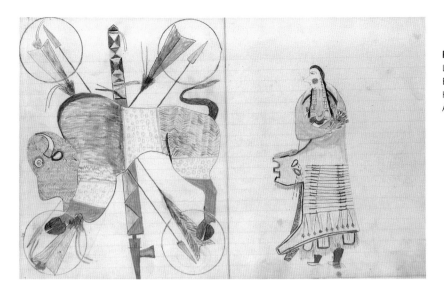

Plate 1 (also cat. no. 118). Black Hawk, Sans Arc Lakota. Drawing of Buffalo Medicine. 1880–81. Eugene and Clare Thaw Collection, Fenimore House Museum, New York State Historical Association, Cooperstown

Plate 2 (also cat. no. 119). Black Hawk, Sans Arc Lakota. Drawing of Buffalo Medicine. 1880–81. Eugene and Clare Thaw Collection, Fenimore House Museum, New York State Historical Association, Cooperstown

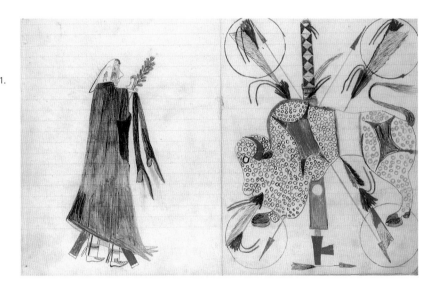

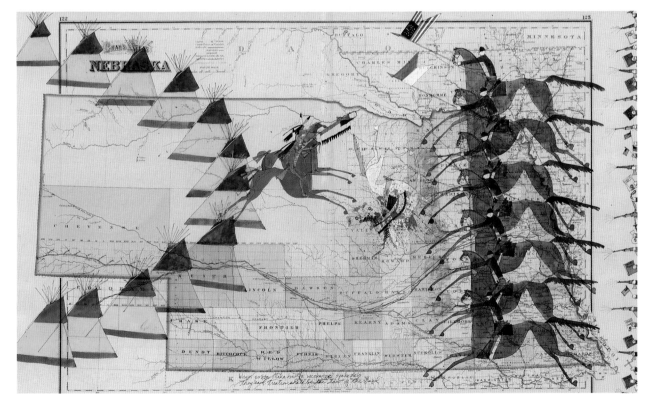

Plate 3. Francis Yellow, Lakota. *Wicoun Pinkte Maka Kin Ta Wicokunze Oyake Pelo (They Said Treaties Shall Be the Law of the Land)*. 1995. Ink on antique map, 27½ x 17¼ in. Collection of the artist

This painting is not merely historical; it speaks metaphorically of both the continuing relations and the nature of those relations between the Lakota people and the American people. Creating a constitutional clause and a body of "Indian law" does not make right the theft of Indian land; nor does disassociating oneself from the actions of the government absolve the ordinary citizen of responsibility. This painting is meant to speak to the past, present, and future generations about the sacredness of our word, intent, and actions.

CATALOGUE

Notes on the catalogue entries

The drawings are organized accord-
ing to tribal affiliation, and within
that, by artist. Unknown artists are
listed first.

Numbers or letters in parentheses
after the titles of some works identify
particular pages within a ledger book.

A few drawings are illustrated in the
essays and artists' statements in
the first half of this book rather than
with their descriptive catalogue
entries. In these instances, a notation
provides the page on which the
image can be found.

The authors of the catalogue entries
are identified by their initials after
each entry.

Arapaho

Artist unknown
McDonald Ledger
Arapaho?

Catalogue Number 1

This drawing is from one of two books that came from the estate of Capt. David N. McDonald and are reported to have been collected by McDonald while he was serving in the U.S. Army "in the Western United States" (object files, NMNH). Lacking further documentation, they were provisionally identified and cataloged as Cheyenne, and their style and content are generally consistent with that identification. But a close examination suggests that the books contain the work of Arapaho as well as Cheyenne artists.

An examination of McDonald's service history shows that he served in the Army from 1877 to 1888. From 1878 to 1881, he was posted at Fort Reno, Indian Territory, adjacent to the Southern Cheyenne and Arapaho Reservation (Cullum 1891:293–94). He presumably acquired the books during that time.

CSG

ARTIST UNKNOWN
1. Rescue of a Comrade Under Heavy Fire (40–41)
ca. 1878–81
Pencil and colored pencil
7³/₄ x 12¹/₄ in.
National Anthropological Archives, National Museum of Natural History, Smithsonian Institution, Washington, D.C., Ms. 4452A–II, 40–41

While many of the drawings in the McDonald books are of Cheyenne warriors, identifiable by their shield designs (Nagy 1994), others show Arapahoes. There has been little systematic study of Arapaho ledger art, making stylistic identification difficult (but see Petersen 1988, 1990). Arapaho shield designs are likewise poorly known, but their shields often bore a distinctive cloth border attached around the lower portion of the disk, with the ends of the cloth flying loose near the top of the shield (Mooney n.d.). Shields of this type are carried by warriors in several drawings in this book, and it is likely that the artists who produced them were Arapahoes.

Several pages of the book are inscribed with the name "Washee." More than one individual with this name appears on the 1892 tribal rolls for both the Southern Cheyenne and the Southern Arapaho, but the name was evidently more common among the Arapaho. The name Washee also appears on drawings in a ledger at the Gilcrease Museum, Tulsa, Oklahoma; the Gilcrease ledger is documented as having been produced by Cheyenne and Arapaho scouts at Fort Reno in 1887 (Greene 1992a).

In this double-page image, an Arapaho warrior is rescuing a comrade whose horse has been killed. Armed only with a lance, the warrior with the yellow shield displayed his bravery by riding close before a line of firing soldiers and escaped without injury, although his horse was shot from under him. To effect the rescue of a downed warrior in such circumstances was very dangerous and was itself credited as a formal war honor, suitable to be proclaimed when men gathered to recite their coups. The bullets that surround them come from the line of cavalry soldiers who appear on the opposite page. They are lined up cookie-cutter fashion, overlapping slightly. From their sameness, it would be easy to suggest that all whites looked alike to Indian artists, but this technique of overlapping and rhythmic repetition of near-identical figures appears in drawings of Native American people and of horses as well. It offered a harmonious way to present large numbers of figures without cluttering the page. In fact, the artist of this drawing has made an extraordinary effort within the limits of the art form to individualize the white enemies, showing a variety of beards and mustaches as well as detailing the accoutrements of the sabered and sashed officer. Plains portraiture was not generally concerned with the delineation of facial features but concentrated instead upon other distinctive features, such as shields, headdresses, horse paint, and other aspects of personal medicine.

CSG

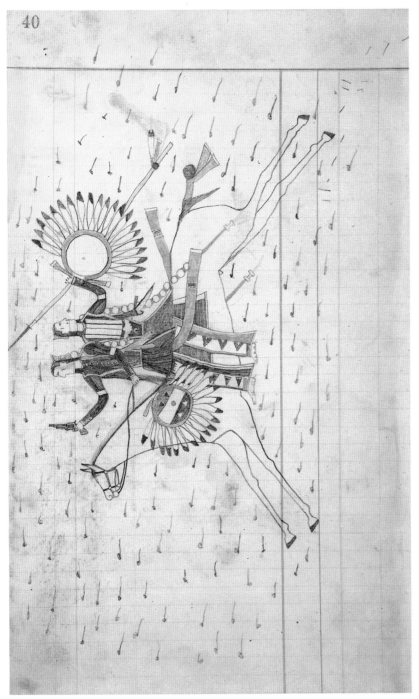

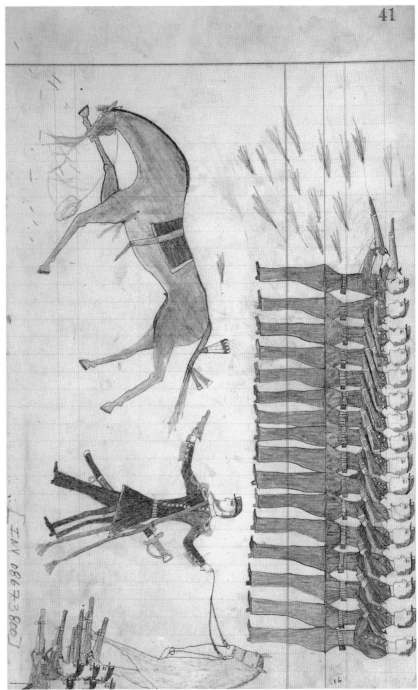

INV 086738007

1

Artists unknown
Schild Ledger
Arapaho?

Catalogue Numbers 2–7

Among the most beautiful as well as the most enigmatic of ledger books is this series of fifty-six drawings now in the collection of the Texas Memorial Museum. Layers of misinformation have accumulated around these drawings during successive generations (Tips 1962). Their date and place of original collection are unknown. The artist and even the exact tribal attribution are unknown. The inscriptions on the drawings are in German, and were probably written some time after the drawings were executed. In most cases, they are completely fanciful.

The museum bought this book in 1964 from a German woman whose father-in-law, Dr. E. H. Tips, was said to have acquired it in 1895 from a Herman Schild of Oak, Arkansas, or Fredericksburg, Texas (both locations are written in the book). Dr. Tips claimed that Schild (for whom the ledger is named) was a "U.S. Indian Commissioner," although no agent of that name appears in any records at the National Archives (letter from National Archives, July 20, 1971, object file no. 1988, Texas Memorial Museum).

The style and iconography of this book mark it as coming from the Southern Plains. A Kiowa attribution is possible, based on some aspects of clothing style (LaMont 1975:17). The elegance of the detail, the attenuated proportions of the small-headed horses in many of the drawings, and the confident rendering of full frontal figures with round faces are reminiscent of certain Arapaho drawings (see cat. nos. 8, 9). We have provisionally labeled it Arapaho here.

While it is not possible to ascribe a precise date to the book, we do know that it is from the early reservation period. Like many other books, it encompasses a range of subjects, from warrior exploits, to social scenes and portraits, to encounters with white soldiers, cowboys, and settlers.

JCB

ARTIST UNKNOWN
2. Frontal Man with Eagle Feather Fan (29r)
3. Frontal Woman in Striped Blanket (15)
4. Two Men in Fine Clothing (11)
1870–80?
Pencil and crayon
12¼ x 7¼ in. each
Texas Memorial Museum, University of Texas at Austin, 1988.29r, .15, .11

The original correspondence from Germany that accompanied this ledger book claims it was drawn by "a Comanche Indian woman named Ollie, wife of Chief Big Foot of North Dakota" between 1840 and 1850. German inscriptions on many of the drawings purport to identify Ollie, Big Foot, and others. It would be highly unusual for a woman to have drawn in a ledger book, but it is not beyond the realm of possibility. While Native American societies held many proscriptions about which arts were the prerogative of men and which of women, individuals occasionally abrogated these rules. We know of an occasional Kiowa and Lakota woman who was the keeper of pictographic or alphabetic calendar counts in the twentieth century, for example. But cat. no. 2, alleged to be a self-portrait of this Comanche woman named Ollie is, in fact, a fine portrait of a Southern Plains man. He carries an eagle feather fan and wears a hair-pipe chest ornament over his sleeveless black cloth vest. His finely beaded and fringed leggings are rendered in great detail. The artist has oriented the paper vertically, which is unusual in ledger art.

Cat. no. 3 presents another portrait in vertical format. Here a woman with red face paint and red coloring in her parted hair stands in a frontal pose, wrapped in a striped trade blanket. Her tabbed skirt and beaded moccasins have been depicted with care. The German inscription reads "daughter of Ollie." Like a number of other pages in the book, this one shows a false start that was partly erased. A male figure with hair-pipe chest ornament is visible to the right, perpendicular to the female figure.

The German inscription identifies the figures in cat. no. 4 as "Ollie Johnson—daughter and grandson." We see two Southern Plains men, as finely dressed as the man in cat. no. 2. They, too, are posed frontally, each wearing a mixture of indigenous and appropriated garments—blue cloth military coats, black vests, skin leggings with beaded panels, and fine sashes. Each carries a feathered rattle in his right hand. The figure on the left also carries an eagle feather fan. This is the only drawing in the Schild Ledger with name glyphs drawn over the heads of the figures.

JCB

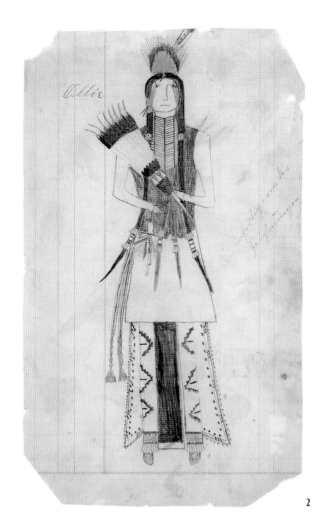

Ollie

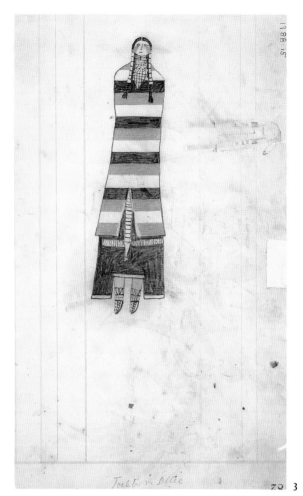

Toilette in Ollie 79 3

2

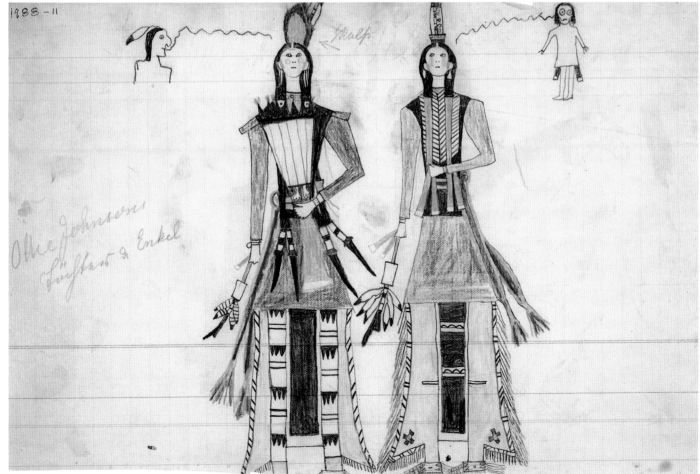

1988-11

Half

Ollie Johnsons Tüchter & Enkel

4

ARTISTS? UNKNOWN
5. Branded Horse and Rider I (9r)
6. Branded Horse and Rider II (12)
1870–80?
Pencil and crayon
7¹/₂ x 10¹/₈ in., 7¹/₈ x 11⁷/₈ in.
Texas Memorial Museum, University of
Texas at Austin, 1988.9R, .12

The hands of at least three artists have
been discerned in this book (LaMont
1975:23–25). The artist of these two draw-
ings renders horses' heads very small in
relation to the size of the animal. He also
draws horses in an unusual stride. Instead
of the "rocking horse" stance (front feet
forward, back legs extended to the rear; see
cat. nos. 17–21, 149, 150), which is the
convention in Plains pictography, he draws
one of the rear feet moving forward, the
other extending back (cat. no. 6).

The horse in the unfinished drawing
(cat. no. 5) stands at attention, its long
black tail between its legs. The artist has
left room for another horse, and he has
begun to draw a horse's head behind the
elbow of the rider. In cat. no. 6, the artist
has reused a page on which a figure had
been begun in a vertical format. The horse
and rider overlap this figure. (The reuse of
pages is evident throughout the book—see
cat. no. 3). The German commentator has
misunderstood this reuse of paper and
labeled the drawing "kidnapped white
woman carried off on a horse."

Both drawings show horses that may
have been obtained through horse raids on
white settlers and army encampments. It is
unlikely that any one horse would have had
this many brands, but the Schild Ledger
artist was clearly fascinated with this
indelible sort of "horse painting," and prac-
ticed it repeatedly in his drawing book.

JCB

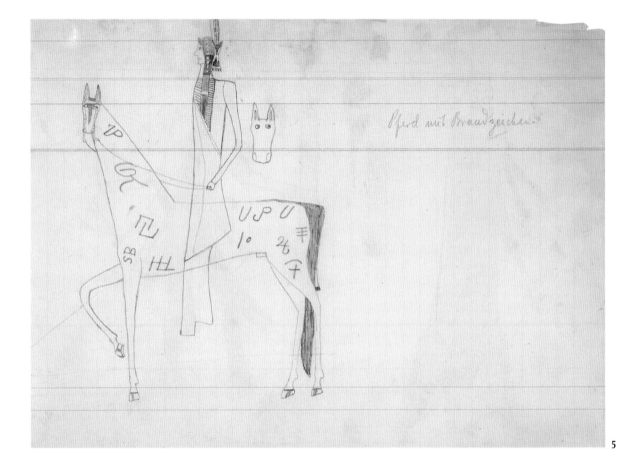

5

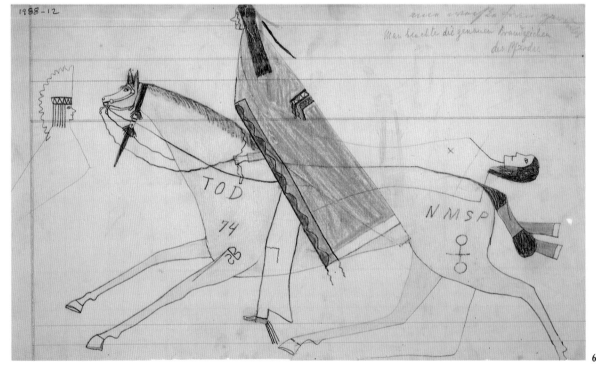

6

ARTIST UNKNOWN
7. Return from Battle with One Wounded
(22r)
1870–80?
Pencil and crayon
7½ x 12 in.
Texas Memorial Museum, University of
Texas at Austin, 1988.22R

Here is another artist's rendition of two high-ranking warriors returning from battle. His handling of the horses is completely different from that of the artist of cat. nos. 5 and 6. The head is larger and the legs are sturdier. The artist has a confident line but renders his figures with less delicacy than the other artist.

While ledger drawings most often focus on success in warfare, they do occasionally chronicle defeats. The military society leader in horned headdress guides his companion's horse home. The man in the fringed buckskin jacket is slumped over his orange horse. Blood drips from his mouth and side. The German inscription above reads "Wounded Indian (fallen from horse)," and the text below says "Black Snake Cheyenes" (sic). A battle shield and rifle float in the upper right corner of the image, suggesting they are meant to function as separate glyphs, identifying individuals or actions. The rifle is a Leman trade rifle, in widespread use in the 1860s (LaMont 1975:114).

JCB

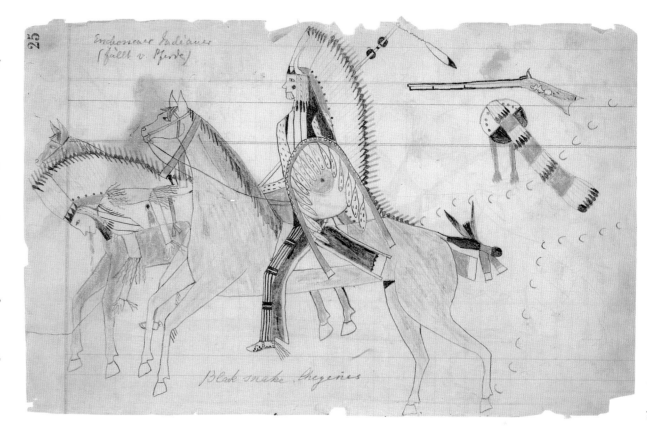

7

Frank Henderson
(1862–1885)
Arapaho

Catalogue Numbers 8–11

We know of the artist Frank Henderson only through the name he was given at the Carlisle Indian School in Pennsylvania and the artistic legacy he left in this superb drawing book executed in 1882. An orphan, Henderson was sent to Carlisle in October 1879, along with twenty-seven other young people from the Cheyenne and Arapaho Agency. He stayed at Carlisle for a year and a half, and then returned to the agency because of ill health. The following year, he produced this book as a gift for Miss Martha Underwood, an elderly resident of the town of Carlisle, who presumably had been a benefactor to him in some way (Petersen 1988:viii–xvi).

One hundred and twenty-two drawings were made in the Henderson Ledger. The eighty-seven finest of these were published before the book was broken up and dispersed. In the inscription to his benefactress, Henderson wrote on the flyleaf, "I try hard to make you Indian Picture." For this reason, we assume that much of the work must be his. Yet the hands of several artists appear in the book. Petersen finds at least five named artists, but has identified them on the basis of pictographs that identify the protagonist of a scene; her guiding principle, that "if only one man is named in the pictograph, he is both artist and subject" (1988:xviii), is flawed. Different hands can only be discerned through a careful study of stylistic features. We know that Plains men routinely drew in each other's books. Moreover, better artists sometimes drew the exploits of other men (see cat. nos. 124, 125, 136–42). In this book, the artist Petersen calls "Horseback" because of his name glyph (and whom I call Frank Henderson Ledger Artist A) is clearly the artist who is depicting the exploits of a man Petersen calls "Hill Man" (Petersen 1988:140, 156).

The work of two artists is represented in the selection published here. Because it is impossible to determine which of these hands might be Frank Henderson's, it seems most prudent at this time to refer to them as Henderson Ledger Artists A and B.

The drawings range from scenes of warfare, to courtship, to visionary scenes, to depictions of ceremonial dances. Very few books present as detailed and well-rounded a picture of nineteenth-century Native American life. Among the few that do are Black Hawk's book, dating to 1880–81 (see cat. nos. 114–19) and Amos Bad Heart Bull's epic book of 408 drawings composed between 1890 and 1913 (Blish 1967). Moreover, Arapaho drawings are relatively rare in the corpus of Plains graphic arts (see Maurer 1992:figs. 211–13; Petersen 1990). This makes the Henderson Ledger all the more important.

JCB

HENDERSON LEDGER ARTIST A
8. Horse and Rider (120)
1882
Pencil, colored pencil, ink, and watercolor
7½ x 12 in.
Mr. and Mrs. Charles Diker

The work of Henderson Ledger Artist A is characterized by an extreme delicacy of line. His figures have finely drawn facial features. His horses have extremely small heads in proportion to their bodies, a stylistic trait that adds to the overall impression of elegance and delicacy. He depicts frontal as well as profile scenes, and in this image combines the two: both horse and rider, though moving left across the page, appear to turn their heads and look out at the viewer. This lends great immediacy and charm to the image.

While this artist's work is interspersed throughout the ledger, a whole series of drawings at the end of the book, of which this page is one, show the ghostly pictograph of a horse and rider as the protagonist's name. For this reason, Petersen refers to this artist/protagonist as "Horseback" (1988:xviii and fig. captions). Because such nicknames can actually impede the process of identifying an individual's name (for such a glyph could just as easily be read as White Horse, Ghost Horse, Rides the Horse, or any other number of interpretive possibilities), I prefer to call him Henderson Ledger Artist A. The book both begins and ends with work by this artist. Moreover, his drawings occur in greater numbers than any other artist's. For these reasons, we might hypothesize that this is the hand of Frank Henderson himself.

JCB

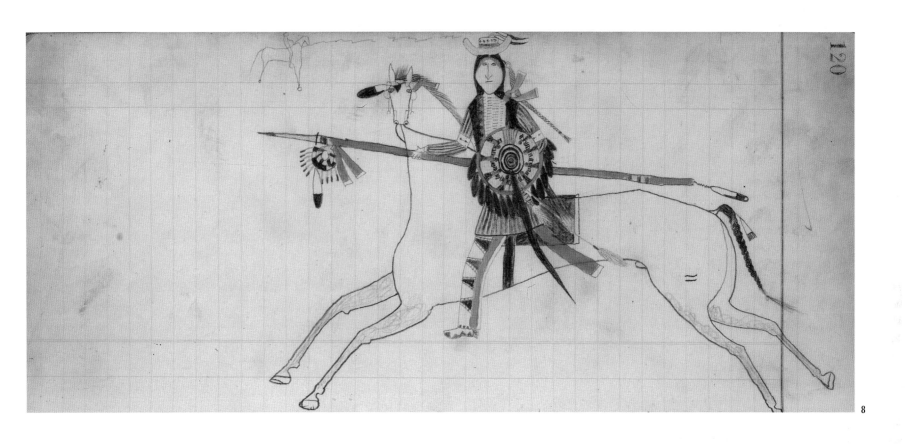

HENDERSON LEDGER ARTIST A
9. Medicine Vision (24–25)
1882
Pencil, colored pencil, and ink
15 1/2 x 24 in.
Mr. and Mrs. Charles Diker

The artist has used two adjacent pages to make a larger canvas for this striking visionary image, the only instance of a double-page image in the Henderson Ledger. On ledger page 24, he drew the torso, arms, and head of an Arapaho man. His arms are raised above his head, his bow and arrows are cast aside, and he stares wide-eyed at the vision that appears above him.

In the vision on page 25, a Medicine Being, accompanied by a hawk, seems to offer a powerful war shield to the man. The shield is spotted red on one side and blue on the other, with an eagle head in the center. Plains men customarily received their war shield designs in visions; the symbols conveyed in such visions became the protective medicine of that particular warrior. The Medicine Being rides a blue Thunder Horse. Red hailstones mark the horse's body. Short, staccato pencil gestures surround him, suggesting his energy and power, or his imperviousness to bullets. Blue and red lines of power radiate from the Medicine Being and from the shield down to the Arapaho man below, who is experiencing this awesome vision.

It may be that the buffalo horn and feathered headdress, the feathered lance, and the tipi painted with potent eagle and otter symbols are all part of the vision as well, showing the young warrior that he will be a great war chief if he honors and uses properly the eagle medicine that has been offered to him in the vision.

Two other vision paintings by this artist occur in the Henderson Ledger (Petersen 1988:figs. 13, 15). In each case, slightly different Medicine Beings appear on a painted horse in front of an ornate tipi and war regalia. In these drawings, butterfly and swallow imagery, and frog imagery, respectively, are offered as protective medicines.

Like the drawings of Thunder Beings by Lakota artist Black Hawk (see cat. no. 116), this is among the most beautiful and potent images in the entire corpus of ledger art.

JCB

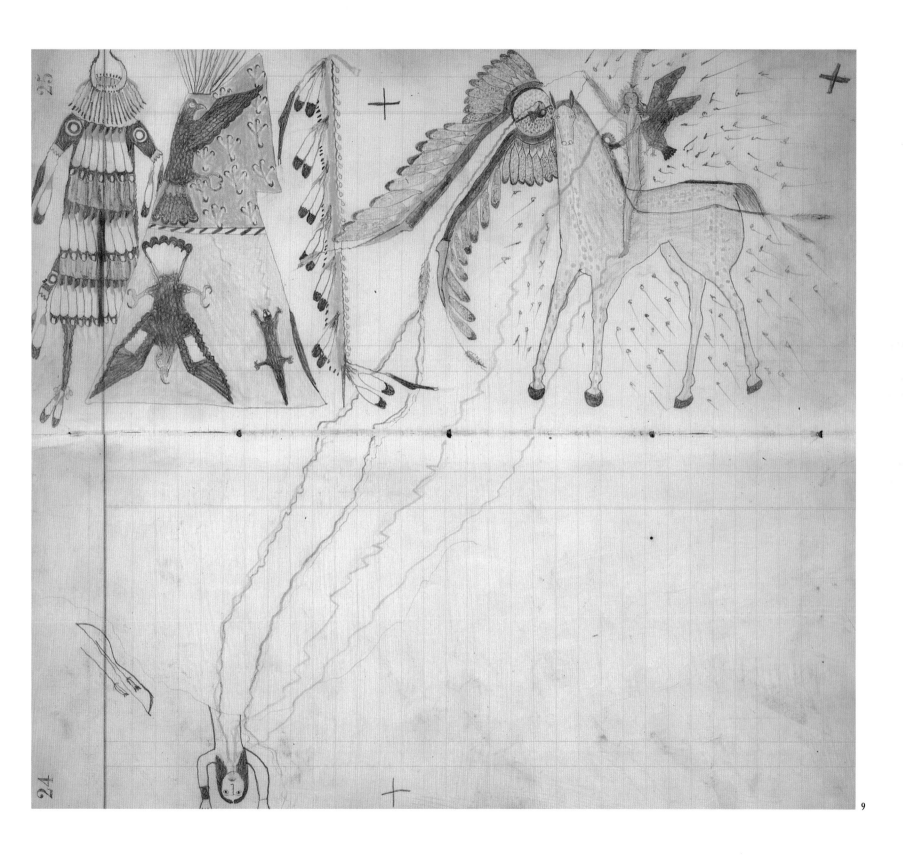

HENDERSON LEDGER ARTIST B

10. A Man and Two Women (92)
11. Two Men Ride to War (98)
1882
Pencil, colored pencil, and ink
7½ x 12 in. each
Mr. and Mrs. Charles Diker

While the stylistic distinctions between Ledger Artists A and B are not as great as those that separate them from some of the other, less accomplished artists in the book, some significant differences do exist. Artist B's horses' heads are still proportionally small, although not as small as those of Artist A. Artist B tends to fill the page with somewhat larger horses and figures than does Artist A. His treatment of feathers and human faces differs as well. Both artists are adept at detailed depictions of clothing.

In cat. no. 11, two men armed with hatchets, rifles, and painted war shields ride off to war. Each rides a fine red pony. The pony on the right arches his neck in an elegant pose as he canters along.

The man and the horse in cat. no. 10 are both dressed in their finery, suggesting a courtship scene. Horse and rider focus their attention on the elegant woman with painted cheeks, shell necklace, and black wool trade cloth dress who stands before them. Her fine elk's tooth dress and intricately beaded moccasins attest to her wealth and her artistry. Behind her hangs a red striped shawl.

A similarly dressed woman, seen from the rear, is drawn in the center of the page. The striped bag she carries on her back mirrors the one under the horse, and her striped shawl is the same as that held by the woman on the left. These details suggest that the artist intends to convey sequential action; that we are seeing the arrival and departure of the same woman. Yet each clearly has a different name glyph over her head. The woman at left has a bear sign, while the woman on the right has a skunk above her head, suggesting that this Arapaho man is courting two different women.

A number of other drawings in the Henderson Ledger are by this artist, among them pages 67, 73, 75, 77, 79, 83, 88, 94, 96?, 98, 100. As is sometimes the case in large books with different artists' hands, the work by one artist may cluster in one portion of the book. Lt. John G. Bourke, writing in his diary in 1877, recorded that his Arapaho scout, Friday, told him that "it is extremely common for intimate friends to insert in each other's books evidence of mutual esteem by drawing scenes from their past lives (to serve about the same purpose as the interchange of photographs and autographs does with us)" (Bourke 1872–96:1972–73).

JCB

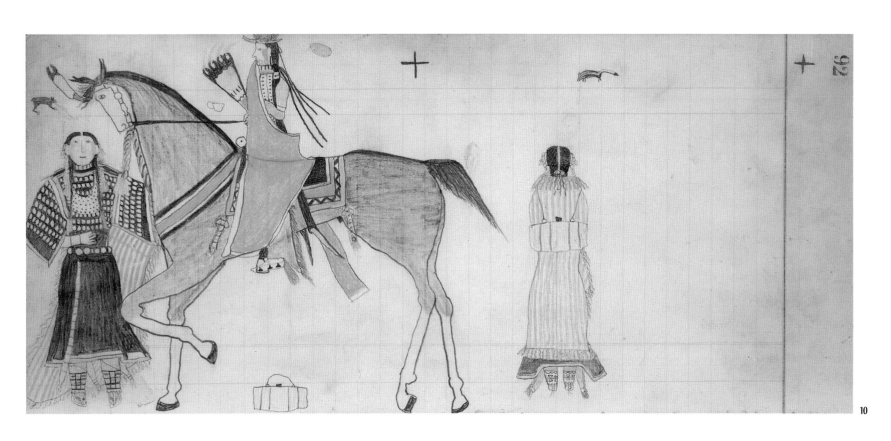

10

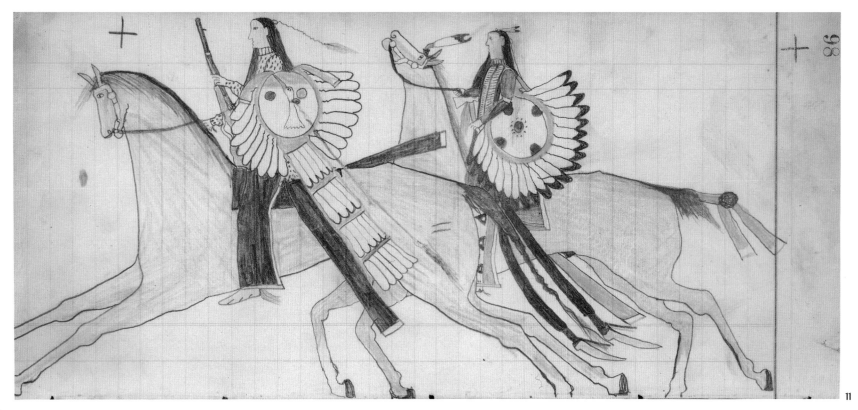

11

Little Shield
(?–after 1876)
Arapaho

Catalogue Numbers 12–16

A previously unknown and unpublished series of twenty-three drawings in the St. Louis Mercantile Library provides a new and early example of Arapaho graphic art. The artist, identified in the ledger inscription as an "Arrapahoe [sic] Chief," evades precise identification. Several Little Shields of both Northern Arapaho (Fowler 1982:45) and Southern Cheyenne descent (Berthrong, 1976:26; Petersen, 1971:107–8, n. 7–8) were active in the post–Civil War West. Although some of the enemies he depicts in his war record—Comanches and Texans—seem to indicate a warrior of Southern Arapaho or Cheyenne origin, the artist was probably the Northern Arapaho chief, Little Shield, who signed a peace treaty at Fort Laramie in 1868 along with other Arapaho and the Yankton Sioux (*Annual Report of the Commissioner*, 1868: 253; Kappler 1904:1005).

This particular identification makes historical sense, and several clues to it can be gleaned from the ledger book. First of all, the inscription on the verso of drawing no. 22 (not illustrated) of the ledger suggests Little Shield's "friendly" status at that time. It reads,

"Little Shield" . . . Arrapahoe Chief
Says he is a good friend to the whites . . .
treat him kindly so long as he behaves
himself.
March 21ˢᵗ / 68
[H.] Douglas
Major Cmnd'g
Fort Dodge, KS

The date, place, and content of the inscription provide valuable information. Prior to the mid-1860s, when overwhelming numbers of settlers poured into the Plains region, "friendly" chiefs who could negotiate peacefully with white officers for land and goods garnered more respect from their people than war chiefs. Often, Arapaho leaders obtained signed papers from white agents or other important whites as evidence of their good will (Fowler

1982:25–26). In late 1867, the *Missouri Republican* reported that Little Shield had sent two emissaries to meet with the Peace Commission at Fort Laramie and express the peaceful intent of the Arapahos he represented (*Missouri Republican*, November 23, 1867). This indicates that Little Shield had achieved considerable influence and high rank in Arapaho society. Furthermore, the *Missouri Republican* correspondent claimed that Little Shield was "an old man, now sick" who "said he wanted peace, and wanted to be away from the Arapahoes," probably referring to the warriors of his tribe still raiding with the Cheyenne on the Kansas frontier (*Missouri Republican*, November 22, 1867; Garfield 1931–32). Thus, the ledger and its inscription could have served as the chief's evidence of his "friendly" intentions toward the Peace Commission when he met with them the following summer at Fort Laramie and his acquiescence to white authority. The warrior's book of exploits displayed what was then "ancient" history.

Second, Fort Dodge, where the inscription (and perhaps the captions as well) was made, was a popular stopping point for the Arapaho and other Plains tribes on their annual journeys due to its central location near the Arkansas River in western Kansas. The fort also had an unsavory reputation for supplying them with arms, ammunition, and liquor (Garfield 1931–32:452; Trenholm 1970:222). However, in February 1868, Agent E. W. Wynkoop decided to issue supplies for the Cheyenne, Arapaho, and Apache tribes at Fort Dodge, Kansas; "it was the point nearest to the Indian camps, and the only place [to] procure sufficient storage for supplies furnished" (*Annual Report of the Commissioner*, 1868:55). Thus, Little Shield's visit just one month later in late March is easily explainable.

After signing the Fort Laramie Treaty, Little Shield remained on the Northern Plains. In 1871, Indian Agent J. W. Wham named Little Shield as one of the Arapaho chiefs assembled with his people at the Red Cloud Agency, along with the Sioux and Cheyenne (*Annual Report of the Commis-*

sioner, 1871:699). Little Shield was counted in the 1876 census at Red Cloud Agency (Buecker and Paul 1994:44); after that, he disappears from the historical record. Once a great Arapaho warrior and chief, Little Shield left behind a life story and drawings that reflect the paradoxes of nineteenth-century white-Indian relations in the American West. The drawings may present a traditional record of the exploits of an Arapaho chief—a warrior autobiography not much different in form and content from those painted on buffalo robes in earlier decades—but Little Shield used his ledger book art not only as a medium for remembrance but as evidence of his submission to white authority as well.

JAC

LITTLE SHIELD
12. *Pen-na-tak-er Co-manch* (2) (Berlo, "Drawing and Being Drawn In," pl. 1 [p. 15])
13. *Texan Killed* (18)
14. *Pawnee Riffle* (sic) (20)
Before 1868
Pencil and ink
3³⁄₄ x 6¹⁄₂ in., 3¹⁄₄ x 5¹⁄₂ in., 3³⁄₄ x 6¹⁄₂ in.
St. Louis Mercantile Library, 78.038.2, .18, .20

Little Shield executed his twenty-three drawings on two different sizes of ledger paper. Though later bound together in book form, they have since been disassembled, framed, and matted for preservation and exhibition. The artist's style and pictographic skill suggest that his work is an early example of the transition from hide painting to ledger book drawing. Little Shield's simple pictographs have more in common with painted buffalo hides dating from the 1830s and 1840s than with the 1869 Summit Springs Ledger, for example (Filipiak, 1964). However, elements of both styles can be observed. As in hide paintings, Little Shield's torso and face are shown frontally while his horse and left leg are shown in

profile. The fact that Little Shield draws only one leg and not two provides evidence of a developing realism. The facial features of all the figures, though, are absent and elaborate details in dress and ornament are minimal. The hands of the figures are absent as well, and the weapons wielded by the warriors are drawn as extensions of the twig-like arms (or at least placed conveniently near the arms); arms are either outstretched or curved around the rectangular bodies to better aim a bow and arrow or fire a gun. Legs and footwear are more carefully outlined, even offering clues to tribal affiliations, such as the distinctive flared black moccasins of the Pawnee warriors, as in *Pawnee Riffle* (cat. no. 14). Other stylized and conventional clues to the identity of his enemies include the Pawnees' hair roaches, the single scalp lock of the Penateka Comanche warrior in *Pen-na-tak-er Co-manch* (cat. no. 12), and the sword and hat of the white Texan in *Texan Killed* (cat. no. 13).

Little Shield himself is identified by the huge shield he brandishes, the one element of all the drawings to which the artist has devoted great attention. Although it functions like a name glyph in identifying the protagonist in twenty-one of the twenty-three drawings, the shield, with its radiating feathers and decorative central design, is unlike a name glyph in that it plays an active role in the event portrayed; it provides the warrior's literal and spiritual protection in warfare. Indeed, in several depictions, stylized bullets fly past the chief as he rides on unharmed. Curiously, this powerful protective device is missing in *Pawnees* (not illustrated) and *Texan Killed*, in which Little Shield encounters, respectively, gun-toting Pawnees and a mounted Texan.

JAC

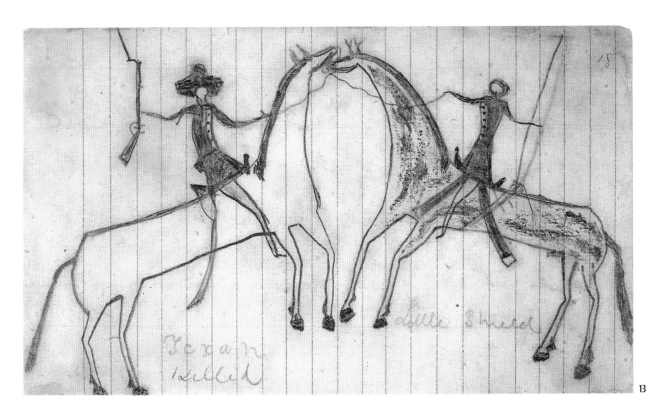

13

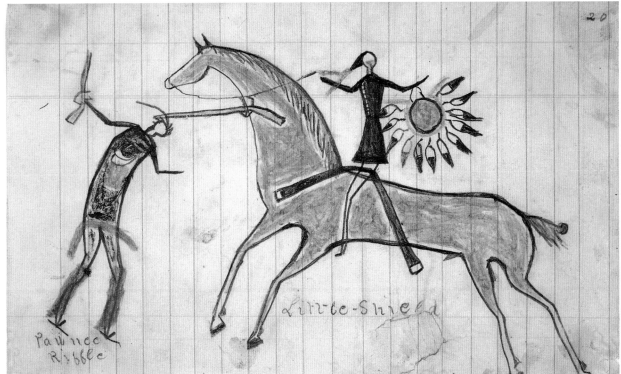

14

LITTLE SHIELD

15. *Pennetaker Comanch Not Killed Run Off*
(4)
16. *Utes/Killed Heap Squaws & Pappoos* (12)
Before 1868
Pencil and ink
3¼ x 5½ in. each
St. Louis Mercantile Library, 78.038.4, .12

On each page, Little Shield rides into the action from the right, a conventional pictorial device, his horse at full gallop, the chief's arms outstretched, his shield held aloft and a bow, lance, or rifle poised to strike his enemy. Like many warrior artists, Little Shield lavished decorative attention on his horse, which displays bright imaginative colors and carefully drawn details: hoofs, mane, bridle, and in some cases, a clubbed tail and split ears. Throughout the drawings color is applied arbitrarily. Some attempt has been made at perspective in drawings such as *Utes/Killed Heap Squaws & Pappoos* (cat. no. 16) by stacking figures and landscape elements and reducing their size so they appear farther away. However, this device also could be attributed to the space constraints of the ledger page itself.

In any case, Little Shield meets most of his combatants on seemingly unfair terms; he on horseback, they on foot. Such encounters were characteristic of the surprise raids launched during the intertribal warfare waged by all Plains peoples in the mid-nineteenth century. Little Shield's enemies are either killed or "run off," as the caption *Pennetaker Comanch Not Killed Run Off* (cat. no. 15) states.

In these drawings, Little Shield depicts himself in combat with Penateka Comanches. Even if the artist of these drawings is, in fact, the Northern Arapaho chief mentioned above, the depictions of Little Shield's southern enemies can be explained historically. Contact with southern peoples was not out of the question for Northern Arapaho. Many factors—the dwindling range of buffalo herds, tribal and band intermarriage, alliances and wars with other tribes such as the Cheyenne, Kiowas, and Comanches, and the annual Offerings Lodge (or Sun Dance) ceremony—often brought the Northern Arapaho peoples south to the Arkansas River area (Fowler 1982:43). Only after the outbreak of Indian-white hostilities in the north in the late 1860s and the creation of the Southern Arapaho Reservation in Indian Territory in 1869 did the two groups separate more permanently (Fowler 1982:44).

Because the Pawnees and Utes, the deadly enemies of the Arapahoes, commanded most of Little Shield's attention in his drawings, one can assume that his encounters farther south with Texans and Comanches were not everyday occurrences during his warrior days. It was not uncommon, however, for Arapahoes to join the Comanches, especially in the late 1840s, in their raids along the Santa Fe Trail, which took many Arapaho warriors as far southwest as New Mexico. In the 1850s, after Texas attempted to place the Penateka Comanches on reservations, many unwilling members of the band moved north to the Arkansas River in Kansas while continuing their raids in central Texas in smaller numbers (Fehrenbach, 1994:420). For this reason, the Texas Rangers formed in 1858 for the second time in the century to defend the frontier against these Comanche raids. Their task—to pursue and destroy—took them out of Texas and as far north as Indian Territory. As a result, by 1861, the Penateka Comanches were listed as "Agency Indians," quite pacified and no longer a threat to white settlement and neighboring Plains people (Fehrenbach 1994:430, 448). Arapaho clashes, as well as alliances, with the Penateka Comanches in the late 1850s could account for the drawing *Pennetaker Comanch Not Killed Run Off*, as well as *Pen-na-tak-er Co-manch* and *Texan Killed* (Berlo, "Drawing and Being Drawn In," pl. 1 [p. 15]; cat. no. 13) discussed above. If this is the case, Little Shield's ledger may represent a warrior's memory of a much larger and freer Plains Indian world, which, just ten years later, at the time of the inscription, was split in two and rapidly shrinking.

JAC

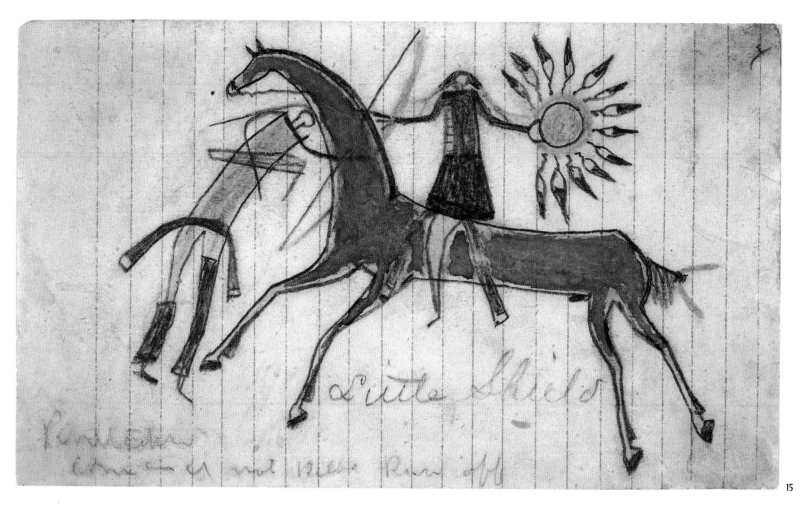

Little Shield

15

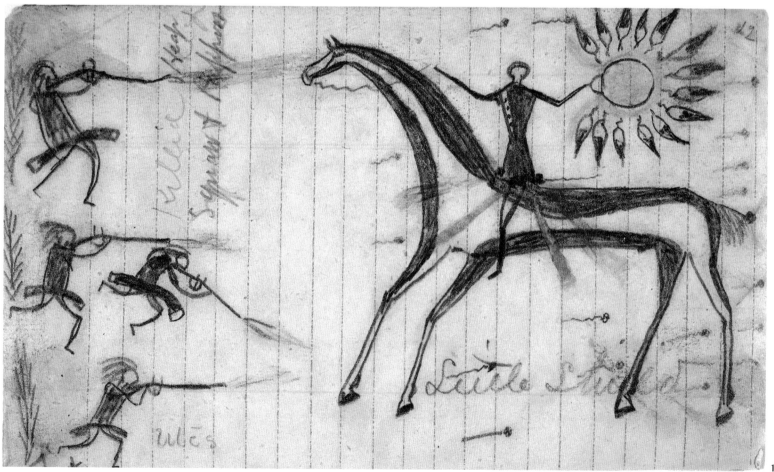

Little Shield

16

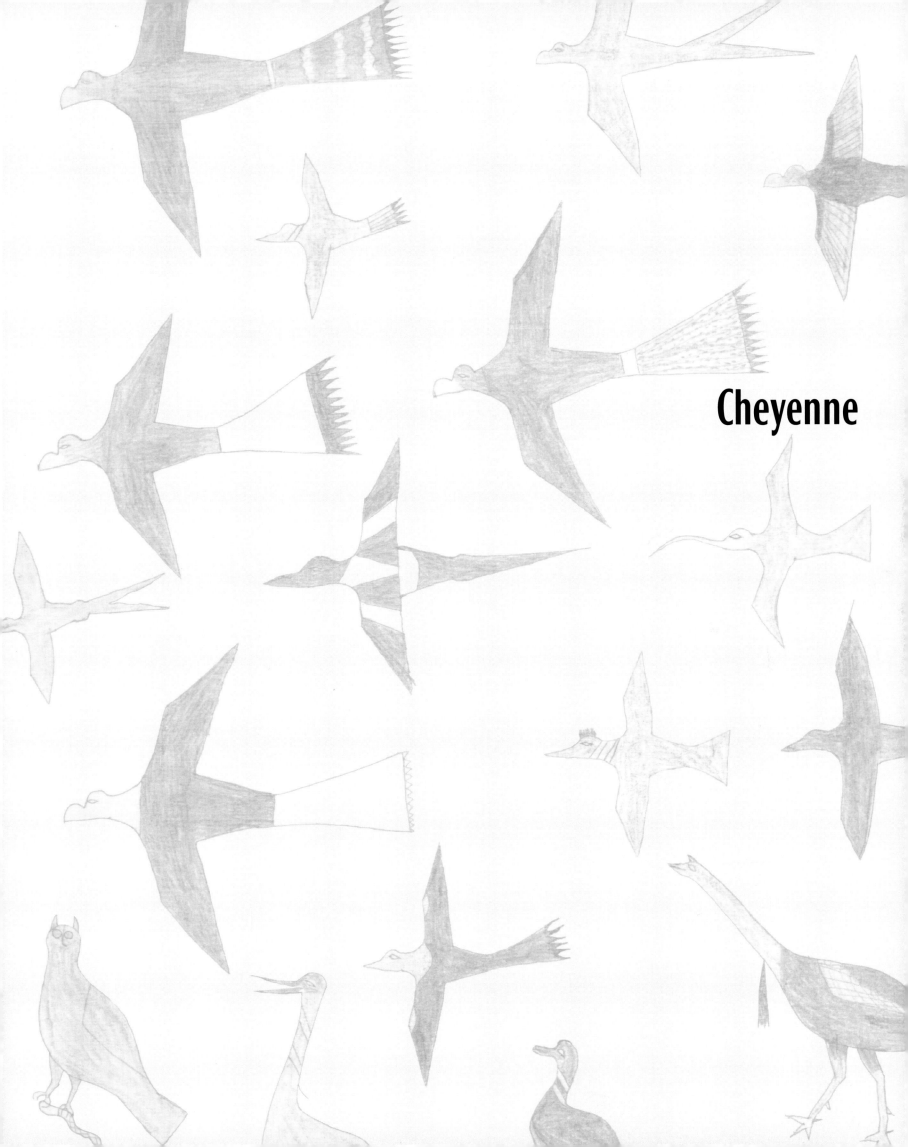

Cheyenne

Artists unknown
Bourke Drawings
Cheyenne

Catalogue Numbers 17–21

John Gregory Bourke was born in 1846, graduated from West Point in 1869, and worked as aide-de-camp to Gen. George Crook of the Third U.S. Cavalry in Wyoming Territory. (Crook had commanded the Department of the Platte in 1875 and participated in the Great Sioux War in 1876.) While under this charge, Bourke made many ethnological studies of Native Americans in the region. He kept diaries from 1872 to 1896, and they are now among the holdings of West Point. Volume 15 (identified as *1877, Powder River Exp.* in ink on its cover) contained thirty-three photographs and twenty-five pencil and colored pencil drawings interspersed among newspaper clippings. Although this volume is unusual in that it does not contain diary entries, per se, the drawings, photos, news clippings, and remarks work together to offer an unusual ethnographic look at Wyoming Territory in the 1870s.

The volume has been dismantled and each leaf conserved. All the drawings are on salvaged ledger pages with accounts for supplies written in from November 1869 through December 1870 (which places the dating of these drawings as no earlier than 1871). On ledger page 51 (diary page 1764–65), there is an account of "Mr. Stiles in Cheyenne." This then places the ledger in Wyoming Territory. The fact that Bourke chose to include a clipping from the *Cheyenne Sun* dated January 1877 gives a clue to the origin of this ledger: "The Cheyenne village was captured and among the trophies was a Sioux book [now identified as Cheyenne] being a pictorial history of their exploits."

JV

ARTIST UNKNOWN
17. Bear Foot, a Contrary, Is Rescued by Last Bull
18. Last Bull Captures a Horse
1871–76
Pencil and colored pencil
6⅞ x 10½ in. each
United States Military Academy Library, West Point, New York (1752, 1754)

Last Bull, Head Chief of the Kit Fox Society, is identified in these two drawings by his shield and Kit Fox Society bow lance. The image in cat. no. 17 depicts the heroic rescue of Bear Foot, a Contrary, by Last Bull, while that in cat. no. 18 shows him capturing a horse.

A second example of the subject of the rescue of Bear Foot appears in the Last Bull Ledger at the American Museum of Natural History in New York (Powell 1981:144). In the Last Bull Ledger, Bear Foot is identified by the name glyph in the upper right-hand corner. The shield carried by the protagonist in the Last Bull Ledger is identical to that carried by the protagonist in these two images from the Bourke diary, which clearly identifies him as Last Bull. Additionally, the two rescue scenes are almost identical—showing Last Bull and Bear Foot both upon the same horse fleeing a barrage of bullets. Consequently, it is reasonable to conclude that the scene in the Bourke diary is the same subject—the rescue of Bear Foot by Last Bull. Although Bear Foot is shown being rescued in this scene, he did not survive the battle.

This scene reveals the importance and value of Contraries as members of war parties. The Contraries who carried the Sacred Thunder Bow assumed tremendous responsibilities. Thunder, "Maiyun," who takes the form of a rider on a white horse or a great bird, appears to a Cheyenne man in a dream or vision and directs him to become a "Hohnuhk'e," or Contrary (Powell

1969:331). Contraries did not make up a separate military society but were men chosen for their bravery, strength, and leadership. Bear Foot (shown as the second rider in cat. no. 17) wears the characteristic red paint and clothing of a Contrary (Berthrong 1963:69). He carries the Thunder Bow (a bow lance with two strings and a stone or metal head attached to one end, and the skin of the tanager and hawk, and owl and eagle feathers, fastened along the length). The Contrary bow-lance was used only for counting coup. Once the bearer shifted it to his right hand, he could never retreat, but had to fight until he was killed or until the enemy retreated (which is what occurred in this scene). Protected by the power of the Thunder Bow, a Contrary warrior charged the enemy alone. Because of their great bravery, Contraries were often asked to lead the charge into battle (Powell 1969:332).

The sequence of events is revealed in this drawing by the hoof prints that originate in the upper left-hand corner. Bear Foot's horse has been shot in the rear flank by a Crow bullet (we know it was Crow because of the accounts that tell of Bear Foot's death on the Little Big Horn River while fighting the Crow [Powell 1981:144]). Last Bull rides in and pulls Bear Foot onto his horse. The two flee, protected momentarily by the power of the Thunder Bow and Last Bull's war medicine (the bird attached to his scalp lock) and his vision shield.

Cat. no. 18 shows Last Bull capturing a horse. His Kit Fox Society bow-lance is extended in front of him, pointing the way. The shield and bird-shaped war medicine attached to his scalp lock identify him as Last Bull. Again he is protected by his shield and war medicine, remaining unharmed despite the hail of enemy bullets.

Both images depict Last Bull during the height of his military career. For this reason, they were probably drawn before November 25, 1876 (the capture of Dull Knife's village by Colonel Mackenzie). Last Bull had countermanded the order of Crow Split Nose, Chief of the Elkhorn Scraper Society, to move the camp to a safer location. Last Bull and his accomplices forced the camp to stay by cutting the packsaddle cinches of the loaded horses. Unfortunately, the assault on Dull Knife's village came at dawn, and resulted in the total destruction of the camp. Because of this and other abuses of his power, Last Bull was deposed by his own society (Llewellyn and Hoebel 1941:120–21). What becomes noteworthy in examining these two drawings is that despite Last Bull's abuse of power later in life, he is still remembered for his valor.

JV

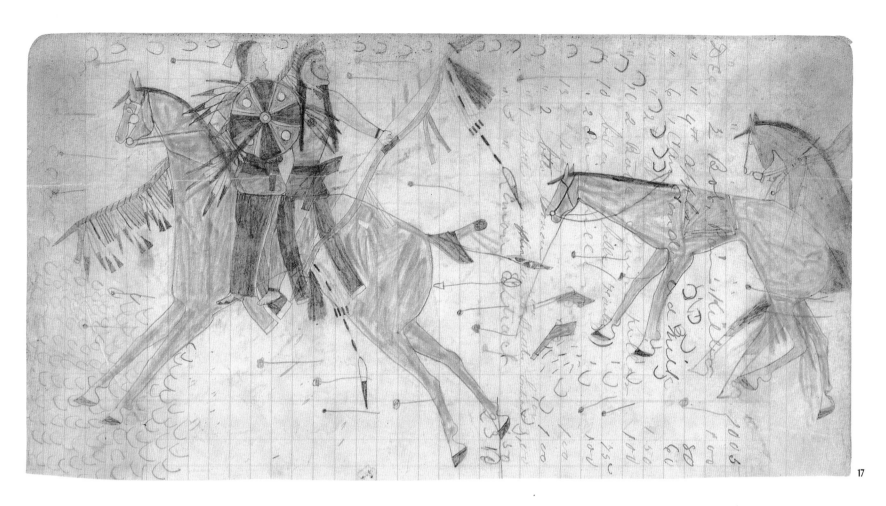

17

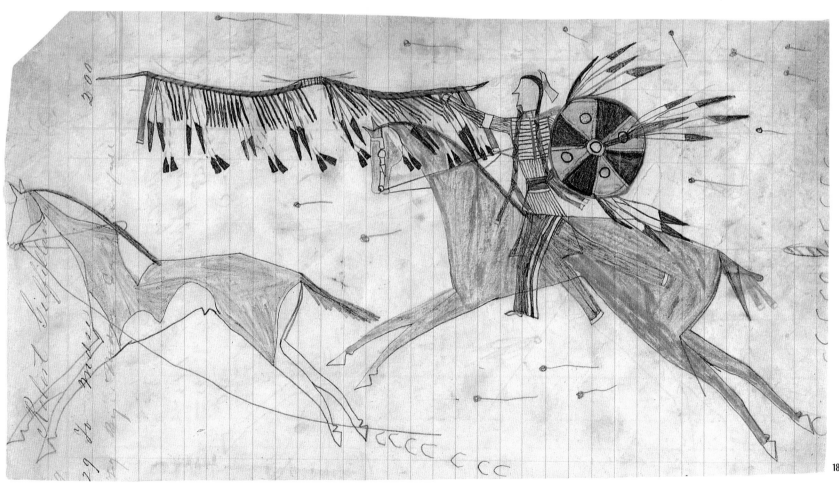

18

ARTISTS UNKNOWN
19. Counting Coup on an Arikara (D)
20. Counting Coup on a Crow Man and
Woman (E)
21. A Warrior Engages an Enemy (F)
1871–76
Pencil and colored pencil
$6^7/_8$ x $10^1/_2$ in. each
United States Military Academy Library,
West Point, New York (1762, 1764, 1771)

These drawings reveal the importance the Cheyenne place on valor. In cat. no. 19, a chief wearing a horned war bonnet counts coup on a mounted Arikara, who is identified by the cuffed moccasins and bandoleer bag that he wears. The Cheyenne warrior wears a beaded and fringed shirt and beaded leggings. Around his left wrist he carries a quirt with an animal skin attached (possibly ermine). His horse's tail is tied for battle with red stroud cloth. Despite the bullets and arrows flying past, he remains unharmed and still counts coup on his enemy, an act that attests to his skill as a warrior.

In cat. no. 20, the Cheyenne counts coup on a Crow man and woman with his lance. He carries a vision shield with a long feather trail attached. Affixed to his scalp lock are a gorget with eagle feathers and silver concha hair plates; a German silver pectoral is around his neck. Wearing a military jacket (probably obtained from a soldier), he charges the two mounted Crow. The Crow warrior shoots arrows at the Cheyenne warrior, but the latter is protected by the power of his shield.

In cat. no. 21, the Cheyenne protagonist is confronted by an enemy while attempting to capture a horse. He has counted coup on his enemy's head, wounding him in the process. The Cheyenne warrior has been struck in the chest with the butt of a rifle and has had coup counted on him with a bow-lance and a quirt. He is bleeding from his chest wound.

In cat. nos. 20 and 21, the artists chose to draw on pages filled with writing. The ledger had previously been used to record accounts. In an effort to express their military superiority, the artists have recorded their military exploits over these records. This artistic strategy adds another layer of meaning to the works; it is an act of resistance as well as a recording of personal achievement. The drawings no longer merely attest to the military prowess of their subjects, rather, they emphasize the strength of Cheyenne culture and the Cheyenne people's will to survive.

JV

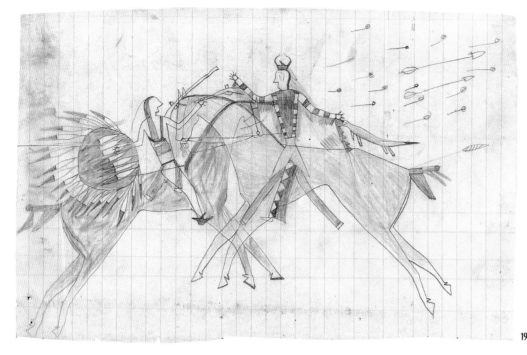

19

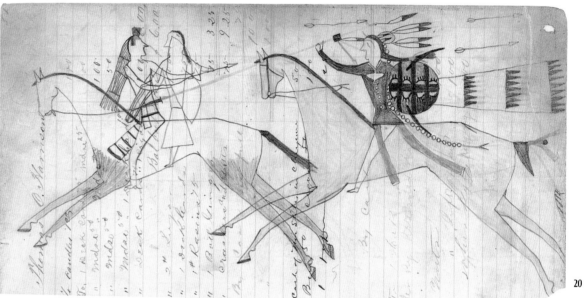

20

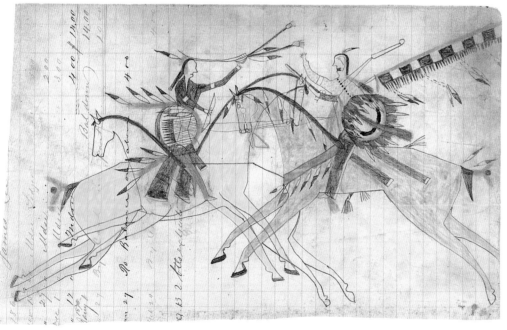

21

Artist unknown
Evans Ledger
Cheyenne

Catalogue Numbers 22–24

These scenes are from a book that was acquired without accompanying documentation; we do not know when its seventy drawings were produced or by whom. As was common in ledger books, the work of many hands is found throughout it, but the majority of the pictures are by the unknown artist who created the works shown here. Evidently, the book at one time was in the possession of Neal Evans, who operated a trading post at Fort Reno on the Southern Cheyenne and Arapaho Reservation, and whose young son Willie added his own pictures of buildings to a few blank pages. Many of the pages are inscribed with detailed captions, which may have been provided by Evans.

CSG

ARTIST UNKNOWN
22. *Cheyenne Stealing Horses out of Corral, Crow Lodges Around Corral* (46–47)
23. *Roman Nose, Cheyenne Fight, at Beecher Island, with Forsyth's Scouts* (104–5)
ca. 1875–80
Pencil and colored pencil
7½ x 12¼ in. each
National Anthropological Archives, National Museum of Natural History, Smithsonian Institution, Washington, D.C., Ms. 4653

A number of pictures in this book are two-page compositions, displaying a classic ledger technique employed when the scope of the action to be depicted was too great for the confines of the single page. Ledger artists usually worked with the book turned sideways, orienting the spine horizontally rather than vertically. The drawings were then made on the far page, with the bottom of the picture closest to the seam of the binding. This orientation must have been the most convenient for an artist seated cross-legged on the ground, holding the book in his lap while he drew, his hand supported by the near page. When making a two-page composition, the artist drew one portion of the picture on one page, then rotated the book 180 degrees and completed the picture on the facing page. These scenes are often connected through the use of footprints or horse tracks, which pass off of one page to the left and re-enter the facing page from the right as in cat. no. 23. This technique often changed when artists became more familiar with Western methods of page orientation. The Fort Marion artists, for example, treated facing pages as a single plane and spread their drawings straight across the surface without interruption (see cat. no. 54 and Greene 1992a: 56–57).

This book is unusual in that several of the battles are identified in captions and can be correlated with events recorded in the historical literature. They include battles ranging in time from 1854 to 1875, and demonstrate that at least some ledgers represent events covering a significant period of time.

Cat. no. 23 shows a famous fight that took place in 1868 between a large war party of Cheyenne, Arapaho, and Brule Sioux and a small group of frontier scouts under the command of Lt. Forsyth. The scouts were surrounded and forced to remain for over a week on a small brushy island in the Arikaree Fork of the Republican River in Kansas. The scouts were armed with repeating rifles, well represented here by the multiple blasts coming from each weapon. The famous Cheyenne warrior Roman Nose was killed in this battle, but the man shown here is not he, for Roman Nose wore a distinctive horned war bonnet in this fight (Berthrong 1963:310–14; Grinnell 1956: 277–92). The unusual inclusion of landscape in this picture is not for decorative effect. The brush behind which the scouts took cover is an integral part of the story.

CSG

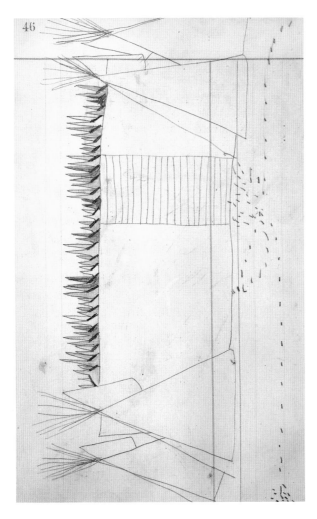

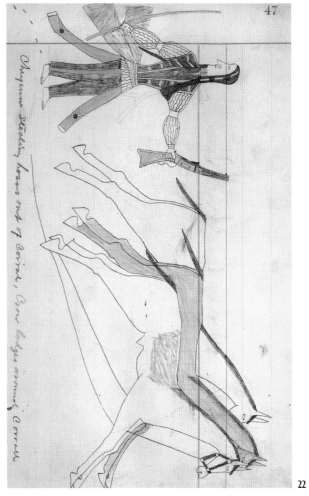

22

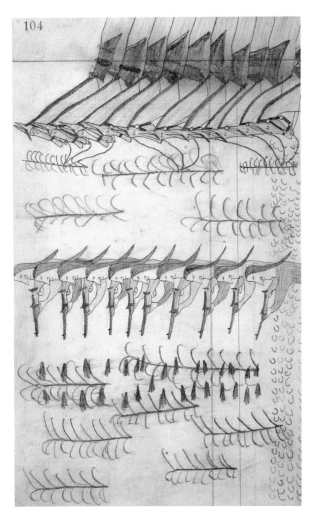

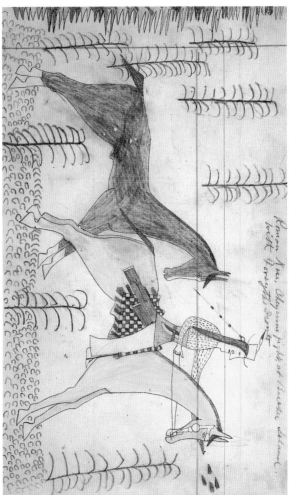

23

ARTIST UNKNOWN
24. *Courting Scene*
ca. 1875–80
Pencil and colored pencil
7½ x 12¼ in.
National Anthropological Archives, National Museum of Natural History, Smithsonian Institution, Washington, D.C., Ms. 4653

Courting scenes, such as the one shown here (the unnumbered frontispiece of the Evans Ledger) of a finely dressed couple seated on a log, are common fare in the male-controlled world of ledger art. While Cheyenne women were constantly exhorted to practice modesty and chastity, men gathered to boast to each other about their amorous conquests. In many books, draw-ings of courting activity are interspersed among the drawings of war as records of manly achievement, although the former are much less explicit than the latter in depicting the exact course of events.

CSG

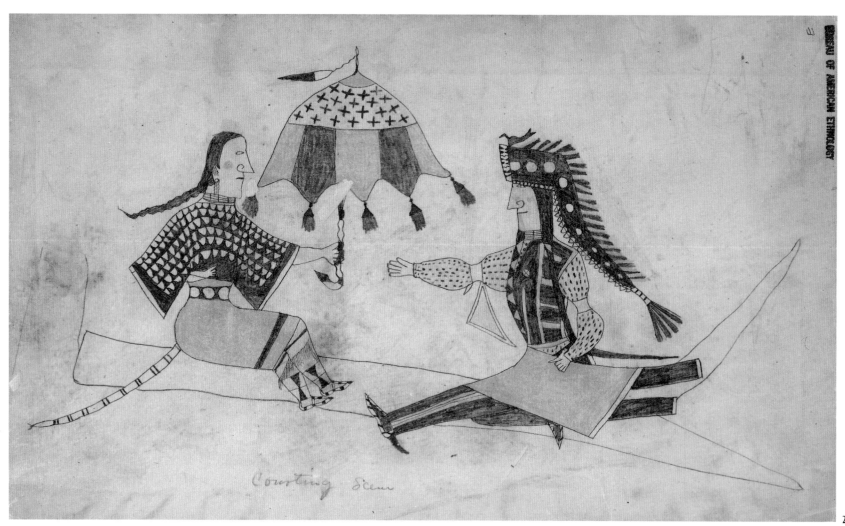

**Artists unknown
McDonald Ledger
Cheyenne**

Catalogue Numbers 25–27

Like cat. no. 1, these drawings are from one of two books said to have been collected by Capt. David N. McDonald during his Army service in the West. McDonald was posted at Fort Reno, Indian Territory, adjacent to the Southern Cheyenne and Arapaho Reservation from 1878 to 1881. Most of the drawings in the book depict Cheyenne warriors and their activities, although some Arapaho works are represented as well.

The drawings illustrated here are the work of three of the several artists who made images in this book. Often, drawings by different men are interspersed through the pages of a book, and there is even occasional evidence of collaboration within a single picture, for example, one artist drawing the horse and another filling in the human figures. Art was clearly a social activity, not one carried out in isolation. We can imagine something of the context in which drawings were produced—men gathering under a brush arbor to discuss noteworthy events of the recent or more distant past, a book of drawings being brought out and passed around (many books are soiled from repeated handling), and a young artist perhaps expressing a desire to add a few more scenes to the compilation.

CSG

ARTISTS UNKNOWN
25. Killing a Crow Enemy (36)
26. A Close Encounter with a Soldier (86)
27. Attack on a Teamsters' Camp (90–91)
ca. 1878–81
Pencil and colored pencil
7³/₄ x 12¹/₂ in. each
National Anthropological Archives, National Museum of Natural History, Smithsonian Institution, Washington, D.C., Ms. 4452A–I

Many ledger drawings are simple scenes of two figures in an undefined setting. The stories that others depict require more complex images, and Plains artists developed a number of conventions for the efficient representation of large numbers of figures and varying features of topography. Cat. no. 27 is such a scene, spreading across two facing pages with the Cheyenne attackers on one page and the teamsters' camp and its defenders on another. The camp, represented by a tent with protruding stovepipe, was situated between two ridges, which are effectively suggested by two converging horizon lines. Through a system of abbreviation, or shorthand, in which a part of a figure stands for the whole, multiple rifle barrels firing blasts from the muzzles and the upper body of one man indicate a number of the teamsters shooting from under cover. Similarly, their herd of long-eared mules is adequately indicated by depicting only the upper bodies. One faces the opposite direction from the others, creating visual interest in the repeating line, as well as perhaps suggesting a disposition characteristic of these animals.

Plains graphic art was developed and continued to serve to illustrate the deeds of particular warriors, and the drawings thus often portrayed specific people. Yet Plains artists conceptualized portraiture quite differently than did Western artists. The delineation of facial features or other distinctive aspects of physical form was of no concern to the ledger artist. Attention was devoted instead to their distinctive accoutrements of war—shields, headdresses, society insignia, and so on. The warrior in cat. no. 25 has no facial features other than those created by the profile line, yet his shield would have provided immediate recognition for those who knew him. The artist who produced cat. nos. 26 and 27 carefully detailed similar identifying features. Yet not all scenes contain such clues to the warriors' identities. Rising young men might not yet have had war medicine to display, or a more established warrior might not employ it on all occasions.

CSG

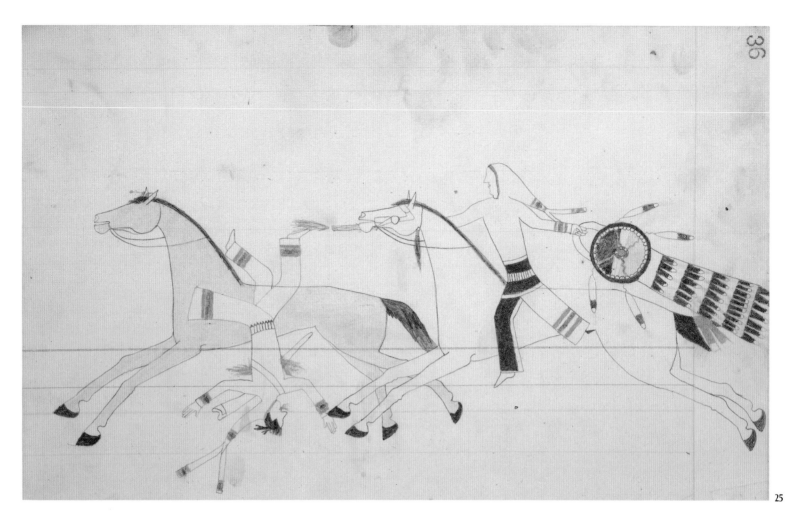

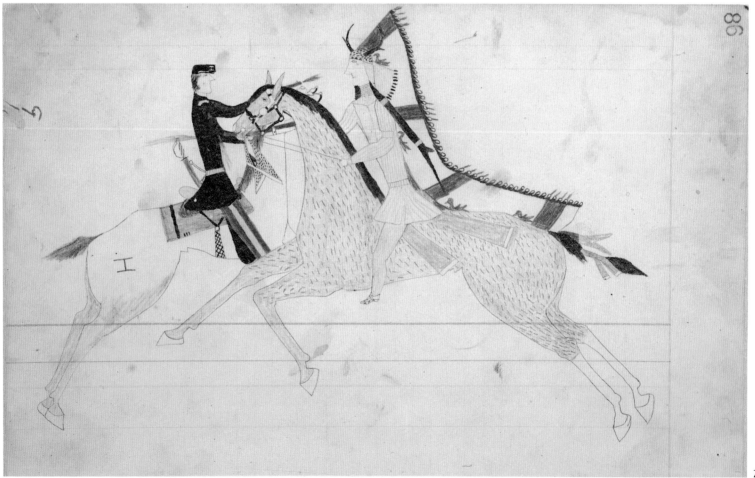

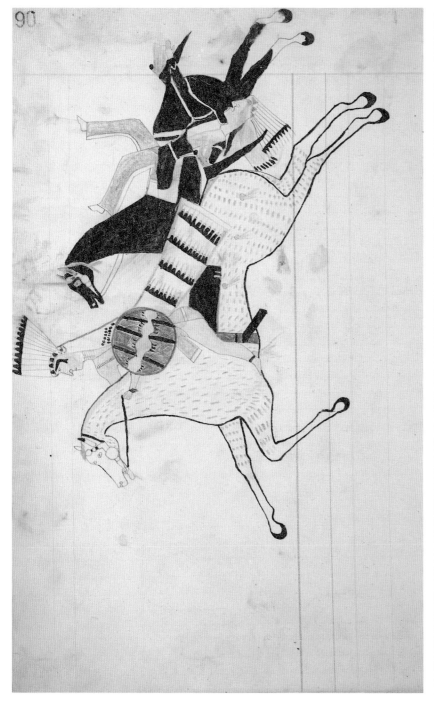

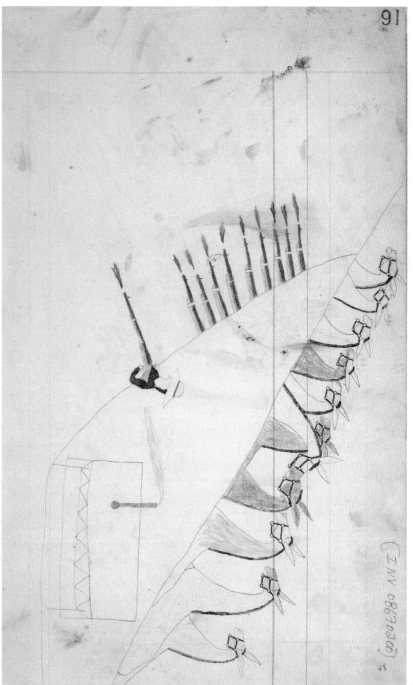

Artist unknown
Pope Ledger
Cheyenne

Catalogue Numbers 28–37

The Pope Ledger, so named for its donor, has also been referred to as the Crazy Dog Ledger for the prominence of Crazy Dog warriors in its drawings (Powell 1981:128). Containing 128 drawings done in watercolor, crayon, and pencil, the Pope Ledger was executed by more than one artist, although the majority of the images were completed by one accomplished individual. Two distinct hands, differentiated by their treatment of the face, are apparent in the images included here. The Pope Ledger was donated to West Point in 1972 by Mary Pope, daughter of Brig. Gen. Francis H. Pope. Francis Pope, whose father, Gen. John Pope, had served in the Civil War and then in Indian country, was appointed a cadet at the U. S. Military Academy on March 20, 1893. An inscription on the first drawing in the ledger gives a clue to its original acquisition: "Francis H. Pope, 1st Lt., 2nd Cavalry. West Point, NY." Pope was at this rank for only a short time (February 2, 1901–August 1, 1903), so it is reasonable to assume that he acquired the ledger book at that time rather than by its passing down from his father. Moreover, the dating of 1890s for this ledger is also appropriate given the late style of the drawings. Brief handwritten inscriptions on some of the drawings (for the most part limited to tribal designations) were probably added by Francis Pope at the time of acquisition.

JV

ARTIST UNKNOWN
28. Lancing of Two Sioux Women (46)
29. An Elkhorn Scraper Lance-Bearer Counts Coup (210)
1890s?
Watercolor, crayon, and pencil
7^{15}/$_{16}$ x 12^{1}/$_{2}$ in. each
United States Military Academy Library, West Point, New York

A comparison of these two drawings reveals the artist's use of Plains pictographic conventions to relay important information. In both works the artist has depicted sequential events (the lancing of two Sioux and then counting coup on two enemies) while revealing important information about the individuals depicted. He communicates sequential events by illustrating one victim being stabbed or touched with a lance and the Cheyenne warrior slaying or touching the second individual with another lance. The presence of two lances in both pictures does not indicate that the individual carried two lances; rather it suggests that a sequence of events has occurred. The mounted Cheyenne warrior in cat. no. 28 has just slain a Sioux woman and is in the process of killing the second woman with his lance. In the second drawing, an Elkhorn Scraper ("him'oweyuhk'is") lance-bearer who has just counted coup on a slain enemy is shown counting coup on the other.

The artist has also incorporated important information about the individuals involved. The mounted Cheyenne warrior in cat. no. 28, who has just slain the two hatchet-wielding Sioux women, wears several accoutrements signifying his status as a warrior. His horse, prepared for battle, has its tail tied up with a long piece of stroud cloth, and its notched ears indicate that it is a racing horse (Powell 1981:344). The value of the horse to its owner is indicated by the silver bridle and the presence of two eagle feathers attached to its mane, and an eagle feather fan inserted into its wrapped tail.

The Cheyenne warrior wears a military uniform probably obtained from a soldier. He carries an otter skin quiver and wears silver arm bands over his sleeves. Silver concha hair plates are attached to his scalp lock, while otter skin has been wrapped around his braids. Around his neck he wears a bone choker. One of the most significant details in this image is the bird, perhaps a kingfisher, attached to the top of the warrior's head as a medicine. The warrior wears this war medicine in hopes that the Sacred Being who appeared to him in a vision in the form of this bird will protect him and bestow the swiftness in combat of a kingfisher diving for its prey (Powell 1981:344).

In cat. no. 29, the artist again communicates important information about the individual through the accoutrements included. Here the Cheyenne warrior carries one of the two crooked lances of the Elkhorn Scrapers. These lances, wrapped with otter fur and clusters of eagle feathers attached along its length, were carried by the two bravest men of the society (Powell 1981:128). During battle, the lance would be used by its bearer to count coup on the enemy (Horse Capture 1992:235). In addition to the lance, he carries a feathered shield bearing symbols marking the four directions. The combination of the lance and the shield reveals his high rank within the society. The Elkhorn Scraper Society is one of six Cheyenne military societies responsible for policing buffalo hunts, settling disputes, maintaining social control, scouting, and fighting battles. They worked as a unit primarily during summer months when the whole tribe came together; members of the various Cheyenne bands would camp with their clans during the winter (Llewellyn and Hoebel 1941:110).

JV

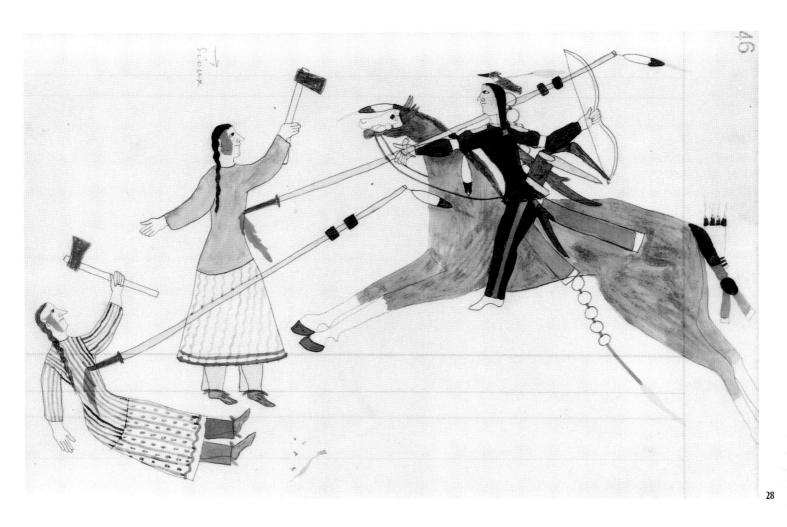

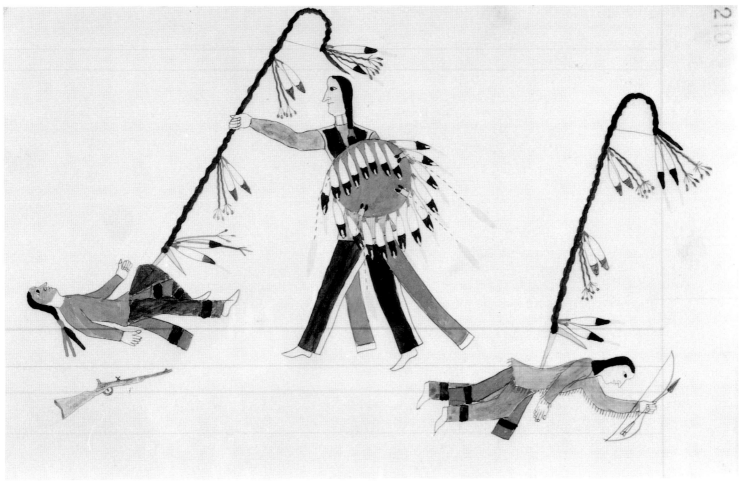

ARTIST UNKNOWN
30. A Meeting with Three Crows (148)
31. A Meeting with Two Crow Men and Two Women (54)
32. A Meeting with Three Crows (76)
1890s?
Watercolor, crayon, and pencil
7^{15}/$_{16}$ x 12^{1}/$_{2}$ in. each
United States Military Academy Library,
West Point, New York

These three drawings all illustrate the same subject: a Cheyenne leader in a friendly exchange with the Crow. Whether they refer to the same event is unclear; the presence of the protagonist in identical clothing and in the same location on each page, however, suggests that they do. The images do not appear in sequentially numbered pages in the ledger; rather, they appear on pages 148, 54, and 76, respectively. Certainly, the presence of the three similar drawings in several different locations in the ledger and the manner in which the Cheyenne figure is dressed signifies the importance of this event to the artists (the third drawing was done by two different artists).

The scenes depicted in this ledger feature pre-reservation ledger subject matter, which emphasized historical events and heroic military encounters, rather than scenes of everyday life, which dominate reservation drawings. The events depicted in the three drawings, however, more likely relate to post-reservation contact between the Cheyenne and Crow, who were long-time enemies. It was not until after the Crow and Northern Arapaho resided on adjoining reservations that the Cheyenne began to develop a friendly relationship with the Crow.

Each page has handwritten inscriptions, presumably added by the army officer who acquired them, Francis Pope. It is probable that the information was obtained from the artist or other Cheyenne familiar with the iconography in the works.

Landscape and groundline are absent, although it is easy to read the ledger column lines as groundlines. The artists focus on the events depicted. Emphasizing the distinguishing details in clothing and body painting, the artists reveal not only the importance of the individuals involved but the audience as well—that of other Plains Indians who would be familiar with tribal variations in dress and hairstyle and who were accustomed to "reading" such images.

In cat. no. 30, a Cheyenne leader, wearing a mountain-lion skin quiver, shakes hands with a Crow man carrying a hatchet. The presence of the two Crow carrying pipes and the handshake reveal that this is a peaceful exchange. In the scene, the protagonist in a calico shirt and a cloth vest wears a breast plate with a German silver pectoral ornament attached to the bottom. Otter fur, painted yellow to represent the sun, and red stroud cloth are wrapped around his braids. His face is painted with the sacred colors yellow and red. Wrapped around his waist is brown wool trade cloth with a white selvedge, underneath which he wears finely beaded blanket leggings and a red breechcloth. The Crow, shown with their characteristic long netted hair attachments (see cat. no. 117), all wear hair-fringed (and in the case of the two men carrying pipes, ermine-trimmed) shirts signifying their success as war leaders (Powell 1981:1120). The two Crows carrying pipes have striped Navajo blankets wrapped around their waists.

The same protagonist is shown again in cat. no. 31, but without the pectoral attached to his breastplate and without the red paint on his face. A bone choker has been added around his neck and he wears a yellow cloth shirt. He is again shaking hands with a Crow leader who here wears a red wool blanket with a richly beaded strip across it. The Crow leader is followed by another man and two women. The Crow men are again shown wearing richly beaded war shirts trimmed with ermine skins and hair. The Crow women wear bone chokers and stroud cloth dresses with dozens of elk's teeth attached to the yokes. These formal garments, worn during the last third of the nineteenth century, indicated the high status of the wearer (Penney 1992:178).

More than one artist worked on the third drawing (cat. no. 32). A comparison of the faces reveals the stylistic differences between the two hands at work here. The artist who has drawn the protagonist, the "Thick-jaw artist," is not as skilled as the other artist, whose work dominates this ledger. This is most evident when examining the treatment of faces and hands. The Thick-jaw artist has drawn the Cheyenne leader's left hand, while the ledger's primary artist drew the right hand that is shaking the Crow leader's hand. The Thick-jaw artist's rendering of the hand is quite rough and his figures are stiffer and less natural. Both artists, however, are concerned with communicating detailed information about the figures.

These drawings reveal a great deal about the styles of dress as well as the influence of trade on Plains adornment. The presence of Navajo blankets, shell gorgets, and trade cloth shirts illustrates intertribal trade as well as contact and trade with Euro-Americans. Because the blanket worn around the waist of the Crow woman in cat. no. 32 is fringed, it is not Navajo but most likely Mexican (the Navajo make continuous warp blankets, which do not have loose warp threads to form into fringe upon completion). Consequently, these three drawings not only depict a friendly exchange between the Cheyenne and Crow, but they also include valuable information about Plains life, customs, and long-distance trade.

JV

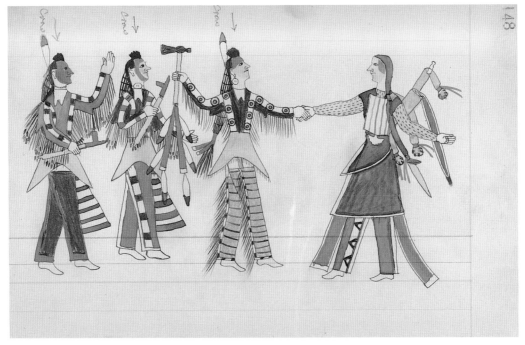

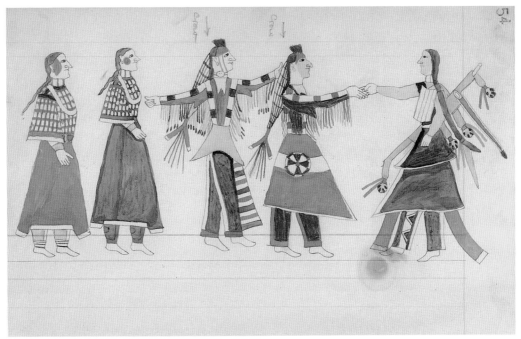

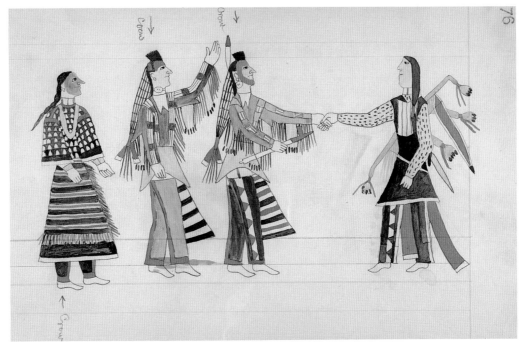

ARTIST UNKNOWN

33. A Cheyenne Warrior Confronts the
Pawnee (108)
1890s?
Watercolor, crayon, and pencil
$7^{15}/_{16}$ x $12^{1}/_{2}$ in.
United States Military Academy Library,
West Point, New York

In this drawing, a Cheyenne warrior is engaged with a number of Pawnee, identified by their characteristic flared-cuff moccasins, shaved heads, and red face painting. Horse tracks originate in the upper left, cross in front of the line of Pawnee and across the bottom of the page, and end in the lower right-hand corner behind the mounted Cheyenne warrior. The tracks indicate the path the Cheyenne has just taken. His horse received many wounds during the journey, but the Cheyenne warrior remained unharmed. Subsequently, he turned in preparation for a charge on the Pawnee line, carrying only a notched quirt and a lance, but the Pawnee fire on him with rifles and bows. One Pawnee, in the lower left-hand corner, steadies his rifle on a stand. Despite its many arrow and bullet wounds, the horse still carries its rider. (The notches in the Cheyenne horse's ears indicate that it was a race horse, which may be the reason it was chosen for the mission.)

Bravery in combat was highly valued in Plains culture. This drawing depicts a Cheyenne warrior's courage in the face of overwhelming odds. The fact that the protagonist is shown uninjured may indicate that he triumphed in this encounter, which would have ultimately raised his warrior status.

JV

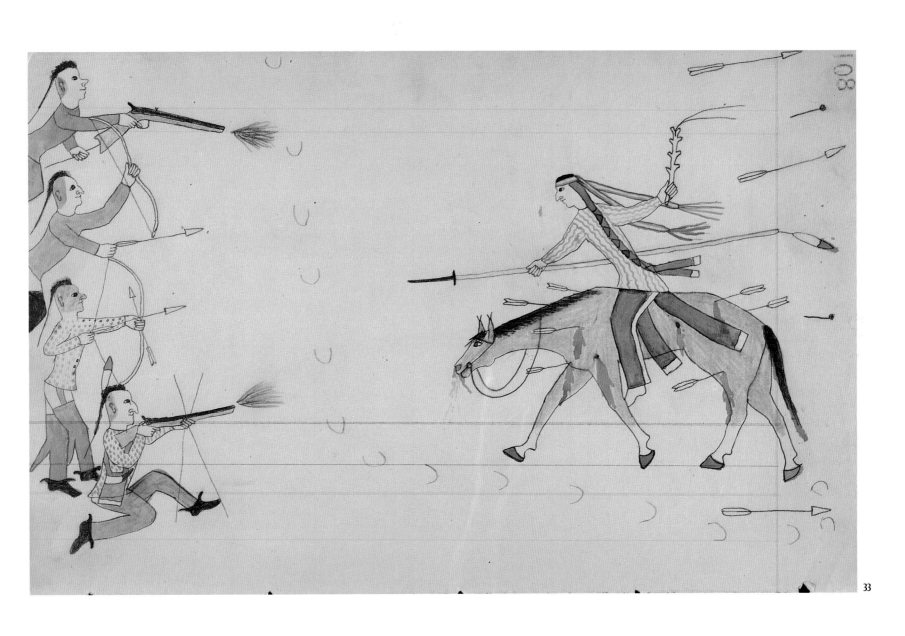

33

ARTIST UNKNOWN
34. A Cheyenne Warrior Counts Coup
on a Sioux Woman (62)
35. A Cheyenne Warrior Counts Coup on
Two Sioux Women (28)
36. A Crow Counts Coup on a Cheyenne
(122)
1890s?
Watercolor, crayon, and pencil
$7^{15}/_{16}$ x $12^{1}/_{2}$ in.
United States Military Academy Library,
West Point, New York

In ledger art, the protagonist depicted was not always the artist of the drawings, as many ledger artists recorded the deeds of their fellow tribesmen. An examination of the present three drawings reveals that this practice was employed in the Pope Ledger. Cat. nos. 34 and 35 were done by the ledger's primary artist, while cat. no. 36 was done by the Thick-jaw artist (see cat. no. 32). It is possible that the first artist depicted his own heroic acts, but given the proliferation in this ledger of different protagonists drawn by the same hand, there is no way to verify this theory. It is also unlikely that the protagonist is the Thick-jaw artist, given his secondary status in producing the drawings in this ledger. The artists in both cases, however, conveyed enough information in the details of the drawing that contemporary viewers would have been able to identify the protagonist.

In these drawings the Cheyenne warrior is seen counting coup and having coup counted on him. In the first two images, made by the ledger's primary artist, the Cheyenne warrior rides a horse painted yellow with sacred symbols painted in red on its flanks and legs. In addition, lightning bolts, a moon, and a dragonfly were painted on the horse's legs to give it swiftness and agility. The protagonist wears a long trail war bonnet and carries a shield.

Although the shields in the two drawings are not identical, the number of similarities suggest that they are meant to refer to the same individual. The shield in cat. no. 35 features a rainbow connecting the sun and moon symbols. A similar shield also appears in cat. no. 36. It has the same characteristic animal skin and eagle feathers affixed to the shield. Inspired by visions, shield designs were personal and quite individualistic. Consequently, they clearly identify their bearer and would have been well known to other members of the tribe.

In cat. no. 34, the Cheyenne warrior tries to count coup but the bold Sioux woman grasps his lance with both hands, challenging his attempt. Perhaps this unusual event was noteworthy enough to be recounted both in pictorial and in subsequent oral retellings of his war exploits. So in this instance the image testifies not only to the protagonist's courage but to that of his foe as well—the Sioux woman. The Sioux were longtime allies of the Cheyenne. Consequently, it is unusual to see them shown here as enemies. It is possible that the inscriptions in cat. no. 35 are incorrect.

Cat. no. 35 shows the protagonist counting coup with his quirt. The artist has employed a pictographic convention for portraying sequential events: the two quirts floating over the heads of the Sioux women represent one object that was used to count coup on both individuals. The Thick-jaw artist also employed this convention in

his rendering of a Cheyenne's encounter with a Crow in cat. no. 36. Here the protagonist's horse has been seriously wounded by rifle shots. The Cheyenne warrior has dismounted and begun to walk away from the fray. In the process, coup was counted on him by a Crow warrior. Bullets fly through the air but miss the protagonist, for the sacred power of his shield protects him. The large number of the Crow force is indicated by the line of carbines along the left edge of the page.

JV

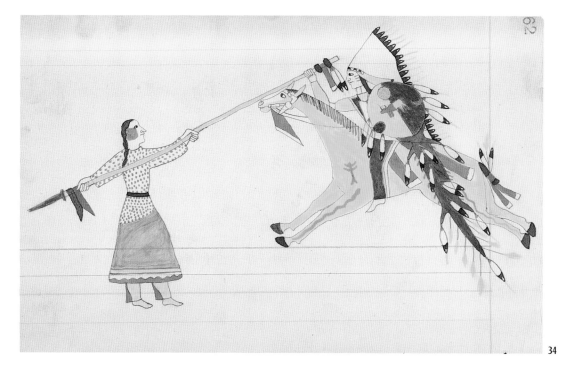

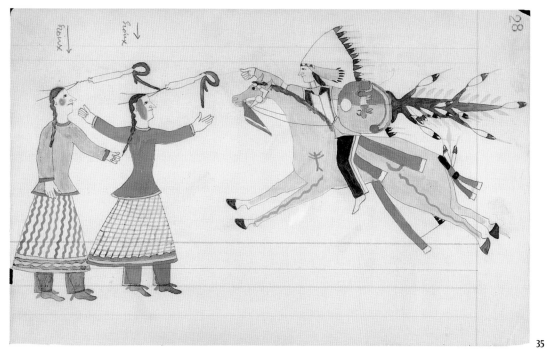

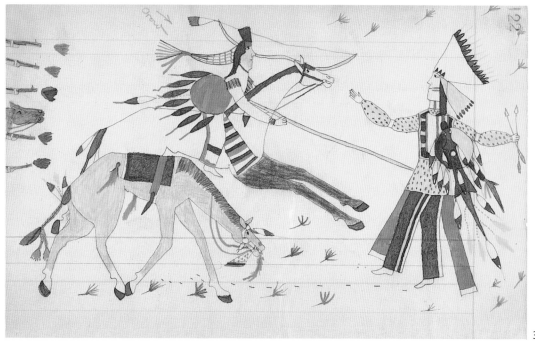

ARTIST UNKNOWN

37. A Crazy Dog Banner-Lance Bearer Is
Killed by the Crow (96)
1890s?
Watercolor, crayon, and pencil
$7^{15}/_{16}$ x $12^{1}/_{2}$ in.
United States Military Academy Library,
West Point, New York

Although the signing of the Friendship Treaty of 1825 by the Cheyenne with the United States marked the beginning of the division of the Cheyenne into Northern and Southern bands, the separation took place over the next fifty years (Svingen 1993:3). Despite the division, the Crazy Dog and Bowstring societies remained ceremonially connected, participating in the other's dances when visiting, and wearing the same paraphernalia. It is most likely that the banner-lance bearer depicted in this drawing is from the Northern Cheyenne, which would make him a Crazy Dog Society member. It is important to note that artists from both the Northern and Southern Cheyenne included in their drawings depictions of warriors from the other group. This complicates accurate identification of these banner-lance bearer figures (Powell 1981:138).

Banner lances were carried by the bravest members of both of these societies. The banner-lance bearer in this scene has just received two severe blows to the head from the Crow: one from a hatchet and another from the butt of a rifle. A third Crow warrior counts coup on the falling Cheyenne with his bow. The Cheyenne protagonist has fallen under the assault of a large enemy force, eight of whom are illustrated in this drawing. Three Crow are engaged in direct combat while the other five are seen at the right-hand edge of the page—four are represented by rifle alone and one from the waist up.

The artist has placed greater emphasis on the details of the Cheyenne's dress than that of the Crow. This reflects the artist's interest in identifying the protagonist and his valor to the viewers, other Cheyenne. The Cheyenne warrior wears leggings and a U.S. military tailored jacket (possibly appropriated by this warrior in a previous skirmish with U.S. troops). He carries a quiver and a shield. Around his neck he wears a bone choker and bandanna with a silver pectoral ornament. In addition to being struck on the head, the protagonist has been shot. His horse has also been shot, and is bleeding from the mouth and flank.

The Crow in this drawing are identified by handwritten inscriptions but are easily recognizable by their characteristic long netted hair extensions. They wear striped Navajo blankets around their waists, and one wears a shell gorget.

The artist has depicted a complicated combat scene in an effort to capture the intensity of the fray. He achieved this through the manipulation of the figures in this scene. The Cheyenne warrior falls head downward over the front of his horse, indicating the severity of the blows to his head. To give a sense of depth to the scene, and to illustrate the simultaneous attack, the three Crow overlap across the picture plane. While the maker of this drawing, the Thickjaw artist, is not the primary artist of this ledger, both he and his more skillful compatriot experimented with the visual representation of their subjects.

JV

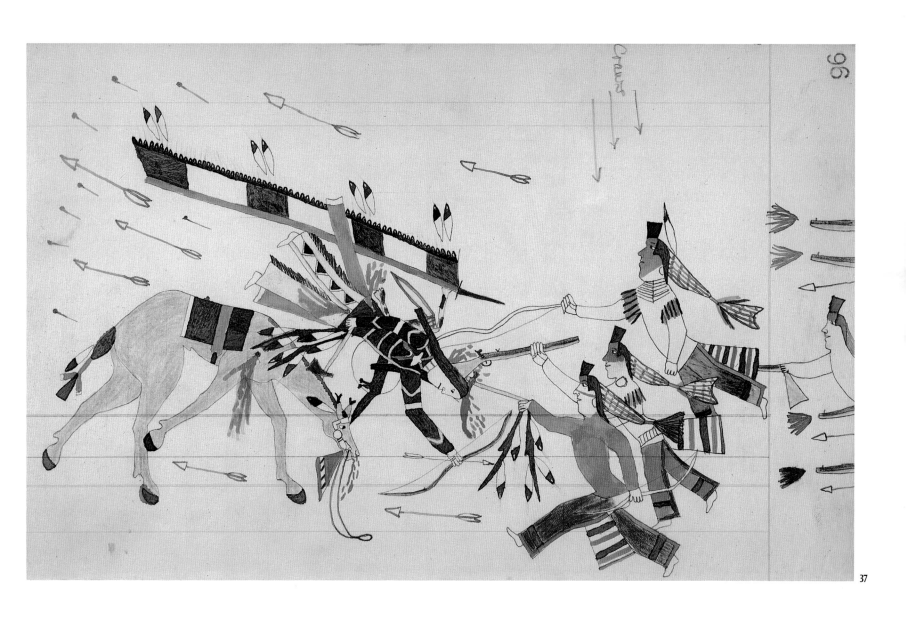

37

**Artist unknown
Wheeler Drawings
Cheyenne**

Catalogue Numbers 38–42

A set of six Cheyenne drawings in the collection of the Brooklyn Museum came from a scrapbook owned by Col. Homer W. Wheeler, a trader, rancher, and soldier on the Great Plains for nearly three decades, from 1868 to 1896. While the artist(s) of the Wheeler drawings remains unknown, a secure date is derived from the paper upon which they were drawn. Watermarked "Japanese Linen 1890" with an image of a crane, this fine paper was made by the Crane Paper Company of Massachusetts (Diana Fane, The Brooklyn Museum, personal communication, 1994).

In 1890 Wheeler was put in command of a troop of Indian Scouts at Fort Reno, Indian Territory. In 1892 he served briefly as Indian Agent at the Cheyenne-Arapaho Agency. He then went to Texas for four years before ultimately serving in Puerto Rico (Wheeler 1990:354–55). Since the paper in the drawings was manufactured in 1890, and Wheeler served most closely with Cheyenne scouts from 1890 to 1892, a date of 1890–92 seems secure.

An avid collector of Indian artifacts, Wheeler boasted, "At one time I had probably one of the largest individual collections of Indian curios in the world" (Wheeler 1990:221). He owned High Bull's Victory Roster (see cat. no. 47; Wheeler 1990:144–45, 221). Given the fine quality of the linen paper, Wheeler probably commissioned these drawings from one of his Cheyenne scouts and provided the paper himself.

JCB

ARTIST UNKNOWN
38. A Dog Soldier in Head-to-Head Combat
39. A Cheyenne Warrior Shoots an Enemy
1890–92
Ink and crayon
8¹⁄₂ x 14 in., 7¹⁄₄ x 12¹⁄₂ in.
The Brooklyn Museum, New York,
1992.27.4, Anonymous Gift;
1992.76.3, A. Augustus Healy Fund

A number of Plains groups, including the Cheyenne and Lakota, had a military organization known as the Dog Soldiers. Members of this group were highly disciplined and extremely brave warriors. The bravest were the "sash wearers," those few leaders selected to wear an unusual item of warrior garb. Originally a slit animal skin, by the late nineteenth century it usually was a red cloth sash, split into two tails adorned with feathers. It was worn over one shoulder and could be staked to the ground so that the wearer would have to fight to his death rather than retreat in battle (Grinnell 1972, v.2:63–72).

The horseman on the left in cat. no. 38 is a sash wearer of the Cheyenne Dog Soldiers. He carries a long banner lance emblazoned with scores of feathers. In this scene, the sash wearer uses his banner lance to stab an enemy horseman. The artist has drawn a striking visual arrangement: not only are the two warriors in conflict, but their horses are in head-to-head combat as well.

Another scene of warfare shows high-ranking Cheyenne warriors engaged in battle against an opponent on foot. The mounted Cheyenne warrior wears a fine eagle feather headdress and carries a shield painted with protective medicine symbols. The headdress is the unusual and powerful one-horn war bonnet. The cloth tab at the bottom of the feather trailer is painted with two dragonfly emblems. To dart like the nimble dragonfly through the path of the enemy, untouched by his arrows and bullets, was the aim of every warrior.

JCB

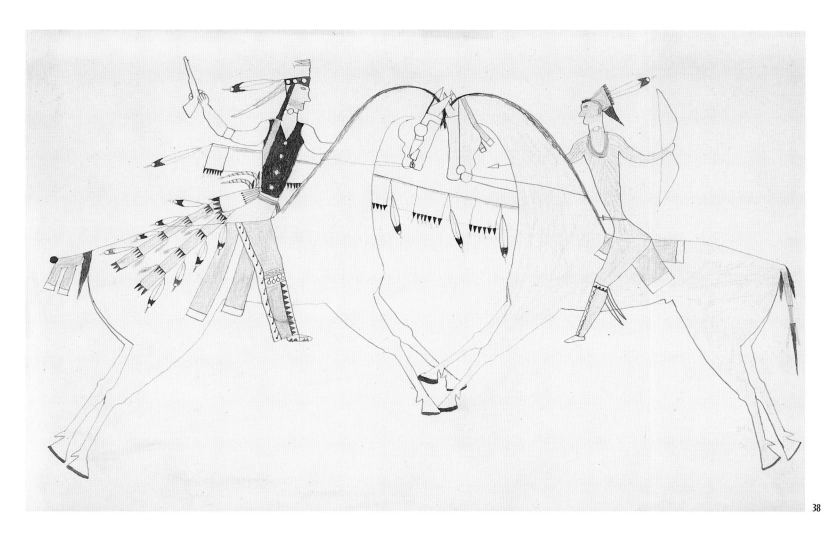

38

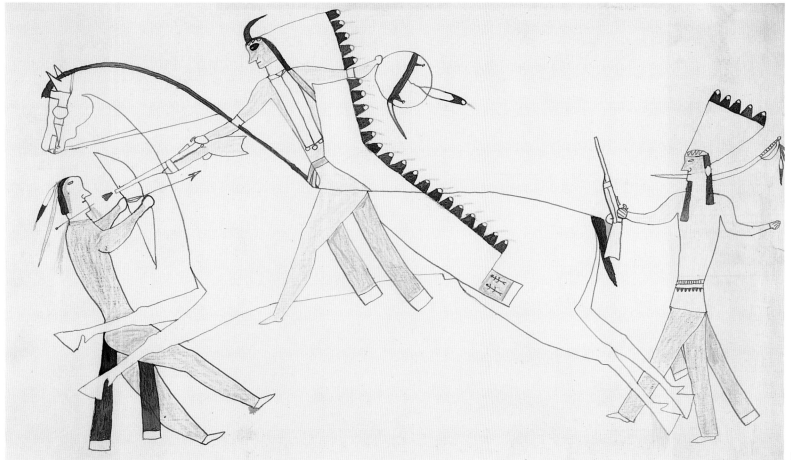

39

ARTIST UNKNOWN
40. Cheyenne Warrior Killing a Wagoneer
41. Cheyenne Warrior Killing a Mexican
42. Army Soldiers Kill a Crooked Lance
Bearer and His Horse
1890–92
Ink and crayon
$6^7/_8$ x $13^3/_8$ in., $6^7/_8$ x $13^3/_4$ in., $8^1/_2$ x 14 in.
The Brooklyn Museum, New York, 1992.27.1,
.2, Gift of the Roebling Society; 1992.27.3,
Gift of the Roebling Society and A. Augustus
Healy Fund

In each of these drawings, the enemy is
the white man, whose encroachments on
Cheyenne territory took many different
forms. In cat. no. 40, a Cheyenne warrior
sinks a hatchet into the forehead of a wag-
oneer. These men moved goods across the
countryside, supplying army troops during
their incursions. The artist shows his
wagon, at a reduced scale in the lower left.

In cat. no. 42, five U.S. Army soldiers
armed with sabers and Springfield carbines
fire upon a distinguished Cheyenne warrior.
He lies on the ground, with blood bubbling
from his mouth, shoulder, and belly. He
clutches his gun in his left hand, but his
fur-wrapped crooked lance has fallen from
his right hand. The lance marks him as
one of the bravest of the Elkhorn Scraper
Society warriors (Powell 1981:128). His
horse staggers as well, having taken at least
three bullets. While ledger art more often
celebrates victory than defeat, this portrait
of a fallen leader memorializes a warrior's
bravery when outnumbered and outgunned.

In cat. no. 41, a Cheyenne warrior in a
striped trade cloth shirt and Army pants
counts coup or lances a white man, who
tumbles off his horse. The white man's stir-
rups are Mexican-style *tapaderos*, which
encase the entire foot. This detail may indi-
cate an attack on a Mexican trader, or a
skirmish far to the south.

All of the Wheeler drawings have a styl-
ized quality. While the artistic conventions
are those of the 1870s, the line is studied
and controlled; it is as if the deliberate rep-
etition of these older norms has resulted in
a kind of archaizing style lacking the vigor
and intensity of earlier Cheyenne drawings
(see cat. nos. 18–20).

JCB

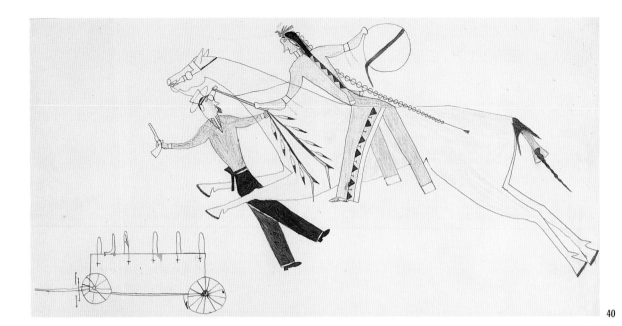

40

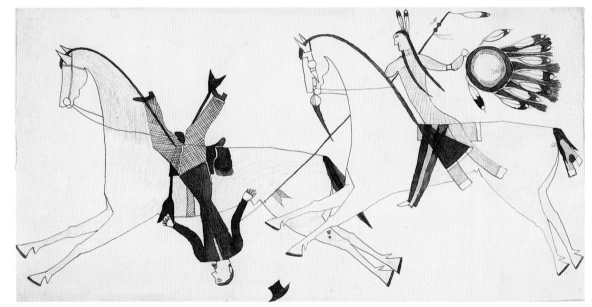

41

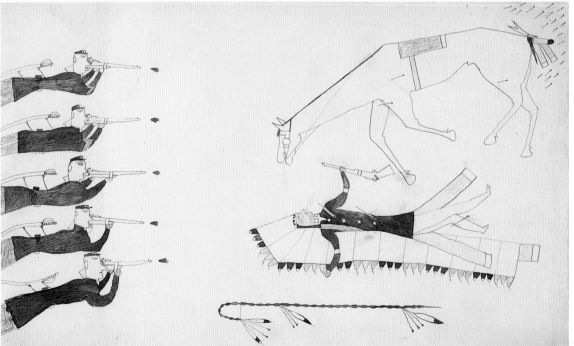

42

Bear's Heart
(1851–1882)
Cheyenne

Catalogue Numbers 43–45

Bear's Heart was one of the most accomplished of the Fort Marion artists, the range of his talent being particularly evident in his book in the collection of the National Museum of the American Indian, an unpublished book on loan to the Minneapolis Institute of Arts, and the multiple artist book to which he contributed, at the Massachusetts Historical Society.

Bear's Heart was especially adept at small-scale pictures of numerous figures; he routinely drew scenes populated by dozens of people. He was also intensely interested in depicting the unusual experiences of the Fort Marion men. Most of his drawings take as their subject the trip from Oklahoma Territory to Florida and the dramatically different world he encountered during his six years away from his Cheyenne homeland.

After three years in prison at Fort Marion, Bear's Heart spent another three years in the East, studying at the Hampton Institute in Virginia. Bear's Heart returned to the Cheyenne-Arapaho Agency in Oklahoma in 1881, eager, as he declared in a public speech, to teach his "mother and sister to work house, and I and brother to work farm" (Petersen 1971:101). Unfortunately, he died at the Agency of tuberculosis just a few months later.

JCB

BEAR'S HEART
43. Troops Amassed Against a Cheyenne Village (34, 35) (Heap of Birds, pl. 1 [p. 67])
1876–77
Pencil and ink
8 x 12⁷/₈ in.
Massachusetts Historical Society, Boston

This book, completed by mid-1877, contains drawings by at least seven of the Fort Marion artists, including particularly notable works by Bear's Heart and Making Medicine. In the back of the book is a handwritten roll-call of prisoners compiled by Making Medicine, as well as an inscription stating: "the Indian prisoners who made these pictures at Fort Marion, St. Augustine, have been there about two years, and had been taught to write, but had not been instructed in drawing." The book was in the personal collection of Francis Parkman (1823–1893), the distinguished historian, who had a great interest in Native American history. There is no evidence that Parkman visited Fort Marion while the Southern Plains prisoners were there, though he did visit St. Augustine in 1885 (Farnham 1900:37). It is noteworthy, however, that Fort Marion artist Howling Wolf spent the second half of 1877 being treated for vision problems at the same hospital in Boston frequented by Parkman, and vacationing with Parkman in western Massachusetts (see cat. no. 55). Perhaps Capt. Pratt, the warden at Fort Marion prison, sent the drawing book north with Howling Wolf as a gift for the eminent scholar. Such books were commonly circulated as gifts among people interested in Indian rights and education (see cat. no. 45).

The small sketchbook contains some twenty-eight drawings in both horizontal and vertical format. Some fill only one page while others, like cat. no. 43, are drawn across two pages. Here, Bear's Heart presents a compelling panorama, contrasting Cheyenne and U.S. soldiers in armed conflict. The white soldiers stand in ramrod-straight profile formation, their horses similarly lined up behind them. Bear's Heart has meticulously shown scores of these figures, and enumerated the troops in Arabic numbers below each column. The white soldiers present an image that is both monolithic and monochromatic, in their blue pants, gray jackets, and rifles on their shoulders—a vivid contrast with the individuality of appearance of the autonomous Cheyenne warriors, who defend their camp with rifles and bows and arrows.

While many books drawn for sale at Fort Marion show the surrender and incarceration of the Fort Marion warriors themselves (see, for example, Etahdleuh Doanmoe's and Zotom's drawings, cat. nos. 79–88, 102–105), very few depict armed conflict between Indians and whites. Perhaps the topic was considered inappropriate in images made for sale to whites. Instead, Fort Marion artists most often depicted their bravery in feats of intertribal warfare or big-game hunting (see cat. nos. 63, 68).

Yet in this very unusual image, Bear's Heart may be representing a particular historical moment in Cheyenne-white conflict, as Howling Wolf sometimes did (see cat. nos. 50, 55). One of the most heinous events on the Southern Plains was the Sand Creek Massacre, on November 29, 1864. Col. John M. Chivington marched over seven hundred men from the First and Third Colorado Cavalry into a large Cheyenne village, slaughtering many of its inhabitants, despite the fact that Chief Black Kettle, who had made many peaceful overtures to whites, waved both a U.S. flag

and a white flag of surrender above his tipi. George Nelson Miles, who served in the western military forces from 1869 to 1890, called the Sand Creek Massacre "the foulest and most unjustifiable crime in the annals of America" (1896:139).

If this drawing depicts the Sand Creek Massacre, it is the beginning stages of the attack, when Cheyenne soldiers, although grossly outnumbered, were bravely advancing toward the cavalry while women and children tried to make their escape, at right. While reports of the number of Cheyenne killed vary from 137 to six hundred (Berthrong 1963:217–20), it was widely agreed that most of those were women and children. Soldiers of the Colorado Cavalry scalped and horribly mutilated the bodies of the dead, taking body parts back to display in Denver as grisly trophies of their campaign. The lodges were plundered and burned.

If, indeed, Bear's Heart has been bold enough to commemorate the Sand Creek Massacre here, he has done so in such a way that the real meaning of the horrendous event would be masked from the eyes of the white audience.

JCB

BEAR'S HEART
44. *Cheyenne Among the Buffalo*
45. *Bishop Whipple Talking to Prisoners*
1876
Ink and colored pencil
8¼ x 11¼ in. each
National Museum of the American Indian,
Smithsonian Institution, 20/6231

Almost all of the Fort Marion drawing books confront, in one way or another, the topic of the transformation of the lives of the men of the Southern Plains since their incarceration in 1875. Many books contrast images of the life of a free warrior or hunter on the prairie with scenes of the U.S. army's military discipline, as in these two drawings. The contrasts are indicated not only through iconographic means, but also through a careful rendering of the differing spatial realities of the two cultures. These Aboriginal artists observed and reported pictorially how order, symmetry, regularity, and conformity were highly valued in the white world. Artists documented the rectangular ordering of buildings at Fort Sill, the rigorous formations of military troops (see cat. no. 43), and the discipline imposed on the artists themselves by the wearing of uniforms, the shearing of their long braids, the classroom lessons (see cat. no. 56), and Christian missionizing.

One of the regular visitors to Fort Marion was Rev. Henry B. Whipple, Episcopal Bishop of Minnesota, who was a national leader in the struggle for Indian rights and reform. In cat. no. 45, Bear's Heart has shown Bishop Whipple in a frontal pose, gesturing with arms outstretched. He looks at Capt. Pratt and another man, almost certainly George Fox, the interpreter. Sixty-two prisoners sit in three rows on benches, facing the bishop; these were the same men who, some eighteen months before, had been living the life shown in the other drawing—riding horses on the Plains and hunting buffalo.

Bishop Whipple was an enthusiastic patron of the graphic arts at Fort Marion. In his letters to Pratt he often requested additional drawing books, which he gave as gifts and undoubtedly used as proof of the power of education and proselytizing in solving "the Indian problem." On March 15, 1876, Whipple wrote to Pratt from Minnesota, "Send me one more copybook of Indian drawings and some photos of the Indians." Pratt replied that the artists sent the book without cost. On July 26, 1876, Pratt wrote to his friend the bishop that "they seldom make a drawing book now without putting you in. The Bishop talking to them, the classes and teacher and their lives as soldiers are three staple pictures. Several good books are in progress. Will send one when done" (Whipple n.d.).

In November 1876, Whipple requested five more drawing books, for which he was charged two dollars apiece. Perhaps it was one of those books that he gave to his friend Jared Daniels, M.D., who served as an Indian Agent among the Sioux. Karen Daniels Petersen's family's ownership of her great-uncle's book sparked her interest in researching the warrior-artists at Fort Marion (Petersen, personal communication, 1995), and the result was a legacy of superb publications on the topic (Petersen 1968; 1971).

Many notable figures of late nineteenth-century American history owned Fort Marion drawing books. The National Museum of the American Indian book discussed here was presented to Gen. William Sherman, commander of the Army in November 1876, on an inspection tour of the fort (Supree 1977:5). It was to Sherman that Pratt addressed his pleas for the exoneration and further education of the prisoners. As a result some of them were sent to the Hampton Institute, a school for freed African-American slaves, and an Indian school was established at Carlisle Barracks in Pennsylvania (Pratt 1964:173).

JCB

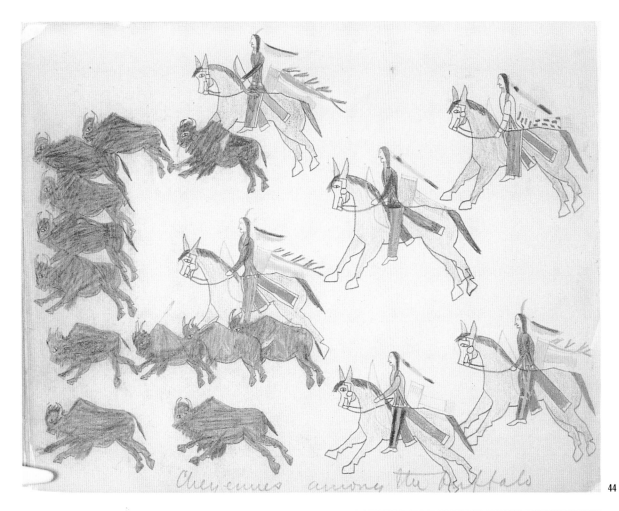

Cheyennes among the Buffalo

44

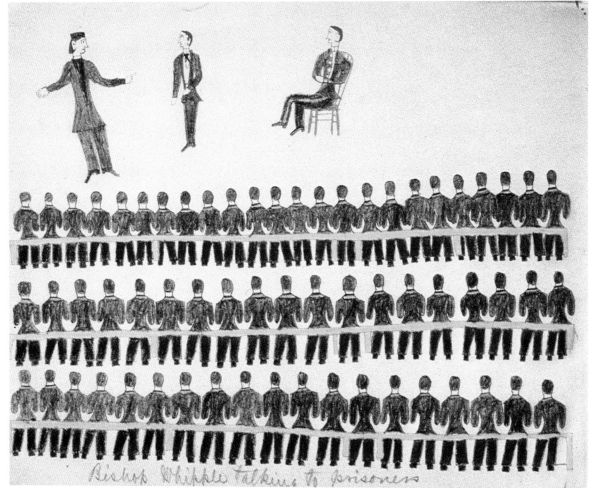

Bishop Whipple talking to prisoners

45

Chief Killer
(1849–1922)
Cheyenne

Catalogue Number 46

Like most of the books produced at Fort Marion, Chief Killer's book contains drawings with subject matter ranging from buffalo hunting on horseback, to Cheyenne social and ceremonial life, to landscapes and cityscapes. This one is unusual in one respect, however. It is one of very few unfinished books that have survived from Fort Marion.

Many of the Fort Marion books are inscribed with the signatures of the artists. Moreover, usually the drawings have captions provided by Richard Pratt, their jailer, or George Fox, the interpreter at the prison. This book was drawn in 1877, by which time the production of these works was a veritable industry. Yet it has no captions, presumably because it was sold before it was finished. Inside the front cover is written "Drawings by Indians on the Reservation in St. Augustine, Florida, March 1877." The name "Cheif Killer" (sic) is written in a different hand on the last page.

On stylistic grounds, Joyce Szabo has attributed all of these drawings to Chief Killer (Szabo 1994a). Aside from this book, very few works by Chief Killer are known; he apparently was not one of the more prolific of the Fort Marion artists. After his release from prison in 1878, Chief Killer returned to the reservation, where he worked as a butcher, policeman, and teamster (Petersen 1971:234).

JCB

CHIEF KILLER
46. Cheyenne Military Society Members
1877
Pencil
8¼ x 11¼ in.
Anne S. K. Brown Military Collection, Brown University Library, Providence, Rhode Island

Of the sixteen drawings in the book, about half are unfinished. This fact has interesting implications for the habits of artistic production at Fort Marion. If all of the drawings are by Chief Killer (and the pages illustrated here are clearly by the same hand as the one page with his signature), it is noteworthy that he apparently worked on numerous drawings at once.

Edwin Wade's study of a Fort Marion drawing book by Zotom (see the essay by Wade and Rand, fig. 1 [p. 47], and Wade n.d.) demonstrates that Zotom drew postage-stamp sized sketches in an upper corner of the page, indicating what he intended to draw on that page. In the Chief Killer book, by contrast, whole pages are sketched out in pencil, and then the details of subject matter are painstakingly added in stages and colored in. Even a completely colored-in landscape replete with architecture and human figures might still be lacking some details on one small house, for example.

On the two pages illustrated here, Chief Killer has drawn a procession of members of a Cheyenne men's military society. The artist clearly intended both pages to be viewed as one scene, despite the fact that the book has tissue paper bound between the pages. (In all of the other drawings, only the left-hand page of the open book is utilized.)

Like most Plains groups, the Cheyenne had several warrior societies, among them the Kit Fox Society, the Elkhorn Scrapers, and the Dog Soldiers. In this drawing, the warrior society members march two by two, carrying the long feathered lances that are the insignia of their membership in the society. At the front, the leader on horseback wears a full eagle feather headdress that trails down his back. His horse has a human scalp—emblematic of a successful war raid—tied to his bridle bit.

Some of the foot soldiers wear leggings and breech cloths made of red trade cloth. Even the white selvedges of the cloth are carefully delineated. Other men wear yellow buckskin leggings. The mounted warrior at the right side of the left page wears a buckskin war shirt with black and white beadwork, a type of shirt that appears in other Cheyenne ledger drawings (see cat. no. 19). The mounted warrior also wears an upright feather headdress, characteristic of the Dog Soldiers, which lacks the cascade of feathers down the back. The artist has delicately demarcated the downy red feathers glued to the tips of the eagle feathers.

On the next page, Chief Killer began by rendering the whole scene in pencil, and would then have proceeded to color vividly. He carefully drew four more pairs of marching soldiers, and a horseman at the rear, who matches the one at the front of the procession. Since Chief Killer intended to fill in the mounted figure at the extreme right with colored pencil or ink, it did not matter that he drew the outlines of the human figure right over the outline of the horse. His method stands in contrast to that of some other Cheyenne graphic artists. In some unfinished drawings, for example, the artist would carefully leave a gap in his contour drawing of the horse, so that he might insert the figure of the rider with few overlapping lines.

JCB

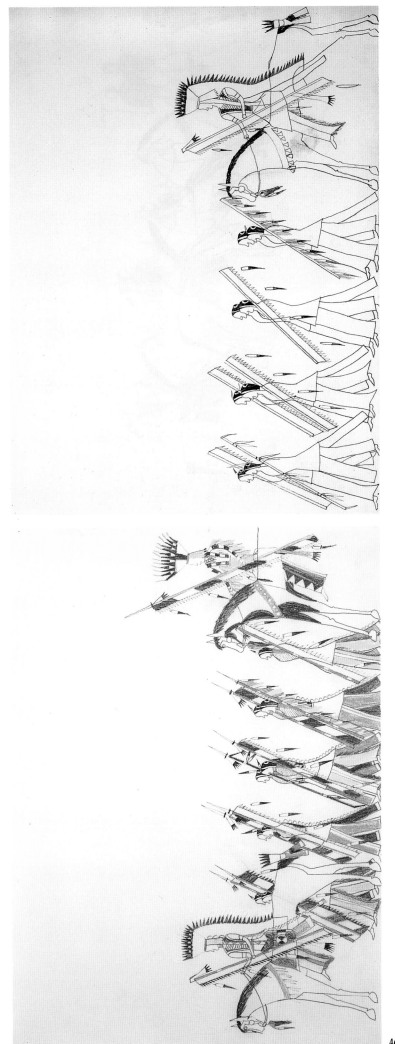

High Bull
(?–1876)
Cheyenne

Catalogue Number 47

Little is known of the life of Cheyenne warrior High Bull, who died in Col. Mackenzie's raid on Dull Knife's village on November 26, 1876. He probably fought in the Battle of Little Big Horn, for the small memorandum book in which he drew scenes of Cheyenne warrior history belonged to First Sergeant Brown of G Troop of the Seventh Cavalry, who died in that battle on June 25, 1876. High Bull may have taken it from Brown's body as one of the spoils of war, and he drew his many historical images in it.

The book was recaptured by white soldiers in Col. Mackenzie's raid in November of the same year. All of the property of the Cheyenne village was either destroyed or looted, and many Cheyenne were killed. Homer Wheeler (see cat. nos. 38–42) was among the troops and described the burning of hundreds of tipis and their contents, the destruction of the stores of food for the upcoming winter, and the killing of horses. This wholesale destruction left the survivors unprepared for winter. In the village the soldiers found much evidence of this band's participation in the Battle of Little Big Horn: Army horsegear and horses with U.S. brands on them, flags, clothes, wallets with money, letters stamped and ready to be sent to loved ones back East (Wheeler 1990:142–47; Powell 1975b).

Old Bear, an elderly Cheyenne to whom George Bird Grinnell showed this ledger book in 1898, identified the book as belonging to and having been drawn in by High Bull, and illustrating High Bull and his cohorts fighting the Crow and Shoshone. Some drawings detail the exploits of other Cheyenne warriors, including White Elk, Crazy Wolf, Weasel Bear, Little Sun, and Yellow Nose (Grinnell n.d.:1–4; see also Powell 1975).

JCB

HIGH BULL
47. Little Sun Counts Coup on Two Shoshone (38)
1876
Pencil and colored pencil
10 x 7½ in.
National Museum of the American Indian, Smithsonian Institution, 10.8725.38

Like a mirror image of the Fort Marion drawing books, which record pictorially the journey that Southern Plains warriors made to the East in 1875, High Bull's Victory Roster started out as a memo book belonging to Sgt. Brown, a member of the Seventh Cavalry, who recorded in it the journey that he and his troop made west and north from Louisiana to Fort Lincoln, Dakota Territory, in 1876. It chronicles their stable duty and police duty, their marksmanship records, lists of horse equipment, and other small traces of the daily life of a military troop. Sgt. Brown's use of the book was brief: April 19 to June 24, 1876. His last entry reads: "McEagan lost his carbine on the march while on duty with pack train, June 24, 1876." The next day, these men would lose their lives in the last great military victory for Cheyenne and Lakota warriors, who wiped out Custer and his troops at Little Big Horn. The Native American victors took souvenirs from the bodies of the soldiers, just as white soldiers did in raids on Indian camps. High Bull took this book, and over the next five months he inscribed his history over the mundane lists and rosters inscribed by Sgt. Brown.

In the image illustrated, page 38 of the book, High Bull has drawn a Cheyenne who has dismounted his horse to count coup on two enemies with his banner lance. According to the notes of George Bird Grinnell, who brought the ledger back to Montana in 1898 to show to his Indian friends, Old Bear reported that "page 38 shows a warrior named Little Sun, counting coup on two Shoshone who were entrenched behind breastworks. He has stopped his horse, dismounted, thrown down the sabre which he was carrying, and rushed up to the breastworks to strike his enemy with the lance" (Grinnell n.d.:3).

The text that underlies the image provides an unintentional layer of irony. Sgt. Brown had been recording the names of the best shots in Company G, men whose marksmanship skills did not, however, save them at Little Big Horn. Moreover, the drawing shows that Little Sun is impervious to the bullets of his enemies' pistols as he advances upon them.

Some twenty-two drawings exist in the book today. Many pages had been torn out sometime between High Bull's use of it and its return visit to the Cheyenne in 1898, for Grinnell reported that Old Bear "recognized the book as soon as it was handed to him, and professed great indignation that many of the pictures had been taken out of it. It was once much larger, he says" (Grinnell n.d.:cover letter).

JCB

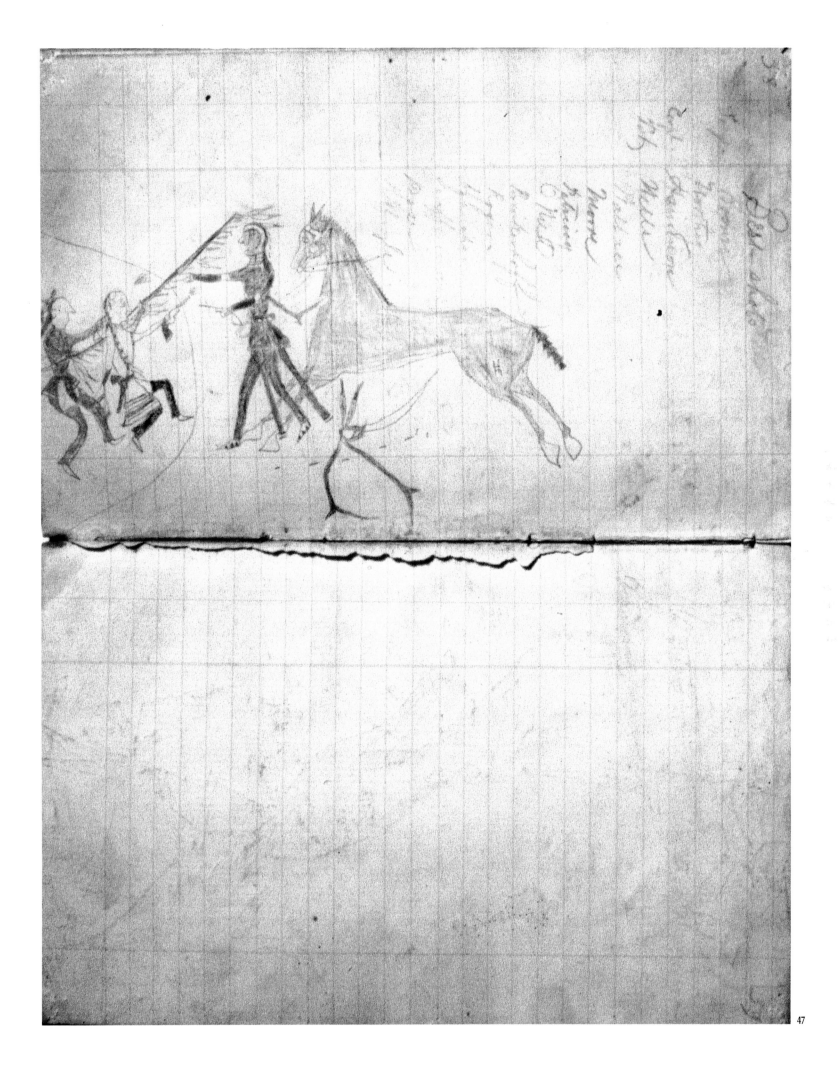

Howling Wolf
(1849–1927)
Cheyenne

Catalogue Numbers 48–56

Howling Wolf holds a singularly important position in the history of nineteenth-century art. He is the only Plains artist currently known to have created ledger drawings in all three phases of that art form: before the reservation era, during his prison exile at Fort Marion, and following his return to the reservation. As such, his work has been the subject of extensive study (Petersen 1968, 1971:221–24; Szabo 1994c, 1992, 1984).

Like most young Cheyenne warriors of the 1860s and 1870s, Howling Wolf fought continually to preserve his people's way of life. Both Howling Wolf and his father, Eagle Head, were members of the Bowstring Society, one of the four fraternal warrior associations of the Southern Cheyenne people (Mooney n.d.:38a–38; Petersen 1964). By the 1870s, the Bowstrings were the strongest proponents of war within Southern Cheyenne society (Hyde 1967:357–58).

Howling Wolf rose within the ranks of his warrior society, counting his initial coup in 1867 (Mooney n.d.:38a–38; Hyde 1967:270). His reputation for bravery grew as he became a headman in his warrior society and a leader in Cheyenne ceremonies (Szabo 1994c:177–83).

Both Howling Wolf and his father were among those seventy-two captives sent to Fort Marion, where they were held as prisoners of war from May 1875 to April 1878. Capt. Richard H. Pratt appointed Howling Wolf one of the sergeants of the prison guard, the Southern Cheyenne's leadership probably established with his fellow exiles by his pre–Fort Marion status as a warrior society leader (Szabo 1992:9; Petersen 1968:22). The many drawings that Howling Wolf created during his Florida imprisonment also suggest his leadership as an artist. Throughout his Fort Marion art, Howling Wolf experimented widely with the new materials readily available to him. Two aesthetic concerns, however, dominate his work: the investigation of different ways of suggesting space, and the patterning of line, shape, and color into bold abstractions.

By April 1876, Howling Wolf's failing eyesight was a cause for concern. Pratt ultimately obtained support to send the Southern Cheyenne artist to Boston for treatment at the Massachusetts Eye and Ear Infirmary (Szabo 1991a; Anonymous 1970). Howling Wolf left St. Augustine for Boston in July 1877 and did not return to Florida until December of that year. The Southern Cheyenne visitor became something of a social celebrity during his six months in New England, even vacationing in the Berkshire Mountains with noted historian Francis Parkman (Anonymous 1970:4–6; Snyder, personal communication, 1983).

Howling Wolf came home to the Plains in April 1878 and turned his attention to the new demands of that life. Only one book of twelve drawings has been dated to the era following his return to Indian Territory in present-day Oklahoma (Petersen 1968; Szabo 1994c:131–32). The warrior-artist's later years were spent enmeshed in the constant struggle of reservation existence. He died in an automobile accident at the age of seventy-seven.

JMS

HOWLING WOLF
48. Cheyenne Village Scene: Women's Work
September 1876
Pencil, crayon, and ink
8$\frac{3}{4}$ x 11$\frac{1}{4}$ in. each
New York State Library, Albany, 672

Purchased by the New York State Library in 1912, the Albany book includes eighteen drawings by Howling Wolf. According to a sales notice kept with the book, the drawings were acquired from Howling Wolf in September 1876 at Fort Marion. Howling Wolf was the artist of the eighteen drawings that appear on one side of each unlined page within the book.

Throughout his Fort Marion works, Howling Wolf repeatedly experimented with ways of illustrating more fully the life he knew on the Plains. Many of his images relate specific events, such as warrior society gatherings or communal village celebrations. Others, such as cat. nos. 48 and 49, explore the variety of activities that might be going on within a village at any one time. Many different people engage in the myriad pursuits that filled the life from which Howling Wolf and his fellow inmates were exiled (Grinnell 1972, v. 1:63–70). In recording this diversity, Howling Wolf again expanded his manner of representing space by experimenting with layers or tiers of action.

In this drawing, Howling Wolf presented a multitude of activities. Three women in the upper tier use elk horn scrapers to remove the fatty layer from hides stretched on the ground. Another woman, to the far right, is cutting meat to dry on the rack above her. Two other women hold objects of special dress for the men who appear in front of them: one holds a saber, complete with what are probably otter fur trailers, and the other a stroud blanket with a beaded blanket strip. A man to the upper right physically overlaps a lodge while he smokes, the red catlinite bowl of his pipe readily distinguishable. The lower level of figures includes one woman reaching for a pail suspended from a pole near her lodge while a larger group of men sit under a sunshade formed by brightly patterned textiles.

Many of the Fort Marion artists recorded what can easily be seen as nostalgic views of the life from which they were exiled. Various village genre scenes exist, but most are limited in the number of figures and actions portrayed. Howling Wolf's drawing differs markedly in the variety of activities illustrated as well as in its largely unparalleled depiction of a multitude of women's occupations. Ledger art produced on the Plains had been an art form created by warriors who had won the right to portray their brave actions in battle. Both the

artists and the subject matter of ledger art in the pre–Fort Marion era were decidedly male. That Howling Wolf has presented with such detail the activities of Cheyenne women suggests that his art in Florida expanded not only the basic subject matter and stylistic tenets of Plains representational imagery but also began to present more diverse aspects of Plains life. The Albany drawing book focuses attention on women in a way unequaled in the artist's other work or in that of other ledger artists currently known.

JMS

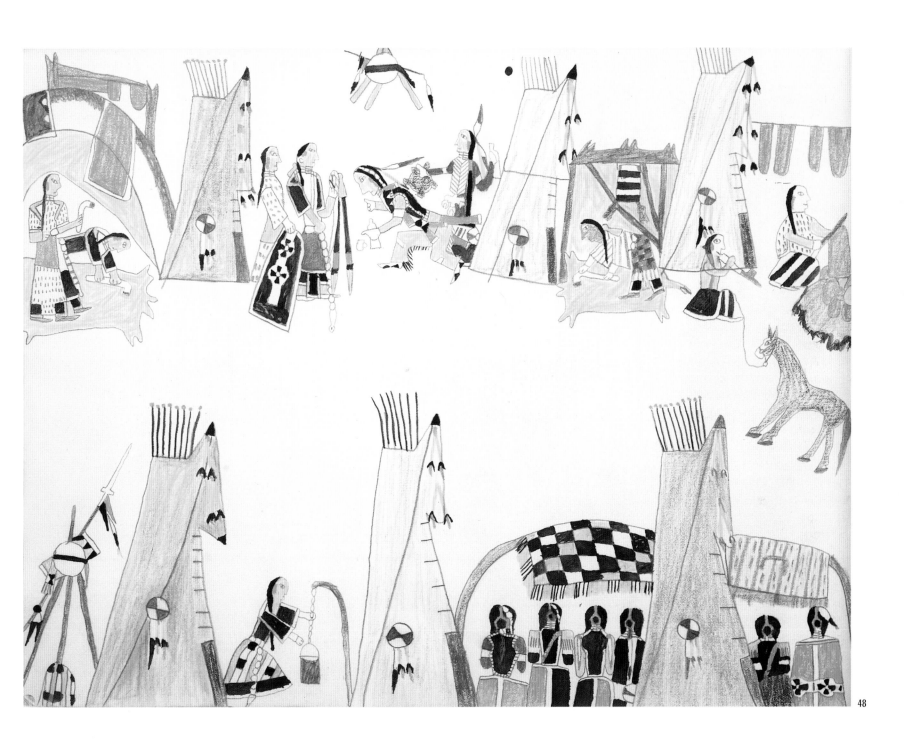

HOWLING WOLF
49. Cheyenne Village Scene: Women's
Ceremony with Large Hide
September 1876
Pencil, crayon, and ink
8¾ x 11¼ in.
New York State Library, Albany, 672

Once again Howling Wolf focused his attention on activities in which Cheyenne women played central roles. A great number of women have gathered around a hide, enlarged in scale perhaps to suggest its cultural importance. As previously noted (Furst and Furst 1982:200–1), the women may be taking part in the communal beading or quilling of the hide. The majority of the figures presented frontally or in profile hold linear forms that may be pieces of sinew or thread. At least four men are here as well, two near the middle of the upper register of figures, the feathers in their hair and the hair pipes of their breastplates differentiating them from the women to their sides. Another man stands at the bottom of the page, his breechcloth apparent; a fourth is kneeling or squatting to the lower left, his head and torso wrapped in a blanket but the red panels of his breechcloth visible. Again, Howling Wolf has detailed vibrant textiles as they form the sunshades and clothing of participants. Mexican, Navajo, and trade cloth blankets with beaded blanket strips create the colorful setting for this ceremony.

The Southern Cheyenne society of quill and beadworkers was a woman's society comprised of honored women who were the best artists in these techniques (Marriott 1956; Grinnell 1972, v.1:159–69). The women's society was as vital to Cheyenne life as the men's warrior societies were. The scene depicted here may well be a gathering of the members of that society either to jointly embellish the robe around which they stand or to celebrate the beginning or the successful completion of such work by members of their society. While men were generally not part of the membership's activities, several warriors did play important roles in recounting their war deeds and counting coup on the embellished work or in removing quills placed incorrectly during the sewing process.

Howling Wolf has used this subject, thus far unique in ledger art, as another opportunity to expand his studies of space and composition. His experimentation with foreshortening of human faces increased during the Fort Marion tenure as he explored the placement of figures in various postures and physical relationships to each other.

JMS

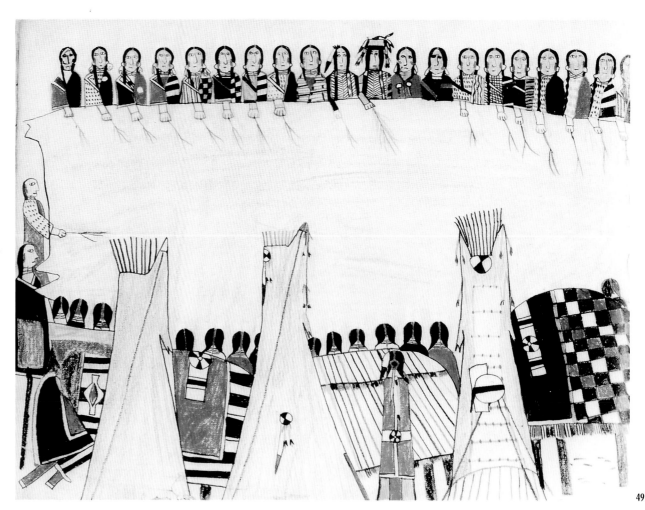

49

HOWLING WOLF
50. Cheyenne Village Scene: Treaty of
Medicine Lodge
September 1876
Pencil, crayon, and ink
8³/₄ x 11¹/₄ in.
New York State Library, Albany, 672

In May 1867, the young warrior Howling Wolf successfully counted coup for his first time (Mooney n.d.:38a–38). As a member of a war party led by fellow Bowstring Society member Lame Bull, Howling Wolf demonstrated his bravery by attempting to corral the lead mare of a supply train at Cimarron Crossing in present-day Kansas. During the struggle, Howling Wolf received a thigh wound. The details of the Cimarron Crossing encounter were recorded in written form by a fellow member of that war party, George Bent, the son of trader William Bent, and Owl Woman, his Cheyenne wife (Hyde 1967:265, 270; Szabo 1992:13; Szabo 1994d).

After the war party returned to their village, Chief Black Kettle asked Bent, who was married to the chief's niece, to accompany him on a trip to a Wichita village. There Black Kettle's party met with other tribal delegations in preparation for a proposed peace treaty with new commissioners from Washington (Hyde 1967:278–82). While it is not recorded that Howling Wolf accompanied Bent and Black Kettle on the journeys made to different villages for the negotiations, Howling Wolf did chronicle those events on the pages of the Albany drawing book. A series of four consecutive pages in the book details visits to neighboring villages, the long distance traveled between those locations, and, finally, the gathering for the Treaty of Medicine Lodge itself, illustrated here (Szabo 1989; Szabo 1994c:99–102).

In the final drawing of the four-page series, Howling Wolf relayed the excitement of the large gathering of people along the hollow at Medicine Lodge Creek south of the Arkansas River in present-day Barber County, Kansas, seventy miles southwest of Wichita. The area where Medicine Lodge Creek converges with Elm Creek was a favorite camping place for Southern Plains people because of its beautiful tree-lined riverbanks (Hyde 1967:283). Howling Wolf has indicated the juncture of the two creeks, angling one stream obliquely into

the composition, and he included a variety of trees, which provide shade for visitors. The vibrantly clad figures seated near their lodges observe the activities taking place in the wooded area before them where Anglo men, with their distinctive hats, meet with various representatives of the Southern Plains tribes. Piles of goods to be offered as part of the negotiations also appear in Howling Wolf's drawing; Bent and the newspaper reporters present at the treaty grounds recounted the immense number of gifts exchanged at the council (Hyde 1967:283–84; Jones 1966:179–80). The actual historic meeting of Southern Plains

people with the new peace commissioners took place in a grove of tall elm trees in the center of various tribal encampments assembled along Medicine Lodge Creek in October 1867. Howling Wolf would surely have been among the five thousand people who gathered for the treaty negotiations. His rendition of the event bears marked similarity to illustrations offered by various newspaper reporters who observed the October discussions (Szabo 1989; Jones 1966).

The Treaty of Medicine Lodge determined the future of the Southern Plains people; through it the federal government made

clear its intention to confine them to reservations. Hostilities from the 1867 signing of the treaty to the time of the Fort Marion imprisonment resulted from Army soldiers trying to enforce the treaty of Medicine Lodge and Southern Plains warriors fighting against the destruction of their way of life. It was, in fact, the Treaty of Medicine Lodge and its aftermath that ultimately resulted in the imprisonment of Howling Wolf and his fellow inmates at Fort Marion.

JMS

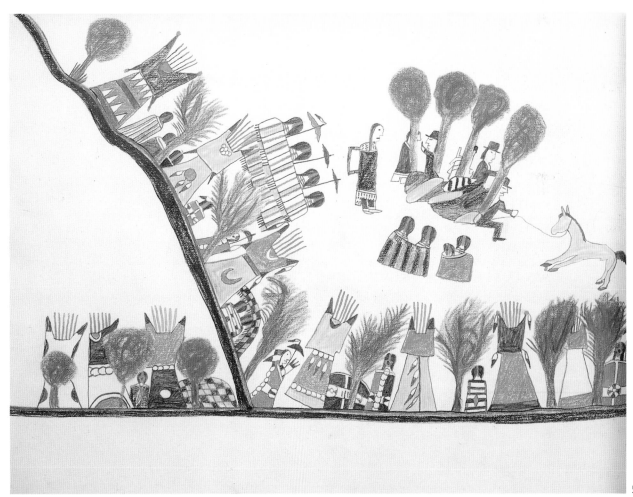

50

HOWLING WOLF
51. Cheyenne Village Scene
52. Dog Soldier Society
53. Bowstring Society
October 1876
Pencil, crayon, and ink
8¼ x 11¼ in. each
Yale Collection of Western Americana,
Beinecke Rare Book and Manuscript Library,
New Haven, Connecticut

Acquired by the Beinecke Library in 1967, the Yale Howling Wolf book contains sixteen pages of drawings. An inscription in the book identifies its artist and the time period of its creation: "Drawn by Howling Wolf (Cheyenne) Oct. 1876 Fort Marion." The drawings demonstrate the exploration of visual concerns similar to those in the Albany book discussed above (see cat. no. 50); the inscriptions from each book underscore the proximity in date established by the visual characteristics of the compositions themselves.

Drawings illustrating activities within Plains villages appear numerous times in Fort Marion art in general and in Howling Wolf's work in particular. In cat. no. 51, Howling Wolf's experimentation with space led him to foreshorten figures, both those facing outward and those turned away from the viewer. The tiered arrangement explored in the Albany drawings of village scenes, such as cat. no. 48 (completed just a month before these) exists here but more readily suggests both near and distant space. Men and women walk in the village. Some are probably engaged in formalized courting activities, everyone handsomely dressed as they would be for such social occasions. A boldly painted lodge hints at the splendor of the Southern Cheyenne village, where lodges of established leaders might bear distinctive painted designs. Often the designs reflected spiritual power given to the original owner through a vision.

A second glimpse into Cheyenne life (cat. no. 52) is far different from the first. Here the casual movements of people suggested in the previous drawing have become the solemn ceremony of a warrior society. Howling Wolf's detailed renditions of lodge, clothing, and paraphernalia associated with this fraternal group allows its identification as the Dog Soldier Society.

Constructed around a tree to which three saplings were tied, the Dog Soldiers' lodge differed from those of any of the other Cheyenne warrior societies; the green foliage of the tree and saplings, rising above the top of the lodge, is apparent in Howling Wolf's drawing. Each of the six warriors in the society lodge wears an upright headdress comprised of eagle feathers in addition to hawk, crow, or raven feathers (Dorsey 1905:21; Grinnell 1972, v. 2:68). Above each man's head appears a deer dew claw rattle, painted red. These hide-covered sticks with extended headpieces, suggestive of snakes (Dorsey 1905:21), were carried by each member of the society. Elaborate body paint with celestial images appears on the warriors' backs. Each man also wears a black and white striped belt around his waist. These belts, worn in society dances, were comprised of four skunk skins with heads intact. The belt was arranged to allow two skunk heads to face each other on the front of the Dog Soldier and two on the back. Deer or antelope dew claws were also attached to the skunk belt and added additional sound during dances.

The man at the right end of the line of figures also wears another Dog Soldier emblem. Four of the bravest members of the society wore over their left shoulders decorated strips of hide, approximately eight feet long. Each of the warriors selected to wear the sashes had special responsibilities during battle that included the protection of their fellow society members, as discussed in cat. no. 38 (see also Dorsey 1905:20–21). The mounted leader to the right of the lodge carries his dew claw rattle, while the mounted figure to the left holds a lance identifying him as a member of the Elkhorn Scrapers. Grinnell reports that at certain Dog Soldier gatherings a member of another warrior society rode with the Dog Soldiers (Grinnell 1972, v. 2:67).

In a second warrior society gathering (cat. no. 53), the participants are members of the artist's own Bowstring Society. All of the men carry the distinctive doughnut-shaped feathered rattles that signify Bowstring membership. A variety of feathered lances are carried by the society members (Dorsey 1905:28). Dorsey records that, as indicated in the origin story of the society, two Bowstring members carried lances whose entire length was trimmed with eagle feathers; these two lances were positioned at either side of the entrance to the lodge. Howling Wolf has also rendered the two eagle-feathered lances in positions flanking the society's lodge.

Given the lance positioned at the top of the lodge and the full feathered headdress also placed there, the Bowstring Society gathering is undoubtedly one that will recall and honor the bravery in battle of members past and present. The large numbers of people who have come to observe the celebration, the two eagle-bonneted figures who appear beside the lodge, and the flanking horses painted as if for battle, indicate that this is a far different type of gathering from that of the Dog Soldiers. Here, the vibrancy of color, crowd of people, and diversity of military ornamentation suggest a more boisterous, celebratory mood. In fact, the Bowstring Society was known as the "noisiest and gayest" of the Southern Cheyenne warrior groups: "The members of the society are distinguished for their gaiety, their songs, their dances, and the various colors of their dress" (Dorsey 1905:26). In his rendition of a ceremony of his own warrior society, Howling Wolf has successfully relayed the lively quality for which such gatherings were known.

JMS

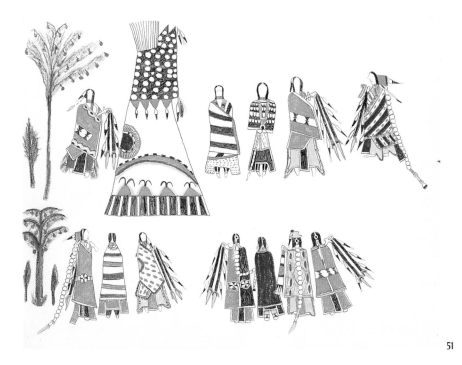

51

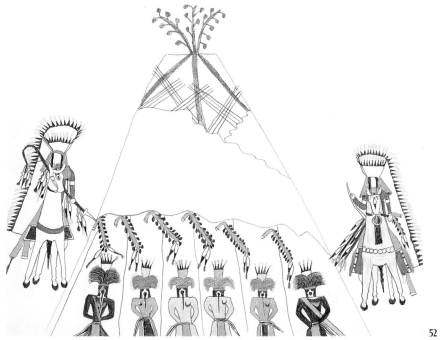

52

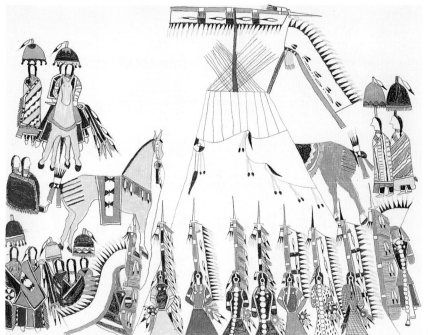

53

HOWLING WOLF
54. Archery Practice
October 1876
Pencil, crayon, and ink
8¹/₄ x 11¹/₄ in.
Yale Collection of Western Americana,
Beinecke Rare Book and Manuscript Library,
New Haven, Connecticut

While Plains artists readily explored the depiction of action and sequence of events in ledger art, they rarely expanded their representations to encompass both facing pages in a ledger book (however, see cat. nos. 22, 23). With greater frequency, but still relatively rarely, Fort Marion artists used facing pages of drawing books as one compositional space, uniting the events illustrated across the seam of the book's binding. Howling Wolf created double-page compositions twice in the Yale drawing book.

In the composition shown here, Howling Wolf illustrated archery practice or a contest held in a Plains village. Men on the right-hand page shoot arrows at a target found in the middle of the left-hand page. Other men observe the action from their vantage point on the left page, while still more men move to take their turn at hitting the mark. Howling Wolf, in using a variation of the

segmented or registered arrangement of space, presents both upper and lower borders, suggesting the boundaries of the village itself. Along the upper border, the tops of various lodges are visible, rendered only as smoke flaps and poles protruding above the line segregating their space. The lower border contains more lodges, some with headdresses or lances and other warrior society paraphernalia positioned nearby. But there are also figures here; at least one man with a feather in his hair has been presented from behind, and three other figures with red paint in the parts of their hair are probably women. An additional figure sits in profile under the shade of an umbrella, at right.

Howling Wolf was not content to depict the lodges and people of the village but also began to explore possible means of suggesting the location of the village itself. The blue band that runs along the lower border of both pages is a river or creek. Shrubs or trees grow along this verdant waterway. The variegated color flecked on

the earth surrounding the river bank emulates the softly undulating hillside of some of the favorite camping locations of the Cheyenne. Indeed, the image suggests that the village Howling Wolf remembered and recorded here was located along the river, just below the rise of the gently swelling countryside. The hillside and the river are both visible as is the view down into the village beyond. Howling Wolf used the element of a flowing river to unite multiple pages into single actions at least two other times in his career, including the series of pages devoted to the preparations for the Treaty of Medicine Lodge of 1868 and the Alliance of 1840 (see cat. nos. 50, 55).

JMS

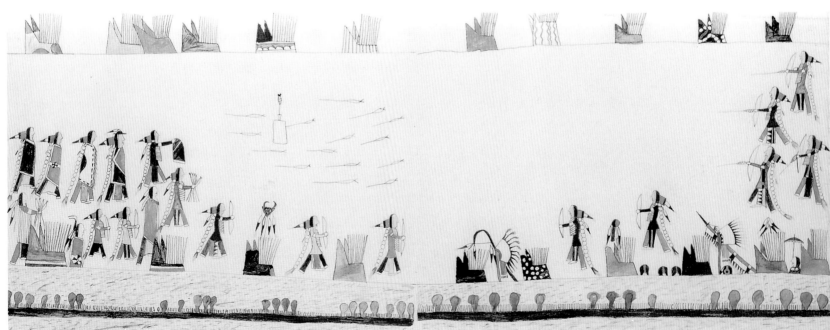

54

HOWLING WOLF
55. Alliance of 1840
Undated, but probably May 1878–May 1881
Ink and watercolor
7¹/₂ x 10¹/₄ in.
Joslyn Art Museum, Omaha, Nebraska,
Gift of Alexander M. Maish, in memory of
Anna Bourke Richardson, 1991.19

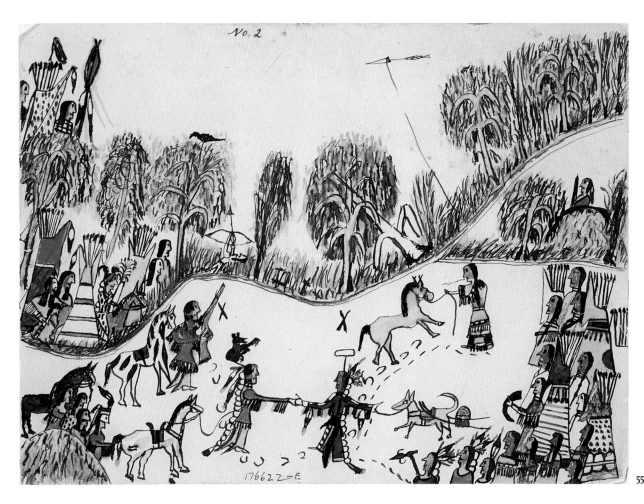

The Joslyn Art Museum drawing book has had an intriguing history. The book, containing twelve images, bears captions in the handwriting of Benjamin Clark, a well-known scout who had served under various military officers in the Plains wars, including George Custer and Nelson Miles. With the end of the Southern Plains wars, Clark, married to a Southern Cheyenne woman, became the interpreter at Fort Reno in Indian Territory. Clark collected books of Plains drawings for John Gregory Bourke, many of whose other drawings are included in this volume (see cat. nos. 17–21). It was apparently from Clark that Bourke received the Howling Wolf book (Petersen 1968:33; Szabo 1994c:131–32). The book, with only eleven drawings in it, came into the collection of Anna Bourke Richardson, Bourke's daughter. An additional page found by Karen Petersen in the National Anthropological Archives was reunited with the book in 1966 (Petersen 1968:38).

The Joslyn book differs significantly from Howling Wolf's other works. Here inks, watercolors, and opaque paint fill pages where the artist's technique of blending liquid color often resembles painting rather than linear drawing. The outlines of the forms represented in the Joslyn book are thicker and more halting than those found in the majority of Howling Wolf's other works. Because of captions found on the various pages, the Joslyn drawing book has been dated to the era following Howling Wolf's return to the reservation in April 1878 but before the death of his father, Eagle Head, in May 1881 (Petersen 1968). Howling Wolf's damaged eyesight, although helped by the treatment he had received in Boston, prevented him from being allowed to stay in the East for further education (Petersen 1968:23). The artist's impaired vision may be partly responsible for the imprecise drawing of the Joslyn images. Howling Wolf was, by 1894, referred to in newspaper reports as "one-eyed" (Anonymous 1894).

While village scenes or treaties and trading negotiations had appeared in the artist's previous work, the Joslyn book contains at least two representations of activities that occurred well before the artist's birth. One of those scenes is illustrated here. Clark's caption identifies the subject as the first time that the Cheyennes traded for horses. Recently, however, it has been suggested that Clark's caption is in error and that this page records an important treaty between the Kiowa and the Cheyenne (Moore 1987:6–7). The treaty is surely that known as the Alliance of 1840, which brought peace between the Cheyenne and Arapaho and their former enemies the Kiowa, Comanche, and Kiowa-Apache people. Howling Wolf has rendered several name glyphs including that of the Kiowa warrior Satank or Sitting Bear, a

young man at the time of this treaty. Moreover, in the only instance thus far recognized in his work, Howling Wolf has provided a place glyph that identifies the river beside which the gift exchange took place; the Flint Arrow Point River (Arkansas River) is so identified by the arrow connected to the river below (Petersen 1968:38). The placement of the two villages on opposite sides of the river is in keeping with Cheyenne memory of the place where the treaty took place. Grinnell reported that the Cheyenne people called that treaty ground "Giving Presents to One Another Across the River" (Grinnell 1956:63).

Howling Wolf's presentation of the Alliance and the X's indicating the exchange of gifts use elements familiar from his depiction of the Treaty of Medicine Lodge of 1868 (see cat. no. 50), with lodges

positioned along the grassy tree-lined river bank. However, this later drawing presents a more complete landscape, with foliage rendered more naturalistically.

What prompted Howling Wolf to render a scene that took place nine years before his own birth is uncertain. Here Howling Wolf acts as a distant historian, recording imagery known to him from cultural rather than personal memory. Howling Wolf's nearly six months in Boston had placed him in extended contact with Francis Parkman, a historian who specialized in American history. Perhaps Parkman's fascination with, and questions about, earlier Plains history influenced Howling Wolf's role as a visual historian of his people.

JMS

HOWLING WOLF
56. Classroom at Fort Marion
1876
Pencil, crayon, and ink
8³/₄ x 11¹/₄ in.
New York State Library, Albany, 672

As part of his reformist program at Fort Marion prison, the warden, Richard Pratt, instituted daily schooling for the prisoners. Volunteer teachers taught reading, writing, and arithmetic in two-hour classes containing about a dozen men each (Pratt 1964:175). Scenes of Indians in their classroom were a common feature of Fort Marion drawing books (see cat. no. 45; see also Harris 1989:fig. 45; Maurer 1992:fig. 293; Szabo 1994c:pl. 6).

In Howling Wolf's version of the classroom, we see two long tables and benches, each seating six men. Howling Wolf has drawn them from behind, their right arms raised, each with pen in hand. The artist's shifting perspective—both a rear view and a modified isometric projection are portrayed—lends an odd quality to the image. While the men may, in fact, have their pencils resting on the tables, their uniformity of gesture also looks like a salute. This impression is reinforced by the profile view of the teacher, whose right arm is similarly raised.

In this image, the "transformation" from autonomous warriors to regimented schoolboys seems to have been fully accomplished. Distinguished visitors to Pratt's model penal colony commented upon this supposed transformation, much as late nineteenth-century photography of Indians focused on a similar change (see the essay by Blume in this volume and Blume 1995). Bishop Henry Whipple, one of the foremost Indian rights activists of the day, who visited Fort Marion several times and bought numerous drawing books (see cat. no. 45), wrote: "I was never more touched than when I entered this school. Here were men who had committed murder upon helpless women and children sitting like docile children at the feet of the women, learning to read" (Whipple 1876; see also Stowe 1877:345).

The warriors at their desks appear not only docile but servile as well. Yet, if we look again at Howling Wolf's image, we find that the monotony of the seated schoolboys is disrupted by the overall chaos of the composition. There is no center to the image, just a set of seemingly unrelated fragments. The teacher with her students is the most comprehensible, but what of the ancillary scene between a student and another man, in the lower right? Their encounter seems to be a confrontation, with the standing figure gesturing toward the class and the seated man raising his hand in response. The inclusion of this side discourse imbues the warrior-students with a subjectivity that is not docile.

Above the teacher's head is an image within the image, a religious painting such as were used as devices of conversion and teaching. To the right is another form, scratched out in black, perhaps indicating a chalkboard with scribbled erasure lines.

This chaotic image contrasts markedly with Howling Wolf's elegant and gracefully rendered traditional scenes of Cheyenne life in the same drawing book (see cat. nos. 48–50). This stylistic contrast of order and clarity (Cheyenne world) versus discord and disarray (schoolroom world) reveals Howling Wolf's commentary on his current life.

AB and JCB

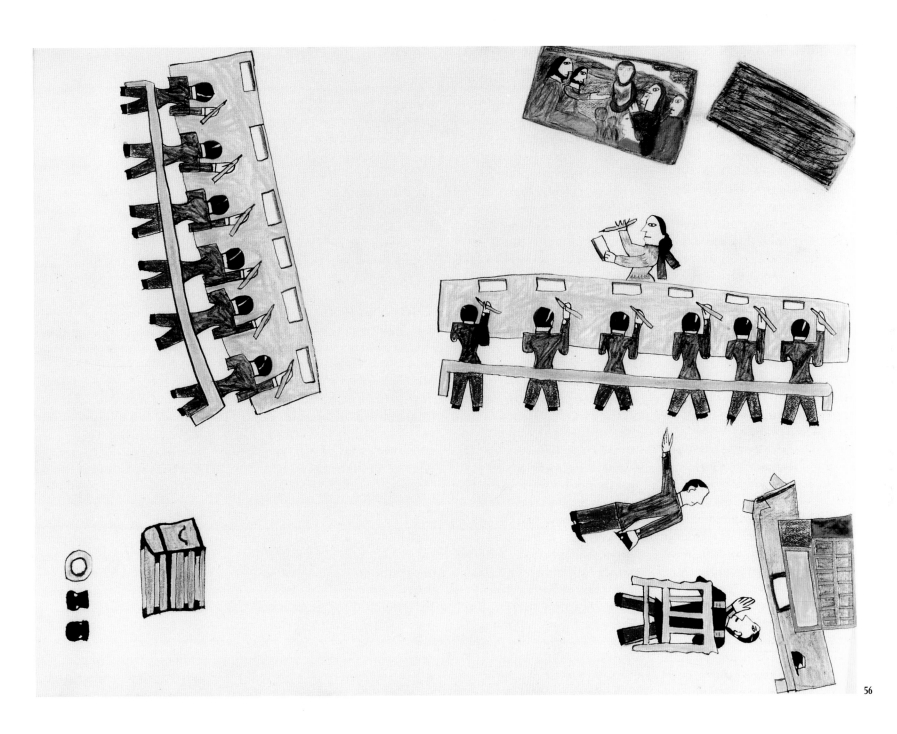

Little Chief
1854–1923
Cheyenne

Catalogue Number 57

Little Chief was a twenty-one-year-old warrior when he was arrested at the Cheyenne Agency on April 3, 1875, along with his uncle, Heap of Birds, and a number of others, and held under the unspecified charge of "ringleader." He was sent to prison in Fort Marion, Florida, in 1875, and remained there for three years, after which he elected to stay on the East Coast for schooling at the Hampton Institute and the Carlisle Indian School. He returned to the reservation early in 1880 (Ludlow 1893:327; Pratt 1964:139). Upon his return home, Little Chief worked as an Army scout, interpreter, and farmer (Petersen 1971:236).

JCB

LITTLE CHIEF
57. Cheyenne Medicine Lodge
1876–78?
Ink, pencil, and watercolor
23½ x 26 in.
National Museum of the American Indian, Smithsonian Institution, 11.1706

This is perhaps the most ambitious drawing on paper produced during the era of ledger book drawing. It contains over five hundred and fifty people, twenty-eight dogs, almost one hundred horses, and more than one hundred tipis and tents. It telescopes Cheyenne history and cosmology into an epic rendering of the Medicine Lodge or Sun Dance encampment.

The drawing was attributed to Little Chief on stylistic grounds by George Eager, a former member of the staff of the Museum of the American Indian, and has been published with this attribution several times (Candace Greene, personal communication, 1995; Moore 1987:pl. 2; Heth 1992: pl. 151). Yet Little Chief's known oeuvre consists of just two small-scale drawings in a multiple-artist autograph book at Yale (Petersen 1971:236–37). It would seem more logical that an ambitious work like this would have been made by an artist such as Bear's Heart (see cat. nos. 43–45),

who is known to have excelled at complex compositions with a multitude of small figures. While some of the tiny figures in Little Chief's drawing are remarkably like those of Bear's Heart, the tipis are drawn in an entirely different manner. Moreover, the handwriting on this drawing is quite similar to Little Chief's signatures on one of his drawings at Yale and in the flyleaf of a multiple-artist sketchbook at the Massachusetts Historical Society. This serves to remind us of how many Fort Marion works have probably been lost in the last century, and how little we know of the complete works of these remarkable artists. It is also possible that such a complex drawing was indeed a collaboration between two artists.

We do not know precisely when this ambitious work was executed. Aside from its larger size—at 23 by 26 inches, it is much larger than most Fort Marion drawings—it is very much in the Fort Marion style, and probably dates to 1876–78.

In his meticulous rendering of a summer Sun Dance encampment, Little Chief has also provided a diagram of an orderly Cheyenne world. The large Medicine Lodge at the center is the spiritual heart of that world. The enormous camp circle of over one hundred tipis and tents is shown from a vantage point looking south. The opening to the ceremonial encampment is at the left, and people and horses stream in. The positioning of the encampment recapitulates on a grand scale the positioning of one tipi; just as a tipi is pitched facing east to welcome the morning sun, so, too, the entire camp circle is oriented in that direction. One tipi embraces one family, but a Sun Dance encampment embraces the whole tribal family and serves as a cosmic diagram of how the world should be.

Each band of the Cheyenne had a particular place within the circle, as did each military society. To the left of the entrance, the Bowstring Soldiers dance in front of the striped tipi labeled as that of Minimic or Eagle Head, who was a chief of the

Bowstrings and later a council chief (Powell 1981:1419). To the right of the entrance is the similarly striped tipi of White Horse (1828–ca. 1882), who was the chief of the Dog Soldiers and later a council chief (Powell 1981:1421). The Dog Soldiers, with their distinctive garb, dance in front of his lodge. These places flanking the entrance to the camp circle were positions of honor. Indeed, the subchiefs of the military societies are known as the "doorkeepers" (Moore 1987:38); in this image they are, literally, doorkeepers.

Little Chief was careful to inscribe the names of many of the most important chiefs and military society leaders in order to orient the viewer to the crucial foundations of this diagram of the Cheyenne world order. In addition to the ones mentioned above, in the lower right he has labeled two painted lodges as belonging to Little Blanket (noted as "Chief") and Whirlwind ("Big Chief"). The distinctive painting on these lodges would, of course, also mark their ownership to the knowledgeable Cheyenne viewer. Little Blanket, more commonly called Little Robe (ca. 1828–1886), was a council chief who had long endeavored to work as a peacekeeper with whites, and who went on a delegation to Washington, D.C., in 1871 (Powell 1981:567, 798–802). Whirlwind (ca. 1823–1891) had been a famous warrior in his youth, but was also a council chief who sought peace with whites. The Kit Fox Society Soldiers dance in front of the tipis of Whirlwind and Little Blanket.

In the upper right, the artist has inscribed the names of Grey Beard and Wopome by two painted lodges. Wopome is known to have been a chief by about 1871 (Powell 1981:1422), and Grey Beard (ca. 1835–1875) was a band chief. Members of another warrior society, probably the Hoof Rattlers, dance in front of their tipis.

While many late nineteenth-century white observers of Sun Dances marveled at the complexity of activity and the enormous crowds of people who assembled for such occasions (Bourke 1872–96:1460–1505; Grinnell 1972, v. 2:211–84), this is, to my

knowledge, the only Native American pictorial account that takes such a panoptical view of the event. Some drawings on muslin by Standing Bear come close (Maurer 1992:fig. 155), but with over eight hundred figures and objects, Little Chief's drawing is a masterwork of activity, encompassing vignettes of dancing, cooking, games, and sweat lodges. The artist even shows a vista of hunting and horses grazing, while sacred offerings are made in the distant hills. The actions of several days are telescoped into one. People crowd around the huge Medicine Lodge to watch the sacred offerings being made within. Interestingly enough, this is the one event the artist does not reveal. We see only the exterior of the sacred lodge, and the forks of the central pole festooned with cloth, cut green branches, and other materials. This work contrasts with the closely rendered scenes of individual Sun Dance participants drawn by Lakota artists such as Bone Shirt and Black Hawk (see cat. nos. 120, 121; Sotheby's 1994:76).

This drawing commemorates one of the last great Medicine Lodge encampments of the late 1860s or early 1870s on the Southern Plains. In 1875, two of the headmen named here, Minimic and Grey Beard, along with Little Chief himself, were arrested and exiled to prison at Fort Marion. Grey Beard was shot on the trip to Florida when he jumped from the train window and tried to escape (see cat. no. 105). In his final moments, he told Minimic that he had wanted to die ever since being chained and taken from home (Pratt 1964:115).

When the artist drew this ambitious scene, he may have believed that the sacred circle he was commemorating had been irrevocably broken by the tumultuous events of the 1870s. He could not know that over a century later, descendants of the people pictured here would continue to follow many traditional spiritual beliefs and to make art that memorialized the strength and tenacity of the Cheyenne (see the statement by Heap of Birds, p. 66).

JCB

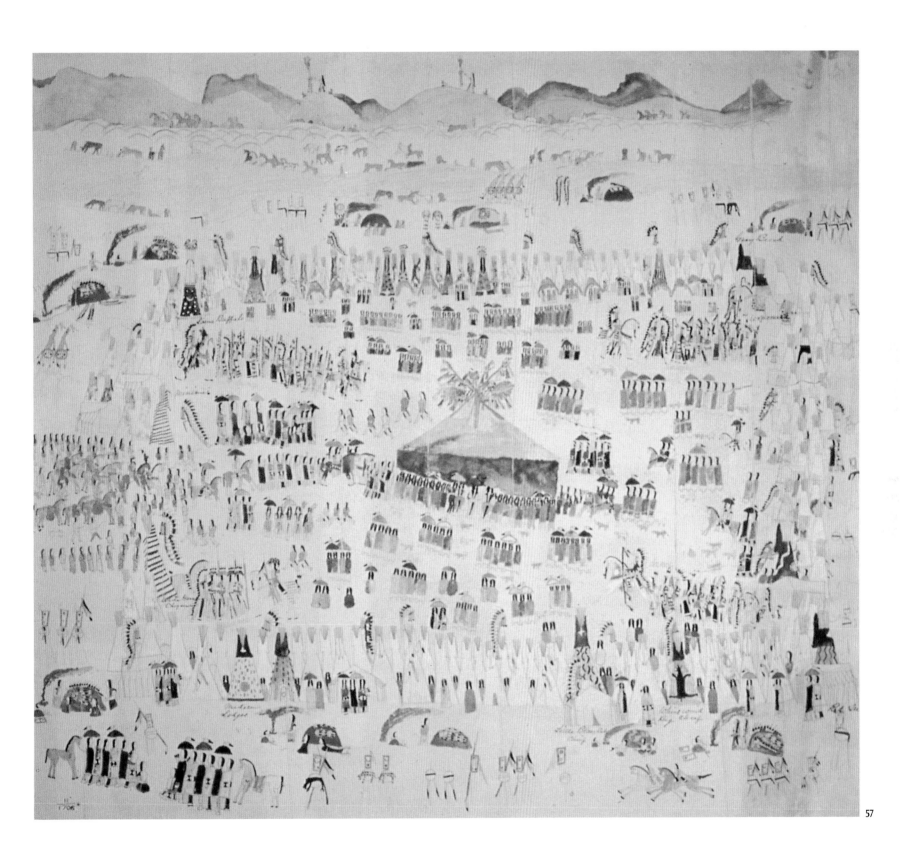

Making Medicine
(1844–1931)
Cheyenne

Catalogue Numbers 58–67

Making Medicine was an officer of the Southern Cheyenne Bowstring soldier society when he was arrested as a "ringleader" on April 3, 1875, and exiled to Fort Marion prison (Petersen 1971:225). While incarcerated, he became first sergeant of the Company of Indian Guards, for the warden had instituted a system by which the prisoners guarded themselves. One of Making Medicine's drawing books is the earliest firmly dated one from Fort Marion. In it, the artist's imagination is focused on the Great Plains, with its free life of hunting. His subsequent books center more intensively on experiences of acculturation and prison life. One unpublished book in a private collection contains some two dozen drawings by Making Medicine, including superb scenes of daily life at Fort Marion that enlarge upon many of the topics he drew in the Silberman and Smithsonian books, illustrated here.

After leaving Fort Marion, Making Medicine recruited students for the Carlisle Indian School and returned to Oklahoma in 1881. Although he had been baptized a Christian under the name David Pendleton in 1878, this Cheyenne man was aptly named the first time; "Okahaton," or "Making Medicine," refers to an engagement in spiritual pursuits. Making Medicine/David Pendleton Oakerhater served as an Episcopal deacon in Oklahoma for fifty years. He was honored by inclusion in the calendar of saints in the Episcopal church in 1986 (Guilbert 1988:324).

JCB

MAKING MEDICINE
58. *Killing an Elk* (10)
1876–77
Pencil and colored pencil
10⅝ x 8⅜ in.
National Anthropological Archives, National Museum of Natural History, Smithsonian Institution, Washington, D.C., 39A

Karen Petersen has dated the Making Medicine book in the Smithsonian to August 1875, making it the earliest firmly dated work from Fort Marion (Petersen 1971:21). In drawing these images Making Medicine held the book vertically, which is rare in the Fort Marion corpus. Notably, this is the way most early ledger books drawn on the Southern Plains were oriented, with the bottom of the image at the binding of the book (see cat. nos. 22, 23).

The drawings in this early book reveal Making Medicine to be a gifted artist, with a confident line and an affinity for precise detail. Petersen (1971:21–61) provides an exemplary look at the early stages of Fort Marion art and illustrates other drawings from the book discussed here (see also the essay by Greene in this volume, fig. 2 [p. 27]). In depicting an elk hunt, Making Medicine overlapped his figures, drawing the horse and then the elk. Such an X-ray view is common in early ledger art from the Southern Plains (see cat. nos. 12–16), but Fort Marion artists soon learned a new technique, that of leaving gaps in the outlines to allow for the insertion of other figures (see cat. no. 46).

JCB

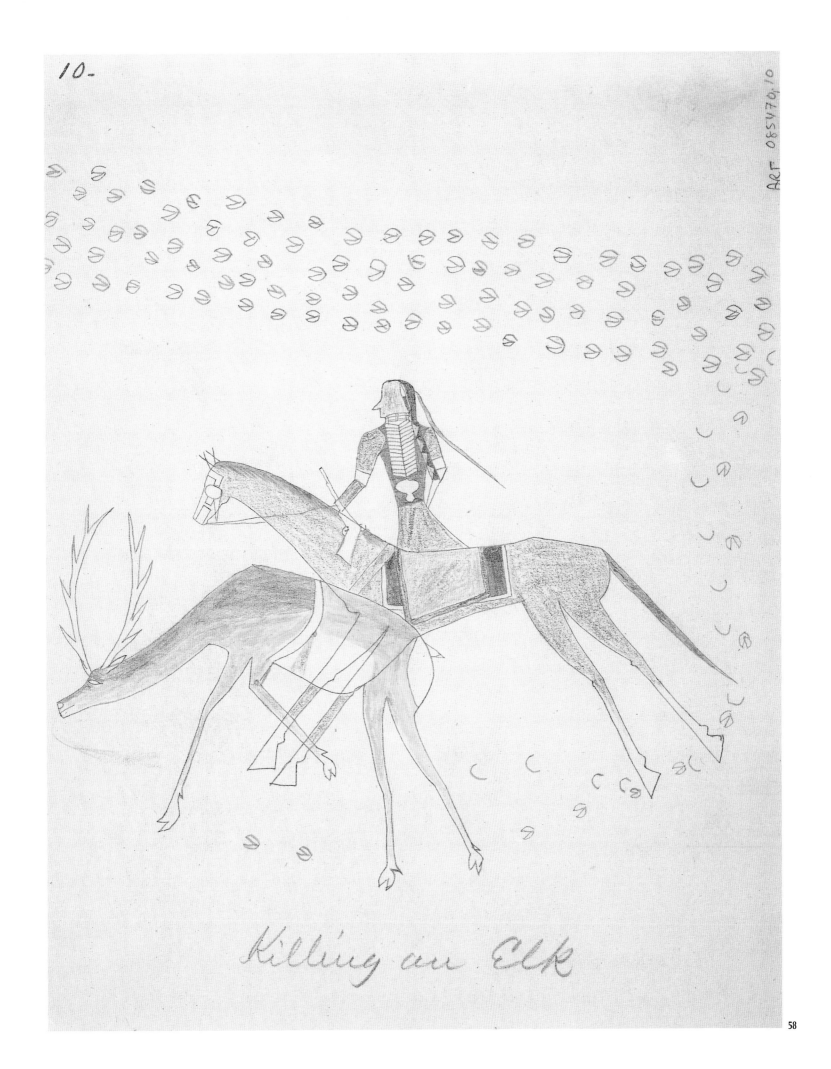

Killing an Elk

MAKING MEDICINE
59. *Fowls of Indian Territory* (12)
1876–77
Pencil and colored pencil
$10^{5}/_{8} \times 8^{3}/_{8}$ in.
National Anthropological Archives, National
Museum of Natural History, Smithsonian
Institution, Washington, D.C., 39A,12

In another page from his earliest extant
book from Fort Marion, Making Medicine
made a study of seventeen different types
of birds from the Southern Plains. He had
the finely trained eye of a hunter and could
discern the distinctive features of numerous
species. The identifiable species in the
present drawing include four kinds of
hawks (white-tailed, red-tailed, marsh, and
zone-tailed), a swallow-tailed kite, a long-
billed curlew, a magpie, a barn swallow,
a kingfisher, a bald eagle, a yellow-headed
blackbird, a turkey, a duck, a crane, and a
great horned owl.

As was conventional in ledger art,
Cheyenne warriors generally rode from
right to left across the page; so, too, the
birds of Indian Territory fly from right to
left. While Fort Marion artists made many
fine drawings of game animals (see cat.
no. 68), to my knowledge this is the only
depiction of birds.

JCB

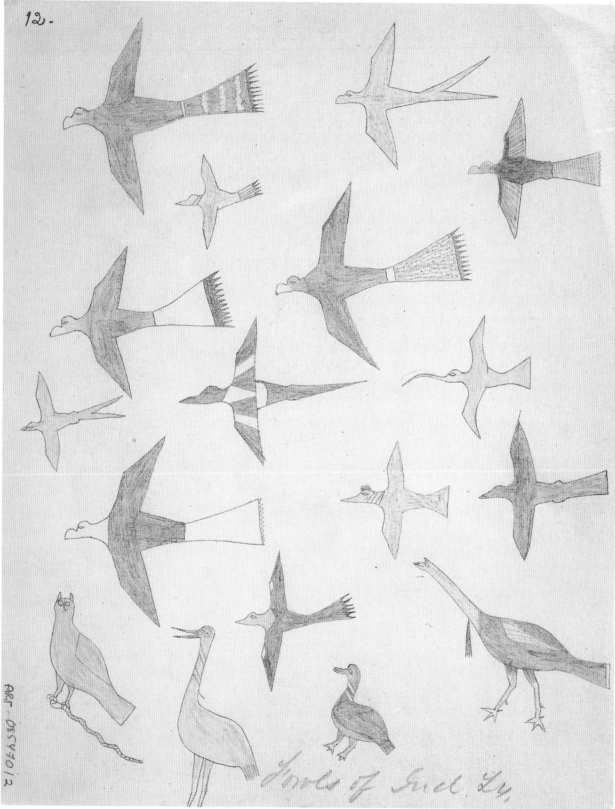

MAKING MEDICINE
60. *Indian Prisoners and Ladies*
Archery Club (1)
1876–77
Pencil and colored pencil
8½ x 11 in.
National Anthropological Archives, National
Museum of Natural History, Smithsonian
Institution, Washington, D.C., 39B

An engraving in *Harper's Weekly Magazine*
of May 11, 1878, entitled "Indian Prisoners
Teaching Archery Lessons" (Witmer 1993:8)
shows a scene much like the one drawn by
Making Medicine. In it the lesson occurs
within the high walls of the fort, while in
Making Medicine's drawing, it takes place
on the parapet. He carefully depicted the
crenellated walls and provided a vista into
the bay beyond. Both engraving and draw-
ing include a seated woman with a fan and
a dog, and two Indian prisoners in military
garb instructing ladies in archery.

As befitted a Plains warrior-artist who
understood the importance of the language
of dress, Making Medicine delineated the
clothing of each archery student with great
delicacy, showing sashes and hatbands
flying in the breeze, and demarcating the
various stripes and checks of each lady's
suit. An imposing dog—perhaps a mastiff
or Great Dane—rests placidly beside two
seated women. As Ed Wade has observed,
Making Medicine may be subtly making fun
of his students in this image: while six
female students and two Native teachers
take aim at the target, only two of twenty-
one arrows have hit their mark—presumably
those aimed by the Indian instructors
(Wade n.d.).

JCB

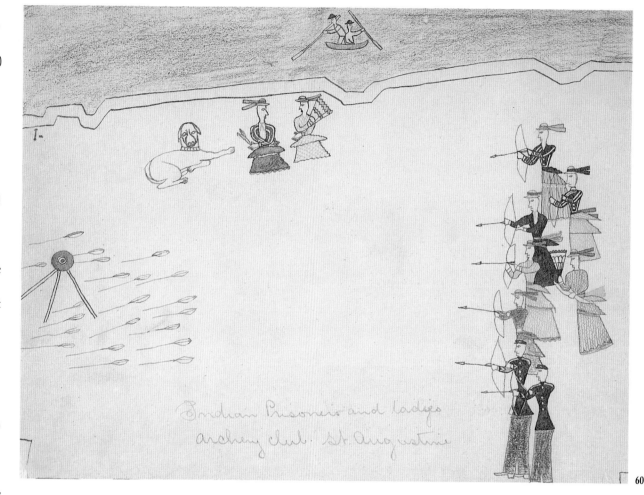

60

61. *Indian Prisoners at Fort Marion Being Photographed* (H)

62. *Inspection of Indian Prisoners, Fort Marion, Fla.* (M) (Wade and Rand, pl. 3 [p. 48])
1876–77
Pencil and colored pencil
8½ x 11 1/16 in., 8½ x 11 in.
National Anthropological Archives, National Museum of Natural History, Smithsonian Institution, Washington, D.C., 39B

Capt. Pratt chose Making Medicine to be first sergeant of the Indian guards at Fort Marion. As such, he worked closely with Pratt, and was responsible for the dispersal of goods and the inspection of prisoners (Pratt 1964:187). Making Medicine drew such an inspection: twenty-seven identically dressed prisoners stand at attention in two rows. The artist located the scene within the walls of the fort, which are rendered in yellow and frame the scene.

In cat. no. 61, Making Medicine has depicted a St. Augustine photographer capturing the images of six Southern Plains prisoners. As in many of his drawings, the artist carefully circumscribed the action within a location: here, too, the walls of the fort are meticulously delineated. Numerous photographs were taken of the Fort Marion prisoners in military garb, as part of Pratt's campaign to reform Indian policies and promote interest in Indian education (Petersen 1971:pls. 1, 2; Pratt 1964:pls. 15, 16).

JCB

63. *Still Hunting Antelope*
1876–77
Pencil and colored pencil
6¼ x 8 in.
The National Cowboy Hall of Fame and Western Heritage Center, Oklahoma City, Arthur and Shifra Silberman Collection, 95.2.657

Making Medicine was equally adept at nature studies and depictions of military regiments. In this hunting scene he has set the action in an abstract landscape. Pronghorn antelope run for cover as Cheyenne hunters, perched atop stylized hills dotted with trees, fire at the animals and wound them.

JCB

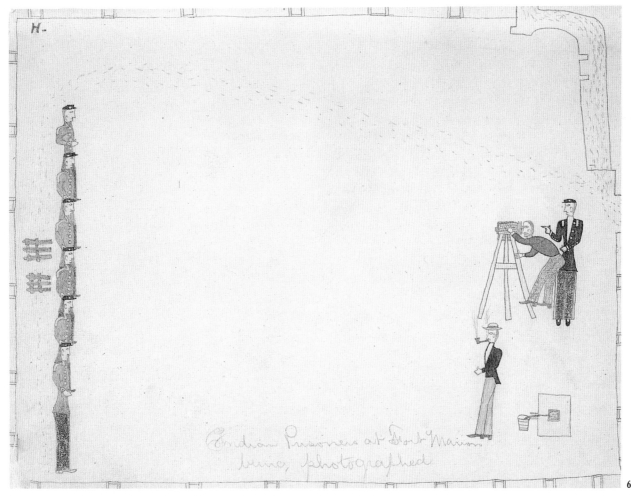

Indian Prisoners at Fort Marion being photographed

61

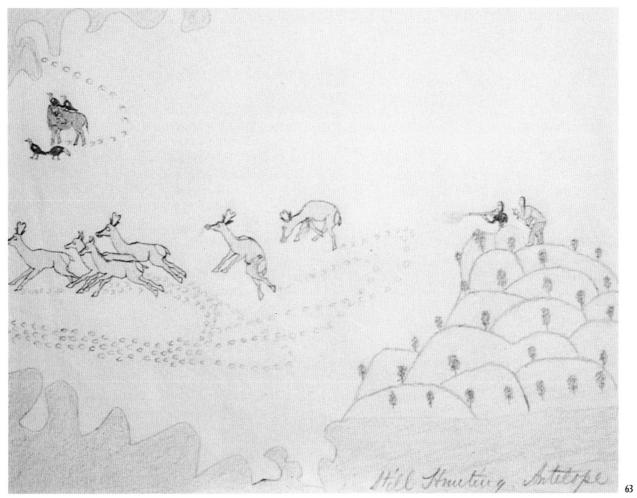

Hill Hunting Antelope

63

64. *Indian Drill "Setting Up Process"* (674)
65. *Shingling the Roof* (750) (Berlo, "Drawing and Being Drawn In," pl. 2 [p. 15])
1876–77
Pencil and colored pencil
6¹/₄ x 8 in. each
The National Cowboy Hall of Fame and Western Heritage Center, Oklahoma City, Arthur and Shifra Silberman Collection, 95.2.674, .750

The autobiographical images of Making Medicine include many activities of white society, which, although quotidian, were previously unknown to the prisoners from the Southern Plains and thus deemed worthy of visual record. The regimen of activities for the Fort Marion prisoners included military drills and calisthenics. In these drawings, Making Medicine captures both the military precision and the hint of ridiculousness involved in such exercises. In his memoir, Capt. Pratt recalled:

Daily drills had been resorted to early, particularly in what in the army is called the "setting up process [gymnastic exercises]," which greatly benefited the health of those who participated, and the drill hour became the favorite period for visitors, attracting attention and favorable comment from distinguished visitors and army officers. The commander of the Department of the East, General Hancock, visited the fort, coming unexpectedly in the drill hour when the Indians were going through movements at double quick with laudable precision. He had watched them some time before he was recognized by a visitor, who came and told me we were under distinguished military observation. I brought the company to a halt, ordered a hand salute, and went over to the doorway where the general stood and saluted. Returning my salute but keeping his eyes on the Indians, he inquired, "What troops are these, sir?" (Pratt 1964:120).

In his drawing of the prisoners shingling a roof (cat. no. 65), Making Medicine captured just one of the labors that the prisoners performed. Pratt describes them clearing land, working as railway baggage handlers, stacking lumber in the sawmill, drilling a well, moving a frame building on rollers, moving a canon (see cat. no. 87), aiding in archaeological digs and natural history expeditions for the Smithsonian, and serving as a bucket brigade for a fire (Pratt 1964:128–35). In this image, the artist rendered with great delicacy the stooped figures of the prisoners and their pipe-smoking supervisor, elevated several stories above ground on a pitched roof.

JCB

66. *Making Medicine* (669)
67. *U.S. Artillery Officers* (664)
1876–77
Pencil and colored pencil
6¹/₄ x 8 in. each
The National Cowboy Hall of Fame and Western Heritage Center, Oklahoma City, Arthur and Shifra Silberman Collection, 95.2.664, .669

Although the artist was held prisoner, subjugated to white military authority, in his drawings he depicted the truth of his identity: Making Medicine was every bit the equal (if not the superior) of the high-ranking Army officers whose portraits he carefully rendered, complete with sabers, scabbards, and plumed dress headgear. Making Medicine, too, wears his plumed dress headgear—with many more fine feathers than the caps of the artillery officers. His self-portrait shows the accoutrements of a distinguished warrior: feather headdress, shield, plumed lance, and war pony.

In only a few drawings do Fort Marion artists deliberately enframe their works, as if mimicking studio photographs or easel paintings. In these two drawings from one book by Making Medicine, the artist did this in an especially effective manner. He surrounded each drawing in a square of embellished lines, making them look like fussy Victorian frames. Wohaw, a Kiowa artist at Fort Marion, also produced enframed portraits that contrasted two modes of military dress—white and Native American (see cat. no. 101, and Harris 1989:pl. 32).

JCB

64

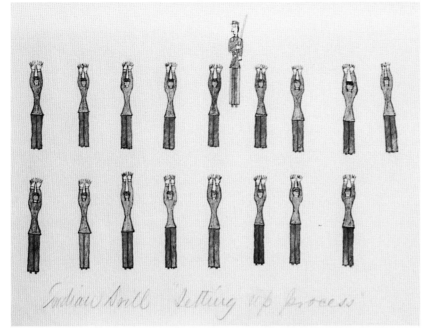

Indian Drill "Setting up process"

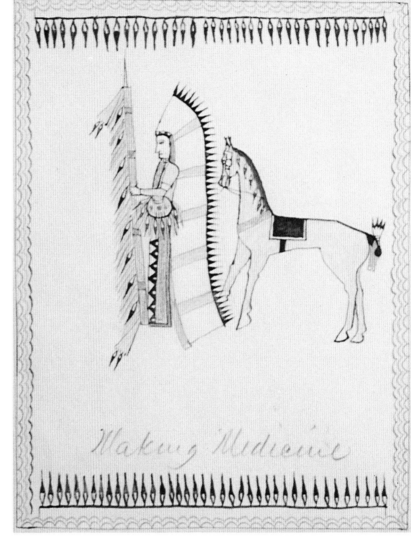

Making Medicine

66

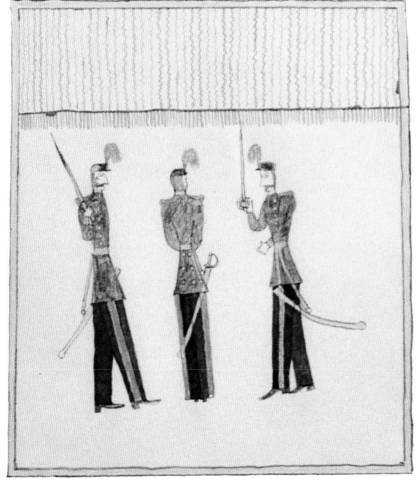

67

Squint Eyes
(1857–1932)
Cheyenne

Catalogue Number 68

Squint Eyes was only seventeen when he was selected to be sent to Fort Marion for incarceration. Several individual drawings and two complete drawing books by him are known, one in the collection of the Smithsonian and one at the Cowboy Hall of Fame. Little is known of his Fort Marion years, but after his release from prison, Squint Eyes traveled extensively. He worked for the Smithsonian as a taxidermist and collector of natural history specimens; he accompanied ethnologist Frank Cushing to the Southwest, and later served as an Indian scout at Fort Reno and Fort Supply before moving to the Northern Cheyenne Reservation in Montana (Petersen 1971:193–206).

Petersen succinctly captured Squint Eyes's unique peripatetic experiences:

Few men of his day could boast of rubbing shoulders with Indians of as many tribes as Squint Eyes had known. He had worked with an Aleut from the northwesternmost tip of the United States and visited the Seminoles in the southeastern extremity. He had traveled with a Zuni and a Hopi, and had married into the Northern Cheyenne. He had camped with the Havasupais and traded with the Navahos. He went to school with Arikaras, Mandans, Gros Ventres, and Sioux. He was imprisoned with Arapahos, Kiowas, Comanches, and a Caddo. He fought the Utes, the Osages, and the Apaches, and he took part in police action against the Chickasaws and the Southern Cheyennes (Petersen 1971:204).

JCB

SQUINT EYES
68. Buffalo Hunt
1876
Pencil and colored pencil
$8^1/_2$ x 11 in.
The National Cowboy Hall of Fame and Western Heritage Center, Oklahoma City, Arthur and Shifra Silberman Collection, 95.2.647

Squint Eyes is not considered one of the major Fort Marion artists, but previously unpublished drawings by him, now in the Silberman collection, add appreciably to our understanding of his work. The one illustrated here is from a signed and dated drawing book by Squint Eyes. Hunters ride on horseback after their prey. They are armed with revolvers, bows and arrows, and quivers made of mountain lion skin. The artist experimented with a semi-abstract design of humped buffalo backs behind a ridge. He abstracted the bison forms so that they provide a decorative rhythmic silhouette against the white page.

JCB

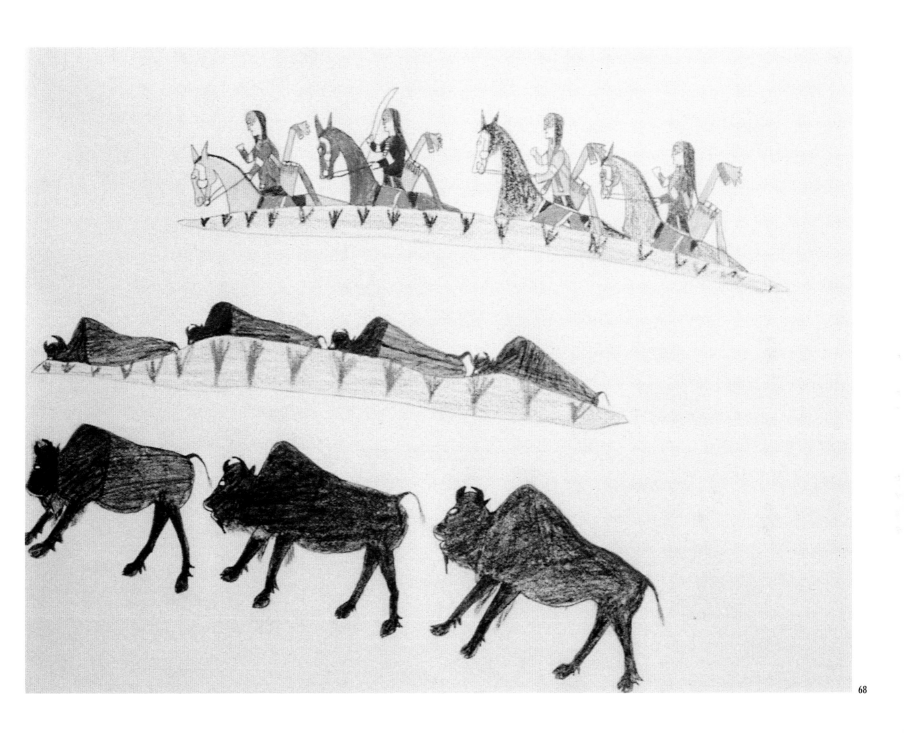

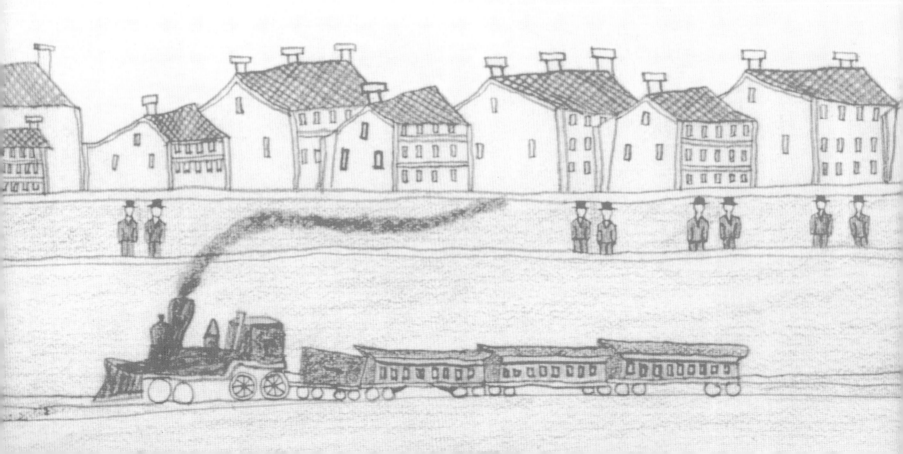

Kiowa

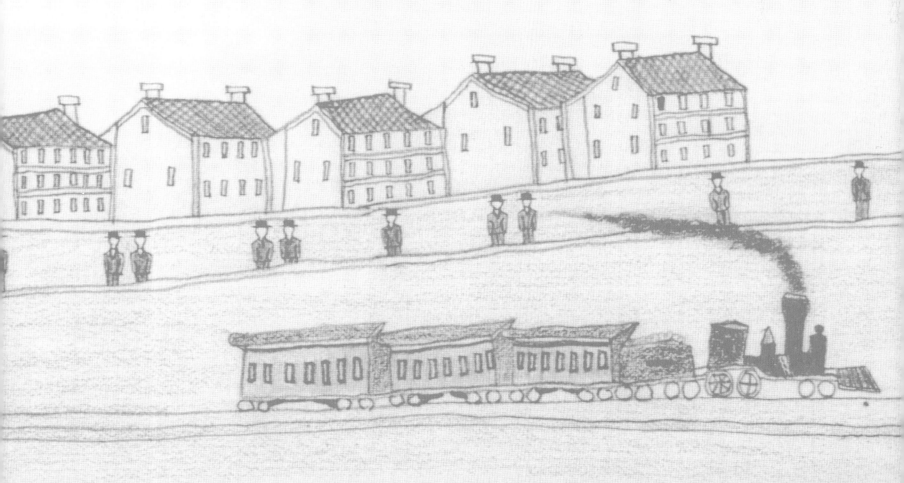

Artist unknown
Barber Drawings
Kiowa

Catalogue Numbers 69–72

These drawings were given to the Cincinnati Art Museum in 1954 by Merritt A. Boyle, a Cincinnati resident and grandson of Merritt Barber, an Army officer who was stationed at Fort Sill, Indian Territory, in 1879–80. The series of eleven drawings (along with three given at the same time to Williams College, from which Barber graduated in 1857) were made by a Kiowa artist for Barber in 1880. While the artist's name is unknown, the caption to cat. no. 70 suggests that he drew himself in the scene.

JCB

ARTIST UNKNOWN
69. *Big Bow Surrounded by Navajos*
70. *Kiowas and Navajos Preparing for a Fight*
1880
Pencil and crayon
7 x 10 in. each
Cincinnati Art Museum, Gift of Merritt A.
Boyle, 1954.196, .205

In the mid-nineteenth century, horse raids among Navajos, Utes, Comanches, and Kiowas were a customary part of warfare. Kiowa warriors and horse raiders ranged from Oklahoma Territory down into Texas and Mexico, as well as west into New Mexico. The famous Kiowa calendars record that the years 1856, 1867, and 1868 were particularly noteworthy for skirmishes with the Navajo, which usually involved the stealing of horses (Mooney 1898:301, 320–23).

The caption written on the margin of the mounting board of cat. no. 69 reads: "Big Bow surrounded by Navajos, kills their chief who is seen falling. Observe bullets and arrows fired at Big Bow from all sides, two arrows having been received in his shield. Observe the marks in a circle which indicate the footprints of Big Bow in the course of his retreat during the fight."

Big Bow, a famous Kiowa warrior born in 1833, was a member of several memorable war parties against the Navajo from the mid-1850s onward. One, from the winter of 1867–68, may correspond to this image, for it is remembered that Big Bow's party was ambushed; while some of the Kiowa escaped, Big Bow was encircled by Navajos. Having been hit by a bullet, he was unable to handle his rifle and had only his war shield to protect him (Nye, 1962:20–29). In this drawing, Big Bow valiantly defends himself with his shield, while bullets and arrows fly at him from all directions. (It was on a different occasion that a younger Big Bow killed a Navajo war party leader who galloped toward him on horseback, while Big Bow himself was on foot [Nye 1962:82–90]. Perhaps the caption writer or the Kiowa narrator has conflated the two exploits in this image.)

While the figures surrounding Big Bow may not seem to be immediately identifiable as Navajos by means of their clothing, the artist has in fact included some features that demonstrate his familiarity with Navajo clothing of the 1850s and 60s. In the mid-nineteenth century, Navajo men did wear fringed buckskin shirts, sometimes dyed yellow, much like the ones the Kiowa artist has drawn here (Kluckhohn, Hill, and Kluckhohn 1971:247–53). They also wore war caps, some of which had appendages across the ridge, like the red cap worn by the figure in the lower right (see, for example, Fane et al. 1991:76–77). Most notably, the twin-peaked red cap on the figure in the middle left conforms to a type of double-flapped buckskin war hat worn by Navajo men before 1870. These were usually festooned with eagle, owl, or turkey feathers as well as abalone or other buttons (Kluckhohn et al. 1971:fig. 184b).

Cat. no. 70 also shows the two tribes in combat. The caption reads: "Kiowas and Navajos preparing for a fight, during which the Kiowas killed about twenty of the enemy and defeated them. The Navajos rallied and defeated the Kiowas. The Kiowa who painted these pictures is represented in the rear with spear, shield, and gun."

In the winter of 1867–68, a Kiowa war party near the Texas–New Mexico border met some Navajo who were coming on foot to steal Kiowa horses (Mooney 1898:322). After one death on each side, the Kiowa vowed revenge the following summer, when a larger party was to be mounted. In this drawing, high-ranking Kiowa military men, including one of the famed Kaitsenko Society members (the Kiowa version of the Dog Soldier Society, which was widespread among the cultures of the Plains), take on the Navajo raiders. Among the Kiowa, membership in Kaitsenko was limited to the ten bravest warriors. The Kaitsenko warrior is recognizable because of the broad red sash extending from his right shoulder across his chest and down to the ground.

JCB

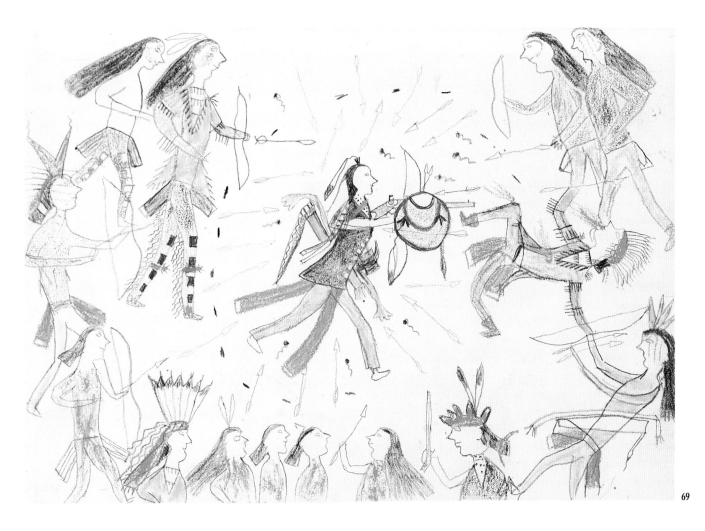

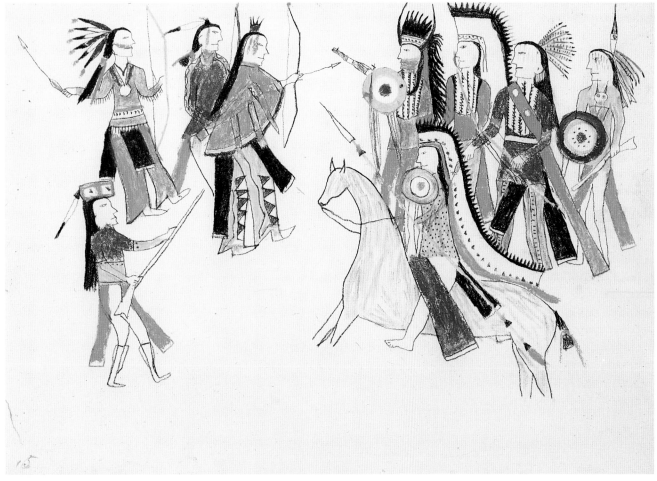

ARTIST UNKNOWN
71. *Sun Boy Dancing Before His Lodge*
72. *Fox Skin Bonnet Returning to His Lodge*
1880
Pencil and crayon
7 x 10 in.
Cincinnati Art Museum, Gift of Merritt A.
Boyle, 1954.197, .202

In most of the images he drew for Merritt Barber, this unknown Kiowa artist depicted exploits of well-known men of his tribe. Here, he depicted Sun Boy (?–1888) and Fox Skin Bonnet (?–ca. 1875) in camp scenes with painted lodges. Sun Boy was a famous Kiowa chief, whose war exploits are depicted in a painting on muslin in the Philbrook Museum (Young 1986).

In cat. no. 71, Sun Boy, wearing a bone necklace, German silver hair ornaments, and a red tradecloth breechcloth, dances in front of a red tipi. Two Kiowa women and a smaller boy wearing a peace medal look on. Behind the women, the artist has drawn a very famous Kiowa tipi, the Porcupine Picture Tipi. Many prominent Kiowa leaders owned the rights to paint their tipis with designs that had come to them in visions, or had been handed down from relatives. Complex laws of permission and copyright governed who had the rights to paint or use particular designs (Greene 1993; Greene and Drescher 1994).

Written in the margin is: "Sun Boy dancing before his lodge. This picture represents an Indian custom of boasting of their deeds of prowess before their wives and the women of their camp. Also their method of decorating their lodges or teepees for which in this case the wild boar has been selected." While the artist's rendition of the small, prickly animals is somewhat boar-like, the composition of the tipi, even to the arrow in the body of the animal that runs up the side of the tipi, is unmistakably that of the Porcupine Picture Tipi, which was renowned in the Kiowa camp circle. It belonged to Chief Black Cap as early as the 1830s. After Black Cap's death, his daughter owned the rights to the imagery. In the 1890s, Kiowa experts told anthropologist James Mooney that this was the last tipi Kiowa women had fashioned from buffalo skins, in 1879 (Ewers 1978:21). After that, buffalo skins were so scarce that lodges were made of canvas.

In cat. no. 72, Fox Skin Bonnet (or Fur War Cap, as his name is sometimes translated) approaches his lodge. The caption states: "Fox Skin Bonnet, a Kiowa chief, returning to his lodge from a war expedition bringing a scalp of a Ute on a pole. A faithful picture of a Kiowa warrior and his weapons. Notice the horse trappings and the private marks of the owner on the shoulder of the animal."

Fox Skin Bonnet owned a tipi of simple design: thin red horizontal stripes ornament an unpainted background. Kiowa elders in the 1890s remembered this tipi as well (Ewers 1978:41). Pictured next to it may be Crazy Bear's Horse Picture tipi. While the painted horses flanking the door are not visible in this view, it does have the red base, yellow body, and red top with a light blue circle in it, elements that characterized that tipi (Ewers 1978:25).

In the drawing, Fox Skin Bonnet returns to his lodge after a successful war party. He carries an arrow quiver made out of mountain lion skin, and displays an enemy's scalp lock on a pole. Throughout Plains art, the recognizable convention for a scalp is a circle that is half red, half black, with hair hanging below. Fox Skin Bonnet's long feathered lance denotes that he is a high-ranking warrior. Since Indians did not brand their horses, the presence of a brand ("DA") on this one suggests he was captured from a white owner in a raid.

JCB

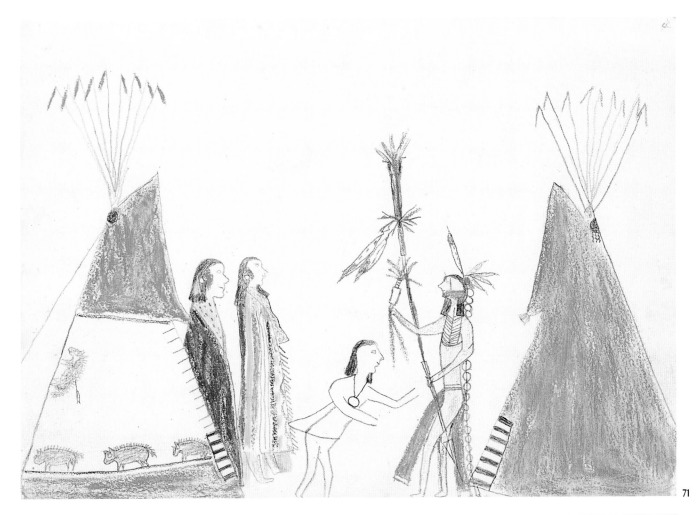

71

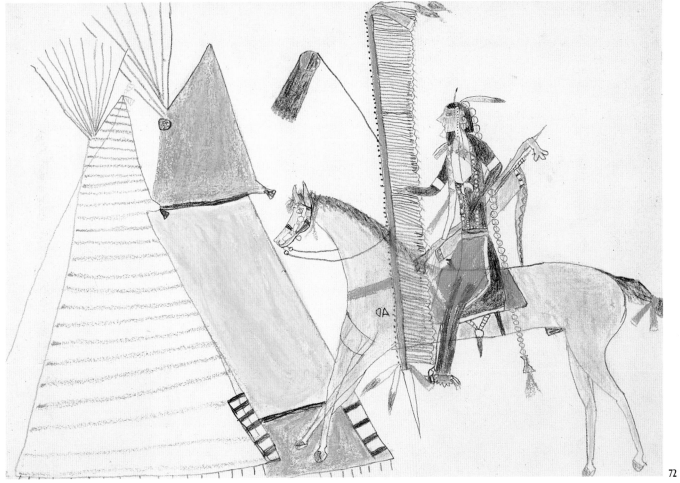

72

149

Artists unknown
Julian Scott Ledger
Kiowa

Catalogue Numbers 73–78

The names of the Kiowa artists who drew the fifty vivid images in the Julian Scott Ledger unfortunately remain unknown to us. At least three artists' hands are evident in this book, the two finest of which are represented here. (The separate pages of the book have been dispersed to various private and public collections, though the book has been published in full in McCoy, 1987). The book is named for its late nineteenth-century owner, who was an artist who portrayed military and Indian themes.

The work of the individual I am calling Julian Scott Ledger Artist A is represented here by five drawings (cat. nos. 73–77). He was probably the owner of the book, for forty-three of the fifty drawings in it are by his hand. His work is characterized by a bold, vigorous style, which to the modern eye is charming in its simplicity and its untutored mix of Native American and European artistic conventions. His line is somewhat unsteady and he fills in large blocks of color in uneven gestural strokes.

On one of the Julian Scott Ledger pages, a notation about an insect that crawled along the page while the Indian was drawing, a date of "Nov. 29, 80," initials "D.O.B.," and a location at the Kiowa, Comanche, and Wichita Agency, Indian Territory, establish a firm date of 1880 for this book (McCoy 1987:4 and pl. 45).

JCB

JULIAN SCOTT LEDGER ARTIST A
73. Kiowa Vanquishing a Navajo (21)
74. A War Party with Scalps (55)
75. Kiowa Couples (27)
1880
Pencil, ink, and colored pencil
7 1/2 x 12 in. each
Mr. and Mrs. Charles Diker

Cat. no. 73 depicts a fight between a Kiowa and two Navajo, as McCoy (1987:60) has convincingly demonstrated. As is often the case in such ledgers, the script identifying the figures as "Ute" and "Sioux" is probably a later, inaccurate addition. Like the Kiowa drawings in cat. nos. 69 and 70, it portrays the conflicts that Kiowa warriors had with their neighbors to the southwest. The victor is a Kiowa, on the left, whose feathered shield, horned headdress, and large feathered lance identify him as a warrior of extremely high rank. He wears buffalo horns on his head, and his chin is painted with war medicine in the form of a buffalo face, with the horns curving upward onto his cheeks, a design that is seen in face painting across the Plains.

Note that a preliminary outline of a horse was sketched out (visible between the human head on the right and the horse's head in the middle) and then abandoned in favor of the three boldly rendered horses that now compose the scene. The central horse, who rears dramatically, was drawn first. The artist neglected to finish the tail on this horse; he drew it in two sections with the intention of coloring the central portion red to indicate red stroud cloth, which was wrapped around a pony's tail in preparation for war. In this fight, the Navajo rider is pierced by the Kiowa's lance and falls backward.

In cat. no. 74, four men return home from a successful raiding party, brandishing enemy scalps on sticks. The lead rider wears the horned and feathered headgear seen in the preceding image but rides a different horse and lacks that man's distinctive face painting.

A widespread convention in ledger drawing, irrespective of tribe, is the drawing of a scalp as a black and red or blue and red circle with black hair hanging from one side. Sometimes these serve as decorative elements on horses' bridles, or women dance with them in victory celebrations.

In contrast to the two scenes of warfare on horseback, the equestrian scene in cat. no. 75 strikes a lighter note. Two pinto horses, one spotted with orange, the other with blue, carry Kiowa couples dressed for a festive occasion. The coloration of the horses matches the bright blankets worn by the riders. The red, white, and blue parasol adds a stylish touch. The horse gear includes *tapaderos*, Mexican stirrups that cover the feet (McCoy 1987:60).

JCB

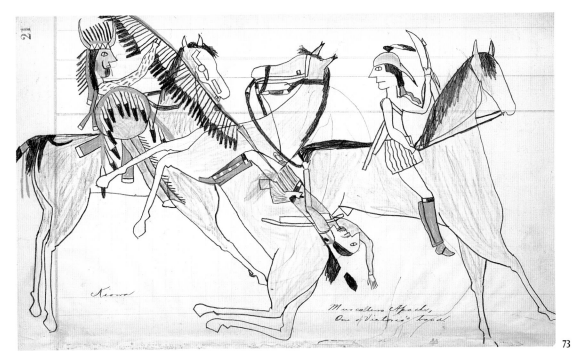

73

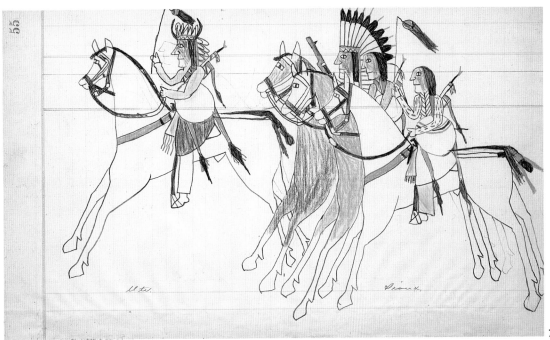

74

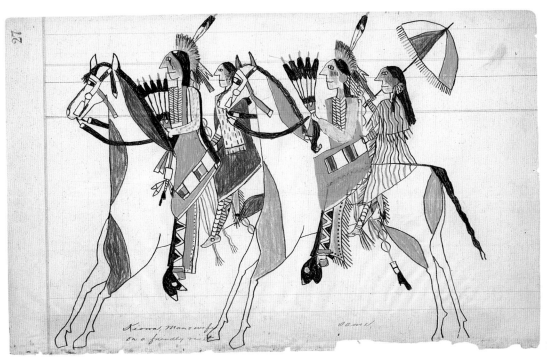

75

JULIAN SCOTT LEDGER ARTIST A
76. Honoring Song at Painted Tipi (57)
1880
Pencil, ink, and colored pencil
7 1/2 x 12 in.
Mr. and Mrs. Charles Diker

JULIAN SCOTT LEDGER ARTIST A
77. *Caddos* (53)
1880
Pencil, ink, and colored pencil
7 1/2 x 12 in.
Mr. and Mrs. Charles Diker

In another drawing by Ledger Artist A, a group of ten men and women approach a cluster of three Kiowa tipis. The tipi in front is an unusual Kiowa tipi known as the Leg Picture Tipi; it is painted with images of dismembered legs and arms, and a stack of red pipes (Ewers 1978:29).

The inscription beneath the figures says "Comanche Women," though half of the figures are male. Comanches dancing in front of Kiowa tipis is a plausible image, for the two tribes had been closely allied since at least 1800. They fought together, camped together, and by the late 1850s received their annuity goods together. They jointly signed the Little Arkansas Treaty of 1865, restricting them to reservation lands in western Texas and southwestern Oklahoma (Mooney 1898:164, 180).

The women in this drawing, whether Comanche or Kiowa, wear items of clothing that reflect the changing times of the second half of the nineteenth century— some are traditional, some were obtained through long-distance trade with other tribes, and some from annuity payments made in the form of yard goods. They include the women's high moccasins of the Southern Plains, dresses of calico, fringed shawls of plain, striped, and plaid trade cloth, and the distinctive red Hudson's Bay blanket with a black stripe.

JCB and JAC

This vivid portrait of a group of Caddos most likely depicts a stomp dance (called the summer pleasure dance by white observers) and not "a visit to the agent," as the banal inscription reads. A description of this dance seems to fit the image:

Two big fires are built, east and west, from ten to fifteen yards apart, and around them anti-sunwise circuits are danced. A man leader gives a shout and other men fall in behind him, the leader singing, the others singing back. After the men have made this start the women fall in, two women behind two men, the leader only going single. Serpentine figures are made, coiling and uncoiling. No drum, no special dress (Parsons, 1941:55).

The constraints of the ledger page probably caused the artist to abbreviate the number of dance participants from groups of two men and women to one of each. The artist did succeed, however, in capturing the joyful spirit of this custom. In the summertime, the Shawnee and other central Oklahoma tribes also held these night social dances or stomp dances. The Shawnee claimed that this kind of dance "with leader shouting and no drum or gourd rattles used," was borrowed from the Creeks (Parsons 1941:55, f.199).

The Caddo were the original occupants of territory in what is now four states: Texas, Louisiana, Oklahoma, and Arkansas. Their location ensured early contact with the expanding American empire in the early nineteenth century and resulted in the forced cession of part of their Aboriginal territory in Louisiana and Arkansas in a treaty with the United States in 1835 (Tanner 1974:16, 98). These bands subsequently moved to Texas (Parsons 1941:7). After the annexation of Texas, the Caddo clustered along the Brazos River, and in 1854 were confined to reservations.

However, whites hostile to the raiding Comanches and Kiowas in their state, soon blamed the peaceful Caddo and the other reservationed tribes. Forced to flee for their lives, they moved in 1859 to Wichita County (present-day Oklahoma), their permanent home ever since (Parsons 1941:7; Tanner 1974:102–3).

Relatively early and brutal encounters with whites made the Caddos eager for peace. By 1874, 401 Caddo were living with their affiliated tribes in log or lumber houses on the Wichita Reservation, where they raised cattle and crops and sent their children to school. The Wichita Agency was situated between those of the Kiowas and Comanches and the Cheyenne and Arapaho; Indians from both reservations were frequent visitors to the Wichita Agency (*Annual Report*, 1874: 223–24). The Caddos depicted here are noteworthy for their highly acculturated dress, including leather shoes for both men and women, tailored jackets, and top hats.

JAC

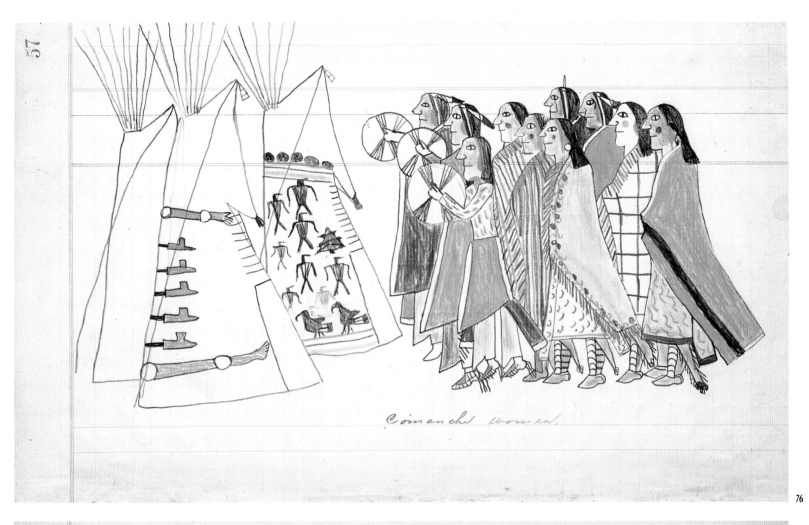

Comanche women.

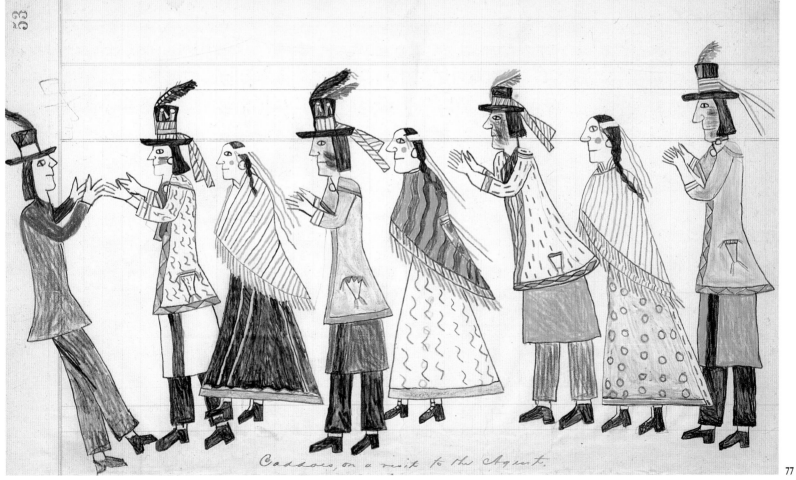

Caddoes, on a visit to the Agent.

JULIAN SCOTT LEDGER ARTIST B
78. Twelve High-Ranking Kiowa Men (59)
1880
Pencil, ink, and colored pencil
7$\frac{1}{2}$ x 12 in.
Mr. and Mrs. Charles Diker

The distinctive work of Julian Scott Ledger Artist B was first discerned by Ron McCoy (1987:5). Both McCoy and Galante (1994a, 1994b) have erroneously claimed that this artist is Pah-Bo, author of the celebrated Kiowa book in the Montclair Art Museum (Maurer 1977:figs. 266a–d). Indeed, one well-known published image by Pah-Bo of a line of finely dressed Kiowa men in profile is, on first inspection of available reproductions, similar to this drawing (Maurer 1977:266b). But a close examination of the original works and a comparison of the details that usually reveal an artist's unique "signature" show that in every case these details are slightly or significantly different: the shape of the nose, the outline of the eye, the shape of feathers, and the delineation of bone breast plates all reveal these works to be by two different hands.

Julian Scott Ledger Artist B has rendered a detailed portrait of twelve Kiowa men in fancy dress. The diversity of materials that make up this finery is extraordinary, ranging from otter skins and feathers to beads, calico, wool cloth, ribbon, German silver, and peace medals. One man wears a red cloth military jacket and carries a saber in a scabbard. All the men wear feathered hair ornaments and have painted faces. The leader has a buffalo head painted over his mouth. Perhaps he is the same warrior whose exploits are commemorated by another artist in cat. no. 73.

JCB

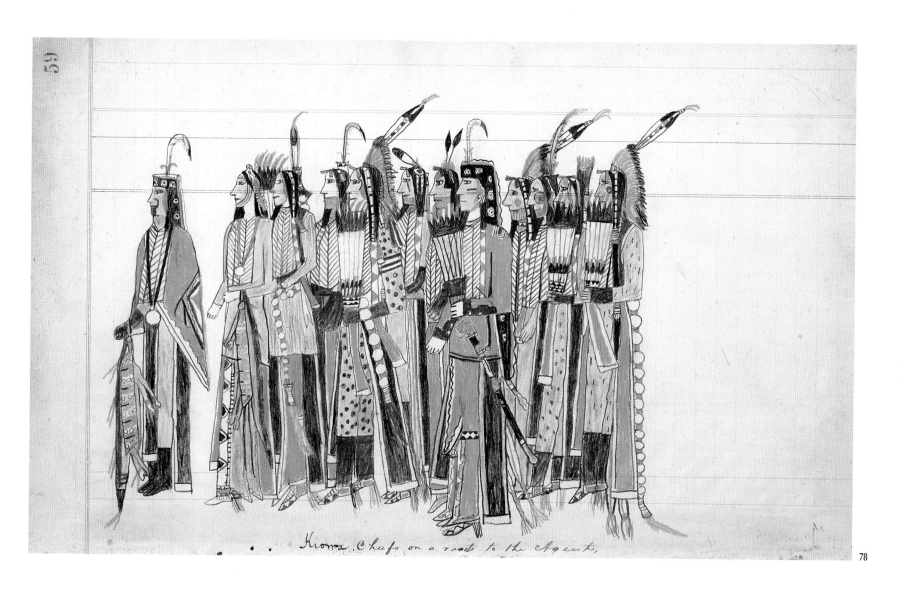

Kiowa Chiefs on a visit to the Agent,

Etahdleuh Doanmoe
(1856–1888)
Kiowa

Catalogue Numbers 79–88

Doanmoe's way of life as a Kiowa warrior was in its ascendancy when it was cut short by the changes sweeping the Southern Plains in the 1870s. He was sentenced to a prison term at Fort Marion, Florida, for his participation in an attack on Adobe Walls, Texas, in 1874 (Pratt 1872–1924). Following his release from Fort Marion in 1878, Doanmoe attended school at the Hampton Institute, Virginia, and in 1879 entered Carlisle Indian School in Pennsylvania. Between brief journeys to the Kiowa Reservation in 1882 and teaching for a brief period in 1887 at the Kiowa Agency school, Doanmoe worked at the Smithsonian and gave several public lectures in the East (Petersen 1971:136). He returned to Kiowa territory in January 1888 to work as a Presbyterian missionary, and died there three months later.

Sixty-nine drawings Doanmoe made at Fort Marion survive today (Petersen 1971:136). Forced to abandon a life based on hunting and to accept the boundaries of a reservation, Doanmoe portrayed in his drawings the collision of competing cultures. His works share with Kiowa artistic traditions a two-dimensional approach to rendering people and events, and an acute attentiveness to visual details. Doanmoe portrayed events drawn from both memory and contemporary experience. In the case of the latter, he expressed an intense interest in Western education, and the symbols and rituals associated with the colonizing power.

Doanmoe eagerly sought, both for himself and other Kiowas, the empowering benefits that Western knowledge appeared to offer. The artist's mastery of writing skills are revealed in his extensive correspondence with Richard H. Pratt, who was the commander at Fort Marion when Doanmoe was incarcerated there (Pratt 1872–1924). These letters also reveal his despair over the poverty and lack of opportunities suffered by his people, and anguish over his prolonged absence from home. Yet his return

to Kiowa territory in 1888 was not easy (Methvin n.d.:58–59). Viewed from a late twentieth-century perspective, Doanmoe's drawings evidence a historical consciousness, an effort to record that consciousness, and a visual acuity in rendering his experiences.

MJW

ETAHDLEUH DOANMOE
79. *A Kiowa Camp* (1)
80. *Plaza and Cathedral, St. Augustine* (36)
1876–77
Pencil and crayon
8½ x 11¼ in.
Yale Collection of Western Americana, Beinecke Rare Book and Manuscript Library, New Haven, Connecticut, 1174

In cat. no. 79, Doanmoe depicted a council session that took place in Kiowa territory. The presence of four decorated tipis, each with its specific icongraphic symbols marking the owner's status and identity, signal that the session was a significant event. Two of the tipis are identifiable. The row of tipis in the foreground stands on what appears to be the northern perimeter of the camp. The second painted tipi from the left, located on the northern flank may be the Buffalo Picture Tipi of Never Got Shot, for it is similar to other depictions of that tipi (Ewers 1978:23). To the Buffalo Picture Tipi's right, and in the center of Doanmoe's drawing, is located the Tail Picture Tipi of the prominent Kiowa warrior and leader, Big Bow, although the tipi's wide blue and narrow red band are transposed in Doanmoe's drawing (see Ewers 1978:18).

Many Kiowa rim the interior of the camp circle. Three of them, including one standing at the eastern entrance to the camp, are wearing German silver hair plates down their backs, indicating their high status (Mooney 1898:318). Three individuals also carry feather fans and one wears a wide-brimmed hat with eagle or crow feathers attached at the top. From inside the camp circle rise two United States flags.

The depiction of a vista to the hills beyond the camp contrasts sharply with the closed-in spaces Doanmoe portrayed in St. Augustine, Florida, where Fort Marion was located (cat. no. 80). His intense curiosity about Western architectural forms resulted in an autobiographical sketch of his journey to the East. In a drawing of the plaza in St. Augustine, the built environment dominates. Doanmoe attentively detailed the church and its bell towers, and the orderly promenades along the plaza pathways. Off to the left of the plaza, and striking in its prominence, is the United States flag, which he rendered with care. In both drawings, the council session and the town plaza, the flags demand further attention.

In seven of his drawings, Doanmoe drew the U. S. flag. In four of these, he accurately reproduced its stars and stripes. The subject matter of those four drawings focused on events in which United States military force was brought to bear against Kiowas. In the drawings of the council session in Kiowa territory and the plaza in St. Augustine, as well as a shark fishing expedition in Florida (not illustrated), Doanmoe altered the flag, replacing its stars with an eagle, a potent symbol of power for both the Kiowas and the U.S. government. Here Doanmoe used the convention of punning, a practice commonly employed in Kiowa language (Watkins 1984). Through the use of punning, Doanmoe transformed the flags' blue and white fields into spaces of artistic autonomy and in the process infused his drawings with layers of ambiguity.

MJW

A Kiowa camp on their reservation near the Washta Mountians. A counsel is in session

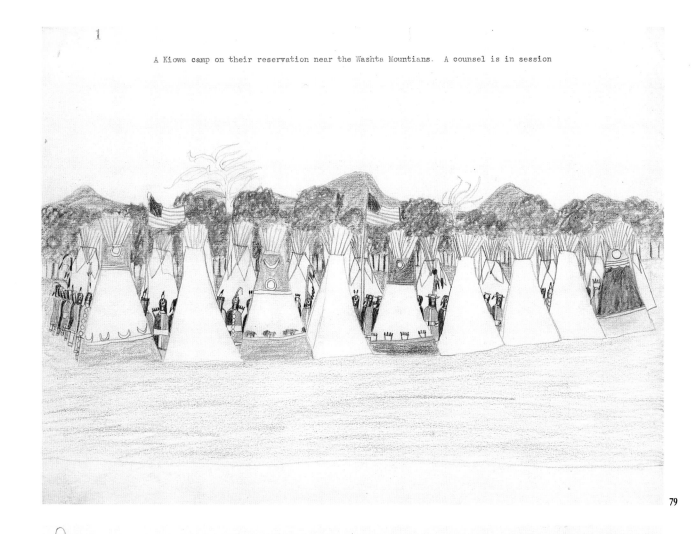

79

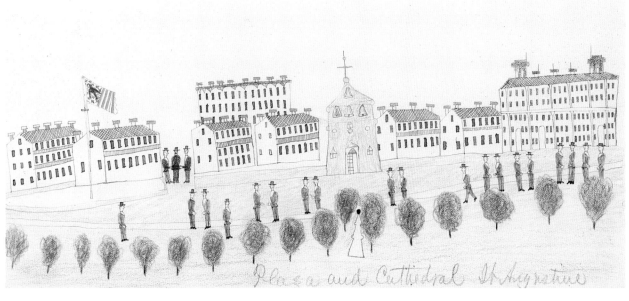

Plaza and Cathedral St Augustine

80

ETAHDLEUH DOANMOE
81. *The Night of the Surrender* (5)
82. *Loading the Prisoners in the Army Wagons* (9)
1876–77
Pencil and crayon
8½ x 11¼ in.
Yale Collection of Western Americana,
Beinecke Rare Book and Manuscript Library,
New Haven, Connecticut, 1174

Doanmoe's drawings of the events surrounding the Kiowas' surrender are enigmatic when compared with their typewritten annotations made by Capt. Pratt. In portraying the surrender, the artist chose three events: the meeting between Big Bow and Kicking Bird (see the essay by Jantzer-White in this volume and her fig. 1 [p. 50]), his last night along Rainy Mountain Creek (cat. no. 81), and the physical reality of captivity (cat. no. 82).

In cat. no. 81, Doanmoe re-created the valley along Rainy Mountain Creek where, on the night following the Kiowas' surrender, they held a dance. The large tipi in the center of the encampment would have belonged to Big Bow, one of the Kiowa leaders. Its sides are raised so that all may participate in the dance. In recalling that night, Pratt stated in the caption that "the Indians had a dance to which they invited Captain Pratt. . . . the incidents of that dance are the most vivid in my memory." Rather than the dance referred to by the caption, Doanmoe depicted the prolonged delay that postponed the dance's start. The Kiowa Awlih, noted for his dancing skill, had been asked by the tribe's leaders to dance but refused to participate (Pratt 1964:98). Awlih and Doanmoe were among those who had been persuaded to surrender.

Doanmoe's drawing includes the military presence at the edge of camp, shown at right. The "colored teamsters" referred to in the caption were members of the four black companies of the Tenth Cavalry, which were stationed at the newly established Fort Sill. The morning following the dance, the Kiowas departed for Fort Sill, as depicted in cat. no. 82. Among those arbitrarily selected for imprisonment by Kiowa leader Kicking Bird were young men such as Doanmoe who had not yet achieved reputations as noteworthy warriors (Auchiah, Pratt Papers). The prisoners were loaded into eight army wagons, their legs secured to chains that extended the length of each wagon. Armed troops of the Fourth Cavalry, seen seated on the left and standing in the foreground, deterred any hope of escape. On reaching the railroad, the Native Americans were transferred to a special train for the trip to Fort Leavenworth, Kansas. From there they would travel to Fort Marion, Florida.

MJW

The night of the surrender and after they had given up their arms and all war material
and had received rations the Indians had a dance to which they invited Capt. Pratt and
his interpreter, Phil McCusker. The incidents of that dance are among the most vivid
in my memory. There were 72 lodges and about that many warriors beside their women and
children, about 200 in all. I had eight Indian scouts, the interpreter, two wagons with
colored teamsters and three tents. (See on one side)

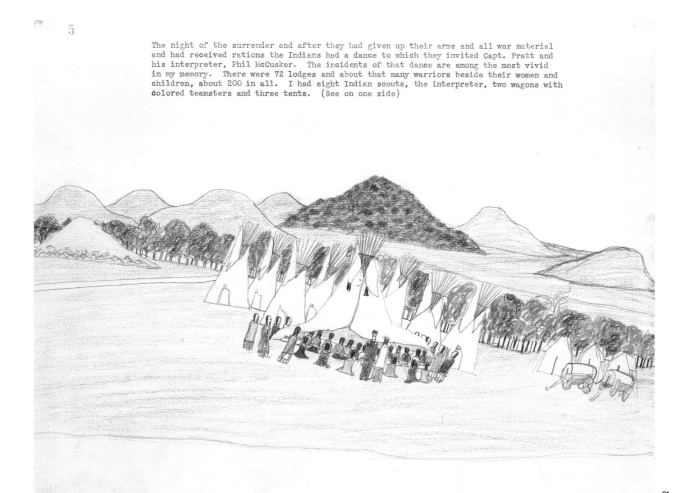

81

Loading the prisoners in the Army wagons in the beds of which they were all securely

chained to be taken 164 miles to this Railroad, enroute to old Fort Marion, Florida.

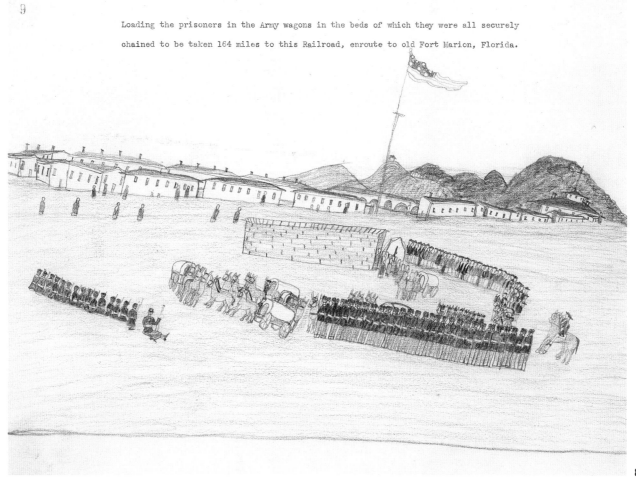

82

ETAHDLEUH DOANMOE

83. *The Arrival in Nashville* (15)
84. Trains and Houses (35) (Berlo, "Drawing
and Being Drawn In," pl. 3 [p. 15])
85. *Transferred from the Train to Steamboat
at Jacksonville* (18)
1876–77
Pencil and crayon
8½ x 11¼ in. each
Yale Collection of Western Americana,
Beinecke Rare Book and Manuscript Library,
New Haven, Connecticut, 1174

In chronicling his journey east, Doanmoe selected architecture and trains as elements expressive of Western identity. Throngs of curiosity seekers crowded the Florida-bound train at each depot—Indianapolis, St. Louis, Nashville, Atlanta, and Jacksonville—to catch a glimpse of the prisoners. Doanmoe's visual perspectives on the Nashville stopover provides a position from which we might approach cat. no. 83. On the platform the curious spectators, with whom the viewer might have identified, await the train's early-morning arrival. A long row of buildings flanks the train, and a church steeple rises behind the railway terminal building. The alienation produced by the Indians' dislocation, which was exacerbated by the objectifying gazes of the crowd, of course, carried its own consequences. On the outskirts of Nashville, the Cheyenne Lean Bear attempted suicide and was carried from the train (drawn by Doanmoe but not illustrated here). He died several weeks later in Florida from self-induced starvation (Pratt 1964:113).

The concept of alienation had no iconographic precedent in pre-reservation Plains artistic practices (but see Berlo 1990:133–41). Yet as the train, traversing town after town, left behind the vast expanses of Kiowa territory, the incongruity of what Doanmoe witnessed did not escape him; expansion of United States cities meant contraction of Southern Plains homelands. Not surprisingly, Doanmoe's

subject matter changed, from warrior activities, in which he had participated only briefly, to the contemporary experiences brought about by deportation to the East. Western strategies of containment generated a new vocabulary with which Doanmoe and others represented its associated experiences.

In cat. no. 84, Doanmoe depicted one of the many towns passed during the journey to Fort Marion. Once again, his straightforward manner of presentation hints at an underlying complexity. Two trains pass each other in the foreground of the drawing, each traveling in different directions. The irony engendered by their juxtaposition is unmistakable. The trains are poignant metaphors for the human cargoes that they carried; the Indians, as not only prisoners, but hostages, were assurances that their respective peoples would desist from engaging in further warfare. Their removal opened the way for unfettered white expansion west onto lands formerly occupied by Indians of the Southern Plains. As in Doanmoe's other drawings of the train's journey, Indians are not directly represented. Their presence is implied by the many spectators who gathered along the train's route.

The men's arrival in Jacksonville, Florida, and their subsequent transfer to a waiting steamboat is the subject of cat. no. 85. Doanmoe chose to depict the moment of boarding. Standing on the long pier behind the Indians is the military, rarely absent from Doanmoe's drawings.

How drawings operated in an Aboriginal context is relevant here, for pictorial imagery functioned in close concert with its oral recountings. Quaker missionary Thomas Battey, working among the Kiowas in 1873, was surprised by the strong responses to his stereoscopic photographs (1968:257). Battey recorded that Kiowas who had never traveled to eastern parts of the country usually expressed skepticism when their peers described both the size of eastern cities and the numbers of their inhabitants. Disbelief vanished when Battey produced his pictures. According to Battey, many Kiowas stated that it was impossible to make an imaginary picture, and insisted that a picture was "proof positive" of an original. Conversely, the possibility of an original depended upon the veracity of its imagery. Doanmoe's drawings of this journey and of the many cities he encountered served as "proof" of his experiences.

MJW

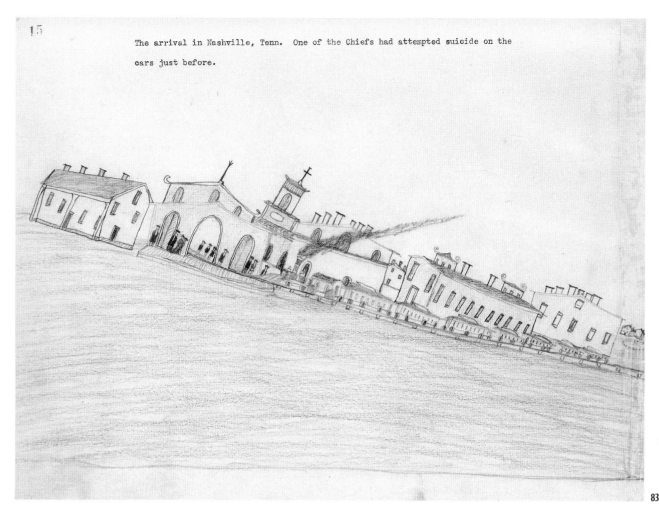

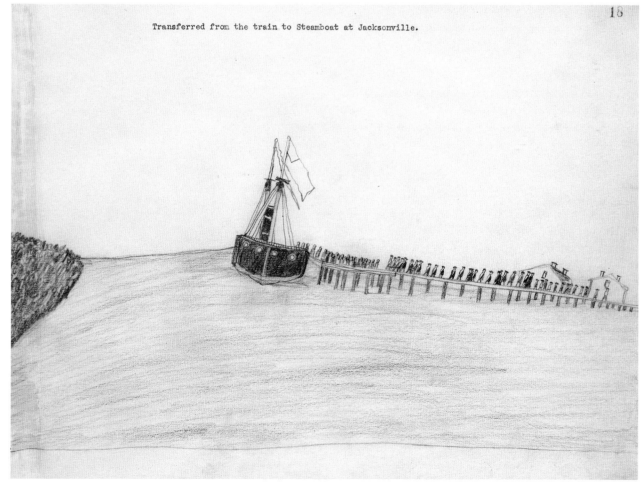

ETAHDLEUH DOANMOE
86. *Inside Fort Marion* (20)
87. *Indians Moving Heavy Cannon* (14)
1876–77
Pencil and crayon
8½ x 11¼ in. each
Yale Collection of Western Americana,
Beinecke Rare Book and Manuscript Library,
New Haven, Connecticut, 1174

Doanmoe's drawings of Fort Marion constitute what, from a twentieth-century perspective, might be described as imaging the "ceremonial of public punishment" (Foucault 1979:43). Exhibited in public, the crime and its punishment have been made legible for all.

The first permanent European settlement on the mainland of the United States, the city of St. Augustine is located on a peninsula that juts southward. Fort Marion is located on the ocean side of the peninsula, and a wall blocks the northern approach to Fort Marion. Originally erected by the Spanish in the late 1600s to counteract French threats from the north, Castillo de San Marcos (Fort Marion) also served as a defense against English threats after the French had been driven from the area (Utley in Pratt 1964:fn.2). The United States renamed the Castillo Fort Marion after it added Florida to its possessions in 1821. A sea wall extended along the ocean side of Fort Marion, creating a moat effect. Following its role in the wars between the Spanish and English during the 1700s, the Castillo was used as a prison for Indians by the United States, after its campaigns against the Seminoles during the 1800s.

In cat. no. 86, a depiction of Fort Marion, Doanmoe singled out a moment of respite on the terreplein, the platform behind the parapet. In anticipation of the Indians' arrival, the local military authorities had boarded up the ramp from the inside courtyard to the terreplein, rendering it inaccessible. A locked entrance in the courtyard provided the terreplein's only access. Restricted to the inside courtyard— roughly one hundred square feet—the captives could neither see out, nor be seen by others (Pratt 1964:117). The terreplein provided a break from the massive stone walls and continuous surveillance. Capt. Pratt arranged for the prisoners to have daily breaks on the terreplein and, within a few

weeks after arriving at Fort Marion, he ordered removal of the men's shackles.

Casements rimmed the interior of the courtyard on all sides. The only windows in the casements opened onto the interior of the courtyard, and these bore heavy iron grills. A drawbridge provided the courtyard's single entrance and exit (Pratt 1964:118).

This architectural and surveillance system defined the mechanisms of power. Its purpose was to contain, discipline, punish, and reform. The arrangement allowed for an exercise of control that, once established, required little overt application of outside force. Early in the prisoners' internment period, Capt. Pratt argued persuasively for the right of the Indians to act as their own guards. Fifty were selected, and throughout the next three years, they fulfilled dual roles as both prisoners and guards.

Employment while in prison earned the men funds with which to purchase personal items and provided "valuable object lessons" (Pratt 1964:130). Enterprises such as operating a block and tackle for well-digging, polishing the shells of sea beans for sale to tourists, and, as shown in cat. no. 87, moving a heavy cannon, broke the tedium of confinement. Here two rows of men are shown pulling a cannon, aided by a track system they have assembled. Initiated by Pratt, work for wages inculcated the concept of private ownership of property.

MJW

Inside Fort Marion. (Indians on terreplein)

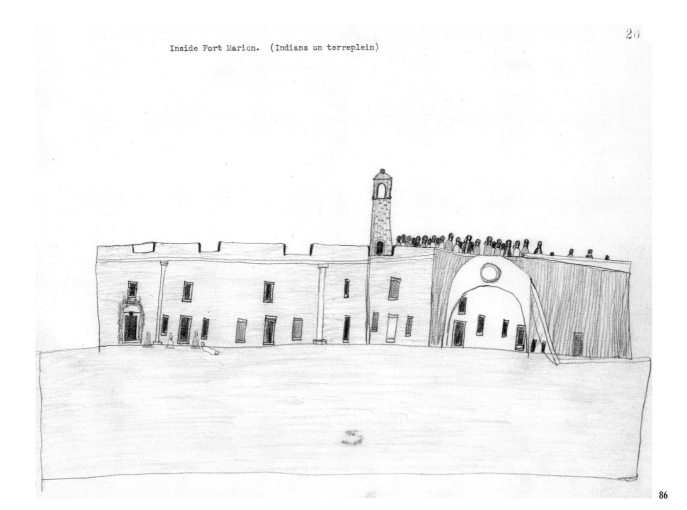

86

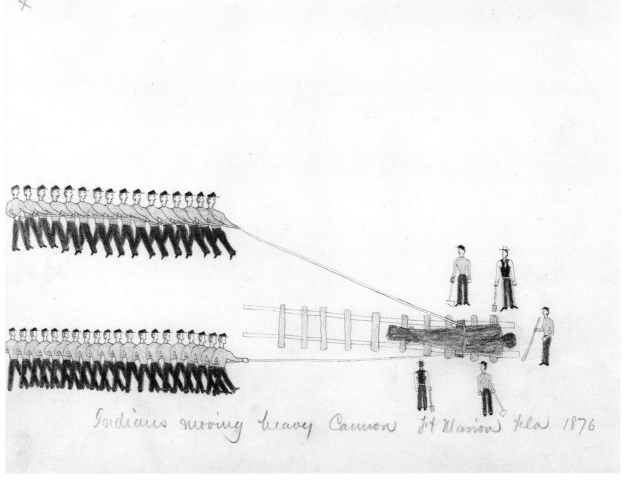

Indians moving heavy Cannon Ft Marion Fla. 1876

87

ETAHDLEUH DOANMOE
88. *An Omaha Dance* (25)
1876–77
Pencil and crayon
8½ x 11¼ in.
Yale Collection of Western Americana,
Beinecke Rare Book and Manuscript Library,
New Haven, Connecticut, 1174

Here Doanmoe depicted the Ohoma (Omaha) or victory dance. While incarcerated at Fort Marion, the men occasionally conducted dances. Doanmoe's drawing of a dance in progress illustrates the gestures and specific movements with which the warriors re-enacted battle deeds. These dances served a vital mnemonic function. Some of the dancers are shown carrying the shortened bows adapted by Kiowas for use on horseback. While on the Plains, the ceremonial drum, the "Voice of Thunder," signaled the start of the dance (Boyd 1983, v. 2:65–67). Here, Doanmoe has substituted a fire for the dance's voice.

Doanmoe's drawing includes numerous Euro-American spectators, whom we see focusing attentively on the nine dancers. But the casual demeanor of an audience of peers, who by that seeming inattentiveness identify themselves as participants familiar with the event, is absent from the spectators depicted here. The tourists in Doanmoe's drawing are not participants but outsiders, and thus not an integral part of the creative process of the dance. Other Fort Marion artists, including Cohoe and Zotom, depicted dances performed at the prison as well (Berlo 1990:fig. 4; Anon. 1969:87).

MJW

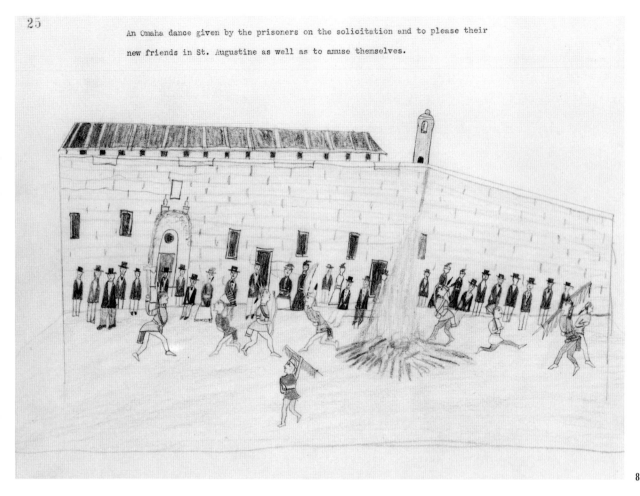

25

An Omaha dance given by the prisoners on the solicitation and to please their new friends in St. Augustine as well as to amuse themselves.

88

164

Silverhorn
(1861–1940)
Kiowa

Catalogue Numbers 89–94

Silverhorn (Haungooah) was the premiere artist of the Kiowa tribe. Sought out by collectors and anthropologists as well as Kiowa patrons, he produced drawings on tipi covers, hides, and muslins as well as a prodigious number of works on paper. His artistic career spanned four decades, and his drawings form a link between the era of Plains ledger art and the revival of painting on the Southern Plains in the 1920s. His first lessons in drawing were provided by his older half-brother, Hill Slope (Haba) (Mooney n.d.). His full brother, Ohettoint (High Forehead), was one of the artists imprisoned at Fort Marion (Petersen 1971:162). Silverhorn, in turn, instructed his nephew Stephen Mopope (Jacobson n.d.), one of the noted Kiowa Five, in drawing; his son George Silverhorn was also a painter.

Silverhorn's earliest known works were produced in the 1880s and are well within the ledger tradition in both style and content. There is no effort to model figures, no depiction of setting beyond a shaded groundline, and the content consists primarily of scenes of warfare, courting, and, less frequently, hunting. Yet Silverhorn's interest in illustrating wider aspects of tribal life was already evident in his early works, as he included in them depictions of the Medicine Lodge (Sun Dance) and other ceremonies. By the next decade he was extensively involved in producing pictures showing many aspects of Kiowa life. Such illustrations of major ceremonies were occasionally made by other artists as well, but Silverhorn's depictions of myths, folk stories, and scenes of daily life represented a unique expansion of traditional subject matter.

During the 1890s Silverhorn experimented with new methods of illustration based on Western concepts of naturalistic depiction (Greene 1993:30–31). He produced figures delineated with sketched lines rather than the firm single outline of ledger art, and he used line and shading to model them into three-dimensional forms. He also tried his hand at portraying individual faces. He placed these new figures in equally new landscapes, complex backgrounds that at times filled the page. The experiment was not, however, continued. Silverhorn soon returned to producing simpler, more traditional representations, eliminating extraneous detail and depicting only the elements that were important to the story he was illustrating. He settled on his mature style because it worked well for what he wished to convey, not because he was ignorant of other alternatives or incapable of producing them.

James Mooney, studying the Kiowa in the late nineteenth and early twentieth centuries, found in Silverhorn an ideal collaborator, and he regularly employed him as an artist during the early years of this century. Under the direction of the older men of the tribe, Silverhorn produced detailed drawings of shield designs and other aspects of culture that Mooney was interested in recording, and subsequently painted the designs onto small buckskin shield models now in the Smithsonian collection (Merrill et al. 1996). At Mooney's request, he also produced a series of paintings on hide (Maurer 1992:162–65), which may have launched his career in that medium. Many of Silverhorn's late works, made in the 1910s and perhaps even 1920s, when his eyesight was seriously impaired, are paintings on hide (see the essay by Rushing in this volume, fig. 7 [p. 59]). In his personal career Silverhorn thus acted out in reverse the sequence of development of ledger art, moving from works on paper to works on hide.

CSG

SILVERHORN
89. *Preparing for a War Expedition* (1)
90. Little Mountain and Navajo (9)
91. Kiowa and Navajo (13)
92. *Kiowa Lancing Osage* (23)
93. *Little Robe Lancing a Navajo* (24a)
94. *Kiowa Lancing a Pawnee* (28)
ca. 1887
Pencil and crayon
9³/₄ x 13¹/₂ in. each
Marion Koogler McNay Art Museum, San Antonio, Gift of Mrs. Terrell Bartlett, 1962.1.1, .9, .13, .23, .24a, .28

Among the earliest known works by Silverhorn, these drawings are from a bound volume of thirty-two pictures, primarily scenes of warfare. The book was acquired by Capt. (later Gen.) John L. Bullis and is inscribed with the name of the artist and with identifying captions provided by Horace P. Jones, who served for many years as an interpreter of Kiowa and Comanche at Fort Sill, Indian Territory (Williams 1990:49). Jones's inscriptions are dated 1887, but the drawings may date from a few years earlier.

Silverhorn's earliest drawings display confidence and energy, with bold figures filling much of each page. Horses are drawn with massive hooves and flaring nostrils, their heads set on soaring necks far above their riders. Human forms are elongated, their verticality echoed in the trailing ends of breech cloths and the streamers from their shields. Four of these drawings (cat. nos. 89, 91, 92, 94) display a motif that Silverhorn was to utilize as a compositional device many times throughout his career—the mounted warrior with lowered lance. The diagonal line of the lance unites warrior and enemy and balances the opposite diagonal formed by the neck of the horse and the rider's trailing gear. In fact, lances were not common weapons among the Kiowa, for once a lance was lowered, the warrior was obliged to charge without retreat (LaBarre n.d.:1204). Silverhorn's love of decorative detail, highly developed in later works, shows itself here in cat. no. 89,

where the warrior's costume is carefully depicted, from the ermine trailers on his bonnet to the beaded bear paw designs on his leggings.

While Silverhorn had a distinctive personal style, these early drawings are firmly rooted within the ledger tradition and its emphasis on scenes of warfare. The works illustrated here show combat with the shaved-headed Pawnee, who harassed the Kiowa on their eastern borders, and the Navajo (with a wrapped club of hair), against whom the Kiowa mounted many horse-raiding expeditions. While the enemies are identifiable, the individual Kiowa warriors are not. The shields that they carry, the most common pictorial method of denoting a warrior's identity, do not match any of the Kiowa shields so fully documented by Smithsonian anthropologist James Mooney. Of the noted warriors named in the captions, Heap of Bears actually carried a black shield with a white disk in the center, while Little Mountain, also known as Little Bluff, had a yellow shield with a scalp wrapped in cloth attached to the center (Merrill et al. 1996). Such discrepancies cast some doubt on the reliability of the captions. Ledger art created for viewing within the Native community was highly accurate in its representation of people and events. Art made for sale to an outside audience was often much less so, and may represent generic pictures of types of events rather than the prized exploits of individual warriors (Greene 1992a:55–56). In these drawings, Silverhorn does not follow the original ledger tradition of celebrating specific personal exploits but instead offers more generalized illustrations of the ways of war, suggesting that these pictures were not intended for a Kiowa audience.

CSG

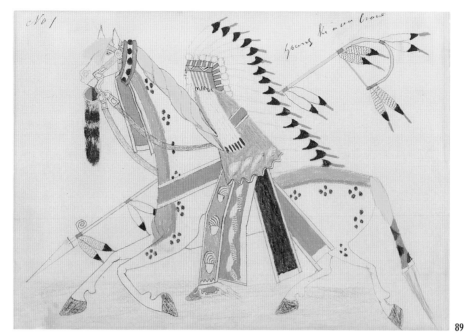

89

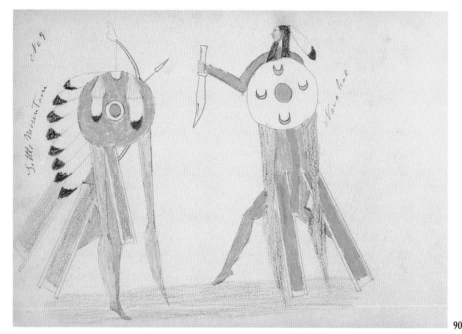

90

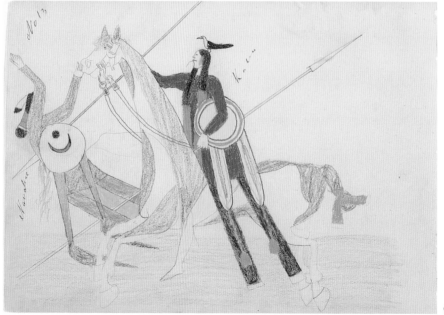

91

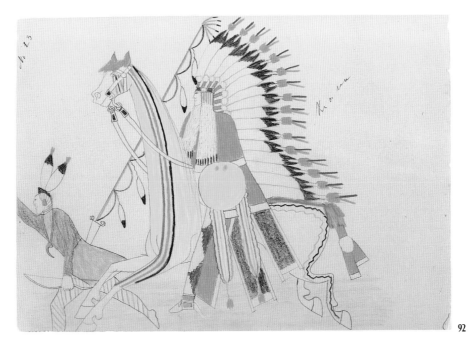

92

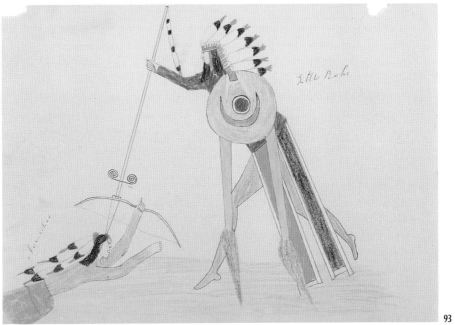

93

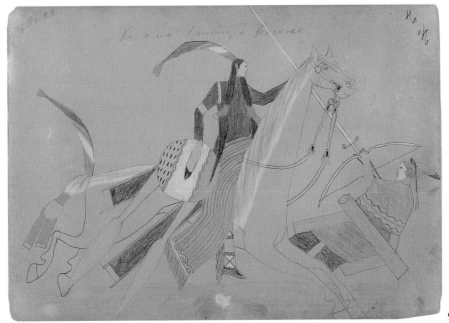

94

Wohaw
(1855–1924)
Kiowa

Catalogue Numbers 95–101

Wohaw was a twenty-year-old warrior who had already been imprisoned at Fort Sill for seven months, accused of killing three whites, when in 1875 he was sent to Fort Marion (Petersen 1971:209). His two drawing books in the Missouri Historical Society provide the most complete record of his work as an artist (Harris 1989; Berlo 1982; Jensen 1950), but an unsigned book of drawings, on loan to the Minneapolis Institute of Arts, may be his as well.

Wohaw did not elect to join the seventeen Fort Marion prisoners who went on to school at the Hampton Institute in Virginia in 1878. He returned to the Kiowa Reservation, where he attended school, dropped out, joined the Indian Agency police force, and later an Indian Troop of the U.S. Cavalry. Wohaw died on the Kiowa Reservation in 1924 at the age of sixty-nine (Petersen 1971:209–10).

JCB

WOHAW
95. High-Ranking Kiowa and Their Tipis (6)
96. Sixteen Prominent Men in Their Trade Cloth Blankets (36)
1876–77
Pencil and crayon
8¾ x 11¼ in. each
Missouri Historical Society, St. Louis, 1882.18.6, .36

In cat. no. 95, Wohaw has depicted Kiowa tipi designs, as did several unidentified Kiowa artists a few years later (see cat. nos. 71, 72, 76). While the ones Wohaw drew are not identifiable today, in the 1870s the identity of the owner would have been common knowledge to a Kiowa viewer. The tipi on the left, with its red flaps, red painted base with blue stripe, and central field bordered by numerous feather fans, is reminiscent of the Tail Picture Tipi of Big Bow, the Kiowa chief and war leader. Big Bow's tipi, as replicated for ethnologist James Mooney by Big Bow's daughter-in-law in 1904, did not, however, have the celestial motifs evident in Wohaw's rendering (Ewers 1978:fig. 10). The tipi on the right features sun emblems, blue Maltese crosses, and green stars on the central field. Both tipis have a blue sun and green crescent moon painted on red at the upper back, near the smoke hole.

That the men standing in front of these tipis were, like Big Bow, high-ranking leaders, is evident from their formal dress. Both wear U.S. military jackets, German silver hair plates cascading down their backs, and bone breast plates. Peace medals on green ribbons are worn conspicuously over their breast plates. These silver medallions, given to Indian leaders from the 1790s to the 1890s in commemoration of treaties and important delegations, became an integral part of ceremonial attire (Prucha 1985).

On the far left, behind the tipis, flies a U.S. flag. Similarly rendered flags fly over the heads of the party of sixteen men in cat. no. 96, indicating perhaps the groups' arrival at a fort or place of treaty. The dense cluster of men forms an almost abstract pattern in red, black, and brown. The artist has carefully delineated the details of their ceremonial dress. Some have their braids wrapped with red and white trade cloth. Most wear bone breast plates, cloth or skin leggings, and fine moccasins. All wear blankets made from trade cloth, either striped or red and black.

Plains Indian women embellished the bold red and black blankets by adding beaded medallion strips (see Penney 1992:figs. 87–91). A dozen of the men pictured here wear such beaded blankets. The striped robes may be either Navajo or Mexican trade blankets, which were so highly prized as an item of long-distance trade that one Lakota winter count even records as the most important event of 1853–54 the first appearance of such blankets on the Northern Plains (Mallery 1893:fig. 238). Even today, on ceremonial occasions, Plains Indian men of wealth and high social standing wear red and black wool blankets with finely beaded strips (see Doll 1994:64).

JCB

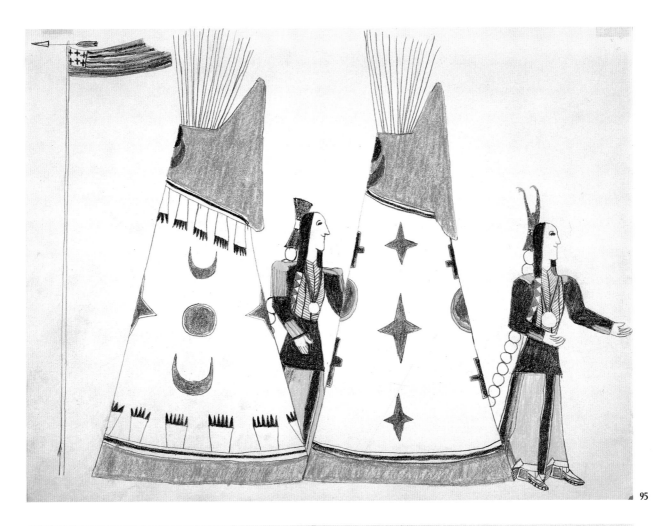

95

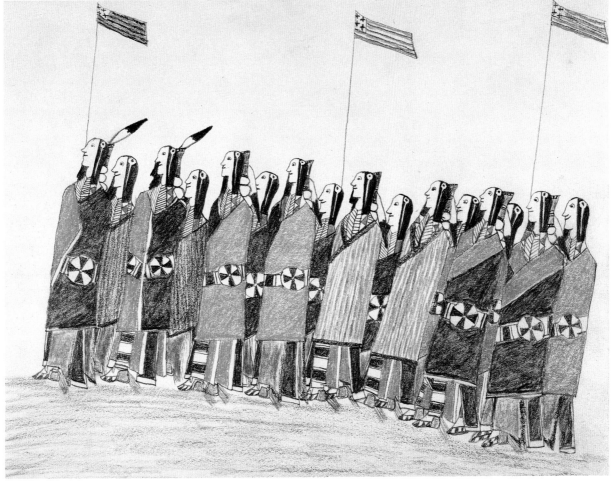

96

169

WOHAW
97. Landscape with Campfire (37)
1876–77
Pencil and crayon
8³/₄ x 11¹/₄ in.
Missouri Historical Society, St. Louis,
1882.18.19, .37

Setting figures in a landscape was not
traditional in Plains pictography. On hides,
robes, and in many drawings, figures float
in a background marked by footprints, fly-
ing bullets, or a line of rifle fire. The artists
at Fort Marion were among the first to
place their figures in landscapes in an
accomplished way. Scenes of military bar-
racks, white settlements, and depictions of
Fort Marion itself were among the most
common in which Euro-American conven-
tions of landscape setting were used, but
a number of artists found these newly
learned pictorial conventions effective for
scenes of traditional life as well.

In the drawing presented here, Wohaw
has depicted a scene in which buffalo ribs
are being cooked over a campfire tended by
three men. Their horses have been relieved
of their trappings and graze nearby. The
rolling, grassy hills of the Southern Plains,
dotted with small green trees, have been
effectively rendered. Wohaw has shown
foreground, middleground, and background
(though the large scale of the heads that
emerge above the far horizon are larger
rather than smaller than the figures in the
foreground). At the left edge of the paper,
a buffalo head peeks over the horizon.

JCB

WOHAW
98. Arrival of the Taimay Keeper's
Messenger (30)
99. The Taimay Power and the Sun Dance
Lodge (46) (Poitras, pl. 1 [p. 69])
1876–77
Pencil and crayon
8³/₄ x 11¹/₄ in.
Missouri Historical Society, St. Louis,
1882.18.30, .46

The Taimay is the ancient sacred medicine
image of the Kiowa; it is displayed only
during the summer Sun Dance. This power-
ful effigy was described by one early
observer as made "in the likeness of a small
person, or doll, without legs. Its head is a
small round stone covered with deerskin
painted to resemble a person. It wears a
shell gorget and has an eagle feather on its
head; its body is made of deerskin and has
short eagle body feathers hanging down all
over it." During the Sun Dance, the Taimay
was "tied to a staff about six feet long,
stuck in the ground, in front of a cedar
screen [in the Sun Dance lodge]" (Scott
1911:348). In cat. no. 99, the Taimay rests
on the ground in front of the Sun Dance
Lodge. The Taimay Keeper, painted yellow,
his arms and face raised to the sky, seems
to mediate between the power of the
Thunderbirds above and the Taimay below.
The Taimay Keeper's body and face paint
correspond to Scott's description a genera-
tion after Wohaw drew them: "When the
Taimay Keeper went into the Medicine
Lodge, his face was painted, like that of the
Taimay itself, with red and black zigzag
lines downward from the eyes. He wore a
skirt made of deerskin painted yellow, and
his body was painted the same color"
(1911:351).

Harris has interpreted the image in cat.
no. 98 as the visit of the Taimay Keeper's
messenger to a Kiowa camp, announcing
the time of the Sun Dance (1989:76).
A finely dressed man arrives at a camp on
horseback, where he is greeted by two
seated men, a standing woman, and a small
girl, all of whom rest within a shady tree-
branch and wattle enclosure. Another
woman stands outside, and three horses,
shown in profile, peer out from behind the
enclosure. The visitor is greeted with
dignity and hospitality: the hosts are finely
dressed, and a pipe is offered for smoking.

Although the honeymooners from St.
Louis, Frances and John Grady, who pur-
chased this book on their trip to Jackson-
ville and St. Augustine in January 1877
certainly had no idea of the meaning of
the images, the artist who made them was
remembering the most sacred mysteries of
his Kiowa heritage and keeping those
memories alive by inscribing their images
in small drawing books.

JCB

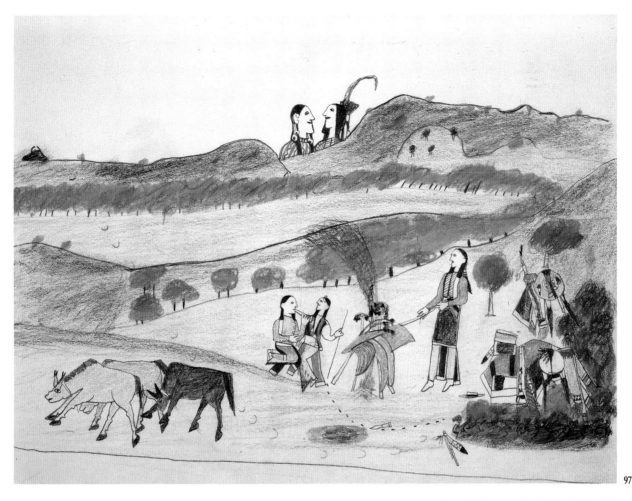

97

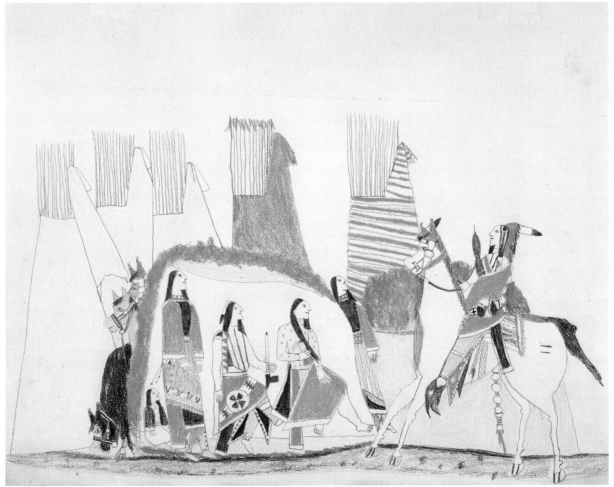

98

171

WOHAW

100. By Steamboat up the St. John's River
(11)
1877
Pencil and crayon
8³/₄ x 11¹/₄ in.
Missouri Historical Society, St. Louis,
1882.18.11

In 1812, the first successful trip by steam-boat down the Ohio and Mississippi rivers showed the country the practicality of utilizing steam-powered vessels in the westward expansion of American civiliza-tion. The first attempt to navigate the Missouri River just seven years later was praised by President Monroe as the means to protect American trading interests and bring not only pacification but "civilization" to the Indians of the Plains region (Whitman 1985:3; Watkins 1913:163). By 1841, steamboat travel on the Missouri River had become so commonplace that one Western observer exclaimed, "Steam navigation col-onized the west!" (Whitman, 1985:10).

Steamboat deck divisions accurately mirrored nineteenth-century societal divi-sions. Lower decks carried the cargo, which included low-ranking crew members and the lower classes; these passengers either paid cheap fares or worked for free passage. Conditions on these decks were crowded and unsanitary, breeding grounds for the many infectious and fatal diseases—such as cholera and yellow fever—that were epidemic in the nineteenth century. The lower decks were also dangerous: they surrounded the steamboat boilers, which tended to explode all too often due to poor construction or mishandling.

The upper decks were reserved for the paying passengers. There, the luxurious amenities and elaborate decor allowed peo-ple to travel in high style, oblivious to the squalor beneath them. Indeed, so resplen-dent were some paddle-wheel steamboats in their size, decoration, and accommoda-tions that they were dubbed "floating palaces" and defined the golden age of steamboating in America. At the industry's peak, in 1871, 155 vessels were launched (Watson 1985:42). However, this large number concealed the steady decline of steamboat travel in America in the wake of the post–Civil War railroad revolution. By the 1880s, railroads had generally replaced steamboats as the preferred means of ship-ment and travel to and in the West; only where tracks were absent did steamboats continue to thrive into the twentieth cen-tury (Whitman 1985; Watson 1985).

In May 1875, a side-wheeler steamboat left Jacksonville, Florida, conveying down the St. John's River some unusual deck passengers bound for Fort Marion prison. Wohaw depicted this steamboat trip to Fort Marion, but he showed not his personal experience of it but rather a detached observance of the American societal reality of steamboat travel described above. He portrayed only the captain and the upper-deck passengers, presumably tourists; neither he nor his fellow Indian captives are in evidence. Probably confined to the lower deck in chains along with other cargo, the future occupants of Fort Marion prison are as invisible to the viewer as they were in "polite" society. Moreover, the placid expressions of the tourists suggest that

this is a pleasure trip for them; the boat's fettered cargo beneath them is irrelevant. Indeed, St. Augustine was a popular resort among the cultural elite of the time and highly prized because of its remoteness (Petersen 1971:65). Ironically, the prisoners themselves would soon add to the tourist attractions of St. Augustine. Thus, Wohaw's curiosity about and meticulous recording of the realities of steamboat travel serves also as symbolic commentary on nineteenth-century Euro-American society and the Indians' place in it.

JAC

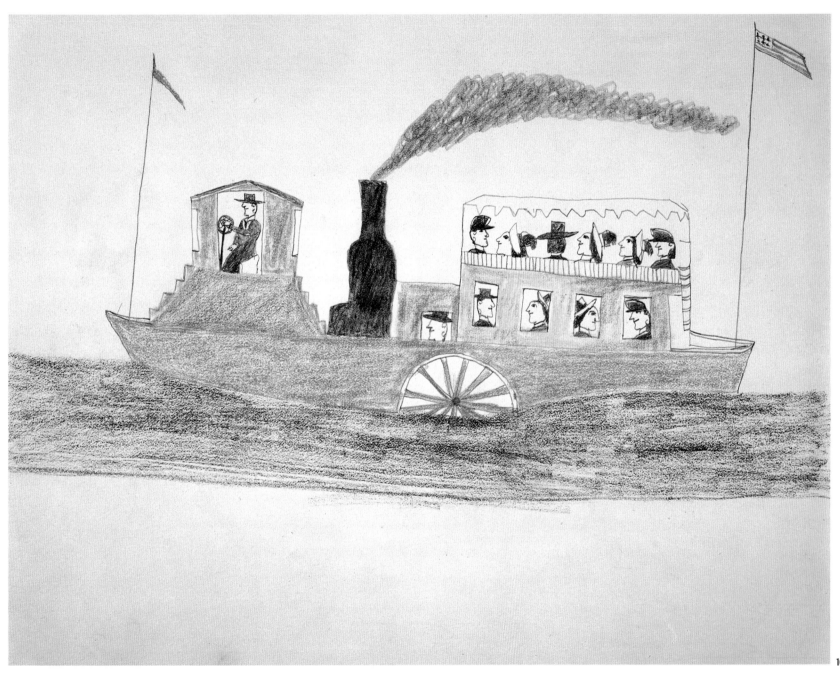

WOHAW
101. Kiowa Portraits
1877
Pencil and crayon
8³/₄ x 11¹/₄ in.
Missouri Historical Society, St. Louis,
1882.18.4

While Wohaw and others at Fort Marion were making images in small drawing books, the art of photography was burgeoning on the Great Plains. By 1870, twenty years after the invention of photography, myriad types of studio portraits and plein-air photographs were being taken of Native Americans as well as their geographic homeland (Blume 1995; Bush and Mitchell 1994). Edward Curtis, among many others, was driven by something between melancholy and acquisitiveness to capture the image of Native Americans before they "vanished." Other prolific photographers who preceded him, in the late nineteenth century, were employees of speculation companies documenting land and incidents of history, or official government photographers documenting treaty signings, for example. Photography was a new technology whose authority in terms of representing the visual world was as astonishing to Native Americans as was the cannon fire that could, with one gesture, destroy an entire area and group of people.

Before he was imprisoned, and certainly while at Fort Marion, Wohaw would have seen many photographs. In his life as a warrior he may have been present at treaty signings with attendant photographers. Many photos were taken of the Fort Marion prisoners, and this event became subject matter for the prisoners' art as well (see cat. no. 61). More than most other Fort Marion artists, Wohaw incorporated the format of the photograph into certain of his drawings. In this particular drawing there are three framed portraits. The one on the left depicts two high-ranking Kiowa men wearing U.S. military uniforms; one wears a peace medal. The middle image is of a Kiowa warrior in traditional dress who appears to be posing in standard portrait style. On the right is a group portrait of Kiowas, both male and female.

Native American drawing, like photography, is prone to meticulous detail of outer appearance. In this drawing this shared aesthetic has made the portraits even more photograph-like than the framing and postures alone would suggest. Most unphotographic, however, at least in composition, is the inclusion of the lone tree between the second and third framed images, and the warrior on horseback riding beneath the portraits, suspended in his own space. In his image of the classroom at Fort Marion (see Blume essay in this volume, pl. 3 [p. 41]), Wohaw had already shown a propensity to use a combination of divergent visual modes as a way to juxtapose or deepen meanings. Here the riding horseman and floating tree, outside the constraints of framing, jar—like a good collage—our assumptions about place and time and relations within a representation. In mimicking the format of photography, Wohaw has already entered a realm of authority he and his cohorts usually played the object to. Here he is the master artificer. To jumble and juxtapose his mastery and imitation of the photograph with these elements of a world seen but not simply contained is to up the ante of meanings and the range of his expression. The tree and warrior are rendered as a trace of what could not be contained or circumscribed by the dominant and expanding culture of the white West.

AB

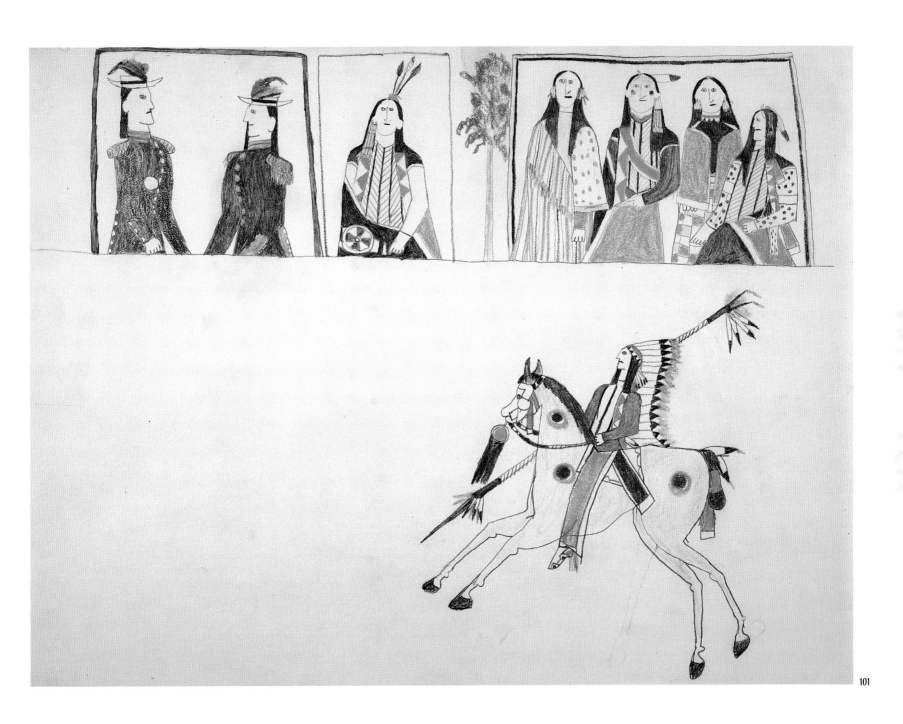

Zotom
1853–1913
Kiowa

Catalogue Numbers 102–5

An accomplished warrior and raider before his incarceration in Fort Marion prison, Zotom was among the several artists who chronicled not only traditional Kiowa life ways but also the vastly changed life of a warrior in captivity. In addition to being an artist, Zotom was a bugler at Fort Marion. After his release, he and Making Medicine went to New York State to train as deacons of the Episcopal church. Zotom then returned to Indian Territory, where after some years he renounced his Christian ministry and turned back to traditional Kiowa spirituality and later to the peyote religion of the Native American church (Petersen 1971:190).

JCB

ZOTOM
102. *Building a Kiowa Medicine House*
1876
Pencil and colored pencil
5 x 7½ in.
Yale Collection of Western Americana, Beinecke Rare Book and Manuscript Library, New Haven, Connecticut, 766

While other drawings in this volume take as their subject matter the sacred activities of the summer Sun Dance (see cat. nos. 57, 99, 120, 121), Zotom drew the construction of the Medicine Lodge in which the rituals will take place. The central forked pole has been raised, and offerings placed in its notch. This pole was cut in a mock battle and carried into camp in rope slings (see Rushing essay in this volume, fig. 7 [p. 59]).

The gathering of materials and construction of the lodge "was generally regarded as the most enjoyable part of the whole Sun Dance gathering. It was an informal social event, characterized by much jolly conversation, singing, dancing, laughter, and horseplay" (Nye 1962:67). Members of the Kiowa soldier societies set up the heavy wall supports and rafters. Zotom has depicted a more modestly sized lodge than was customary: the traditional Kiowa medicine lodge had a diameter of about sixty feet. Nye describes that when the uprights and rafters had been set, the men of the soldier societies:

. . . had a roughhouse in and around it, running, jumping, and leaping. It was a wild frolic, the men wrestling, striking, kicking, and trying to tear the clothes from each other. The small boys particularly enjoyed watching this.

After this free-for-all sport had subsided, the walls and roof were put on the lodge. The wall coverings consisted simply of small cottonwoods with their branches and leaves intact lashed horizontally between the seventeen uprights to form a shade sufficiently open so that spectators might peer through at the performers. An opening was left for the entrance on the east side, facing the sunrise—always the place for the door of a lodge. Brush was placed as a shade on the outer third of the roof. The central two-thirds was left open to the sky, except for the rafters, so that the priests and dancers might stare up at the sun (Nye 1962:69).

This drawing book by Zotom, which was in the collection of Capt. Pratt, the warden at Fort Marion, contains scenes of traditional Kiowa life as well as images of the regimented life at the Army prison in Florida.

JCB

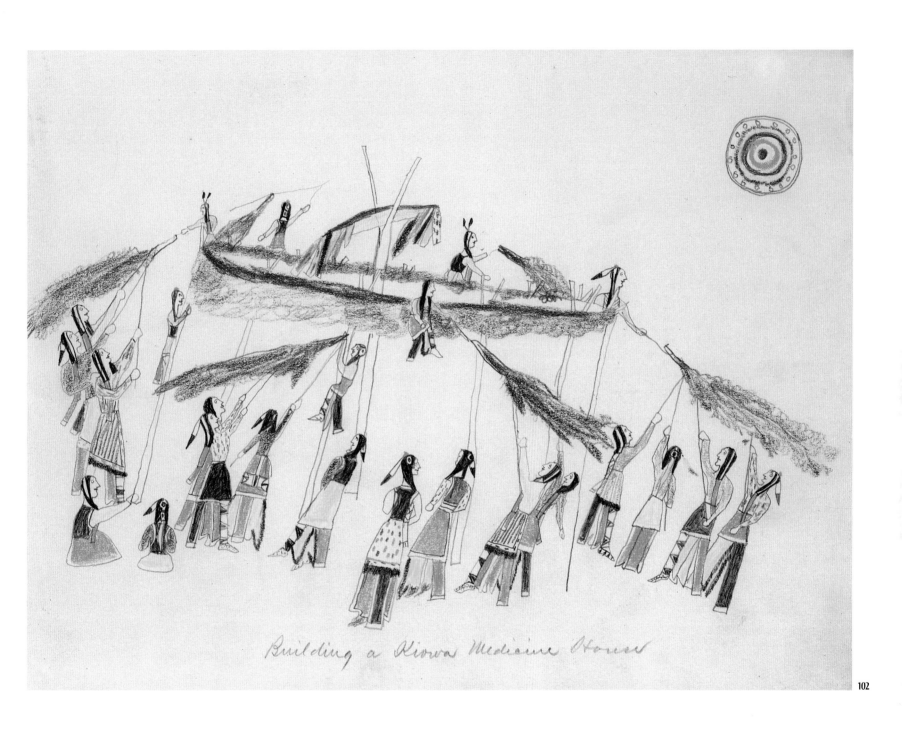

Building a Kiowa Medicine House

102

ZOTOM

103. *Crossing the St. Louis Bridge* (685)
104. *Leaving Lean Bear at Nashville* (686)
105. *Killing of Grey Beard* (680) (Wade and Rand, pl. 1 [p. 46])
1876–77
Pencil and colored pencil
8¼ x 10¾ in. each
The National Cowboy Hall of Fame and Western Heritage Center, Oklahoma City, Arthur and Shifra Silberman Collection, 95.2.680, .685, .686

Zotom was one of several artists who chronicled events in the journey from the Southern Plains to Fort Marion. In each of the drawings presented here, the artist adopted a distant vantage point, surely the result of his familiarity with photographic images. Zotom drew the railroad bridge over the Mississippi River at St. Louis, the attempted suicide of the Cheyenne prisoner Lean Bear in Nashville, and the shooting of Grey Beard in the scrubby palmetto forests on the Georgia-Florida border.

According to Pratt, the Army officer who accompanied the prisoners on their cross-country train trip, Lean Bear had tried to commit suicide by stabbing himself in the neck just before the train's arrival in Nashville. He bled profusely and was left for dead in that city. He revived and was brought to Fort Marion several weeks after the rest of the prisoners. He refused to speak or to eat, and died soon thereafter (Pratt 1964:113). Zotom has shown a large contingent of soldiers, presumably surrounding Lean Bear's body outside the Nashville railway station.

Pratt recounted another incident of the journey, one involving the Cheyenne chief Grey Beard: "Going through the cars with my oldest daughter, then six years of age, I stopped to talk with Grey Beard. He said he had only one child and that was a little girl just about my daughter's age. He asked me how I would like to have chains on my legs as he had and to be taken a long distance from my home, my wife, and little girl, as he was, and his voice trembled with deepest emotion. It was a hard question" (Pratt 1964:113). As the train crossed the border into Florida, Grey Beard jumped from a window—whether to commit suicide or to escape is unclear. He was tracked down and shot, and died soon after.

Considering that most of the Fort Marion artists avoided depicting adversarial encounters between Native Americans and whites in their drawings, it is noteworthy that Zotom has captured two of the saddest events of the journey in these images. While he did not depict graphically Lean Bear's or Grey Beard's struggles, bearing witness to these events through pictorial accounts was an important act for the artist as well as for his cohorts.

A sequence of thirty-two drawings of the journey from Indian Territory to Florida, the fullest pictorial narrative Zotom created, occurs in a large, unpublished two-artist book in a private collection. That series includes versions of the three scenes published here, with enough variation in the imagery to demonstrate that although the artists had stock themes that they repeated in their drawing books, they were not making exact replicas of other drawings. Individual drawings vary at least slightly in format, scale, or angle of perspective, or catch slightly different moments in the action.

JCB

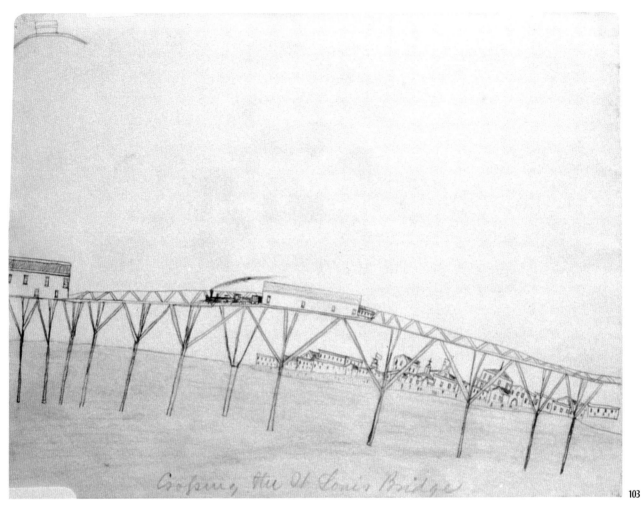

Crossing the St Louis Bridge

103

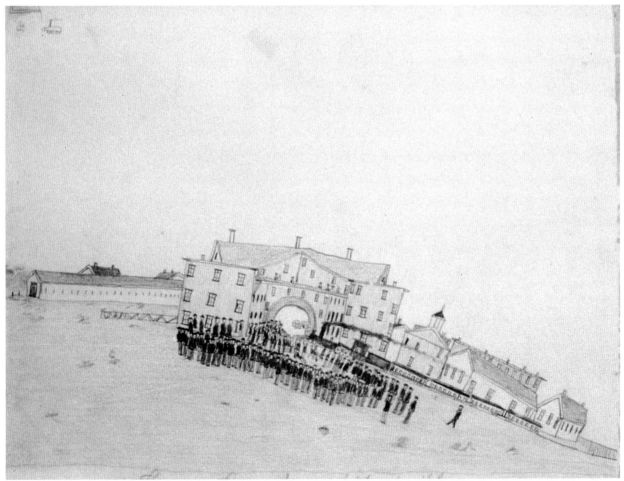

104

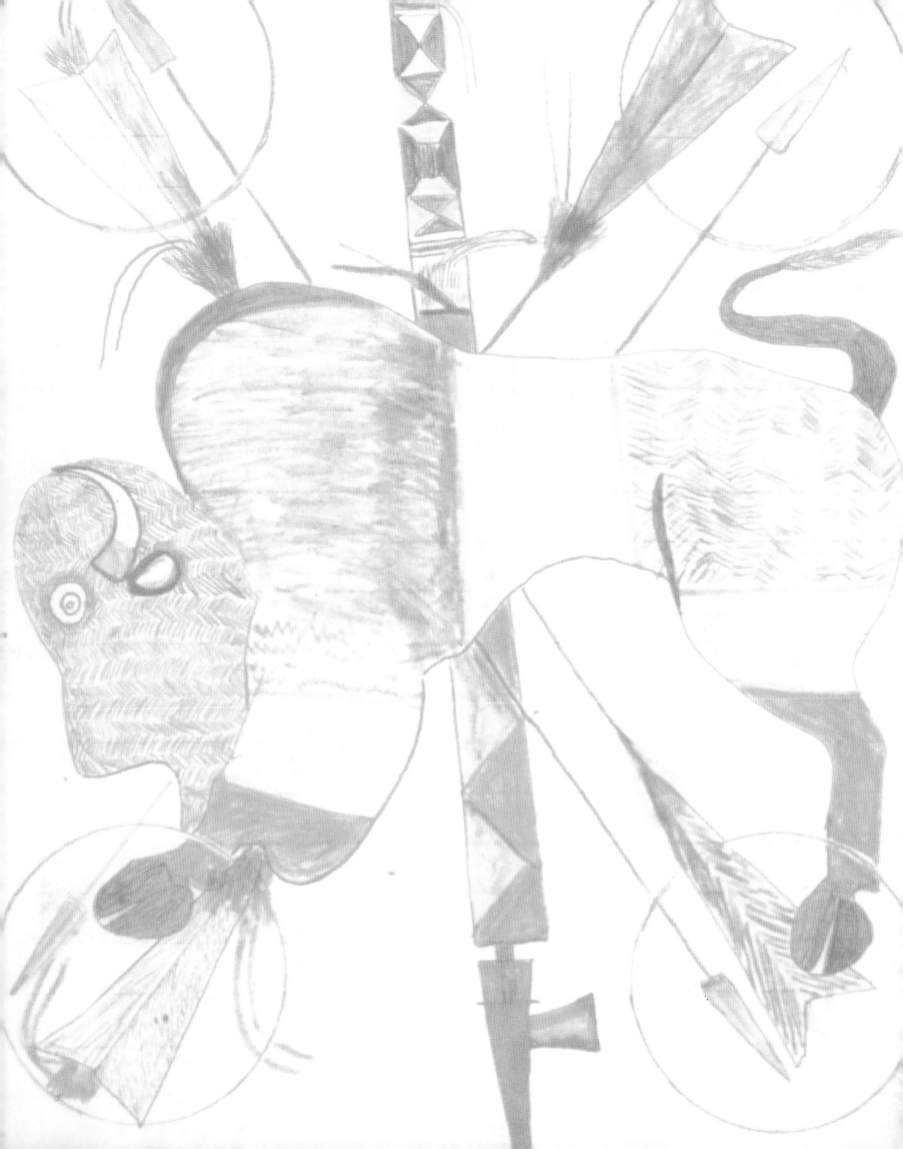

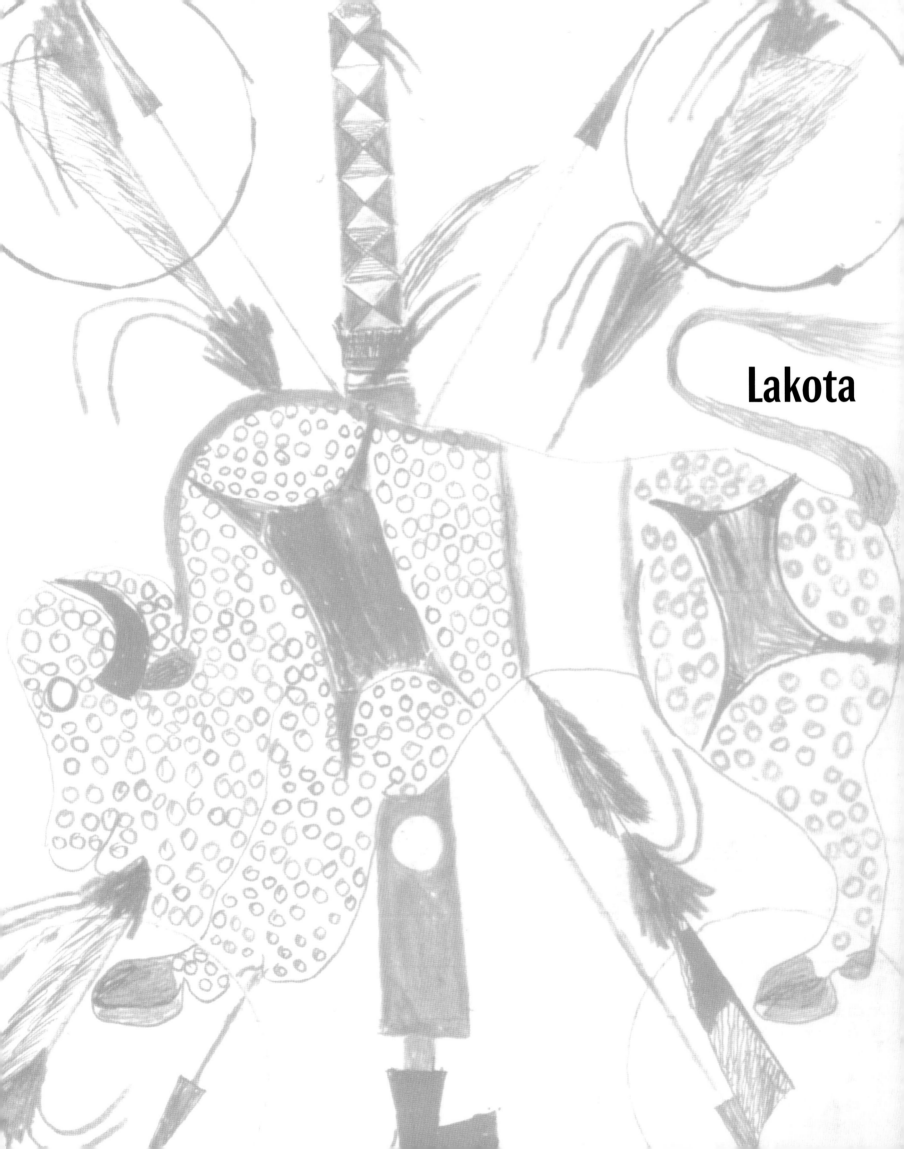

Lakota

Artist unknown
Collins Drawings
Hunkpapa Lakota

Catalogue Numbers 106–9

A series of eleven drawings, originally from one long, narrow, storekeeper's ledger, today makes up part of the Mary C. Collins Collection at the South Dakota State Historical Society. Collins was a Congregationalist missionary at Standing Rock Agency after 1885 and probably acquired the drawings during her tenure there.

The drawings chronicle the war exploits of four men: Okicinintawa (His Fight, birth date unknown, four of whose exploits are illustrated here), Kangiwanagi (Crow Ghost, born 1854), Wasumato (Hail Bear, born 1844), and Matokiyatake (Sitting Bear, birth date unknown). The first three belonged to the Hunkpapa division of the Lakota; their names and ages are recorded (both in English and Lakota) in various census rolls of the Standing Rock Agency between 1879 and 1905. Matokiyatake, Okicinintawa's brother, was killed in a skirmish with the Crow (Smith 1943:126) and did not live to be recorded in the white man's official records.

The exploits of all four men seem to have been drawn by one artist, which is why we are not necessarily claiming Okicinintawa as the artist of the works illustrated here. All eleven drawings are rendered in the typical Lakota style that is familiar from the works of Four Horns, No Two Horns, and Red Hawk (see cat. nos. 124, 125, 130–33, 136–42).

JCB

ARTIST UNKNOWN
106. Miwatani Society Officer on Horseback (75)
107. Okicinintawa Counts Coup on Crows (47)
1880–85
Pencil, colored pencil, and possibly crayon
6¾ x 16⅝ in. each
South Dakota State Historical Society–State Archives, Pierre

In each of the four drawings depicting the personal history of Okicinintawa (cat. nos. 106–9), the warrior's Lakota name is written in script as well as in a pictograph. His name is not translated into English on any of the drawings, but in the 1896 Standing Rock Agency census, which lists the tribal members by their Lakota as well as their English names, entry no. 3773 is "Okincinintawa, His Fight, age 30" (Record Group 75, Bureau of Indian Affairs, National Archives–Central Plains Region, Kansas City). Clearly too young to have been engaged in the traditional scenes of warfare depicted here, he must have been named for the forebear pictured. In 1880, the artist and traveler DeCost Smith encountered a Hunkpapa man at Standing Rock whom he calls both "His Fight" and "O-ki-tcin Ta'-wa," and describes as a warrior, artist, and holy man (1943:125–37).

The name pictograph of opposing horse hoof tracks and the volley of bullets drawn on all of these works (and which Smith, too, describes as the name glyph of the man he knew called "His Fight") successfully conveys the idea of warfare. Okicinintawa's pictorial autobiography tells us he was a high-ranking member of the Lakota Miwatani Society, for he is depicted in cat.

no. 106 wearing the distinctive long red sash of that military brotherhood. (A similar sash is worn by Red Hail in cat. no. 131, and one is worn by a Cheyenne Dog Soldier in cat. no. 38.) A protective raven and feather medicine object is attached to the tail of his horse, to provide him with extra power in warfare. In cat. no. 107 Okicinintawa counts coup on a Crow man and woman with a stick he holds in his left hand. Here the Hunkpapa warrior wears red cloth leggings and has a blue cloth blanket tucked around his waist.

The missionary Mary Collins, who collected these drawings, lived in the Grand River area of the Standing Rock Agency after 1885.

JCB

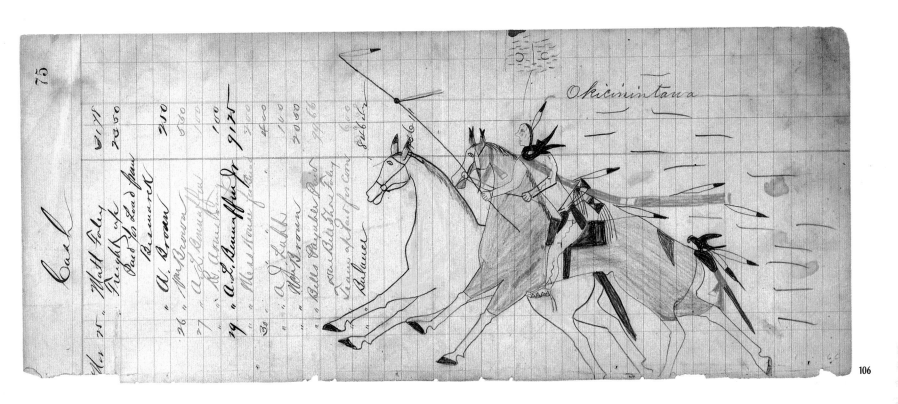

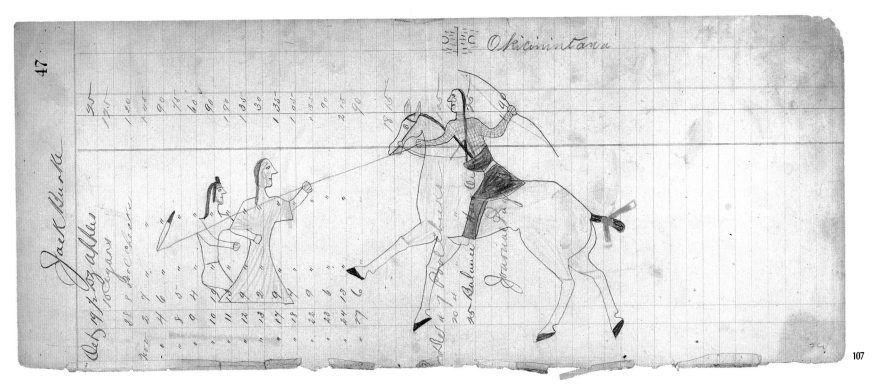

ARTIST UNKNOWN
108. Okicinintawa Outnumbered by Crows
109. Okicinintawa Kills an Enemy (19)
ca. 1880–85
Pencil, colored pencil, and possibly crayon
6¹/₂ x 16⁵/₈ in., 6⁷/₁₆ x 16⁵/₈ in.
South Dakota State Historical Society–State
Archives, Pierre

In both of these drawings Okicinintawa wears a red cloth cape into battle; this may be the wrapping material of his war medicine bundle, which would have served as a protective cloak (see cat. no. 138). In one encounter (cat. no. 108), he is on foot, crouching behind tall grass and shooting his revolver. He is greatly outnumbered by eleven Crow warriors, who are represented in shorthand fashion by their heads (with distinctive Crow hairdo) and gun barrels. All eleven fire at him.

In cat. no. 109, Okicinintawa rides a blue horse as he runs down an enemy and shoots him twice in the back. Perhaps he takes the enemy's horse as a trophy of war, for a yellow horse with similar markings appears in cat. no. 106. As he fires, the hero leans all the way over the right-hand side of his horse for better aim, somewhat like the figure in cat. no. 122, drawn by Bone Shirt.

JCB

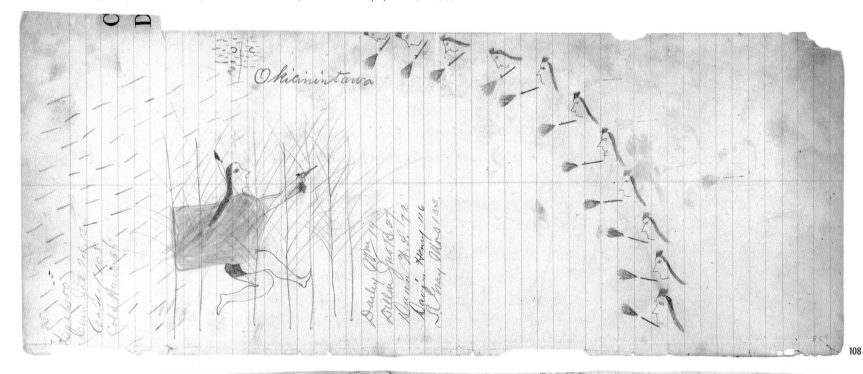

108

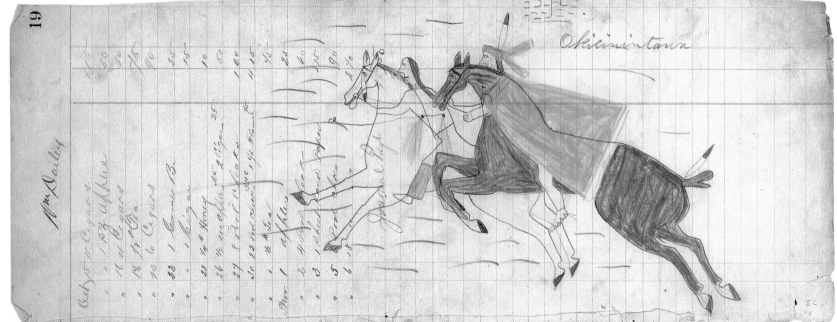

109

Artist unknown
Cronau Drawings
Lakota

Catalogue Numbers 110, 111

The German artist and journalist Rudolf Cronau collected many drawings during his travels through the Standing Rock and Pine Ridge agencies in the early 1880s, and in 1886, when he brought a group of Plains Indians on a tour of Europe in his own version of a Wild West Show (Cronau 1890). Cronau recorded the names of some of the artists, most notably Sinte, whose work is discussed later in this section (see cat. nos. 143–48), but the Cronau Collection at the American Museum of Natural History in New York contains a number of fine drawings whose makers' names are unknown.

JCB

ARTIST UNKNOWN
110. *Sioux Indian in a Shower of Enemy Bullets*
111. *Invitation to the Dance*
1881–86
Pencil and colored pencil
2^1/$_2$ x 4^5/$_8$ in., 7^7/$_8$ x 11 in.
American Museum of Natural History, New York, 50.2100.19b, .43

In cat. no. 110, a gem of miniature ledger drawing, the rider bends over, as if to fit himself within the confines of the tiny page, and shoots, blindly, behind him. A volley of bullets from unseen enemies surrounds him, but both he and his painted horse flee unscathed.

The other scene (cat. no. 111) is characteristic of reservation-era life, with its mixture of traditional dances, canvas tipis, frame houses, and covered wagons. The artist has rimmed the edges of the paper with tiny dwellings and wagons but has shown us, by increasing the scale, that the central dance house and ceremonially garbed figure are the most important features. Two women appear wrapped in blankets at the left. Behind them are six frontal heads, each wearing warrior society feathered regalia.

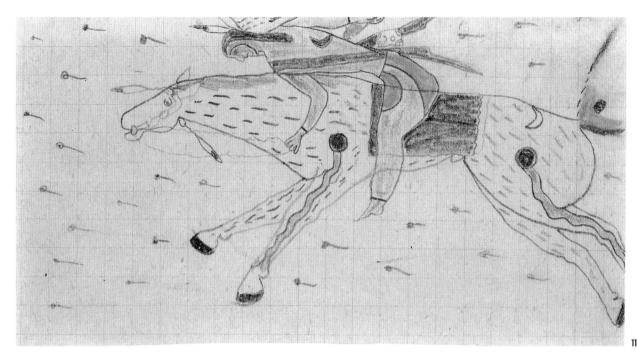

110

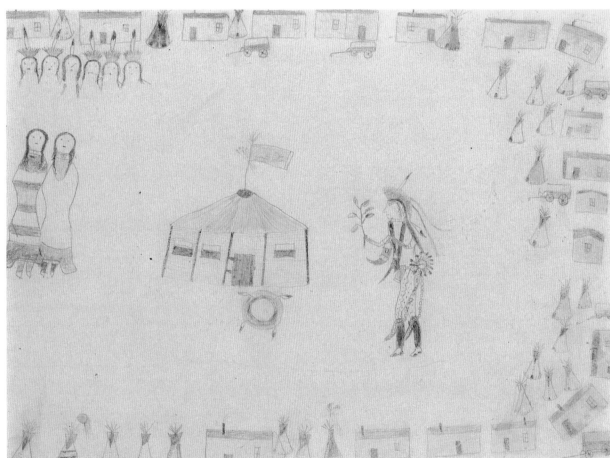

111

Cronau's own notes on this drawing say, in part, "Painted messenger of the camp calls the warriors together, and they are collecting in the dance house" (object file no. 50.2100, AMNH). This type of log or timber dance house with an earthen roof was a standard feature in each district of the reservation. They appear in early photos (Hamilton and Hamilton 1971:pls. 108, 109) and in Bad Heart Bull's drawings (Blish 1967:fig. 411).

JCB

Artist unknown
Wallihan Drawings
Oglala Lakota

Catalogue Numbers 112, 113

A *Denver Post* newspaper correspondent, George P. Wallihan, traveled to the Red Cloud Agency in Nebraska in the spring of 1877 to report on the events of the surrender of Crazy Horse, the renowned Lakota warrior, and his band of nearly nine hundred followers. Some years later, Wallihan boasted that he was the only newspaper man to witness the surrender. He wrote, "later I visited all the noted Chieftains, and Crazy Horse gave me this book, telling me, through an interpreter, that it pictured the life of a famous warrior, but would not say it was himself" (memo dated 1915, object file no. 1986.581, Denver Art Museum).

Ten drawings from this book, two of which are illustrated here, are in the collection of the Denver Art Museum. No name glyphs or other identifying features allow us to determine who the protagonists are—whether Crazy Horse himself or one of the other 217 adult men of his band whose names were recorded at the Red Cloud Agency on May 6, 1877 (Buecker and Paul 1994:157–64).

JCB

ARTIST UNKNOWN
112. Lakota Warrior Defeats Pawnee (4)
113. Lakota Man Captures Six Horses (5)
1870–77
Pencil and colored pencil
6⅝ x 8 in. each
Denver Art Museum Collection,
1986.581.4, .5

Like Four Horns's drawings from the same decade, this artist has revealed the essential features of the narrative. In cat. no. 112, a warrior attacks three Pawnee. Sequential parts of the story are merged in one image: the rider lances a woman; behind the horse, his lance touches another woman; his gun (in front of the horse) fires at the man. In cat. no. 113, the protagonist has captured six fine horses, shown here in traditional Lakota shorthand form.

JCB

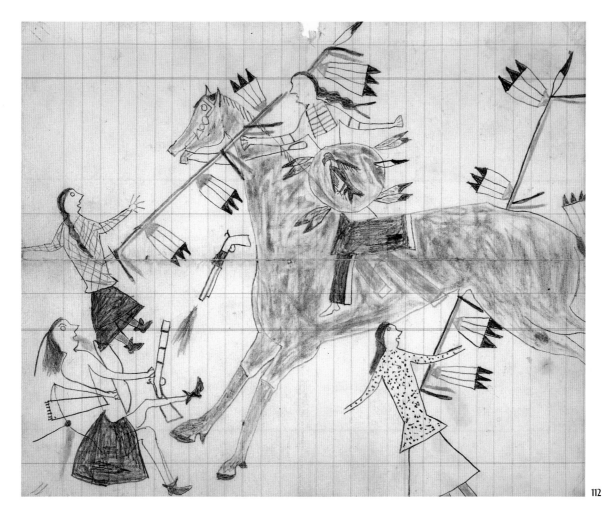

112

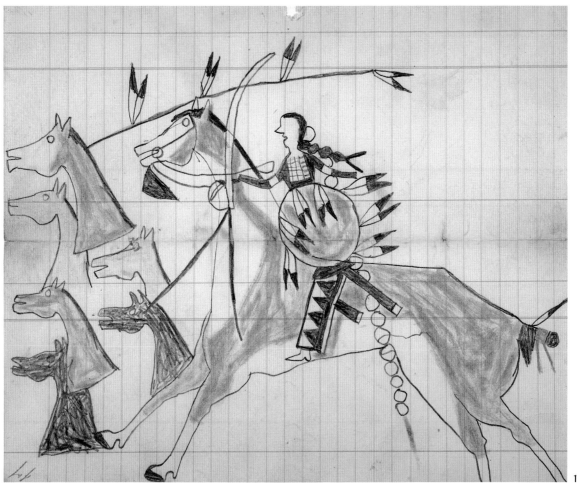

113

Black Hawk
(1832?–ca. 1889?)
Sans Arc Lakota

Catalogue Numbers 114–19

In the winter of 1880–81, a Lakota man named Black Hawk and his family were starving. It had been a long, cold winter at the Cheyenne River Agency in Dakota Territory. For fifty cents each, Black Hawk drew pictures on sheets of foolscap for William Caton, the trader at the agency. By making these drawings, Black Hawk was able to provide food for his family. Caton later bound the drawings into a handsome book. According to Caton's family documents, which were handed down with the book, Black Hawk lived in the southern part of the agency, near the Cheyenne River. These documents further claim that Black Hawk was "chief medicine man" of the Sans Arc band of the Lakota, that he was born in 1832 and had probably died by 1889 (Sotheby's 1994).

Will and probate records at the Cheyenne River Sioux Agency in Eagle Butte, South Dakota, reveal that neither Black Hawk nor his wife, Hollow Horn Woman, were given any tribal land allotments, so no official tribal records exist for them, except what appears in the file of their son, John Black Hawk, born in 1862. His records state that his parents came from the Cherry Creek district of the reservation. Annuity and Goods Disbursement records from the Cheyenne River Sioux Agency do verify Black Hawk's existence there during the 1880s; the last record of him seems to be a census of adult males made in 1889, where he is listed as fifty-eight years old (Record Group 75, Bureau of Indian Affairs, Cheyenne River Sioux Agency, National Archives, Central Plains Region, Kansas City, Missouri).

Black Hawk was unknown until the handsome bound book of seventy-five of his drawings emerged on the auction market in 1994; now his work stands as the most complete extant visual record of Lakota life, since Amos Bad Heart Bull's larger opus exists only in reproductions (Blish 1967). Black Hawk's book contains scenes of hunting, natural history drawings, dance scenes, including the Sun Dance, ceremonial activities, pictures of head men of the Lakota, and numerous depictions of Crow warfare and ceremony.

JCB

BLACK HAWK
114. Birds of the Prairies (34)
115. Porcupines and Wild Cats (57)
1880–81
Pencil, colored pencil, and ink
10 x 16 in. each
Eugene and Clare Thaw Collection,
Fenimore House Museum, New York State
Historical Association, Cooperstown

Black Hawk drew eighteen images that we might characterize as natural history studies, for they depict animals in their natural habitat, not being hunted or utilized in any way. All are animals that were once a familiar sight on the northern Plains: elk, mountain sheep, birds, bats, bears, pronghorn antelope, mountain lions, porcupines, and others. In cat. no. 115, Black Hawk has drawn two porcupines on the limb of a tree on the left, and two wildcats in a tree on the right. Red foxes, drawn with exact attention to the details of their coloration, prowl the ground beneath the trees.

Three Great Horned Owls, a Sandhill crane, and a type of crow fill cat. no. 114. While realism of scale is of no apparent interest to the artist, he has provided enough detail that most of the ornithological species are easily recognizable.

Aaron McGaffey Beede, an Episcopal missionary to the Lakota in the first two decades of the twentieth century as well as an avid student of ethnology, remarked several times upon the pronounced scientific attitude of the Lakota. His understanding of this was unusual for a Euro-American of his era. Beede recounts an instance in which a museum scientist gave His Horse Appears, an elderly Sioux man, an oral examination in the field of natural history, which His Horse Appears passed with a grade of 95 percent. Beede comments on "the trenchantly scientific exact knowledge of this Indian," and remarks that he knows a score of other men with similar knowledge (Beede n.d.) Such knowledge accrued from a lifetime's worth of keen observation of nature, and from hunting for food and materials used in daily life and ceremony. It was passed on predominantly though oral teaching. A few individuals, such as Black Hawk, set down a visual record of their knowledge of natural history as well.

JCB

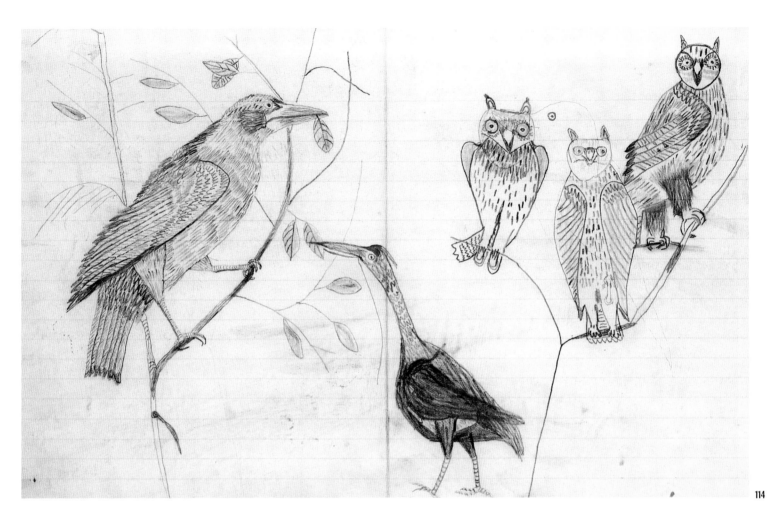

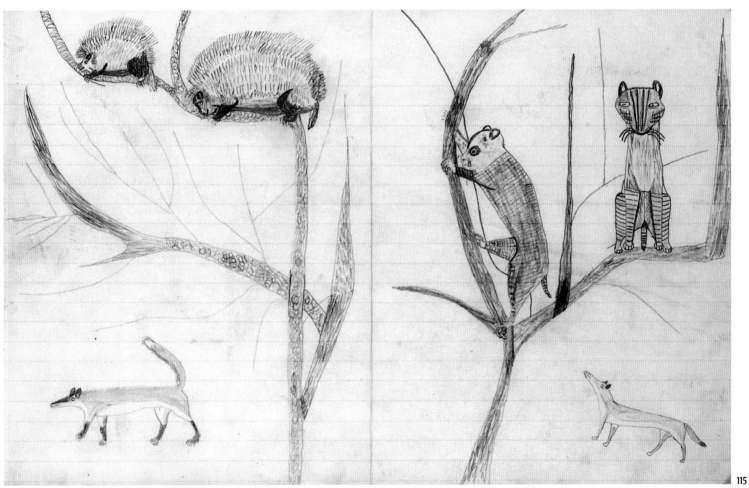

BLACK HAWK

116. *Dream or Vision of Himself Changed to a*
Destroyer or Riding a Buffalo Eagle (2)
1880–81
Pencil, colored pencil, and ink
10 x 16 in.
Eugene and Clare Thaw Collection,
Fenimore House Museum, New York State
Historical Association, Cooperstown

Black Hawk's book opens with two arresting images of Thunder Beings, one of which is illustrated here. Since the book was said, by the trader who commissioned it, to be a chronicle of Black Hawk's visions, these images are surely the core of that visionary experience. Thunder Beings are powerful supernatural creatures, usually manifested in visions and in art as amalgamations of animals such as horses, buffaloes, and eagles. Black Hawk's fine drawings, elemental and bold, successfully convey the awful and awesome power of these sky dwellers.

While every vision is a unique and personal experience, visions of Thunder Beings that conform to certain visual patterns have been reported by a number of Lakota. The most well known is the vision of the famous Lakota holy man Black Elk, who describes horses with necklaces of buffalo hoofs and elk's teeth, and lightning and thunder around them. Some of the horses have horns, just as Black Hawk has depicted them here. Black Elk saw "great clouds of horses in all colors" neighing like thunder, who turned into buffalo and elk (Neihardt 1972; DeMallie 1984:114–15).

Black Hawk's two drawings of spirit-beings are among only three in his book that have captions. These read: "Dream or Vision of Himself Changed to a Destroyer or Riding a Buffalo Eagle." The animal he has drawn combines aspects of horse, buffalo, and winged creature. It has horns, eagle talons where hoofs should be, and it is spotted with hail. Its tail turns into a rainbow, which arches over the scene. The creature who rides the "Buffalo Eagle" is also a composite. It, too, is horned, with blue limbs, hail-speckled chest, and piercing yellow eyes. Lines of power radiate from its hands.

The Lakota believe that the power derived from such a transformational spiritual experience must be used for the good of the people. Black Hawk was said to be a medicine man of the Sans Arc band of the Lakota. Perhaps his healing powers derived from the encounters with sacred beings that he recorded in this book.

JCB

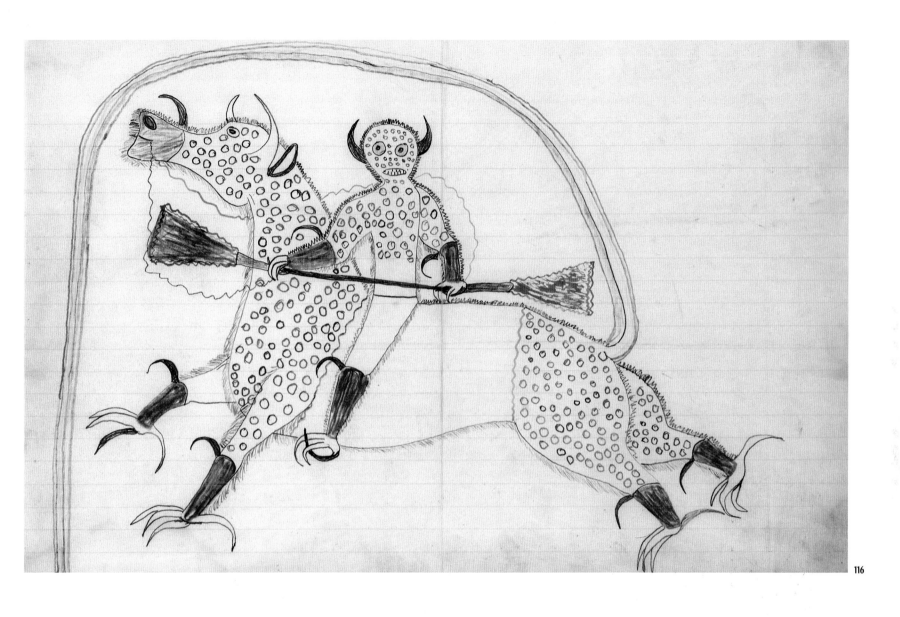

BLACK HAWK

117. Crow Men in Ceremonial Dress (19)
1880–81
Pencil, colored pencil, and ink
10 x 16 in.
Eugene and Clare Thaw Collection,
Fenimore House Museum, New York State
Historical Association, Cooperstown

Fully one-third of the drawings in Black Hawk's book depict Indian peoples other than the Lakota. Eighteen of these drawings depict fairly straightforward encounters between mounted Lakota warriors and their enemies, most of whom appear to be Crow. But the most intriguing of the group of twenty-six drawings of non-Lakota peoples are four in which Black Hawk has painstakingly portrayed a series of high-ranking Crow men, dressed and painted for war. One of these drawings, depicting six Crow men, is illustrated here.

Their hair has been brought up in the front in a pompadour, and in back it has been artificially lengthened. In the nineteenth century, Crow men greatly increased the length of the hair by "working in other hair, so that sometimes the strands were so long as almost to touch the ground. . . . On ceremonial occasions many of the young men imitated the manner of hairdressing by having many long locks fastened to a band worn at the back of the head. Both the real hair and the introduced strands were decorated from end to end with spots of red pigment" (Curtis 1909:23).

All six men carry bandoleer bags with long fringe, another object characteristic of the Crow. The men's bodies are painted, many with a yellow body paint overlaid with crosses, stripes, and semicircles in red. They hold lances, staffs, feathered shields, and the bandoleer bags. One man holds a flute, the end of which is capped with a

crane head. Crow men dressed and painted themselves this way not only for war but for the Sun Dance as well. Yet no details here suggest the Sun Dance: there are no eagle bone whistles, no banners or ceremonial enclosures. While the exact occasion that Black Hawk was recalling here remains unknown to us, he clearly had an opportunity to scrutinize closely the ceremonial gear of his traditional enemies.

JCB

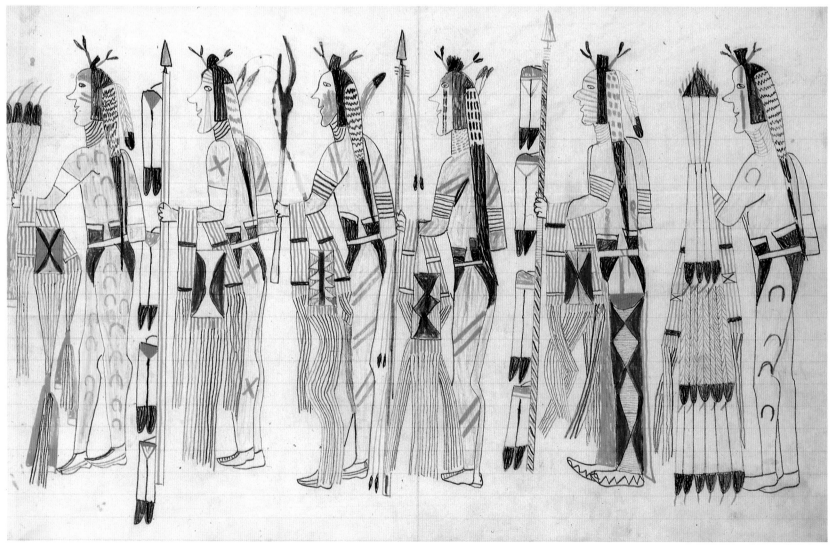

BLACK HAWK
118. Drawing of Buffalo Medicine (30)
(Yellow, pl. 1 [p. 71])
119. Drawing of Buffalo Medicine (54)
(Yellow, pl. 2 [p. 71])
1880–81
Pencil, colored pencil, and ink
10 x 16 in. each
Eugene and Clare Thaw Collection,
Fenimore House Museum, New York State
Historical Association, Cooperstown

Sets of four are important in Lakota thought. Items, prayers, or actions often occur in sets of four, usually relating to the four directions of the compass. Four drawings in Black Hawk's book (two of which are illustrated here) show a person on one side and an unusual assemblage on the other. These may simply depict visions, or they may be diagrams of altars made as a result of a vision. Certainly buffalo skulls are often used as altars by the Lakota, but here the entire buffalo and its associated paraphernalia form a three-dimensional personification of an altar. The sacred pipe extends vertically through the image, like an *axis mundi*, linking the earth with the sky. In cat. no. 119, the tip of the pipe is actually stuck into the ground, and an arrow is laid in front of it, giving further credence to the idea that these are altars.

In each image, four arrows and four hoops are laid diagonally across the image, and the uniquely painted buffalo is placed across it all. Each pipe is different, each buffalo is different, as is each human who carries a bunch of sacred herbs to the altar. These may represent four altars for specific types of medicine (Arthur Amiotte, personal communication, 1995). The man in cat. no. 119 wears a black robe and holds a saber, whose handle, tied with a black sash, projects from his robe. Perhaps, armed for battle, he asks for war medicine. In cat. no. 118, the supplicant is a woman who wears an old-style tabbed dress and a beaded or quilled buffalo robe. Possibly she is looking for spiritual aid in matters that concern women, such as artistry or procreation. (The individuals in the other two drawings in this series appear to be a man going courting and a hunter.) Like visions, altars and sacred bundles are idiosyncratic, based on highly personal spiritual revelations that have come to their owners. These drawings may be diagrams of Black Hawk's sacred tools for use in ceremony.

JCB

Walter Bone Shirt
(ca. 1832–after 1896)
Lakota

Catalogue Numbers 120–23

Thirty drawings, all rendered by one artist, are contained within the covers of a small unlined autograph album. We date the drawings to about 1895 based on stylistic analysis of the album conducted by an expert in Victorian ephemera, Helen Fraser. According to her, this style of autograph book dates to 1894–98 (Helen Fraser, personal communication, 1991). Inscribed on the flyleaf is the notation, "pictures drawn by Walter Bone Shirt for 'The Committee,' compliments of M. E. Mead." M. E. Mead is almost certainly Mary Eliza Mead (1840–after 1927), longtime resident of western Nebraska and South Dakota, whose husband was a trader on the Pine Ridge Agency, and who had both an interest in Indian culture and artifacts and in prose-lytizing efforts by the Episcopal church (Mead 1927). We know from census records that names such as "Bone Shirt" and "Bone Necklace" occurred at both the Rosebud and Pine Ridge in the 1880s. Indeed, there are Lakotas named Bone Shirt who live in South Dakota today. Ongoing research may reveal more about this artist. At present, the most likely candidate is a Brule Lakota named Bone Shirt who is listed as the head of a family of seven in the 1877 census roll at the Spotted Tail Agency in Nebraska. He appears again in the Brule census at the Rosebud Agency in 1896, where he is listed as being sixty-four years old (Record Group 75, Bureau of Indian Affairs, National Archives, Central Plains Region, Kansas City, Missouri).

A series of drawings in the Gilcrease Museum in Tulsa (4526.13) is clearly by the same artist, despite the fact that "Charles Littlefeather had the book" is written in Lakota on one of the book's pages. His handling of line, color, and subject matter is nearly identical to that of the artist of these thirty drawings. Both sets of drawings are vignettes of Lakota ceremonialism and horsemanship. A similar work by an artist said to be from the Rosebud Reservation is in the collection of the Detroit Institute of Arts (Penney 1992:pl. 220a–f; Margolin 1991). The use of the autograph album format and the restriction of the subject matter to a narrow range of themes—the Sun Dance, the Black Tail Deer Dance, painted horses, and the like—suggest that the drawings may have been made within a fairly circumscribed geographic range and were perhaps principally for sale to out-siders.

JCB

WALTER BONE SHIRT
120. Tied to the Sun Dance Pole (42)
121. Sun Dancer and Rawhide Offerings (20)
(Cutschall, pl. 2 [p. 65])
Mid-1890s
Ink, pencil, and watercolor
5 x 7¾ in. each
Private collection

The Sun Dance is a profound ritual prac-ticed among most Plains tribes, in which human beings celebrate their place in the universe, fulfill vows that they have made, and mortify their flesh in sacrificial rites. These two drawings depict moments in the Lakota Sun Dance. In one image (cat. no. 121), one of the Sun Dancers looks at the sacred pole, which has been erected within the Sun Dance circle. Flags of trade cloth and feathered offerings surround the pole, from which hang small rawhide effigies of a horned human figure and a blue horse.

It is more typical to affix a small rawhide buffalo, rather than a horse, to the Sun Dance pole. Considering that this book was drawn in the 1890s, it may be that in some ceremonies the horse effigy was sub-stituted for the buffalo, for by that time the buffalo had been nearly wiped out. In the victory chant that precedes the cutting of the Sun Dance pole, people sing "Horses I want, horses I desire." Tied to the pole, along with the desired horse, is a man. He is emblematic of the enemy—understood in Lakota metaphysics to be not just the external enemy but also the flaws within man himself that sometimes makes him his own worst enemy (Arthur Amiotte, personal communication, 1995).

In cat. no. 120, the artist has depicted one of several ways that a Sun Dance cele-brant may sacrifice his flesh in the ritual. The skin and underlying flesh of the pec-toral area is pierced and a pointed stick is passed through. Sinew thongs wrapped securely around each stick are fastened to a rope attached to the sacred tree. The dancer's act of sacrifice (ritually akin to an act of warfare) lies in ripping himself away from the pole. The ritual celebrant perceives this not as torture, but rather as the embodiment of the profound truth: for a short time he has been joined to the sacred power inherent in the sun, the tree, the zenith of the sky where the pole reaches, and the nadir of the earth where the pole is planted. Through sacrifice, he, too, is transformed into something sacred.

In some of the drawings in this auto-graph book, including cat. no. 121, Walter Bone Shirt seems to have designated the sacred Sun Dance enclosure by means of a curved wall of printed calico cloth, either on the side of the picture or across the background. During the reservation period, yards of colorful calico were sometimes used as tipi liners and backdrops. Indeed, all of the drawings in this book reveal how trade cloth had become a fundamental part of Lakota life during the second half of the nineteenth century: flags, banners, women's dresses and shawls, Sun Dancer's breech cloths were all made from yard goods.

The Sun Dance was initially forbidden by local Indian agents and officially banned by the U.S. government in 1883, but it contin-ued unofficially even after the ban. Among many societies of the Great Plains, the Sun Dance continues today as an enduring symbol of traditional values, ideals, and hardships. It demonstrates that people still maintain an unbroken link with ancient, sacred traditions (Amiotte 1987). By draw-ing imagery of the Sun Dance during a decade when such practices were officially outlawed, Walter Bone Shirt helped keep alive the most sacred mysteries of the Lakota.

JCB

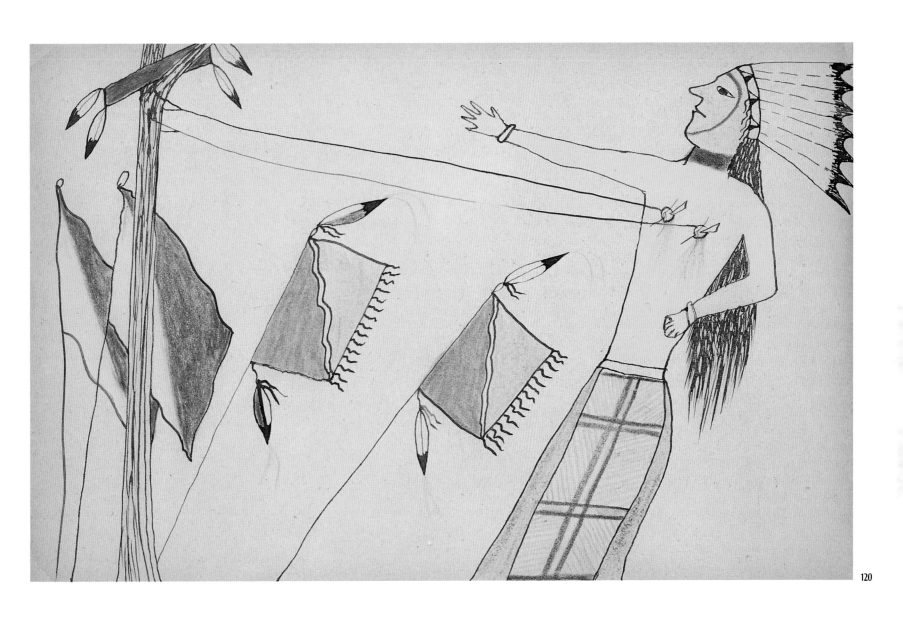

120

WALTER BONE SHIRT
122. Horse and Rider (26)
123. A Woman and Her Horse (52)
(Cutschall, pl. 1 [p. 65])
Mid-1890s
Ink, pencil, and watercolor
5 x 7³/₄ in. each
Private collection

In this autograph book, Walter Bone Shirt has shown a typical Lakota penchant for clustering things, especially sacred ones, in fours. There are four portrayals of the Buffalo Dance, an element of the traditional Lakota Sun Dance (Walker 1917:114–15; Maurer 1992:fig. 46). Four Sun Dancers wear ceremonial regalia and carry cloth banners. Four women wearing their male relatives' horned headgear participate in the Victory Dance portion of the Sun Dance (Maurer 1992:fig. 73). Four warriors ride painted horses, and there are four drawings of women leading horses; examples of both of these are illustrated here.

In each of the four drawings of a mounted warrior, the rider is portrayed lunging over the right side of the horse. His face is hidden, but in his right hand he brandishes a revolver, a lance, or as in cat. no. 122, a saber. In every case, he holds in his left hand a different painted shield, and each horse is uniquely painted with powerful emblems. In cat. no. 122, a yellow horse with clipped ears is painted with dragonflies, recognizable by the long needle-like bodies and double sets of wings. A powerful creature who darts about, and seems always to evade capture, the dragonfly is an appropriate emblem for a war pony. Said by the Lakota to possess the power to

escape a blow, the dragonfly "can not be hit by man or animal, neither can the thunder injure it" (Wissler 1905:261).

In cat. no. 123, a woman leads her horse by the bridle. The woman wears a trade cloth dress and blanket and carries a rawhide container on her back. Her horse is outfitted with a woman's saddle, identifiable by the curved wooden pommel and cantle, both of which are festooned with feathers. Tied to the saddle, presumably on each side, are painted parfleche bags with soft quilled possible bags (multipurpose bags) above them. A quilled or beaded crupper is attached to the tail.

JCB

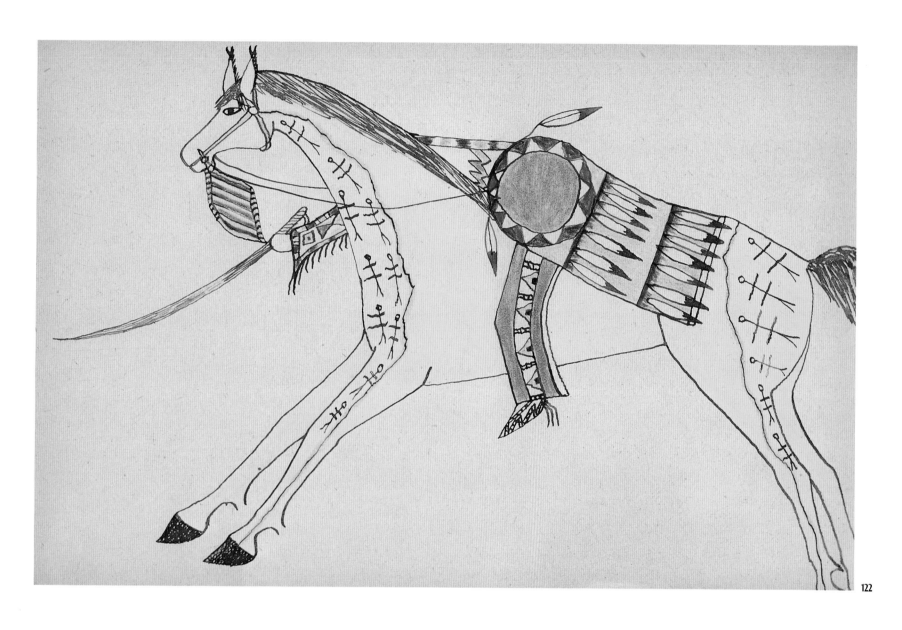

122

Four Horns
(1814–1887)
Hunkpapa Lakota

Catalogue Numbers 124, 125

Four Horns was one of the most widely respected chiefs of the Hunkpapa Lakota. He earned great prestige as a warrior in the 1850s and 60s, and was the beloved uncle and advisor to the famous chief Sitting Bull through his entire life. A decidedly minor part of his long and distinguished life was his activity as an artist: this activity looms large here principally because his depictions of Sitting Bull from 1870 are among the earliest firmly dated Lakota drawings on paper.

Sometime in 1869, Four Horns, one of the four Hunkpapa Shirt Wearers (an executive council of highly esteemed men with skills in diplomacy, spirituality, and the military arts) conceived a plan to unite the Sioux. He and his nephew were among the leaders of those who resisted reservation life and scorned the Treaty of 1868, which created the Great Sioux Reservation in western Dakota Territory. Four Horns put forward his nephew Sitting Bull for the new office of paramount chief of the Sioux confederacy, an office that was alien to the traditional Sioux political organization of band autonomy (Utley 1993:76–89). Four Horns stood by Sitting Bull during his retreat to Canada and his surrender at Fort Buford in 1881 (Utley 1993:230–31). He lived out his final years at Standing Rock Agency.

JCB

FOUR HORNS
124. Sitting Bull Captures Crow Horses (38)
125. Sitting Bull Shoots a Frontiersman (23)
(Berlo, "A Brief History of Lakota Drawings," pl. 1 [p. 34])
1870
Ink and watercolor
7³/₄ x 10¹/₂ in. each
National Anthropological Archives, National Museum of Natural History, Smithsonian Institution, Washington, D.C., 1929A, 23, 38

In 1870, Four Horns drew his pictorial account of his nephew Sitting Bull's life as a Hunkpapa warrior. The creation of these drawings during this year is indisputable, for Sitting Bull's own pictorial record, upon which this one is based, includes a Sioux victory over the Crow in 1870, and Army doctor James Kimball collected Four Horns's set of fifty-five drawings in 1870, at Fort Buford, in Dakota Territory (Stirling 1938:1–3). (Sitting Bull's own drawings are now lost; none of his works before 1881 have survived. See Maurer 1992:figs. 177–80.)

Four Horns drew on discarded Army roster sheets. As seen in the two drawings illustrated here, he included large, naturalistically rendered bulls as name glyphs to identify Sitting Bull as the protagonist of most of the drawings. The activities he chronicled are limited principally to killing Crows and whites, and episodes of horse capture. In cat. no. 125, Sitting Bull's victim is a frontiersman in a buckskin jacket. While elements of facial features were unimportant to the artist, he carefully rendered the flintlock rifle, saddle, war shield, and name glyph with great accuracy. In cat. no. 124, Sitting Bull wears a war bonnet of the Strong Heart Military Society and runs off seven Crow ponies, shown in an overlapping cluster of faces and legs.

While it was not uncommon for a fine draftsman to be commissioned to draw the exploits of another (and, indeed, the available evidence persuades us that Four Horns was a better artist than his nephew), we may wonder if in this instance Four Horns was conducting a campaign of political propaganda. By visually commemorating the courageous military deeds of Sitting Bull, the influential leader Four Horns was documenting Sitting Bull's unparalleled bravery and personal generosity—traits needed in the new role of paramount chief that Four Horns was proposing for his nephew in 1869.

We can surmise that these drawings represent not only an accurate historical record of one man's career but also the pleasure a warrior uncle took in the successes of his illustrious and beloved nephew. Sitting Bull counted his first coup at the age of fourteen (Utley 1993:14). By 1870, they had traveled on many war parties together, captured many horses, and fought many Crow.

JCB

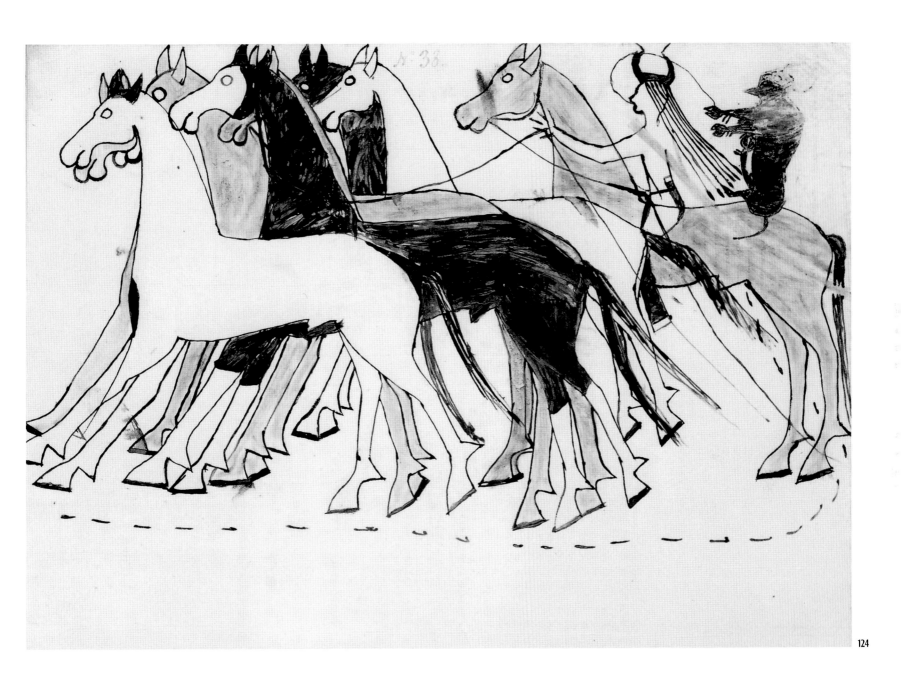

124

Andrew Fox
(1862–after 1921)
Yanktonais Sioux

Catalogue Numbers 126, 127

Drawings by Sioux other than Lakota (Western Sioux) are relatively rare compared to the prodigious number of drawings documented as Lakota. Andrew Fox was born a Yanktonais (a subgroup of the Dakota who lived to the east of the Lakota). He was educated at the Hampton Institute in Virginia, where he made these drawings. After leaving Hampton, he moved to the Standing Rock Agency, where he worked closely with Sitting Bull (Ewers et al. 1985:31).

JCB

ANDREW FOX
126. Battle Scene with Sitting Bull
127. Winter Hunting Scene
1879
Ink, watercolor, colored pencil, and pencil
8³/₄ x 11 in. each
Museum of American Art of the
Pennsylvania Academy of the Fine Arts,
Philadelphia, 1982.X.153, .170

These drawings may well be by the youngest artist represented in this volume. Andrew Fox was only seventeen when he arrived as part of the first group of students to be educated at the Hampton Institute in Hampton, Virginia, in November 1878. The students who arrived from the reservations of the Great Plains were met by seventeen of the Fort Marion prisoners who had elected to continue their education after their incarceration was over. Just as at Fort Marion, the making of drawings was part of the activities engaged in by the Indian students at Hampton. While they were not sold to tourists, like the Fort Marion drawings, some drawings were sent to supporters of the school as a premium for subscribing to *The Southern Workman*, the institute's newspaper (Ewers et al. 1985:5).

A journalist writing on Indian education at Hampton and Carlisle in 1881 remarked that "the blackboards of an Indian recitation room are usually rich in works of art illustrative of the day's doings or memories of home life" (Ludlow 1881:673). Indeed, scores of drawings from these schools still exist, done by the children newly arrived from the Dakotas or Indian Territory as well as by adult students who had come by way of Fort Marion (see Ewers et al. 1985; Smith 1988; and Hultgren 1987).

Like the Fort Marion drawings, the Hampton drawings range from depictions of traditional hunting and warfare, to ceremonial activities, to scenes of acculturation. The use of watercolors in some of them, however, is a feature not seen much on the Great Plains until a later date. Andrew Fox drew typical scenes of Sioux life, in each case signing his name with a great flourish on the front of his drawings. In the hunting scene (cat. no. 127), the two men on foot wear capotes made of warm woolen Hudson's Bay trade blankets. The three deer they are following leave tracks in the snow.

Cat. no. 126 is most like the traditional ledger book drawings of warrior exploits. But here, young Andrew Fox showed not his own scenes of bravery but those of the most famous chief in the West: Sitting Bull. The artist has identified Sitting Bull by writing his name in the lower left. Significantly, the Hunkpapa chief is not pictured. His horse and his crooked lance are shown, but he is just beyond the left edge of the page. We wonder if the young artist, cognizant of the fact that under the traditional pictographic system he had no right to draw the exploits of Sitting Bull, showed his respect for this tradition by not drawing his image.

By 1879 Sitting Bull was in his forties; his days as a warrior occurred before Andrew Fox's birth or in his early childhood, and in a region well west of Yanktonais Territory. The young artist at the Hampton Institute was engaging in a kind of history painting, portraying an important public figure who would play a central role in Fox's own life when he returned to the West in the 1880s.

JCB

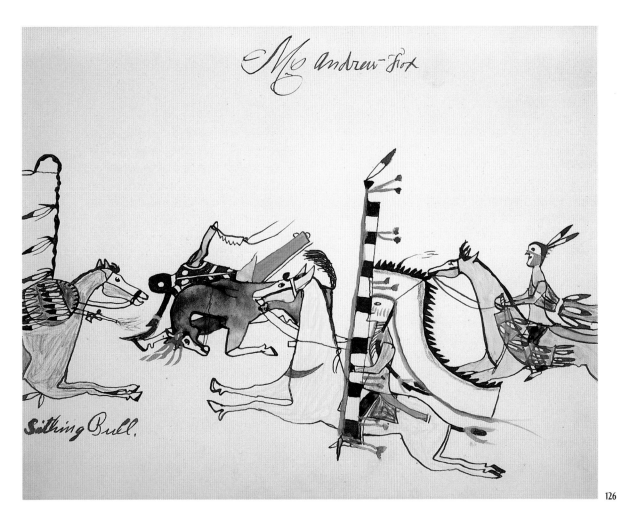

126

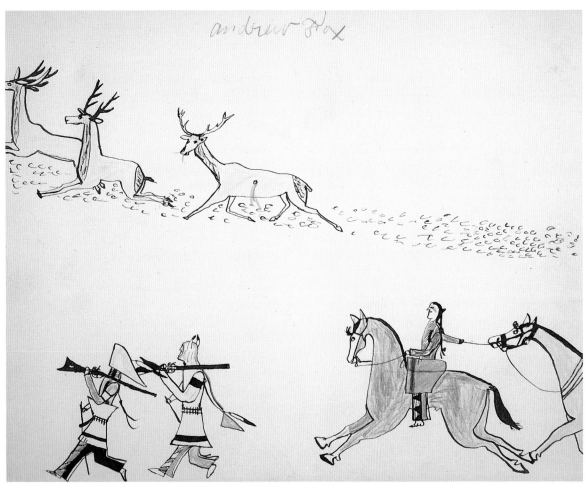

127

Battiste Good
(1822–1894)
Brule Lakota

Catalogue Numbers 128, 129

Battiste Good's name first appears on a December 1877 census at the Spotted Tail Agency in Nebraska. He later lived on the Rosebud Agency in South Dakota, where he was a tribal historian and kept a pictographic winter count of the Brule Lakota. Several versions of his count are known, some done by Good himself and some by his son-in-law, High Hawk. The version illustrated here is in the collection of the Denver Art Museum.

One of Good's winter counts was first published by Garrick Mallery (1893:287–328); the Denver book is quite similar to the one Mallery illustrated. The Denver book and an accompanying narration were obtained from Joseph Good, who was said to be the son of Battiste Good. But the narration (of unknown authorship, dated 1939) mistakenly identifies Battiste Good and High Hawk as the same person. High Hawk continued his father-in-law's historical chronicles and replicated them several times, apparently for sale. The Denver winter count looks very much like another one by High Hawk published in part by Curtis (1908, v. 3:159–82). A winter count done in two drawing tablets by High Hawk, in the collection of the Beuchel Memorial Lakota Museum (Saint Francis Indian Mission, Rosebud Reservation, South Dakota), is clearly by a different artist than the book illustrated here. The two artists use the same pictographs for most events, but the Beuchel book's yearly count extends to 1920 and encompasses such local events as the burning of St. Francis Mission in 1916.

The Good/High Hawk winter counts are distinguished from most other pictographic histories in that they begin not in the eighteenth or nineteenth century but in mythic time, before the Lakota had either buffalo or horses and before they kept track of time through annual counts. In the Good and High Hawk books, the cycles of time before the year 1701 are shown by camp circles within which sacred events unfold.

BATTISTE GOOD
128. The Coming of White Buffalo Woman
129. Winter Count 1871–1880
ca. 1888
Pencil, colored pencil, and ink
5¼ x 7¼ in.
Denver Art Museum Collection, 1963.272

The Denver winter count by Battiste Good consists of several parts: eighteen pages of drawings depicting events prior to 1701, each epoch depicted by a camp circle; fourteen pages of pictographs for the years 1701–1888, in which each Arabic year number is accompanied by a pictographic representation of an event from that year; and several pages of brief English glosses for the yearly calendrical symbols. Although the artist had written in the numbers for 1889 and 1890, with a blank space for the insertion of a pictograph, the last pictograph drawn was for 1888, suggesting that this was the year in which Good stopped recording in the book. Two pages of the book are illustrated here.

On the first page (cat. no. 128), Good has drawn a camp circle of twenty-eight Lakota tipis. In the center is a white buffalo. This image refers to one of the most sacred mysteries of Lakota cosmology: the appearance of the White Buffalo Woman and her gift of the sacred pipe. While there are several versions of this event, in essence it describes two hunters who encounter a beautiful young woman in their travels. She bestows upon them a sacred pipe and tells them, enigmatically, "You shall call me grandmother. If you young men will follow me over the hill, you shall see my relatives" (Mallery 1893:291; see also DeMallie and Jahner 1991:109–12). Over the hill is a large herd of buffalo, given as sustenance to the Lakota people.

In this drawing, the supernatural figure is depicted not as a beautiful woman but as an albino buffalo calf, with the pipe above her head; the year 900 is written there as well. The buffalo calf is enclosed within the camp circle, while the two hunters are shown outside. The sacred pipe of the Lakota that tradition says was given by White Buffalo Woman on this occasion is said to have been maintained by one family for nineteen generations (Doll 1994:110). Lakota people still venerate White Buffalo Woman and recall with humility and gratitude the spiritual and material gifts she has bestowed upon them.

In the first section of the book, Battiste Good located the events within the camp circle to indicate that he was describing historical events of the Lakota people, even though these events transpired before the reckoning of linear annual counts. In the second part of the book, each page records a decade or more of events, with each year symbolized by just one pictograph. Every pictograph in the winter count would have served as a mnemonic device upon which tribal historians would hook all of the other events they had recollected about a particular year. Cat. no. 129 records the events of the 1870s as follows:

1871: A warrior named High Breast killed by Shoshone
1872: Roan Bear died
1873: Issue of commodities from the government (indicated by a striped blanket next to the tipi)
1874: Year of measles outbreak
1875: Utes stole hundreds of Lakota horses
1876: Chief Buffalo Head sponsored ceremonies
1877: Chief Elk-Walks-Crying died
1878: Crazy Horse killed
1879: Cheyennes killed in a house
1880: Sent the boys and girls to school
(Mallery 1893:326–28; object file 1963.272, Denver Art Museum).

JCB

The last event mentioned is particularly noteworthy in the history of Lakota-white relations. In 1880, the Brule Lakota were persuaded to send their children to school in the East. Some Lakota from the Standing Rock and Cheyenne River Sioux agencies further to the north had already sent some of their children to school at the Hampton Institute in Virginia (see discussion on p. 200). But no Brule children had yet gone East. Richard Pratt, the former warden at Fort Marion prison, and current head of the Carlisle Indian School in Pennsylvania, traveled personally to the Rosebud and Pine Ridge agencies to argue the cause of Eastern education. He succeeded in persuading Spotted Tail, chief of the Brules, to send his own children. Ultimately, eighty-four children from Rosebud and Pine Ridge accompanied Pratt to Carlisle (Pratt 1964:213–29). They were sent off in proper Lakota fashion, with an honoring ceremony that involved the distribution of horses, clothing, yard goods, and food to the poor, all presided over by Spotted Tail.

Less than a year later, however, Red Cloud and Spotted Tail, part of a delegation to Washington, made a detour to Carlisle and Hampton to see the schoolchildren from their bands. Spotted Tail was shocked to find his sons wearing soldier uniforms and participating in drills, and even more aghast to see that one of his sons was in solitary confinement in the guardhouse for having stabbed another student in the leg (Pratt 1964:237–39). Spotted Tail took his own children back to the reservation, though the others stayed on.

JCB

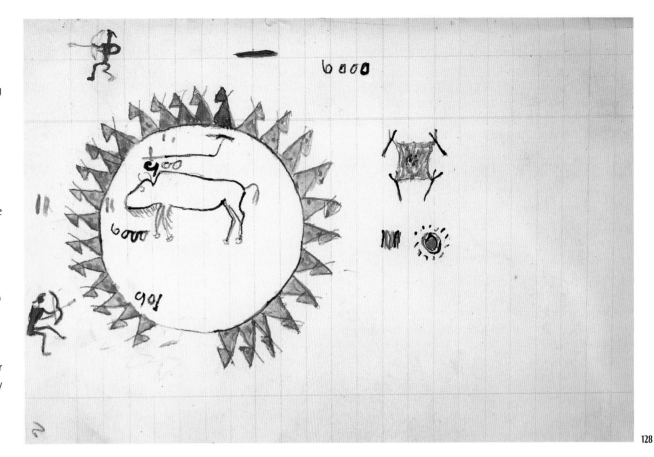

128

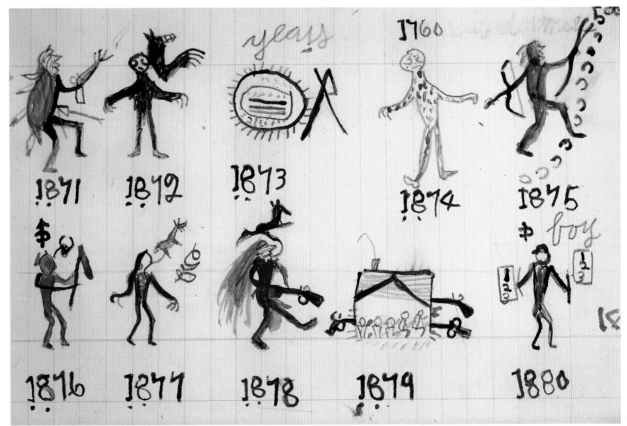

129

No Two Horns
(1852–1942)
Hunkpapa Lakota

Catalogue Numbers 130–33

One of a large group of Hunkpapa artists active at the Standing Rock Agency at the turn of the century, No Two Horns worked in wood, hide, cloth, and paper (Wooley and Horse Capture 1993). The Reverend Aaron McGaffey Beede, who was an Episcopal minister and director of Indian mission work in North Dakota, collected these drawings from No Two Horns and gave them to the Historical Society of North Dakota. They were originally made in an artist's drawing book (complete with geometric projections and other imagery and captions printed in the margins of some pages). Today forty-three loose pages from this book are accounted for. All appear to have been drawn by No Two Horns himself, though they depict events not only from his own early years as a warrior but also in the life of his father and other Hunkpapa warriors.

While the drawings are not dated, they were acquired by the museum in 1916 and seem to have been made shortly before that time (Wooley and Horse Capture 1993:37).

JCB

NO TWO HORNS
130. Red Hail Counts Coup on a Crow
(Berlo, "A Brief History of Lakota Drawings," pl. 2 [p. 38])
131. Red Hail Captures a Crow Horse
ca. 1915
Pencil, colored pencil, and ink
8 x 10 in. each
State Historical Society of North Dakota
(State Historical Board), Bismarck,
9380.E, .F

In these drawings, No Two Horns commemorated incidents in the early life of his father, Red Hail (1831–?). While arrows whiz past him (cat. no. 130), Red Hail rides toward his Crow enemy and touches him with his coup stick. He rides a horse that is painted with lightning emblems. Red Hail himself is scantily dressed, but his face is painted for war.

In the other drawing (cat. no. 131), Red Hail wears heavy leggings and a warm wool capote. His name glyph is shown over his head, connected by a thin line to his mouth. He leads a Crow pony that he has gotten on a horse raid. The awkward stance of the horse—he is shown partly in profile and part frontally—suggests that the horse is balking as Red Hail tries to lead him away. Red Hail is heavily laden with implements strapped over his bulky coat. He carries a skin quiver, a bow, a rifle, and a horn container. Slung over his shoulder is the sash of the Lakota Miwatani Society. Members of this warrior society pledged that they would sacrifice their own lives in war to defend the lives of their cohorts (Densmore 1918:327).

JCB

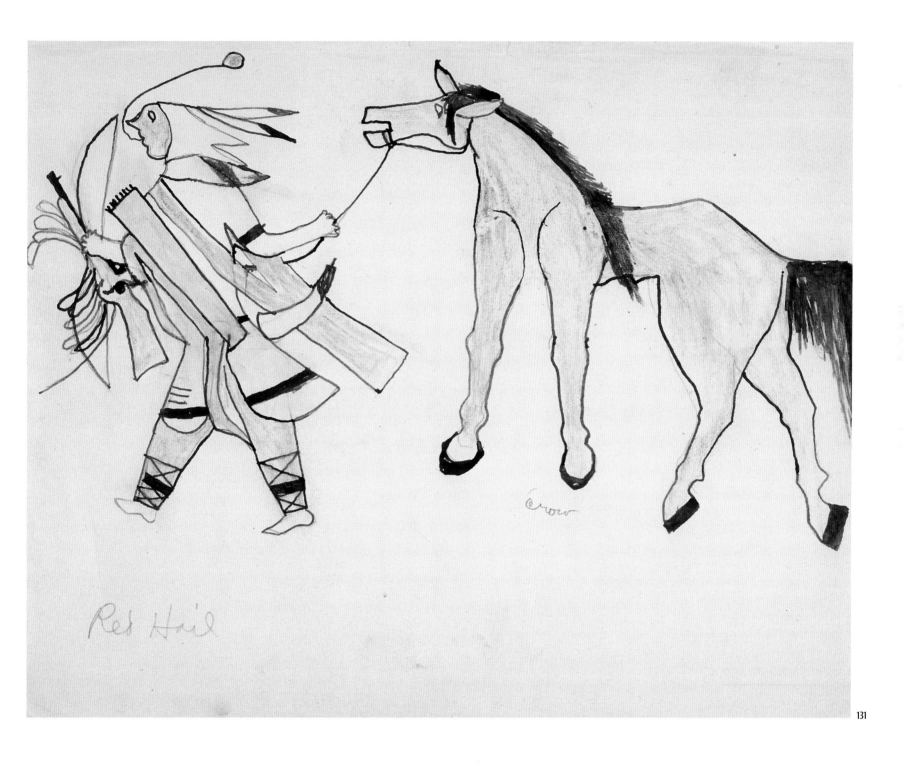

Red Hail

Crow

NO TWO HORNS

132. No Two Horns Rescues a Strong Heart
Society Warrior
133. No Two Horns Fleeing from Enemy
Gunfire
ca. 1915
Pencil, colored pencil, and ink
8 x 10 in.
State Historical Society of North Dakota
(State Historical Board), Bismarck,
9380.H, .K

In cat. no. 132, No Two Horns is recogniz-
able by his painted shield, on which is
depicted a bird with wavy lines represent-
ing power, emanating from its wings. No
Two Horns's upper face is also painted with
similar wavy lines. Several examples of this
distinctive shield exist in museum collec-
tions (Conn 1979:fig. 171). In the present
drawing, the artist depicted himself in the
act of rescuing one of his cohorts from a
volley of gunfire from four enemies, whom
we see on the right. The man seated behind
No Two Horns wears the split horn feather
bonnet that indicates his membership in
the Strong Heart Society, an organization of
fearless warriors of generous spirit and fine
moral character (Densmore 1918:320–21).
In a similar scene (cat. no. 133), No Two
Horns flees from his Crow or Assiniboine
opponents, all of whom shoot at him as he
makes his escape.

In a number of the drawings done by
No Two Horns, including these two, the
horses seem to have been drawn with the
aid of a template or stencil (Mark Halvorson,
State Historical Society of North Dakota,
personal communication, June 1995). It is
possible that the artist came up with this
solution to make multiple drawings more
quickly and easily, for his right hand was
crippled. Despite this handicap, which
stemmed from a hunting accident that

occurred when he was young, No Two Horns
was a prolific artist (Wooley and Horse
Capture 1993:34). He and many of his con-
temporaries made drawings, carvings, and
muslin paintings for sale to scholars, collec-
tors, and tourists. Some of them earned
money dancing and selling artifacts to visi-
tors who rode the Northern Pacific Railroad
spur that ran to Cannonball, a town on the
Standing Rock Reservation (Wooley n.d.).

JCB

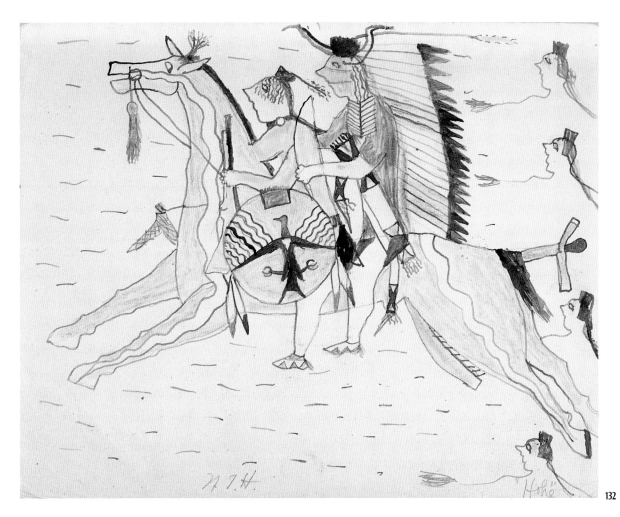

132

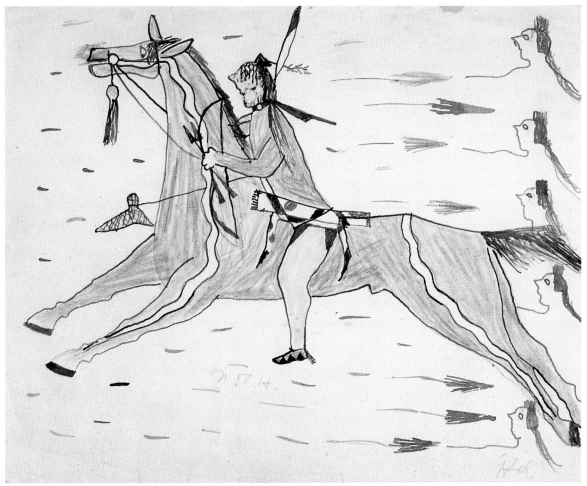

133

Moses Old Bull
(1851–1935)
Hunkpapa Lakota

Catalogue Numbers 134, 135

Moses Old Bull was one of the close circle of Hunkpapa warriors who were loyal to Sitting Bull and accompanied him on his retreat into Canada in 1876. Like White Bull (see cat. nos. 151–53), Old Bull was one of the principal Lakotas whom Walter Stanley Campbell relied upon when researching Sitting Bull's life. Between 1928 and 1932, Campbell worked with Old Bull and paid him for a series of seventeen drawings (Miles and Lovett 1994). They depict events from Old Bull's life on the Northern Plains in the 1870s, when he was in his twenties—a young warrior in his prime. In recalling the events of those days, the artist at age eighty continued to rely on Lakota artistic conventions of that earlier era.

JCB

MOSES OLD BULL
134. Lone Man and Sitting Crow Fight the Crows
135. Fighting Crows at Bear Butte Mountain on Kicking Bear's Warpath
ca. 1930
Pencil, colored pencil, and crayon
8³/₄ x 11³/₄ in. each
Western History Collections, The University of Oklahoma Libraries, Norman

In a lively scene filled with shorthand images of mounted Lakota warriors, Old Bull has recalled a raid on a Crow camp (cat. no. 134). A dozen Lakota on horseback fill the right-hand side of the page, each drawn in a Lakota pictographic style that has changed little since the 1870s (compare cat. no. 113). Except for the coloration, most of the horses' heads are undifferentiated. The only rider who has any distinguishing features is Old Bull himself. Second from the top, ŏn the right, he carries a hatchet and his face is adorned with a line of paint. On the left side of the page, Old Bull depicted the circle of Crow tipis in an almost abstract fashion. The only Crow shown are the three who were killed— according to the caption on the back, a boy, a man, and a woman. As was common in the nineteenth-century pictographic tradition, to which Old Bull was still faithful even in 1930, individuality was less important than action. The success of the gunfire and the galloping group of horsemen are the lasting impressions conveyed in this drawing.

In cat. no. 135, Old Bull related another incident from the 1870s. Evidently he was not a direct participant in this action, for the protagonists are identified as Lone Man (attired in red, on the left) and Sitting Crow.

They stand in the center of the action, looking to the right and firing their weapons. Each wears an animal skin medicine object ("wotawe," in Lakota). Lone Man's is on his right shoulder, Sitting Crow's on his left wrist. Sometimes the cloth wrapping from a medicine bundle—imbued with the spiritual energy of its contents—would be worn into battle as a cape, or a stuffed bird or animal skin might be affixed to one's hair or body (see cat. nos. 28, 138).

Crows on horseback encircle the two Lakota. As in the other drawing, a large group of horsemen is indicated by the horse-heads and upper bodies of the riders. Though the artist has given the figures no individuality through clothing, their identity as Crow enemies is made clear by the pompadour hairdo carefully drawn on each one.

Old Bull was one of the experts that ethnomusicologist Frances Densmore relied upon in 1913 during her research on Lakota music and culture. She illustrated details of two muslin paintings done earlier by Old Bull (whom she calls Old Buffalo). In both, he also depicted skirmishes with the Crow Indians (Densmore 1918:figs. 33, 34); the subject apparently preoccupied him for many years.

JCB

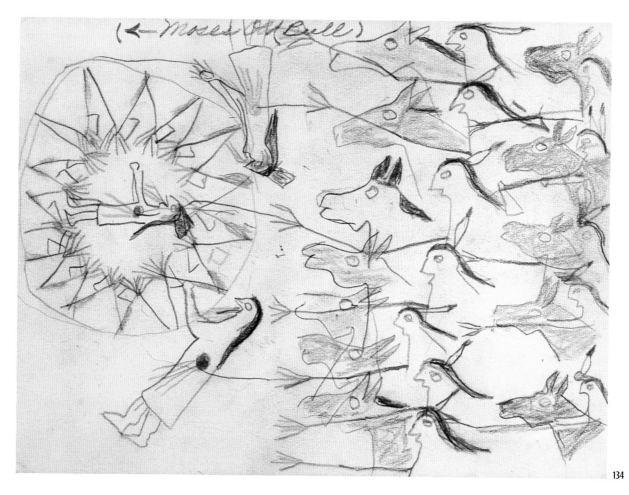

134

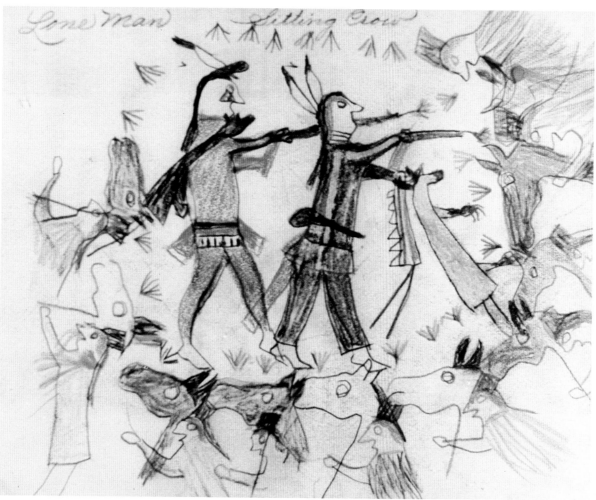

135

Red Hawk and others
(ca. 1826–after 1914, or 1854–after 1914)
Oglala Lakota

Catalogue Numbers 136–42

In the spring of 1890, Kicking Bear, Short Bull, and several other Lakota returned from a trip west where they went to investigate the new Native American spiritual movement, the Ghost Dance, that promised the demise of the whites and the return of the ancestors and the buffalo. From summer into autumn, adherents of the Ghost Dance religion grew more numerous at Pine Ridge and the other Lakota agencies. On December 29, white soldiers, who had worked themselves into a state of paranoia about the intentions of these people, massacred over two hundred men, women, and children, many of them followers of the new Ghost Dance faith, at Wounded Knee Creek.

During the next several weeks, as bodies lay frozen on the snow-covered ground, military men, newspaper reporters, and photographers swarmed over the killing field and the Pine Ridge Agency. One Washington journalist wrote, "the relic hunter has been all over the battlefield and has taken away everything of value and interest that was above the surface. Occasionally one will find a memento worth carrying away, but not often. Whatever was beautiful or odd in the clothing of dead or wounded Indians was taken by the victors and either kept for personal gratification or sold for cash" (Jensen et al. 1991:108).

One of these relic-hunters was Capt. R. Miller, of Rapid City, South Dakota, who on January 8 acquired a ledger book containing 116 drawings by Red Hawk and other artists. Though it is often assumed that he took the book from a dead body, it is more likely that he bought it from Red Hawk himself, who lived at Pine Ridge for at least another twenty-three years after the slaughter at Wounded Knee. Another contemporary newspaper report, written from Pine Ridge on February 1, 1891, declared, "This place has been full of busy

men for two months past, but none have labored with less cessation or more enthusiasm than the collector of curios, the aggregator of relics, the purchaser of everything—good, bad, indifferent—that was offered for sale. . . . Everything salable has been dragged out of the teepee and disposed of at "war prices" (unattributed press clipping, Bourke 1872–96, v. 104: unpaginated).

The artists who drew in this book continued the established Lakota tradition of memorializing exploits in warfare. In style, the drawings look very much like those of the previous twenty years by Four Horns and others (see cat. nos. 124, 125, 106–109). Indeed, many of the events depicted, such as numerous fights against the Crow, and horse raids, probably happened in the 1850s, 60s, and 70s. Of the 116 drawings, at least fourteen depict the actions of Red Hawk, whose name is written inside the front cover. Sitting Hawk and Holy Standing Buffalo are the heroes of approximately a dozen drawings each. Fourteen other men are represented by one to ten drawings apiece. Their names are written on most drawings, sometimes in Lakota, sometimes in English, and sometimes in both languages. Notably, the handwriting of the English names is different from the several different handwritings of the Lakota names. The same ink used in drawing the pictures seems to have been used in the names written in Lakota, suggesting that those names were written by one or more of the artists. The captions beneath the pictures are in yet a different hand and, as discussed in cat. no. 138, may have been added some years after the drawings were made.

Red Hawk and the other men pictured in the drawing book were members of Red Dog's band of Oglala. Pages 130 and 131 of the ledger contain lists of names written in Lakota, labeled "Wounded Knee, Red Dogs Camp." Some of the drawings' heroes are named in these lists. Red Dog's band settled in the Wounded Knee district of the Pine

Ridge Agency, where this book was made. Many of the protagonists appear in the 1874–1905 census rolls for that district; in 1890, their ages ranged from thirty-six to sixty-four.

The census rolls of the Wounded Knee district reveal that two Red Hawks lived in this area of the Pine Ridge Agency. One, born about 1826, was an informant for Walker's researches on the Lakota (DeMallie and Jahner 1991:284). The other, born in about 1857, was an informant to Edward Curtis, and is pictured in his work (Curtis 1908:188). More work is needed to resolve the issues of artistry and ownership of this important drawing book.

JCB

RED HAWK AND OTHERS

136. *Drives off 2 Horses* (61)
137. *Escaping with One Scalp* (67)
1880s?
Pencil, ink, and crayon
7½ x 12¼ in. each
Milwaukee Public Museum, 2063

Illustrated here are three of the seven drawings in Red Hawk's ledger that depict war exploits of Matoniyaluta, whose name has been rendered on these drawings as "Red Living Bear," though a more literal translation might be "Red Breath Bear," a family name still occurring today at Pine Ridge (Arthur Amiotte, personal communication, 1995; see also cat. no. 138).

In cat. no. 136, Red Living Bear captures two horses. His face is painted with red stripes, he wears a red cloth tie at the top of his head, and his braids are wrapped with black and white cloth. He also wears a tailored cloth vest and beaded fringed leggings. He is armed with both a pistol and a rifle. Young Lakota men often organized horse raids, particularly against the Crow; returning home with fine Crow ponies was a source of pride and honor.

Cat. no. 137 commemorates Red Living Bear's act of bravery in coming to the aide of his comrade Little Shield, helping him escape a volley of bullets. Both men wear war paint of vertical stripes on their faces. Red Living Bear is attired in the same clothes he wore in the previous drawing. Little Shield wears a fringed and beaded war shirt; he bleeds from the mouth, chest, and back as they make their escape. Little Shield appears nowhere else in the ledger book; perhaps he did not survive these wounds.

Despite the grisly subject matter, there is an elegant sense of movement in this drawing, not only through the rhythm of the horses' legs stretched out at both sides of the drawing, but also through the positioning of the heads: one horse looks forward, one looks at the viewer, one man looks forward, one looks back at the gun-fire. The artist of these works, whether Red Living Bear himself or another Oglala, renders horses in a particularly elegant and delicate manner.

JCB

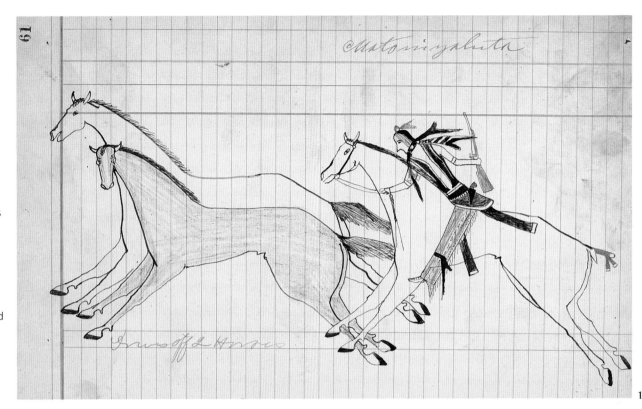

136

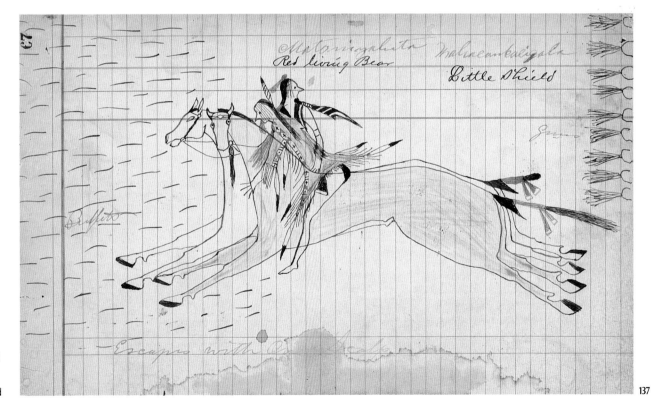

137

RED HAWK AND OTHERS

138. *Ghost Shirt Protecting a Sioux Escapes*
(65)
1880s?
Pencil, ink, and crayon
7½ x 12¼ in.
Milwaukee Public Museum, 2063

Red Living Bear (identified only by his Lakota name, Matoniyaluta) and an unidentified companion escape on one horse; their second horse gallops behind. Both men turn and fire at nearly a dozen assailants, visible only through the volley of shots that issues from their weapons at the right side of the page. The artist has drawn a superb portrait of a lunging horse, who strains forward across the page, away from the fusillade.

The caption reads "Ghost Shirt Protecting a Sioux Escapes." An element of the Ghost Dance faith that developed in 1890 exclusively among the Lakota was the belief that special painted muslin shirts would make their wearers impervious to bullets. Curiously enough, none of the five drawings in this ledger with captions about the "Ghost Shirts" (ledger pages 43, 45, 65, 196, and one unnumbered page) depicts the recognizable iconography of the muslin Ghost Dance shirt painted with stars, moons, and birds (Josephy et al. 1990:figs. 11, 33, 36). In the drawing illustrated here, the red-cloaked warrior wears what may be simply the wrapping cloth of his "wotawe," or medicine bundle, which warriors wore into battle for protection long before the idea of bullet-proof Ghost Dance shirts gained currency among the Lakota. For example, Sitting Bull's wotawe is a green trade cloth painted with elk and dragon-flies, which he is said to have worn during the fight against Custer in 1876 (1234, Sioux Indian Museum, Rapid City, South Dakota).

In another scene said to include a Ghost Dance shirt, the man wearing a painted skin cloak is clearly fighting Crows (Ritzenthaler 1961:pl. 31). While several of these draw-ings do show the riders braving a veritable hail of bullets (this drawing and Maurer 1992:fig. 131), nothing in their iconography links them to the Ghost Dance or its cloth-ing. In another example, the caption reads, "Testing the Ghost Shirt Bullett Proofs/

Many Indians Come to Witness this Test" (Ritzenthaler 1961:pl. 27). The protagonist is identified in both Lakota and English as Standing Bear. Yet Standing Bear was, in fact, traveling in Europe as part of Buffalo Bill's Wild West Show during the Ghost Dance craze and did not return until late January 1891, a month after the massacre that ended it (Arthur Amiotte, personal communication, 1995). It is more likely that the drawing recalls a youthful exploit of Standing Bear, when he defended Lakota horses against a Crow horse thief or engaged in some horse raiding of his own.

All of these examples suggest that per-haps new captions were put on old draw-ings. Moreover, they caution that the truth of Plains pictography lies in the images themselves, not in the "explanatory" cap-tions that overlay them like a scrim. When Capt. Miller purchased the book in January 1891, the Ghost Dance movement was uppermost in the minds of those who flocked to Pine Ridge, eager to acquire "souvenirs." Current events clearly clouded the interpre-tation of incidents that had occurred in the past, and of drawings that may have been made a decade earlier.

JCB

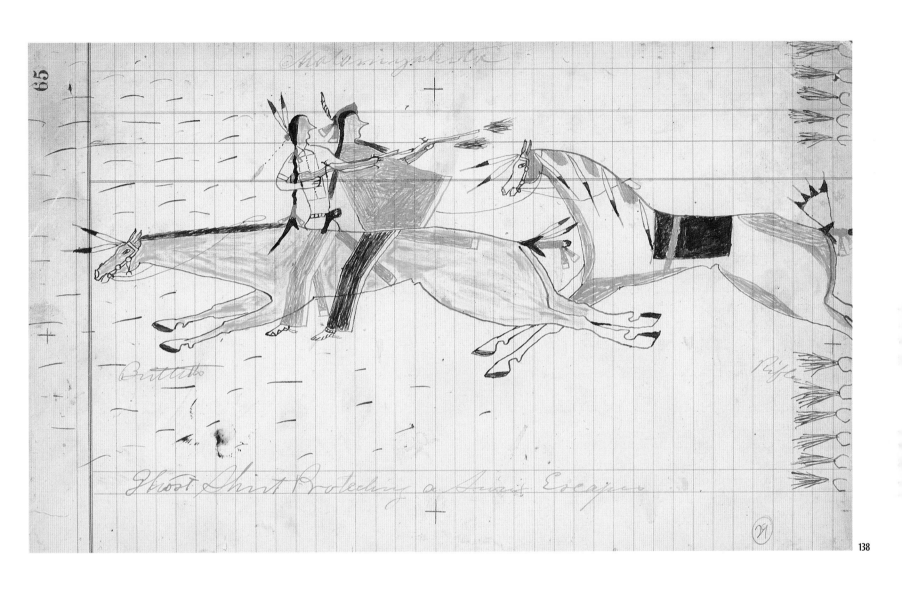

Ghost Shirt Protecting a Sioux Escapee

138

RED HAWK AND OTHERS
139. *Steals 2 Horses* (170)
140. *Steals Goverment* [sic] *Horse and Saddle* (172)
141. *Running off Ponies* (174)
142. *Steals Sioux Pony* (176)
1880s?
Pencil, ink, and crayon
7$\frac{1}{2}$ x 12$\frac{1}{4}$ in. each
Milwaukee Public Museum, 2063

Quick Thunder's exploits are recorded in five drawings in the Red Hawk ledger, all of which depict scenes of horse capture. Four are illustrated here. In two of them (cat. nos. 139, 140), Quick Thunder wears a feathered war bonnet and a cloth cape painted with a crescent moon and dragonflies. The dragonflies endow Quick Thunder with great speed, which allows him to excel at horse raiding.

Facial features are sketchy or nonexistent in these drawings, yet the artist has shown enough detail on the weaponry to identify the guns as Springfield carbines. The pictures also record the different sorts of horses he captured, including a U.S. government horse complete with saddle (cat. no. 140). In cat. no. 142, Quick Thunder may be relating an instance when a Crow stole horses from him. One raid occurred in the winter (cat. no. 141), for Quick Thunder, riding the same swift yellow horse he used when stealing the government horse, wears a hooded wool capote made of a striped Hudson's Bay blanket.

The artist followed two standard Lakota conventions for showing a group of horses: either a floating, overlapping group of full figures (cat. no. 142) or a cluster of disembodied heads (cat. no. 141; see also cat. nos. 113, 151). While it is commonly assumed that in a ledger book containing the visual narratives of numerous men, each one would have drawn his own history, the Red Hawk ledger demonstrates that the situation was more complex than that. Several artists worked on the book, and there is clear evidence that in many instances more than one artist recorded the deeds of an individual. In the case of Quick Thunder, the artist who drew the horses in cat. no. 140, with their angular feet, pointed fetlocks, and relatively large heads, was not the same artist who drew the horses' curvilinear hoofs and small, delicate heads in the other three Quick Thunder drawings. While the name Quick Thunder does not appear in the late nineteenth-century census rolls of the Wounded Knee district, a man named Fast Thunder (born about 1841) appears in the 1874 and the ca. 1890 censuses, and may well be the individual depicted here (Record Group 75, Bureau of Indian Affairs, National Archives, Central Plains Region, Kansas City, Missouri).

JCB

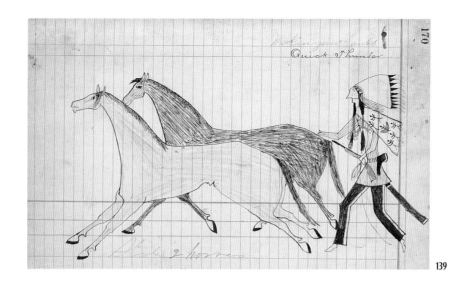

139

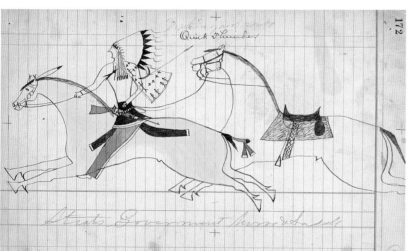

140

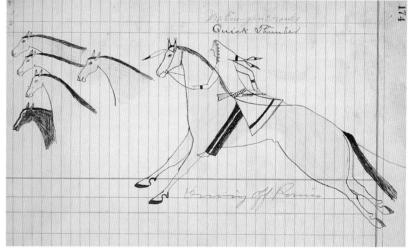

141

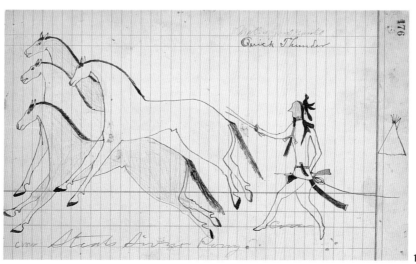

142

Sinte
(1860?–?)
Lakota

Catalogue Numbers 143–48

Twenty-five drawings by a previously unknown and unpublished artist, Sinte ("Tail"), are held by the American Museum of Natural History. Nine are included in this exhibition. Sinte made these drawings for Rudolf Cronau, a German writer and illustrator who was a journalist for *Gartenlaube*, a weekly periodical published in Leipzig. Little is known about the life of Sinte, but Cronau probably met him in 1881–83, when the German visited Standing Rock Agency, Fort Randall, Pine Ridge Agency, and other western settlements. Cronau describes his overtures of friendship to the Lakota men he met, and how he began to acquire his large collection of drawings. While visiting the tipi of a chief, and making a drawing of him, other Lakota men gathered to watch him draw:

In order to convince the redskins of the harmlessness of my artistic studies and at the same time to interest them in the latter, I gave one of the Indians sitting next to me one of my sketchbooks, lead, and paints, and indicated to him that he might also try at fine painting and depict me. The Indian went to work without much feigned hesitance and put together one of those sharply outlined drawings which are so characteristic of Indian art. . . . The method of leading one or another of my audience to draw paid off splendidly. I owe my exceedingly rich, probably unique collection of original Indian drawings to that, since I received the art work in question many times as a gift or acquired them some other way. They represent all sorts of episodes of Indian life, such as love and courting scenes, hunting scenes, battle episodes, dance fests, and representations of the abduction of horses and women. Costumed figures, animals, landscapes, geographical maps, and mythological representations were also not lacking. In short, almost every phase of life on the prairie is touched on (Cronau 1890:66–67; translation by Elizabeth Ross).

Sinte and a group of other Indians traveled with Cronau on a tour of Berlin, Frankfurt, Leipzig, Vienna, and other European cities in 1886 (Stirling 1938:35; Cronau notes, object file 50–2100, AMNH). According to Cronau's annotations that accompany the drawings, most of Sinte's works were done during that trip. Because Sinte so accurately drew the Pine Ridge Agency (see cat. no. 148) during his trip to Germany, we might posit that he is an Oglala from that agency. The Pine Ridge census from the Wounded Knee district in 1887 lists a man named Tail who was twenty-seven years old that year. Perhaps further research will uncover more about his life.

JCB

SINTE
143. Game Animals of the Lakota
144. Hunting Buffalo
1886
Pencil and colored pencil
11 x 8³/₈ in. each
American Museum of Natural History,
New York, 50.2100

In cat. no. 143, Sinte has drawn six different animals hunted by the Lakota: bear, elk, buffalo, mountain sheep, antelope, and deer. These animals were plentiful in the Black Hills, the region that Sitting Bull called the Meat Pack because of the riches they offered the Lakota (Utley 1993:115). In the drawing, the animals stand alone, not as part of a hunting scene, but rendered more as natural history drawings, like those of Black Hawk (see cat. nos. 114, 115). In cat. no. 144, a Lakota hunter on horseback stalks buffalo and an elk, successfully bringing down one buffalo with his arrows.

Of the bounty of the plains in the 1860s and 70s, Gen. George Forsyth wrote:

In those days it was an Indian paradise, for within a few miles of the most advanced settlements, plover, quail, and grouse sprang into the air with a startled whir, and fluttered away to cover in every direction, as the early traveler urged his horse along the trail or through the thick grass that bordered the path on his journey's way. Wild fowl of almost every variety nested and raised their young fearlessly in the reeds along the course of the rivers and among the lakes and swamps of the South and West, while vast flocks of wild turkeys feasted and fattened on the hazel and pecan-nuts of Indian Territory and Texas. The mountain streams were filled with trout, and far in the rugged depths of the Rocky Mountains brown, black, and grizzly bear, together with wildcat and mountain lion, gave the added zest of danger to the Indian hunters; bands of elk and antelope and herds of deer ranged at will among the foot-hills of the mountains, while the great plains were at times covered as far as they eye could reach with vast herds of buffalo, which grazed, comparatively unmolested, from Indian Territory on the south to the bad lands of Dakota on the north (Forsyth, 1994:5).

JCB

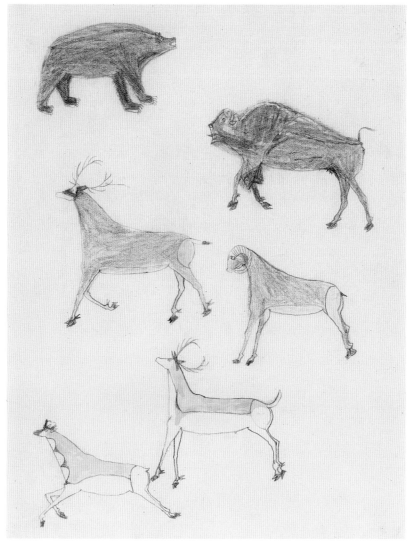

143

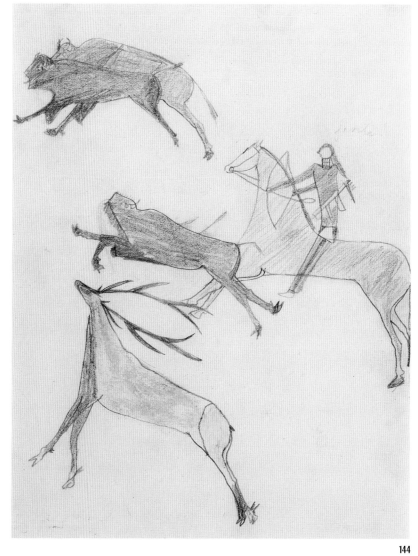

144

217

SINTE

145. *Sinte Riding at a Gallop*
1886
Pencil and colored pencil
4⅝ x 7½ in.
American Museum of Natural History,
New York, 50.2100.59a

A Lakota warrior headman, wearing a split-
horn headdress and holding a crooked staff,
sits astride his war horse, and moves from
right to left across the page. He faces fierce
gunfire, which comes from the left edge
of the composition. None of it wounds him,
and the hoofprints indicate that he has
ridden in front of these riflemen and turned
to face them again.

JCB

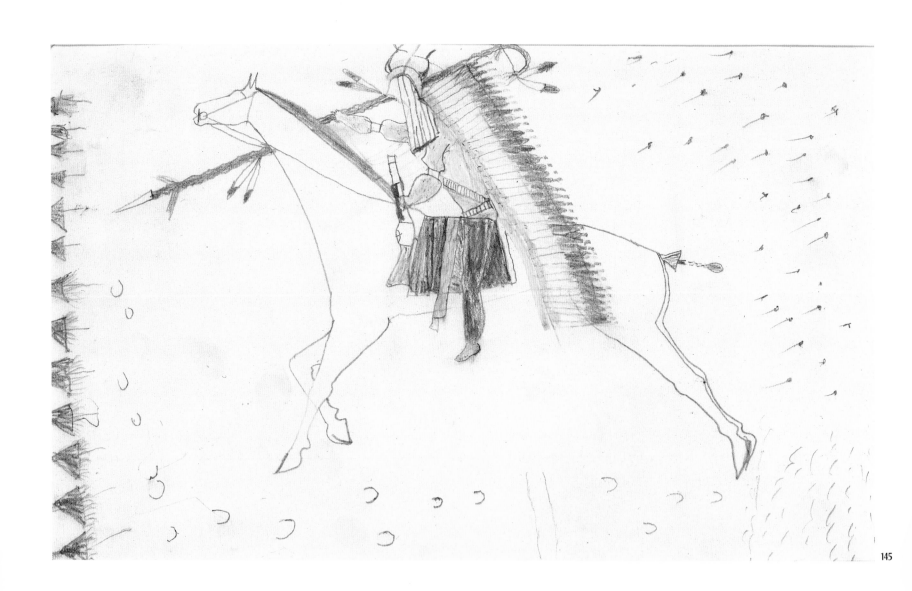

145

SINTE

146. *Indian Butchering Celebration*
147. *Drawing of the Pine Ridge Agency*
148. *A Settlement*
1886
Pencil and colored pencil
8³⁄₈ x 10¹⁄₂ in., 8³⁄₈ x 11¹⁄₈ in., 4⁵⁄₈ x 5³⁄₈ in.
American Museum of Natural History,
New York, 50.2100.39, .51b, .51c

In addition to his depiction of classic scenes of warfare and hunting, Sinte was adept at portraying settlements with an almost cartographic clarity. On small sheets of one-quarter-inch graph paper, Sinte accurately mapped an Indian settlement of the 1880s (cat. no. 148), in which tipis coexisted with log houses. A tiny covered wagon is pulled by four horses, and trees line the river banks.

In two larger drawings, Sinte continued the theme of landscape and townscape. In cat. no. 146, a butchering celebration is taking place. This is an accurate depiction of the early reservation practice of the beef issue, carried out like a buffalo hunt. One Lakota described the custom: "In the earlier years of the beef issue, the cattle were turned loose on the prairie and the Indians shot them from horseback, somewhat like a buffalo hunt. It offered diversion as well as meat, and the Indian families would then skin and dress the animal out on the prairie where it fell" (Hamilton and Hamilton 1971:98). The only oddity in Sinte's drawing is the representation of both buffalo and cattle together, for by the time this sort of beef issue was held, the buffalo were nearly extinct.

Cronau's notation for cat. no. 147 reads: "Drawing of the Pine Ridge Agency and the complete ground plan. Left, school; right, church of brick, and block houses surrounded by fences; and in the middle of the plaza is a flag pole where the American flag is flying. Above the flag is an arrow which shows the wind direction." The Pine

Ridge Agency was established in 1879. Sinte has shown the impressively large Indian boarding school, and the red brick Episcopal church, which, only a few years later, would serve as the hospital for Lakota shot in the massacre at Wounded Knee. Contemporary photos show the agency looked essentially as Sinte drew it (Jensen et al. 1991:fig. 26).

While such depictions were common in the works of Southern Plains artists at Fort Marion in the 1870s, on the northern Plains these scenes of acculturation are rare until the work of Amos Bad Heart Bull in the 1890s (Blish 1967:figs. 355, 359, 362). In the existing corpus of Lakota drawings from the 1880s, Sinte's works are unusual indeed. Cronau remarked of these drawings that they were "drawn from memory by Sinte during his stay in Europe in 1886. According to the testimony of the people who were with him, they should be very correct and give a faithful interpretation of these things" (object file 50.2100, AMNH).

JCB

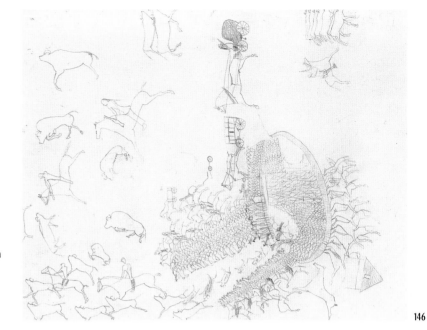

146

147

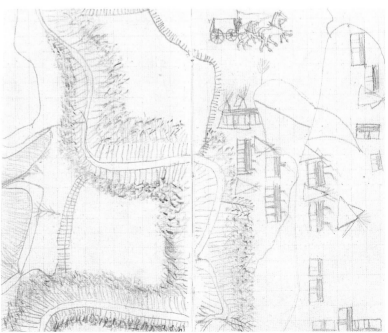

148

Swift Dog
(ca. 1845–1925)
Hunkpapa Lakota

Catalogue Numbers 149, 150

Like No Two Horns, White Bull, and Old Bull, Swift Dog was a member of Sitting Bull's band, which retreated to Canada in 1876 rather than submit to reservation life. On his return to the United States some years later, he resided on Standing Rock Reservation, where Frances Densmore consulted him for her study of Lakota music and culture (1918). Swift Dog painted a number of winter counts on muslin in the first decades of the twentieth century (McCoy 1994). The drawings reproduced here are probably earlier works, though precise dating is impossible.

JCB

SWIFT DOG

149. No Two Horns Fights a Crow (175)
150. Swift Dog in Pursuit of a Mounted Crow Warrior (169)
Date unknown
Ink and watercolor
7½ x 12 in. each
Mr. and Mrs. Charles Diker

Swift Dog's simple yet confident drawing style effectively communicates the essence of warfare. In two drawings, he depicted a high-ranking Lakota warrior pursuing a Crow enemy. In both cases, he chose to represent the moment just before the act of counting coup or wounding the opponent. In cat. no. 150, both warriors are on horseback. The Crow, with his long hair and pompadour upsweep in front, looks back at Swift Dog, who bears down on him, hatchet in hand. Swift Dog is dressed in his fine

split-horn bonnet with cascading ermine tails, perhaps the same one he wore for Frances Densmore's photograph in 1913 (1918:pl. 69).

In cat. no. 149, the mounted Lakota advances upon his opponent, whose two arrows have missed their mark, for the artist shows them flying past horse and rider. The Lakota's face is painted black and red. He carries a feathered war shield painted with a bird of prey. Though this drawing has been interpreted as a self-portrait of Swift Dog (McCoy 1994:fig. 2), the hero's shield closely resembles that of No Two Horns, another distinguished Hunkpapa warrior. No Two Horns's shield features a frontal bird of prey with profile head and outstretched talons, as does the shield that Swift Dog has drawn. Missing are the lines of power radiating from the wings, which No Two Horns always rendered in his own shield paintings (compare cat. no. 132; see also Wooley and Horse Capture 1993:figs. 2, 5, 10, 11, 12; Maurer 1992:figs. 172, 173, 174; and Conn 1979:fig. 171).

We know from No Two Horns's drawings that he was a member of the Kit Fox Society and had the right to use the bow lance, which is also depicted in this portrait by Swift Dog. It is likely that Swift Dog and No Two Horns, who were approximately the same age, were cohorts in war expeditions of the 1860s and 70s. Perhaps Swift Dog has depicted the exploits of his brave companion, as so many other Lakota artists did in their books (see cat. nos. 124, 125, 130–33, 136–42).

The Crow opponent in cat. no. 149 wears a pierced hide shirt, ornamented by quill or beadwork. These shirts were worn by men of several tribes of the northwestern Plains, including Crow, Blackfeet, and Gros Ventre (Batkin 1995:26–27).

These and other drawings by Swift Dog have been dated in two recent publications as "ca. 1870" (Maurer 1992:figs. 233, 234; McCoy 1994:73 and figs. 1, 2) and elsewhere as "ca. 1866" (McCoy 1984:629). A former owner of these drawings dates them to 1865 (Mark Lansburgh, personal communication, 1993). None of the dates are verified by any data other than style. As demonstrated in Berlo's essay "A Brief History of Lakota Drawings" in this volume, many drawings with "early" stylistic traits were executed by Lakota artists well into the twentieth century; moreover, some artists, like White Bull, used ledger books even in the 1930s (see cat. nos. 151–53). The rest of Swift Dog's oeuvre clusters between 1890 and 1922 (McCoy 1994). The precision of detail in clothing and weaponry rendered in the Swift Dog drawings makes a date in the 1860s unlikely. Yet their loose, flowing style probably antedates the muslins he painted in his old age (compare McCoy 1994:figs. 3, 4, 6).

Unlike some ledger artists who calculated the gaps they had to leave in the horse's outline in order to fit the rider in with no overlapping lines, Swift Dog worked with a free, sure line, unconcerned about the overlapping outlines of his figures. This gave his work a transparency and immediacy that is very pleasing.

JCB

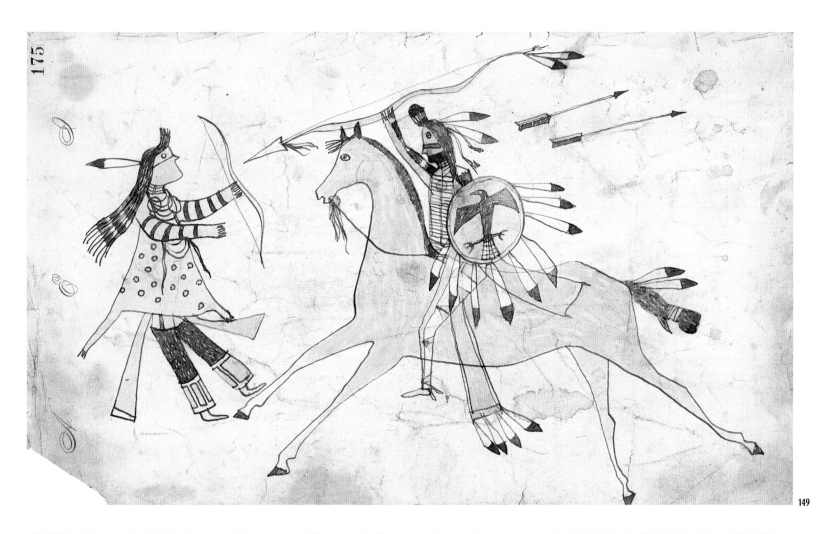

149

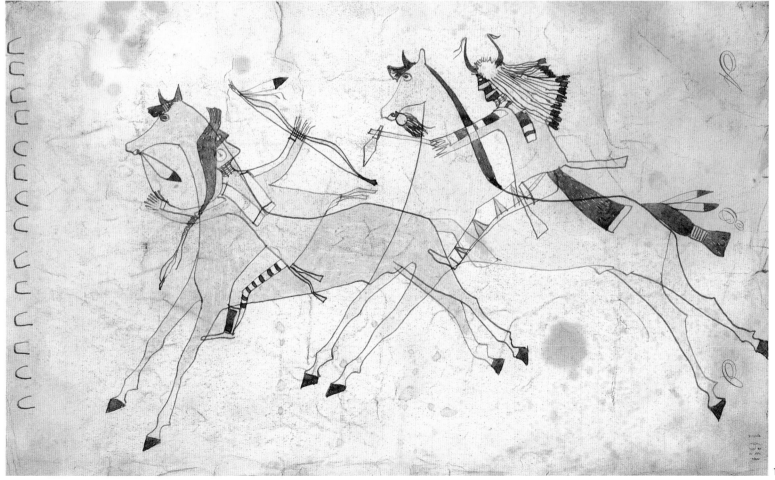

150

White Bull
(1849–1947)
Minniconjou and Hunkpapa Lakota

Catalogue Numbers 151–53

The English name of this Lakota artist, warrior, historian, and chief, White Bull, does not fully render the poetry of the original Lakota. Pte San Hunka means, literally, "Hunka of the White Buffalo," or "He Who Is Profoundly Related to the White Buffalo" (Arthur Amiotte, personal communication, 1995). In nature, a white or albino buffalo is a rare occurrence. In Lakota cosmology, the White Buffalo was the mythological figure who brought the buffalo and a sacred pipe to the Lakota (see cat. no. 129).

White Bull was the son of a Minniconjou chief named Makes Room, and a high-ranking Hunkpapa woman, Good Feather Woman, who was the sister of Sitting Bull (Miles and Lovett 1995:51). Throughout his pictorial autobiography, White Bull repeatedly describes himself as the nephew of Sitting Bull. He was, in fact, also an adopted son of his famous uncle. Among the many battles he took part in were the Fetterman Fight of 1866, the Wagon Box Fight of 1867, and the notorious Battle of Little Big Horn, where he claimed to be the one who killed Custer. Notably, he was also a player in the fiftieth reenactment of that battle, in 1926.

In 1931 and 1932, two men paid White Bull substantial sums to record his autobiography, both in pictures and in a Lakota text. Usher Burdick, a North Dakota lawyer, congressman, and avid student of Lakota culture, paid fifty dollars. Some months later, historian Walter Stanley Campbell paid White Bull seventy dollars for a similar account (Miles and Lovett 1995:54). These were substantial sums during the Depression years. Excerpts from the Campbell ledger book have been published (Vestal 1934; Miles and Lovett 1995), and the Burdick book has been published in full (Howard 1968).

As Miles and Lovett have pointed out (1995:59), a number of White Bull's relatives and associates also made pictographic drawings, among them Sitting Bull, Jumping Bull, and Moses Old Bull. All of them, including White Bull, continued the Lakota tradition of hewing closely to the conventions for autobiographical drawings that had been established by 1870 by Four

Horns and others (see cat. nos. 124, 126). To my knowledge, none of White Bull's associates produced as ambitious a manuscript as his. The Burdick manuscript contains thirty-nine drawings, each extensively annotated with a Lakota text. They focus principally on the highlights of his life as a warrior in the 1860s and 70s. The book begins with a winter count (textual rather than pictographic) for the years from 1764 to 1931, and an abbreviated textual account of White Bull's reservation-era life as a tribal policeman, judge, catechist, and chief (Howard 1968). It is noteworthy that in describing himself in these latter roles, for which there were no standardized pictorial conventions upon which to rely, White Bull omitted a visual record entirely rather than creating a new iconography, such as the Southern Plains warrior artists at Fort Marion did, for example (see Etahdleuh Doanmoe's drawings, cat. nos. 79–88).

JCB

WHITE BULL

151. White Bull Steals Crow Horses (Berlo, "A Brief History of Lakota Drawings," pl. 3 [p. 38])
152. The Ceremonial Camp Circle of the Minniconjou
1931
Pencil, crayon, and ink
10½ x 14¾ in. each
Elwyn B. Robinson Department of Special Collections, Chester Fritz Library, University of North Dakota, Grand Forks, OGL 183.29

In cat. no. 151, White Bull has recalled himself as a young warrior who has just succeeded in the dangerous act of stealing horses from a Crow encampment. The circle of Crow tipis is shown in miniature at the right with numerous hoof prints, indicating that he took the horses from within the camp itself—a most daring venture. He

speeds away with seven brown and beige horses, several of them labeled in Lakota "le waste" ("this was a good one"). Two small colts, labeled "cincala" ("young ones"), are drawn between the legs of the larger horses. While Lakota artists sometimes used a pictographic convention of representing just the horses' heads in a herd (see cat. nos. 113, 134, 135), White Bull has rendered them in fully realized form, creating an elegant group of overlapping bodies.

His inscription reads: "Chief White Bull. I was twenty-four years old. We brought them home safely. It took us four days to get home. They were really chasing us" (Howard 1968:69). With the advent of literacy in English, the artist himself made use of the complementary pairing of text and image. He amplified the image, much as he would have orally, a generation before, when such books were passed around a circle of cohorts. The text here is not at odds with the image, as in so many of the earlier examples where the inscriptions added later by owners were either inaccurate (see cat. no. 138) or overbearing (see cat. nos. 81, 82).

In cat. no. 152, White Bull has rendered a diagram of the traditional Minniconjou camp circle. He drew fifteen tipis around the perimeter of the circle, labeling in his Lakota text a number of important ones, including his own, the red one at the top of the page. He shows the Sacred Thunder tipi in the center and a number of figures walking and carrying pipes. Between the tipis, buffalo meat dries on racks. In the center of the circle he wrote in Lakota, "I have diagrammed these tipis as I remember them from living in the camp, my friend." The principal Lakota text has been translated as follows:

A long time ago there were many chiefs in the Minniconjou sub-band, but only a few are left. There were many good men among them, my friend. Now I have finished writing, August 14, 1931. I wrote this with my own hand, friend. They dried a lot of meat and hung it up. This was buffalo meat.

A long time ago these people planted their fields close to the water and raised good crops there. It was from this that they received their name [Minniconjou]. They maintained themselves that way, by raising fine crops. From this they got their name. My father told me this, my friend. They had a good reputation, friend (Howard 1968:80)

JCB

WHITE BULL
153. White Bull in Ceremonial Dress
1931
Pencil, crayon, and ink
10½ x 14¾ in.
Elwyn B. Robinson Department of Special Collections, Chester Fritz Library, University of North Dakota, Grand Forks, OGL 183.49

At the front of White Bull's ledger book is pasted a photographic portrait of the artist taken in his old age. He is seated in profile and wears his war bonnet and beaded leggings. Almost all of the drawings in the book refer to his exploits as a young warrior. But the photo at the beginning, and this splendid drawing of White Bull in his full chiefly ceremonial regalia, placed at the end of the book, bracket all those intervening images. In the drawing, he wears a long feather bonnet with extra eagle feathers attached to the red cloth edging, a beaded war shirt, and leggings with dragonflies painted on them. He carries a peace pipe and a feathered staff. Even White Bull's horse is decorated, with numerous feathers on mane, tail, and bridle, to indicate its history as a war pony. The text that surrounds this self-portrait reads as follows:

I prepared these pages my friend. Chief White Bull. I finished this on August 14, 1931. I am eighty-one years old. This is me in my costume which is worn on festive occasions. It looks fine when worn at the gatherings of the Lakotas. I wear this while riding in parades, and you have seen me wearing it, my friend. You have seen my deeds pictured. My war bonnet is double tailed. I have owned three of these, my

friend. The white horse I raised from a colt. It is eight years old August 14, 1931. I am the son of Makes-room. I am the nephew of Sitting Bull. One Bull is my brother. My friend, I have written and given many things to you. Are you satisfied? If there is any other thing that you wish let me hear from you. Then, I shake hands with you. I am your friend, Chief White Bull. The shirt I am wearing is a scalp shirt. It is the shirt of a chief. I am one of them (Howard 1968:82).

The text eloquently explains his position in Lakota society, and highlights the fact that making this book was an economic and intercultural transaction, as well as a highly personal act of self-revelation. On this page, White Bull finished writing and drawing his history. He was among the last to do so in this fashion.

JCB

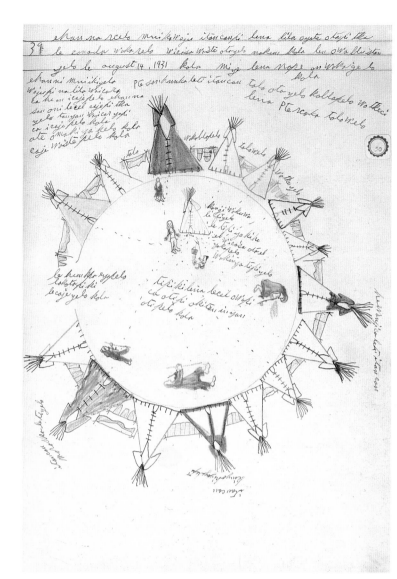

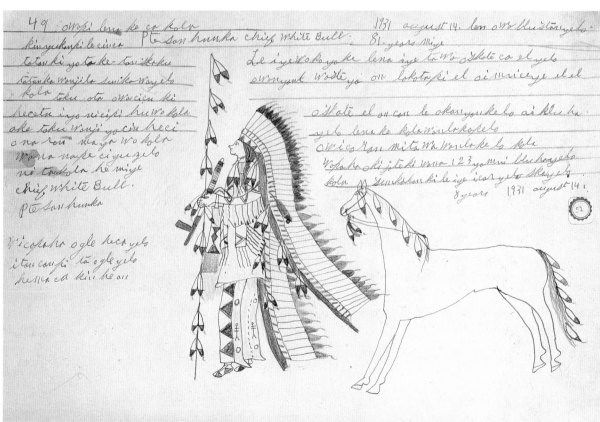

Bibliography

Alexander, Hartley Burr

1938 *Sioux Indian Painting*. Nice, France: C. Szwedzicki.

Amiotte, Arthur

1987 "The Lakota Sun Dance: Historical and Contemporary Perspectives." In *Sioux Indian Religion*. Ed. Raymond J. DeMallie and Douglas R. Parks. Norman: University of Oklahoma Press. 75–89.

1989 "An Appraisal of Sioux Arts." In *An Illustrated History of the Arts in South Dakota*. Ed. Arthur Huseboe. Sioux Falls, SD: The Center for Western Studies, Augustana College. 109–46.

Amiotte, Arthur, and Janet Catherine Berlo

1995 Typescript of an unpublished interview, April 1995.

Anderson, Gard Clayton, and Alan R. Woolworth, eds.

1988 *Through Dakota Eyes: Narrative Accounts of the Minnesota Indian War of 1862*. St. Paul: Minnesota Historical Society Press.

Anonymous

1894 "Still at Large." *Daily Herald*, El Reno, Oklahoma, February 2.

1969 "Rediscovery: An Indian Sketchbook." *Art in America* 57 (Sept./Oct.): 82–87.

1970 "Howling Wolf." *Massachusetts Eye and Ear* (June): 1, 4–6.

Auchiah, James

n.d. Correspondence in Richard H. Pratt Papers, box 22, fld. 719. Western Americana Collection, Beinecke Rare Book and Manuscript Library, Yale University, New Haven.

Batkin, Jonathan, ed.

1995 *Splendid Heritage: Masterpieces of Native American Art from the Masco Collection*. Santa Fe: Wheelwright Museum of the American Indian.

Battey, Thomas C.

1968 *The Life and Adventures of a Quaker Among the Indians*. Norman: University of Oklahoma Press.

Beede, Aaron McGaffey

n.d. "The Scientific Attitude of Indians." Undated manuscript. Beede Archives, North Dakota Historical Society, Bismarck, ND.

Benjamin, Walter

1960 "The Work of Art in the Age of Mechanical Reproduction." In *Studies on the Left* 1(2): 28–46.

Berlo, Janet Catherine

1982 "Wo-Haw's Notebooks: 19th Century Kiowa Indian Drawings in the Collection of the Missouri Historical Society." *Gateway Heritage: Journal of the Missouri Historical Society* 3(2): 2–13.

1990 "Portraits of Dispossession in Plains Indian and Inuit Graphics." *Art Journal* 49(2): 133–41.

n.d. "Arthur Amiotte's Collage Series 1988–1995: Lakota History, Art, and Social Criticism." Unpublished paper presented at Plains Indian Art Seminar, Buffalo Bill Historical Center, Cody, WY, Oct. 1995.

Berlo, Janet Catherine, ed.

1992 *The Early Years of Native American Art History*. Seattle: University of Washington Press.

Bernstein, Bruce

1995 "Dorothy Dunn and a Story of American Indian Painting." In *Modern by Tradition: American Indian Painting in the Studio Style*. Bruce Bernstein and W. Jackson Rushing. 3–25. Santa Fe: Museum of New Mexico Press.

Berthrong, Donald J.

1963 *The Southern Cheyennes*. Norman: University of Oklahoma Press.

1976 *The Cheyenne and Arapaho Ordeal: Reservation and Agency Life in the Indian Territory, 1875–1907*. Norman: University of Oklahoma Press.

Blish, Helen H.

1967 *A Pictographic History of the Oglala Sioux*. Lincoln: University of Nebraska Press.

Blume, Anna

1995 "Ways Through Amnesia: Photographs and Native American History." *Print Collector's Newsletter* 26(3): 113–15.

Bol, Marsha

forthcoming "Lakota Tourist Arts." *Unpacking Cultures: The Arts of Encounter in Colonial and Post-Colonial Worlds*. Ed. R. Phillips and C. Steiner. Berkeley: University of California Press.

Bourke, John G.

1872–96 Unpublished diaries, Library of the United States Military Academy, West Point, NY.

Boyd, Maurice

1981–83 *Kiowa Voices: Vol. I, Ceremonial Dance, Ritual and Song. Vol. II, Myths, Legends, and Folktales*. Fort Worth: Texas Christian University Press.

Brown, Dee
1991 *Bury My Heart at Wounded Knee: An Indian History of the American West*. New York: Vintage.

Buecker, Thomas, and R. Eli Paul
1994 *The Crazy Horse Surrender Ledger*. Lincoln: Nebraska State Historical Society.

Bush, Alfred, and Lee Clark Mitchell
1994 *The Photograph and the American Indian*. Princeton: Princeton University Press.

Caruth, Cathy, ed.
1995 *Trauma: Explorations in Memory*. Baltimore: Johns Hopkins University Press.

Catlin, George
1973 *Letters and Notes on the Manners, Customs and Conditions of the North American Indians*. 2 vols. New York: Dover Publications (reprint of 1844 ed.).

Chittenden, Hiram M., and Alfred T. Richardson
1969 *Life, Letters and Travels of Father De Smet*. 3 vols. New York: Arno Press and *The New York Times*.

Clark, W. P.
1885 *Indian Sign Language*. Philadelphia: L. R. Hamersly.

Cohodas, Marvin
1992 "Louisa Keyser and the Cohns: Mythmaking and Basket Making in the American West." In *The Early Years of Native American Art History*. Ed. Janet Catherine Berlo. Seattle: University of Washington Press. 88–133.

Commissioner of Indian Affairs
1868–74 *Annual Report of the Commissioner of Indian Affairs*. Washington, DC: Government Printing Office.

Conn, Richard
1979 *Native American Art in the Denver Art Museum*. Denver: Denver Art Museum.

Cowles, David C.
1982 White Swan: Crow Artist at the Little Big Horn. *American Indian Art Magazine* 7(4): 52–61.

Cronau, Rudolf
1890 *Im wilden Westen: Eine Künstlerfahrt durch die Prairien und Felsengebirge der Union*. Braunschweig, Germany: O Löbbeke.

Cullum, George W.
1891 *Biographical Register of the Officers and Graduates of the U.S. Military Academy at West Point, N.Y.* Boston: Houghton Mifflin.

Curtis, Edward S.
1908–9 *The North American Indian*. Vols. 3 and 4 (reprinted by Johnson Reprint Company, New York, 1970).

Cutschall, Colleen
1990 *Voice in the Blood: An Exhibition of Paintings by Colleen Cutschall*. Brandon: Art Gallery of Southwestern Manitoba.

DeMallie, Raymond J.
1978 "George Bushotter: First Lakota Ethnographer." *American Indian Intellectuals*. Ed. Margot Liberty. St. Paul: West Publishing. 90–102.
1984 *The Sixth Grandfather: Black Elk's Teachings Given to John G. Neihardt*. Lincoln: University of Nebraska Press.

DeMallie, Raymond J., and Elaine A. Jahner, eds.
1991 *Lakota Belief and Ritual*. Lincoln: University of Nebraska Press.

Densmore, Frances
1918 "Teton Sioux Music." *Bureau of American Ethnology Bulletin* (61). Washington DC: Smithsonian Institution (reprinted as *Teton Sioux Music and Culture*, University of Nebraska Press, 1992).

Dodge, Richard I.
1882 *Our Wild Indians: Thirty-Three Years' Personal Experience Among the Red Men of the Great West*. Hartford: A. D. Worthington.

Doll, Don
1994 *Vision Quest: Men, Women, and Sacred Sites of the Sioux Nation*. New York: Crown Publishing.

Dorsey, George A.
1905 "The Cheyenne." *Field Columbian Museum Publication* (99). Anthropological Series 9 (1, 2). Chicago: Field Columbian Museum.

Dunn, Dorothy
1968 *American Indian Painting of the Southwest and Plains Area*. Albuquerque: University of New Mexico Press.
1969 *1877: Plains Indian Sketch Books of Zo-Tom and Howling Wolf*. Flagstaff, AZ: Northland Press.

Eastman, Elaine Goodale
1935 *Pratt: The Red Man's Moses*. Norman: University of Oklahoma Press.

Eliade, Mircea
1975 *Myths, Dreams, and Mysteries*. New York: Harper Torchbooks.

Ellison, Rosemary
1972 Introduction. In *Contemporary Southern Plains Indian Painting*. Ed. Myles Libhart. Anadarko, Oklahoma: Oklahoma Indian Arts and Crafts Cooperative. 7–31.

Ewers, John C.
1939 *Plains Indian Painting: A Description of an Aboriginal American Art*. Palo Alto, CA: Stanford University Press.
1957 "Early White Influence upon Plains Indian Painting: George Catlin and Carl Bodmer Among the Mandan, 1832–34." *Smithsonian Miscellaneous Collections* 134(7): 1–11. Washington, DC: Smithsonian Institution.
1971 Review of J. J. Brody, *Indian Painters and White Patrons*. *The American West* 8: 50.
1978 *Murals in the Round: Painted Tipis of the Kiowa and Kiowa-Apache Indians*. Washington DC: Smithsonian Institution Press.

1983a "A Century and a Half of Blackfeet Picture Writing." *American Indian Art Magazine* 8(3): 52–61.

1983b "Plains Indian Artists and Anthropologists: A Fruitful Collaboration." *American Indian Art Magazine* 9(1): 36–44.

Ewers, John C., Helen M. Mangelsdorf, and William S. Wierzbowski

1985 *Images of a Vanished Life: Plains Indian Drawings from the Collection of the Pennsylvania Academy of the Fine Arts.* Philadelphia: Pennsylvania Academy of the Fine Arts.

Exposition of Indian Tribal Arts

1931 *Annual Report.* Wilmington, DE: John Sloan Archives, Delaware Art Museum.

Fane, Diana, Ira Jacknis, and Lise M. Breen

1991 *Objects of Myth and Memory: American Indian Art at the Brooklyn Museum.* Seattle: University of Washington Press.

Farnham, Charles

1900 *A Life of Francis Parkman.* Boston: Little, Brown.

Fehrenbach, T. R.

1994 *Comanches: Destruction of a People.* New York: Da Capo Press.

Filipiak, Jack D.

1964 The Battle of Summit Springs. *The Colorado Magazine* 41(4): 343–54.

Folsom, Cora Mae

n.d. "Memories of Old Hampton, Vol. 2." Unpublished manuscript. Hampton College Archives, Hampton, VA.

Forsyth, George A.

1994 *Thrilling Days in Army Life.* Lincoln: University of Nebraska Press.

Foucault, Michel

1979 *Discipline and Punish.* Trans. Alan Sheridan. New York: Vintage House.

Fowler, Loretta

1982 *Arapaho Politics, 1851–1978: Symbols in Crisis.* Lincoln: University of Nebraska Press.

Furst, Jill, and Peter Furst

1982 *North American Indian Art.* New York: Rizzoli.

Galante, Gary

1994a "The Kiowa Ledger Book." Exhibition brochure. Montclair, NJ: Montclair Art Museum.

1994b "A Very Fine Ledger Book of Drawings." In *Fine American Indian Art.* Auction catalogue (May 1994). New York: Sotheby's.

Garfield, Marvin H.

1931–32 "Defense of the Kansas Frontier, 1868–1869." *The Kansas Historical Quarterly* 1: 451–73.

Greene, Candace S.

1985 "Women, Bison and Coup: A Structural Analysis of Cheyenne Pictographic Art." Ph.D. diss., University of Oklahoma.

1992a "Artists in Blue: The Indian Scouts of Fort Reno and Fort Supply." *American Indian Art Magazine* 18(1): 50–57.

1992b "Silverhorn." In *Visions of the People: A Pictorial History of Plains Indian Life.* Ed. Evan Maurer. Minneapolis and Seattle: Minneapolis Institute of Arts and University of Washington Press. 162.

1993 "The Tepee with Battle Pictures." *Natural History* 102(10): 68–76.

Greene, Candace S., and Thomas Drescher

1994 "The Tipi with Battle Pictures: The Kiowa Tradition of Intangible Property Rights." *Trademark Reporter* 84(4): 418–33.

Greene, Candace S., and Frederick Reuss

1993 *Saynday Was Coming Along....* Washington, DC: Smithsonian Institution Traveling Exhibition Service.

Grinnell, George B.

n. d. "Double Trophy Roster," Unpublished manuscript, object file 10/8725, National Museum of the American Indian, New York.

1926 *By Cheyenne Campfires.* New Haven: Yale University Press.

1956 *The Fighting Cheyenne.* Norman: University of Oklahoma Press.

1972 *The Cheyenne Indians.* 2 vols. Lincoln: University of Nebraska Press (originally published in 1923).

Guilbert, Charles M., ed.

1988 *The Proper for the Lesser Feasts and Fasts Together with the Fixed Holy Days.* 4th ed., New York: The Church Hymnal Corporation.

Hamilton, Henry W., and Jean Tyree Hamilton

1971 *The Sioux of the Rosebud: A History in Pictures.* Norman: University of Oklahoma Press.

Harris, Moira F.

1989 *Between Two Cultures: Kiowa Art from Fort Marion.* St. Paul, MN: Pogo Press.

Heap of Birds, Edgar

1989 "Oh! Those South African Homelands You Impose U.S. Indian Reservations." In *Claim Your Color.* Edgar Heap of Birds, et al. New York: Exit Art. 22.

Hegeman, Susan

1989 "History, Ethnography, Myth: Some Notes on the 'Indian-Centered' Narrative." *Social Text* 23: 144–60.

Heidenreich, C. Adrian

1981 "The Crow Indian Delegation to Washington, D.C., in 1880." *Montana: The Magazine of Western History* 31(2): 54–67.

1984 "The Content and Context of Crow Indian Ledger Art." In *Proceedings of the Fifth Annual Plains Indian Seminar.* Ed. George Horse Capture and Gene Ball. Cody, WY: Buffalo Bill Historical Center. 111–32.

Hertz, Robert

1960 *Death and the Right Hand.* London: Cohen and West.

Hewitt, J. N. B., ed.

1937 "The Journal of Rudolf Friederich Kurz." *Bureau of American Ethnology Bulletin* (115). Washington, DC: Smithsonian Institution.

Hill, Tom

1994 "Visual Prayers." In *Creation's Jour-
ney: Native American Identity and
Belief.* Ed. Tom Hill and Richard W.
Hill, Sr. Washington, DC: Smithson-
ian Institution Press. 65–106.

Hodge, F. W., Oliver La Farge,
and Herbert J. Spinden

1931 *Introduction to American Indian
Art.* 2 vols. New York: Exposition of
Indian Tribal Arts.

Hoebel, E. Adamson

1978 *The Cheyennes.* New York: Holt,
Rinehart, and Winston.

Hoebel, E. Adamson, and
Karen Daniels Petersen

1964 *A Cheyenne Sketchbook (by Cohoe).*
Norman: University of Oklahoma
Press.

Hoig, Stan

1993 *Tribal Wars of the Southern Plains.*
Norman: University of Oklahoma
Press.

Horse Capture, George, Anne Vitart,
Michel Waldberg, and
W. Richard West, Jr.

1993 *Robes of Splendor: Native Ameri-
can Painted Buffalo Hides.* New
York: The New Press.

Horse Capture, Joseph

1992 Catalogue entry. In *Visions of the
People: A Pictorial History of Plains
Indian Life.* Ed. Evan Maurer. Min-
neapolis and Seattle: Minneapolis
Institute of Arts and University of
Washington Press. 235.

Howard, James, H., ed.

1968 *The Warrior Who Killed Custer: The
Personal Narrative of Chief Joseph
White Bull.* Lincoln: University of
Nebraska Press.

Hoxie, Frederick E.

1984 *A Final Promise: The Campaign to
Assimilate the Indians, 1880–1920.*
Lincoln: University of Nebraska
Press.

Hultgren, Mary Lou

1987 "American Indian Collections of
the Hampton University Museum."
American Indian Art Magazine
13(1): 32–39.

Hyde, George E.

1967 *Life of George Bent Written from
His Letters.* Ed. Savoie Lottinville.
Norman: University of Oklahoma
Press.

Hyer, Sally

1990 *One House, One Voice, One Heart:
Native American Education at the
Santa Fe Indian School.* Santa Fe:
Museum of New Mexico Press.

Jacobson, Oscar B.

n.d. Unpublished manuscript, Papers of
Oscar Jacobson, Western History
Collection, University of Oklahoma.

1929 *Kiowa Indian Painting.* Nice,
France: C. Szwedzicki.

Jensen, Dana O.

1950 "Wo-Haw: Kiowa Warrior." *Bulletin
of the Missouri Historical Society*
7(1): 76–88.

Jensen, Richard, R. E. Paul, and
J. E. Carter

1991 *Eyewitness at Wounded Knee.*
Lincoln: University of Nebraska Press.

Jonaitis, Aldona

1992 "Franz Boas, John Swanton, and the
New Haida Sculpture at the American
Museum of Natural History." In *The
Early Years of Native American Art
History.* Ed. Janet Catherine Berlo.
Seattle: University of Washington
Press. 22–61.

Jones, Douglas C.

1966 *The Treaty of Medicine Lodge: The
Story of the Great Treaty Council
as Told by Eyewitnesses.* Norman:
University of Oklahoma Press.

Josephy, Alvin M., Jr., Trudy Thomas,
and Jeanne Eder

1990 *Wounded Knee: Lest We Forget.*
Cody, WY: Buffalo Bill Historical
Center.

Kappler, Charles J., ed.

1904 *Indian Affairs: Laws and Treaties.*
Washington, DC: Government Print-
ing Office.

Karol, Joseph, ed.

1969 *Red Horse Owner's Winter Count:
The Oglala Sioux 1786–1968.*
Martin, SD: Booster Publishing.

Kluckhohn, Clyde, W. W. Hill, and
L. W. Kluckhohn

1971 *Navaho Material Culture.* Cam-
bridge: Harvard University Press.

Kubler, George

1962 *The Shape of Time: Remarks on
the History of Things.* New Haven:
Yale University Press.

LaBarre, Weston, ed.

n.d. "Notes on Kiowa Ethnography:
Santa Fe Laboratory of Anthropolo-
gy Expedition, 1935," unpublished
manuscript. Papers of Weston
LaBarre, National Anthropological
Archives, Smithsonian Institution.

LaMont, Barbara Loeb

1975 "The Schild Ledger: Plains Indian
Drawings," Master's thesis, Depart-
ment of American Studies, University
of Texas, Austin.

Lessard, Dennis

1992 "Plains Pictographic Art: A Source
of Ethnographic Information."
American Indian Art Magazine
17(2): 62–69.

Lévi-Strauss, Claude

1963 *Totemism.* Boston: Beacon Press.

Libhart, Myles, ed.

1972 *Contemporary Southern Plains
Indian Painting.* Anadarko, OK:
Oklahoma Indian Arts and Crafts
Cooperative.

Llewellyn, K. N., and E. Adamson Hoebel

1941 *The Cheyenne Way: Conflict and
Case Law in Primitive Jurispru-
dence.* Norman: University of Okla-
homa Press.

Ludlow, Helen

1881 Indian Education at Hampton and Carlisle. *Harper's New Monthly Magazine* 62(371): 659–75.

1893 *Twenty-Two Years Work of the Hampton Normal and Agricultural Institute at Hampton, Virginia.* Hampton, VA: Normal School Press.

Mallery, Garrick

1886 "Pictographs of the North American Indians: A Preliminary Paper." In *Fourth Annual Report of the Bureau of Ethnology, 1882–83.* Washington, DC: Smithsonian Institution.

1893 "Picture-Writing of the American Indians." In *Tenth Annual Report of the Bureau of Ethnology, 1888–89.* Washington, DC: Smithsonian Institution (reprinted in 2 vols. by Dover Publications, 1972).

Mardock, Robert Winston

1971 *The Reformers and the American Indian.* Columbia: University of Missouri Press.

Margolin, Linda G.

1991 "A Lakota Autograph Book from the Detroit Institute of Arts," Master's thesis, Department of Art History, Wayne State University, Detroit.

Marriott, Alice

1956 "The Trade Guild of the Southern Cheyenne Women." *Bulletin of the Oklahoma Anthropological Society* 4: 19–27.

Maurer, Evan

1977 *The Native American Heritage.* Lincoln: University of Nebraska Press.

1992 *Visions of the People: A Pictorial History of Plains Life.* Ed. Evan Maurer. Minneapolis and Seattle: Minneapolis Institute of Arts and University of Washington Press.

McCoy, Ronald

1984 "Images of the Buffalo Culture." *The World and I* (April): 624–73.

1987 *Kiowa Memories: Images from Indian Territory, 1880.* Santa Fe, NM: Morning Star Gallery.

1992 "Short Bull: Lakota Visionary, Historian, and Artist." *American Indian Art Magazine* 17(3): 54–65.

1994 "Swift Dog: Hunkpapa Warrior, Artist, and Historian." *American Indian Art Magazine* 19(3): 68–75.

Mead, Mary E.

1927 "Story of Western Experience," Parts 1 and 2. *Western Nebraska Churchman* 21(12): 1–10; 22(1): 13–21.

Merrill, William, Marion K. Hansson, Candace S. Greene, and Frederick Reuss

1996 "A Guide to the Kiowa Collections in the Smithsonian Institution." *Contributions to Anthropology,* National Museum of Natural History, Smithsonian Institution. Washington, DC: Smithsonian Institution.

Methvin, J. J., Rev.

n.d. *In the Limelight or History of Anadarko and Vicinity from the Earliest Days.* Anadarko, Oklahoma.

Mignolo, Walter D.

1994 Afterword. In *Writing Without Words.* Ed. Elizabeth Hill Boone and Walter D. Mignolo. Durham and London: Duke University Press. 270–313.

Miles, Nelson A.

1896 *Personal Recollections and Observations of General Nelson A. Miles.* Chicago: Werner.

Miles, Ray, and John R. Lovett

1994 "The Pictorial Autobiography of Moses Old Bull." *American Indian Art Magazine* 19(3): 48–57.

1995 "'Deeds That Put a Man Among the Famous': The Pictographs of Joseph White Bull." *American Indian Art Magazine* 20(2): 50–59.

Milner II, Clyde A., Carol A. O'Connor, and Martha Sandweiss

1994 *The Oxford History of the American West.* New York: Oxford University Press.

Missouri Republican

1867–68 Missouri Historical Society, St. Louis.

Momaday, M. Scott

1969 *The Way to Rainy Mountain.* Albuquerque: University of New Mexico Press.

1976 *The Names: A Memoir.* Tucson: University of Arizona Press.

Mooney, James

n.d. Unpublished manuscripts 2531 and 2538, National Anthropological Archives, Smithsonian Institution.

1896 "The Ghost Dance Religion and the Sioux Outbreak of 1890." In *Fourteenth Annual Report of the Bureau of American Ethnology.* Washington, DC: Smithsonian Institution (reprinted by the University of Chicago Press, 1965).

1898 "Calendar History of the Kiowa Indians." In *17th Annual Report of the Bureau of American Ethnology.* Washington, DC: Smithsonian Institution (reprinted by the Smithsonian, 1979).

1907 "The Cheyenne Indians." *Memoirs of the American Anthropological Association* 1(6): 357–442.

Moore, John H.

1974 "A Study of Religious Symbolism Among the Cheyenne Indians," Ph.D. diss., New York University.

1984 "Cheyenne Names and Cosmology." *American Ethnologist* 11: 291–312.

1987 *The Cheyenne Nation: A Social and Demographic History.* Lincoln: University of Nebraska Press.

Nagy, Imre J.

1994 "A Typology of Cheyenne Shield Designs." *Plains Anthropologist* 39(147): 5–36.

Needham, Rodney, ed.

1974 *Right and Left: Essays on Dual Symbolic Classification.* Chicago: University of Chicago Press.

Neihardt, John G.

1972 *Black Elk Speaks: Being the Life Story of a Holy Man of the Oglala Sioux.* New York: Pocket Books (originally published in 1931).

Nye, Wilbur Sturtevant

1962 *Bad Medicine and Good: Tales of the Kiowas.* Norman: University of Oklahoma Press.

1969 *Carbine and Lance: The Story of Old Fort Sill.* Norman: University of Oklahoma Press.

Parsons, Elsie Clews

1929 "Kiowa Tales." *American Folklore Society Memoirs* 22: 1–151.

1941 "Notes on the Caddo." *Memoirs of the American Anthropological Association* (57).

Penney, David W.

1992 *Art of the American Indian Frontier.* Seattle: University of Washington Press.

Petersen, Karen Daniels

1964 "Cheyenne Soldier Societies." *Plains Anthropologist* 9: 146–72.

1968 *Howling Wolf: A Cheyenne Warrior's Graphic Interpretation of His People.* Palo Alto, CA: American West Publishing.

1971 *Plains Indian Art from Fort Marion.* Norman: University of Oklahoma Press.

1988 *American Pictographic Images: Historical Works on Paper by Plains Indians.* Santa Fe, NM: Morning Star Gallery.

1990 *The Edwards Ledger Drawings: Folk Art by Arapaho Warriors.* New York: David A. Schorsch.

Peterson, Jacqueline, with Laura Peers

1993 *Sacred Encounters: Father DeSmet and the Indians of the Rocky Mountain West.* Norman: University of Oklahoma Press.

Petroski, Henry

1990 *The Pencil: A History of Design and Circumstance.* New York: Alfred A. Knopf.

Phillips, Ruth

1989 "Souvenirs from North America: The Miniature as Image of Woodlands Indian Life." *American Indian Art Magazine* 14(2): 52–63, 78–79.

Phillips, Ruth and Christopher Steiner, eds.

forthcoming *Unpacking Cultures: The Arts of Encounter in Colonial and Post-Colonial Worlds.* Berkeley: University of California Press.

Porte Crayon

1876 "Sitting Bull—Autobiography of the Famous Sioux Chief." *Harper's Weekly Supplement* (July 29): 625–28.

Porter, Joseph

1986 *Paper Medicine Man: John Gregory Bourke and His American West.* Norman: University of Oklahoma Press.

Powell, Peter J.

1969 *Sweet Medicine: The Continuing Role of the Sacred Arrows, the Sun Dance, and the Sacred Buffalo Hat in Northern Cheyenne History.* 2 vols. Norman: University of Oklahoma Press.

1975a "Artists and Fighting Men: A Brief Introduction to Northern Cheyenne Ledger Book Drawing." *American Indian Art Magazine* 1(1): 44–48.

1975b "High Bull's Victory Roster." *Montana: The Magazine of Western History* 25(1): 14–21.

1976 "They Drew from Power: An Introduction to Northern Cheyenne Ledger Book Art." In *Montana Past and Present.* Peter J. Powell and Michael Malone. Los Angeles: William Andrews Clark Library, University of California. 3–54.

1981 *People of the Sacred Mountain: A History of the Northern Cheyenne Chiefs and Warrior Societies, 1830–1879, with an Epilogue, 1969–1974.* 2 vols. San Francisco: Harper and Row.

Pratt, Richard H.

1872–1924 Richard H. Pratt Papers, Western Americana Collection, Beinecke Rare Book and Manuscript Library, Yale University, New Haven.

1964 *Battlefield and Classroom.* Ed. Robert M. Utley. New Haven and London: Yale University Press.

Praus, Alexis A.

1955 "A New Pictographic Autobiography of Sitting Bull." *Smithsonian Miscellaneous Collections* 123(6): 1–4. Washington, DC: Smithsonian Institution.

Prucha, Francis Paul

1976 *American Indian Policy in Crisis: Christian Reformers and the Indian, 1865–1900.* Norman: University of Oklahoma Press.

1978 *Americanizing the American Indians: Writings of the "Friends of the Indian," 1880–1900.* Lincoln: University of Nebraska Press.

1985 *Peace and Friendship: Indian Peace Medals in the United States.* Washington, DC: National Portrait Gallery.

1994 *American Indian Treaties.* Berkeley: University of California Press.

Quimby, George I.

1965 "Plains Art from a Florida Prison." *Bulletin of the Chicago Natural History Museum* 36(10): 2–5.

Ritzenthaler, Robert

1961 "Sioux Indian Drawings," Primitive Art Series 1, portfolio and unpaginated brochure. Milwaukee: Milwaukee Public Museum.

Robertson, Valerie

1992 "Plains Ledger Art: The Demonstration of a Way of Life Through the Nineteenth Century Pictorial Account of an Unknown Assiniboine Artist." *Prairie Forum* 17(2): 263–74.

1993 *Reclaiming History: Ledger Drawings by the Assiniboine Artist Hongeeyesa.* Calgary: Glenbow-Alberta Institute.

Rodee, Howard

1965 "The Stylistic Development of Plains Indian Painting and Its Relationship to Ledger Drawings." *Plains Anthropologist* 10(30): 218–32.

Rushing, W. Jackson

1992 "Street Chiefs and Native Hosts: Richard Ray Whitman and Edgar Heap of Birds Defend the Homeland." In *Green Acres: Neocolonialism in the United States.* Ed. Christopher Scoates. St. Louis: Washington University Gallery of Art. 23–36.

1995a "Modern by Tradition: The 'Studio Style' of Native American Painting." In *Modern by Tradition: American Indian Painting in the Studio Style.* Bruce Bernstein and W. Jackson Rushing. Santa Fe: Museum of New Mexico Press. 27–73.

1995b *Native American Art and the New York Avant-Garde: A History of Cultural Primitivism.* Austin: University of Texas Press.

Schrader, Robert Fay

1983 *The Indian Arts and Crafts Board: An Aspect of New Deal Policy.* Albuquerque: University of New Mexico Press.

Scott, Hugh

1911 "Notes on the Kado, or Sun Dance of the Kiowa." *American Anthropologist* n.s. 13: 345–79.

Shine, Carolyn, and Mary L. Meyer

1976 *The Art of the First Americans.* Cincinnati: Cincinnati Art Museum.

Silberman, Arthur

1978 *100 Years of Native American Painting.* Oklahoma City: Oklahoma Museum of Art.

Smith, DeCost

1944 *Indian Experiences.* Caldwell, Idaho: Caxton Printers.

Smith, Linda Franklin

1988 "Pictographic Drawings at the Carlisle Indian Industrial School." *Cumberland County History* 5(2): 100–7.

Sotheby's

1994 *Fine American Indian Art.* Auction catalogue (Oct. 1994). New York: Sotheby's.

Starita, Joe

1995 *The Dull Knives of Pine Ridge: A Lakota Odyssey.* New York: G. P. Putnam's Sons.

Stirling, Matthew W.

1938 "Three Pictographic Autobiographies of Sitting Bull." *Smithsonian Miscellaneous Collections* 97(5): 1–56. Washington, DC: Smithsonian Institution.

Stowe, Harriet Beecher

1877 "The Indians at St. Augustine." *The Christian Union* 15 (April 17, 25): 345, 372–73.

Supree, Burton

1977 *Bear's Heart: Scenes from the Life of a Cheyenne Artist of One Hundred Years Ago with Pictures by Himself.* Philadelphia and New York: J. B. Lippincott.

Svingen, Orlan J.

1993 *The Northern Cheyenne Indian Reservation 1877–1900.* Niwot: University Press of Colorado.

Szabo, Joyce M.

1984 "Howling Wolf: A Plains Artist in Transition." *Art Journal* 44(4): 367–73.

1989 "Medicine Lodge Treaty Remembered." *American Indian Art Magazine* 14(4): 52–59, 87.

1991a "A Case of Mistaken Identity: Plains Picture Letters, Fort Marion, and Sitting Bull." *American Indian Art Magazine* 16(4): 48–55, 89.

1991b "New Places and New Spaces: Nineteenth-Century Plains Art in Florida." *Archaeology, Art and Anthropology: Papers in Honor of J. J. Brody,* Archaeological Society of New Mexico Papers 18: 193–201.

1992 "Howling Wolf: An Autobiography of a Plains Warrior-Artist." *Allen Memorial Art Museum Bulletin* 46(1). Oberlin, OH: Oberlin College.

1994a "Chief Killer and a New Reality: Narration and Description in Fort Marion Art." *American Indian Art Magazine* 19(2): 50–57.

1994b "Shields and Lodges, Warriors and Chiefs: Kiowa Drawings as Historical Records." *Ethnohistory* 41(1): 1–24.

1994c *Howling Wolf and the History of Ledger Art.* Albuquerque: University of New Mexico Press.

1994d "Howling Wolf: An Autobiography of a Plains Warrior-Artist." *Gallery Guide* (Jan.). Albuquerque: University Art Museum, University of New Mexico.

Tanner, Helen Hornbeck

1974 *Caddo Indians IV: The Territory of the Caddo Tribe of Oklahoma.* New York: Garland Publishing.

Tips, Carlos

1962 "Texanische Indianerbogen." *Der deutsche Jäger* 25 (Mar. 9): 506–8.

Trenholm, Virginia Cole

1970 *The Arapahoes, Our People.* Norman: University of Oklahoma Press.

Turner, Victor

1969 *The Ritual Process.* Ithaca, NY: Cornell University Press.

Utley, Robert M.

1973 *Frontier Regulars: The United States Army and the Indian, 1866–1891.* Lincoln: University of Nebraska Press.

1993 *The Lance and the Shield: The Life and Times of Sitting Bull.* New York: Henry Holt.

Vaughan, Alden T., ed.

1985 *Early American Indian Documents: Treaties and Laws, 1607–1789.* Frederick, MD: University Publications of America.

Vestal, Stanley

1934 *Warpath: The True Story of the Fighting Sioux Told in a Biography of Chief White Bull.* Boston: Houghton Mifflin.

Wade, Edwin L.

n.d. "Reading Between the Lines: The Aesthetics of Internment," paper presented at the Native American Art Studies Association, Santa Fe, November 1993.

Walker, J. R.

1917 "The Sun Dance and Other Cere-
 monies of the Oglala Division of the
 Teton Dakota." *Anthropological
 Papers of the American Museum of
 Natural History* 16 (Part 2).

Warner, Christopher, ed.

1985 *Ledger Art of the Crow and Gros
 Ventre Indians: 1879–1897.* Billings,
 MT: Yellowstone Art Center.

Watkins, Albert

1913 "First Steamboat Trial up the
 Missouri." *Collections of the
 Nebraska State Historical Society*
 17: 162–204.

Watkins, Laurel J.

1984 *A Grammar of Kiowa.* Lincoln:
 University of Nebraska Press.

Watson, Ken

1985 *Paddle Steamers: An Illustrated
 History of Steamboats on the
 Mississippi and Its Tributaries.* New
 York: W. W. Norton.

Weidman, Dennis, and Candace S. Greene

1988 "Early Kiowa Peyote Ritual and Sym-
 bolism: The 1891 Drawing Books of
 Silverhorn (Haungooah)." *American
 Indian Art Magazine* 13(4): 32–41.

Wheeler, Homer W.

1990 *Buffalo Days: The Personal Narra-
 tive of a Cattleman, Indian Fighter
 and Army Officer.* Lincoln and Lon-
 don: University of Nebraska Press.

Whipple, Henry B.

n.d. Unpublished papers, Minnesota
 Historical Society, St. Paul.

1876 "Mercy to Indians." *The New York
 Daily Tribune* (Apr. 1).

Whitman, William B.

1985 "Steamboats on Western Rivers."
 *Gateway Heritage: Journal of
 the Missouri Historical Society*
 5 (Spring): 2–11.

Wildhage, Wilhelm

1990 "Material on Short Bull." *European
 Review of Native American Studies*
 4(1): 35–42.

Williams, Jean Sherrod, ed.

1990 *American Indian Artists: The Avery
 Collection and the McNay Perma-
 nent Collection.* San Antonio, TX:
 The Marion Koogler McNay Art
 Museum.

Wissler, Clark

1905 "The Whirlwind and the Elk in the
 Mythology of the Dakota." *The Jour-
 nal of American Folklore* 18(71):
 257–68.

1912 "Societies and Ceremonial Associa-
 tions in the Oglala Division of the
 Teton-Dakota." *Anthropological
 Papers of the American Museum of
 Natural History* 11 (Part 1).

Witmer, Linda F.

1993 *The Indian Industrial School,
 Carlisle, Pennsylvania, 1879–1918.*
 Carlisle, PA: Cumberland County
 Historical Society.

Wong, Hertha Dawn

1989a "Pictographs As Autobiography:
 Plains Indian Sketchbooks of the
 Late Nineteenth and Early Twentieth
 Centuries." *American Literary His-
 tory* 1(2): 295–316.

1989b *Sending My Heart Back Across the
 Years: Tradition and Innovation
 in Native American Autobiography.*
 New York and London: Oxford
 University Press.

Wooley, David

n.d. "Male Artists At Standing Rock
 Reservation," lecture given at
 Wheelwright Museum, Santa Fe,
 May 1995.

Wooley, David, and
 Joseph D. Horse Capture

1993 "Joseph No Two Horns, He Nupa
 Wanica." *American Indian Art
 Magazine* 18(3): 32–43.

Young, Gloria

1986 "Aesthetic Archives: The Visual
 Language of Plains Ledger Art." *The
 Arts of the North American Indian:
 Native Traditions in Evolution.* Ed.
 Edwin L. Wade. New York: Hudson
 Hills Press. 43–62.

About the Contributors

Janet Catherine Berlo is Professor of Art History at the University of Missouri–St. Louis. She has also taught at the University of California–Los Angeles and at Yale, where she received her Ph.D. She has published books and articles on numerous topics on the art history and archaeology of the Americas. From 1994 to 1996, Berlo's work on the Plains graphic arts tradition was supported by grants from the Getty Foundation and the National Endowment for the Humanities.

Anna Blume is an independent scholar living in New York City. She is currently writing a manuscript on the nature of images as they circulate between cultures in Central America.

Jennifer A. Crets received her B.A. in art history and her M.A. in history from the University of Missouri–St. Louis. She is currently Manuscript Specialist at the Western Historical Manuscripts Collection at the University of Missouri–St. Louis.

Colleen Cutschall is an artist of Oglala-Sicangu descent living and working in Manitoba, Canada. She is Associate Professor and Coordinator of Visual Arts at Brandon University, specializing in Aboriginal art history. Her recent writing and curating activities include the exhibition and catalogue *Jackson Beardy: A Life's Work* (1993), toured by the Winnipeg Art Gallery.

Candace S. Greene is Specialist for North American Ethnology in the Department of Anthropology of the National Museum of Natural History, Smithsonian Institution. Her research interests center on the art and culture of the Southern Plains, and she is currently working on a book on the Kiowa artist Silverhorn. She holds a Ph.D. in anthropology from the University of Oklahoma.

Edgar Heap of Birds is a leader of the Cheyenne Elk Warriors Society and an instructor in the Cheyenne earth renewal ceremony. He is also a great-great-grandson of Cheyenne principal chief Many Magpies (Heap of Birds), who was imprisoned at Fort Marion. He has completed graduate work leading to an M. F. A. at the Royal College of Art, London, and the Tyler School of Art, Philadelphia, and teaches at the University of Oklahoma. Heap of Birds's art works are exhibited nationally and internationally.

Marilee Jantzer-White is a Ph.D. candidate in art history at the University of California–Los Angeles. She is completing her dissertation on the iconography of American Indian activism in Minnesota during the 1960s and 1970s. She has published on Native artist Tonita Peña in *American Indian Quarterly* (1994).

Gerald McMaster (Plains Cree) was born in Saskatchewan, Canada, and grew up near North Battleford on the Red Pheasant Reserve. He has been the Curator of Contemporary Indian Art at the Canadian Museum of Civilization since 1981. He is an active visual artist and author of numerous articles on contemporary Aboriginal art and culture. McMaster served as the Curator for the Canadian Pavilion at the 1995 Venice Biennale.

Jane Ash Poitras (Cree/Chipewyan), one of Canada's most acclaimed artists, received her M.F.A. from Columbia University. Her work is in many major collections, including those of The Brooklyn Museum, The Canadian Museum of Civilization, Yale University, and the Winnipeg, Vancouver, and Edmonton Art Galleries.

W. Jackson Rushing is Associate Professor of Art History at the University of Missouri–St. Louis, author of *Native American Art and the New York Avant-Garde: A History of Cultural Primitivism* (University of Texas Press, 1995), and co-author of *Modern by Tradition: American Indian Painting in the Studio Style* (Museum of New Mexico Press, 1995). He has been a fellow of the National Endowment for the Humanities and the Howard Foundation at Brown University.

Jacki Thompson Rand (Choctaw) is a Ph.D. candidate in the Department of History at the University of Oklahoma, where she was awarded an American Fellowship from the American Association of University Women. Her dissertation focuses on late nineteenth-century American Indian history, with specific attention to Kiowa material culture. She worked for the Smithsonian Institution from 1983 to 1994.

Joyce M. Szabo, Associate Professor of Art History at the University of New Mexico, wrote her dissertation on ledger art, and has published on various aspects of Plains representational imagery. In addition, she is the author of *Howling Wolf and the History of Ledger Art* (University of New Mexico Press, 1994).

Jennifer Vigil (Navajo/Hispanic/Euro-American) is a Ph.D. student in art history at the University of Iowa, specializing in twentieth-century cultural studies and Native American art history. She worked in the American Indian Program at the Smithsonian's National Museum of Natural History before attending graduate school.

Edwin L. Wade is Deputy Director of the Museum of Northern Arizona, Flagstaff. Among his numerous publications are *Art of the North American Indian: Native Arts in Evolution* (Hudson Hills Press, 1986) and *The Thomas Keams Collection of Hopi Pottery* (Heard Museum, 1980). He has curated many traveling exhibitions, including *What Is Native American Art?* and *Beyond the Prison Gate: The Artistic Legacy of the Fort Marion Experience*.

Francis Yellow is a Lakota warrior artist of Hunkpapa, Kul Wicasa, Oohe Numpa, Itazipcola, and French heritage who grew up in a Catholic boarding school and returned to the People when old enough to make the choice. Although educated up to the graduate level, he is proud to say that before he was educated, he learned how to learn through the Lakota ways.

233

Index